D1265898

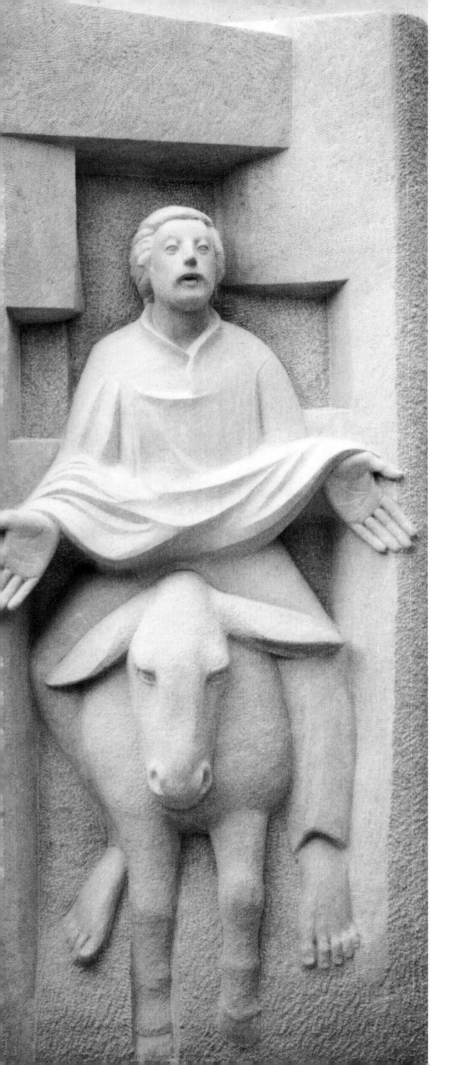

DIVINE FAVOR

THE ART OF JOSEPH O'CONNELL

EDITOR
Colman O'Connell, O.S.B.

PHOTOGRAPHY
RESEARCH
Fredric Petters

DESIGN
Greg Becker

INTRODUCTION
Dear Joe
by J. F. Powers

TRIBUTE
He Was in the Arts, You Know
by Garrison Keillor

A Liturgical Press Book

 THE LITURGICAL PRESS
Collegeville, Minnesota

Cover: *Eve in Baroque* (detail), 1990, marble

Title page: *Christ the King* (detail), 1995, limestone

All photographs are by the artist, except the following:

Greg Becker: cover, pages 25, 77, 86, 87

Peg Murphy: title page, pages 84, 100, 101, 102, 103, 104, 112

Fredric Petters, Jr.: pages 16, 40–41, 47, 92, 93

Art Direction: Ann Blattner

© 1999 by The Order of Saint Benedict, Inc., Collegeville, Minnesota. All rights reserved. No part of this book may be reproduced in any form or by any means, electronic or mechanical, including photo-copying, recording, taping, or any retrieval system, without the written permission of The Liturgical Press, Collegeville, MN 56321. Printed in the United States of America.

1 2 3 4 5 6 7 8

Library of Congress Cataloguing-in-Publication Data

Divine favor : the art of Joseph O'Connell / editor, Colman O'Connell ;
 photography research, Fredric Petters : design, Greg Becker ;
 introduction by J.F. Powers.
 p. cm.
 ISBN 0-8146-2573-8 (alk. paper)
 1. O'Connell, Joseph, 1927–1995—Appreciation. I. O'Connell,
Colman.
N6537.0265D58 1999
709'.2—dc21 99–37605
 CIP

Contents

Preface

COLMAN O'CONNELL, O.S.B.

Joseph O'Connell's many friends have agreed that a book of photographs of the artist's work should be made available to the widest possible audience. Collaborating as writers, designers, photographers, and editors, these friends present the following pages as glimpses of the prodigious creativity of Joe, the master-artist: printmaker and sculptor of wood, metal, and stone.

Those of us who live in Saint Joseph and Collegeville, Minnesota, where Joe produced most of his work, have watched these deeply moving sculptures and prints take shape in the studios where Joe labored among us for forty years. We have been moved by Joe's fearlessly exposing oppression and poverty in our affluent society. We have been filled with hope as we share the wisdom of Joe's insights into the glory and folly of the human condition. We have laughed in surprise at Joe's probing the human and humorous side of familiar religious themes. His work has forced us to look unblinkingly at both the degradation and the splendor of our lives.

We realize that these experiences are vivid, not just because of the artist's choice of subjects—moving as these are—but because of the magic of Joe's art, grounded in a consummate craftsmanship. Influenced as a young artist by Eric Gill's liturgical art, O'Connell, too, produced many works inspired by religious themes. He had an unsettling ability to put familiar scriptural images, like Christ the King or Judas Iscariot, into a contemporary scene where we prefer not to see them. Working as sculptor and printmaker,

O'Connell developed his own visual voice, a unique style—at once representational and stylized, simple and elegant—which distinguishes his work from that of other twentieth-century artists. He honed his skills as a sculptor, using no power tools, but only chisels and hammers like those of the master-craftsmen who carved stone images on the great medieval cathedrals.

While the life of Joseph O'Connell ought to be written, we designed this book of photographs only to introduce the artist's principal works to a broader public. Readers, however, will find a brief sketch of O'Connell's life and work in the "Chronology of the Principal Events in the Life and Work of Joseph O'Connell"; an affectionate introduction to the life of Joe as artist and friend in the Introduction, "Dear Joe," by J. F. Powers; and a tribute to the man and artist in Garrison Keillor's "He Was in the Arts, You Know." The other writers present reflections on their favorite works. They represent the hundreds of viewers who admire a favorite print or sculpture.

Joseph O'Connell's friends are confident that their ranks will swell as you view the photographs in *Divine Favor*.

Dear Joe

J. F. POWERS

Joe O'Connell—his mother's maiden name was DesMarais—was born in 1927 in Chicago. His father was a principal in the public schools there. His paternal grandfather worked for the telephone company and had invented things for it, for which he was rewarded by the company. He liked Joe. Joe liked him too. Joe also liked the wrought-iron fence in front of his grandfather's house. He hoped to have one like it someday.

Joe's best friend (they'd met in second grade) had become a fine jazz pianist and singer at the Drake Hotel and now went by the name Buddy Charles. Buddy's stepfather was Muggsy Spanier, the famous cornetist. (Joe's first-born, Tom, was named after Buddy's brother, a director in Hollywood.) After leaving home, Joe had lived for a time with Muggs, his wife, Ruth, and Buddy in their big apartment. Muggs had turned into one of Joe's best subjects—Joe was a marvelous mimic, but in no other sense an artist yet. He drove a Checker cab at night. During the last year of World War II, he served in the Army, mostly on Okinawa.

In 1953 Joe and Jody Wylie, herself an artist, a lovable, lethal, left-handed caricaturist, had met at a commercial art college in the Loop, were married in Holy Name Cathedral, and went to live in the woods near Chesterton, Indiana, near the Dunes.

They had decided to rent an old house there because of friends who owned a new house nearby, Norbert and Harriet Smith, both painters of some reputation. Norbert's day job was art director of an advertising agency on Michigan Avenue in Chicago and Harriet's was the Smith children. Norbert had encouraged Joe to do *something* and had got him his first commission—a couple of carved pilasters for a Swedish society of some kind. Joe got his next commission—a short, life-size Saint Francis holding a bird, in limestone—for a church in Chicago.

Joe was then offered and accepted a teaching job for a year in the art department of Saint John's University at Collegeville, Minnesota. After that, Joe accepted an offer from Siena Heights College in Adrian, Michigan, where

Joseph O'Connell, 1992

he and Jody were well treated and were urged to stay on. But they decided to return to Minnesota, Joe not to teach, not to have to, with, for security, a commission to do a baptismal font for a church in Illinois. And they now had the inheritance from Joe's grandfather to buy the house in Collegeville they liked just well enough to buy—they would *save* it and make it their very own, inside and out, and they did—that old frame house, in which Joe would die peacefully forty years later.

During those years he went from cigarettes to cigars to pipes to nothing, and from Martinis and Scotch to wine and beer to nothing.

He was an entertaining, accommodating host, but not perfect in that respect. He knew what it was like to have a guest get up after going to bed and leave in the night without saying goodbye.

How do I mean that?

Well, Garrison Keillor is someone—Dorothy Day, Gene McCarthy, Pope John, and Pope John Paul II are others—Joe was appreciative and admiring of, perhaps to a fault, for if one of *them* were ever criticized in his presence he'd start to frown and sort of hover over offenders if they were sitting down or sort of walk into them if they were standing up.

Joe's studio at the College of Saint Benedict in Saint Joseph was where he taught and where he worked on heavyweight commissions, but he'd had another studio built near, though not too near, the house. Here he kept his records, tapes, cassettes, mostly jazz—no bop, no rock. But he was not above Bach, which is force-fed to listeners of Minnesota Public Radio, and which he and I argued about. Here, too, he kept his soprano sax, which once he'd played for fun—he admired Sidney Bechet—but later only to resuscitate his lungs.

Two of his sons became musicians, Eric and Brian, who performed at Joe's funeral, as did two friends, Don and Jeanne Molloy, playing beautiful Ellingtonia beautifully.

Joe had traveled regularly to the Twin Cities for reasons medical—Dr. "Mal" Blumenthal—and musical—to hear Brian before he moved to New Orleans. But there were other trips. To visit Buddy in Chicago, Garrison in New York, Ruth (Muggs had died) in California. To Detroit, where Joe had a big three-figure piece (*The Family* for the American Dental Association in Chicago) cast in bronze and where he was stuck up one night in a parking lot. "*Hey!*" he'd called after the hoods. "I need the *wallet!*" It was thrown at him and nothing missing except the money.

To Cincinnati, to see Louise, his stepmother, on her deathbed (his own mother, Cecile, had died three days after his birth). Louise did recognize him, but only for a moment when she opened her eyes, the last time she did. Joe—he could never get over this—had been the odd one in the family: his half brother Dick, a gifted silversmith, and his three half sisters, Sharon, Suzanne, Jeanne, were all more related to each other than he was to them. Later, when he learned that under the terms of Louise's will he would receive a full share, though this wasn't really surprising, he cried.

In Italy, where their older daughter Laurie and her husband and the children were living, and also "Duke," their younger daughter, Joe wore himself out daily looking at work he might have done, not only in museums but in the streets, at monuments, and at detail on buildings.

On one trip, Joe and Jody stopped in Paris to see Norbert Smith, who then lived and later died there.

On another trip to Italy, Joe went through customs with, in a heavy little white suitcase, a tombstone for one of his grandchildren, the littlest one, Adriana.

Before beginning his commission for Christ the King Catholic Community in Las Vegas, Joe visited the site, but by the time he'd finished the job (four years later) he wasn't well enough to attend the dedication ceremonies. Fortunately, his apprentice, David Cofell, did attend and was given a video by the person in charge, Mary Jane Leslie. So Joe was able to see the ceremonies, to hear Father William Kenny's eulogy, which Joe thought excellent, and to view the work in question, all from his bed.

Joe's coffin was made at the Saint John's Woodworking Shop by Br. Gregory Eibensteiner, O.S.B., K. C. Marrin, and Michael Roske, from whom I learned that Joe had decided not to use the English walnut he owned and had been ageing for this purpose, but the basswood ordinarily used by monks, and he showed signs of not wanting to be talked out of it.

In 1958 Joe had produced a slate tombstone for Don Humphrey, a consummate silversmith who'd been employed by Saint Ben's before Joe had, and who was a good friend of mine and I hope will be again, as I hope Joe will.

Dear Joe. For his love and mercy I believe he has received divine love and mercy, and for his works of art, I dare say, divine favor.

(J. F. Powers died on June 12, 1999, soon after completing this introduction about his friend Joe.)

He Was in the Arts, You Know

GARRISON KEILLOR

Joe didn't care to have a eulogy at his funeral and so there wasn't any. He wasn't one to be coy about it. If he'd secretly longed for someone to stand up over his coffin and talk about the lyricism of his work, he'd have said so, or left it an open question, and then one of us would have stood up and done it. Probably me. I could have said that he was an Italian artist of the Renaissance, a friend of Ghirlandaio, who was dropped into Stearns County in the mid-twentieth century, one of God's noble experiments. I could have said a lot. Maybe he wanted to spare me the trouble. Probably he hoped to spare the congregation. Having tried so hard all his life not to promote himself, he didn't care to be wrapped in gold foil and sprinkled with canary feathers at the end. And Joe was a Christian who tried to live by his faith and avoid large pronouncements. And so we skipped the ten-minute talk about his lyrical sensibility and cut to the postlude, Duke Ellington's "Please Don't Talk About Me When I'm Gone," and everybody left the church smiling and trooped down the road to the cemetery and laid him in the ground.

He was an extraordinary fine artist who looked like a former boxer and talked like a carpenter. A wiry guy with large, muscular hands, a hank of black hair falling over his forehead, black hornrim glasses on a creased face, and a really majestic grin. He was a great friend and a classy guy, elaborately kind, and nobody else could be charming the way Joe could. He really knew how to bestow himself.

I think of him as he was on a fall morning back around 1970, working in his old studio on the side of the hill, woods behind it, overlooking the

meadow and the railroad tracks between Saint Joseph and Albany. It's ten o'clock in the morning and I just finished my shift at the radio station at Saint John's. I walk in, the studio smells of sawdust and wood fire, music is playing, a hot jazz band from the twenties. Joe is bent over a wooden Christ on the cross propped up on a sawhorse, running his fingers over the face and chest, brushing away shavings and flecks of sawdust, squinting at the grain, worrying over it. The piece looks finished to me, a stunning achievement, but to Joe it is a sick patient in a painful late stage of treatment. A tiny crack on the left cheek is troublesome to him, and he feels that the nose is off and needs reshaping. Meanwhile, the priest from the church that commissioned the figure is pressing Joe for a definite delivery date, the original deadline having passed some months before. The priest is pressing him hard, wanting to schedule the dedication. Joe is supposed to telephone him today—Joe groans at the thought.

Joe put a lot of feeling into a groan. He had a great repertoire of groans, with real gravel in them, and he always smiled when he groaned, as if savoring his own hopeless situation. And he had plenty of hopeless situations to choose from. "I am in the arts, you know," he would say. He liked that phrase.

He had a wife and five children, was supporting his family by carving and sculpting and printmaking, most of it done on commission for churches whose fee, divided by the hours it took to produce work to Joe's standard, made for something less than the minimum wage, but how could you ask for more, knowing that churches could buy poured-stone copies of Virgins and Christs that their congregations might even prefer to Joe's?

So I started calling him Sisyphus, after the myth of the man condemned eternally to roll the stone up the hill and see it come rolling back down. Then I called him Josyphus. "Almost got that rock where I want it now," he'd say. "Any day, it'll be done." It was comical to him and me that my work was transient and got attention, and that his work, as he put it, would last forever but nobody would notice it.

On this fall morning, with the priest looming ahead of him, he invites me up to sit in his loft and have a cup of coffee. The loft was small, like the

bridge of a ship, with a bunk, a work table, a filing chest, and shelves. He was very neat about his clutter, his tape and record collection, his tools, little carvings, postcards, clippings. I sit on the bunk, drinking coffee, and I give him a couple stories of mine to read—he was a very generous reader, a great enthusiast about his friends' work—and he brings out a few of his prints to show me: Peter strangling the cock that crowed when Peter betrayed Jesus, Adam and Eve tiptoeing from the Garden under the weary, patient gaze of God the Father, a man in a suit grabbed by a giant hand in the dark. Joe did not portray jubilation, as a rule, or bliss and contentment. Joe didn't do angels. His specialty was the dignity of suffering, which he himself was acquainted with and which was the source of his humor.

I talked to him on the phone a few days before he died. He was weak but still himself. He took the phone and said hello. I said, "Saint Joseph—" and he said, "Not yet." And then his voice drifted away and he handed the phone to his son and faded into merciful unconsciousness.

But on this fall morning, he is leaning back in his chair, postponing the conversation with the priest, listening to Louis Armstrong and King Oliver kick up their heels, and the music naturally reminds him of his hometown Chicago, about which he told so many stories. He was the best one I ever knew to tell a story. One night at Fred and Rosemary Petters' house, he told an epic tale about going to confession at his parish church in Chicago, which had a high altar so magnificent and high that stairs had to be rolled in for the priest to climb up to open the door of the ark that contained the Host, though the story also included his Grandpa the inventor and his friend Buddy and his eccentric Aunt Margaret, who gradually filled up the rooms of her house with unopened merchandise from Marshall Field's and died on a stack of boxes and newspapers, her face a few inches from the ceiling. The story took about an hour to tell and consisted of three small scenes with elaborate backdrops and all of us sat weeping with laughter, and on the way home I realized that it could not be summarized or duplicated, it had no frame, it was pure abstract comedy. Also, we'd had quite a bit to drink.

On this fall morning, though, the music reminds him of the Chicago cornetist Muggsy Spanier, who was a sort of foster father to Joe, and that

leads to W. C. Fields, the notorious hater of small children, and that leads to a story I tell on myself, about driving up my driveway with my two-year-old son standing on the front seat next to me and gunning the engine to try to make it through a snowbank, the dumbest thing I ever did as a father, and this reminds Joe of a true story about himself, which I wrote down later and which went something like this:

The circus came to the ballpark in Saint Joseph, one of those little tent circuses that you walk into and discover that the woman who sold you your ticket is also the bareback rider and has a dog act, and on the way out the lion-tamer is selling cotton candy and offering tickets for twenty-five cents to go into another tent and see the tattooed lady, who, he suggests, is not wearing much of anything, and she turns out to be the bareback rider and has three tattoos and is dressed in a bathing suit.

Anyway, that kind of circus, not the kind you run away to join. The kind you might be born into. But my kids thought this was the last word in entertainment, to sit on the top row of the bleachers under the canvas and jump down to the ground and run around under the bleachers and throw popcorn at each other.

The day after we saw the circus, the kids and I drove to town in our old VW to get groceries. It was like a clown car with four of them in it and the back seat full of groceries. They were still talking about the circus and recalling some of the acts when we drove by the ballpark and there, staked in the middle of the field, was the elephant, Mazumbo. This was a one-elephant circus and she was it. The kids wanted to go feed her. They begged me. "Please, oh please, please, please, please, please, please can we? This would be the neatest thing. We've got peanuts!"

Well, we did have peanuts. Two big bags of them. I said, "All right, but you stay in the car. Nobody gets out of the car." And I drove onto the ballfield and up to the elephant. And Eric rolled down the window and stuck out a handful of peanuts and Mazumbo swung her

trunk over and picked them up and put them in her mouth. Then it was Brian's turn to feed her. And Laurie, and Duke. By the time they got through a bag of peanuts, Mazumbo had quite a bit of her trunk inside the car, feeling around for provisions. It made me nervous, this gigantic, long, bristly thing snaking around inside the VW and brushing the back of my neck and snuffling around the kids, especially since the tip of Mazumbo's trunk looked like Mazumbo had a bad cold. But the kids, of course, were delighted. Utterly beside themselves. They were squealing and sticking fistfuls of peanuts in her trunk, of which almost the whole trunk seemed to be in the car. And when we ran out of peanuts, we opened up a pack of Oreos and some candy bars and potato chips. I was trying to keep calm, be the master dad, the old hand with elephants, and I turned and fished around in the grocery sack for the vegetables, and I felt the car lift slightly and then this large, cold thing on my face and I jumped and banged my head on the ceiling and slipped the car into reverse and backed up, slowly, because Mazumbo was reluctant to let go of us. We inched back and I could hear the ridges on the trunk slide across the window frame, bonk, bonk, bonk, bonk, bonk, and the kids were laughing all the way home, and I was imagining the story in the newspaper, "Family of 6 Perish in Circus Mishap; Father Parked Car Next to Elephant."

I miss listening to Joe talk. You get a conversation going with someone that you really enjoy and then they go and die on you. But then I come across the work he left behind, such as *Adam Waiting in the Garden*, which hangs over my desk, the First Man in abject boredom waiting for the First Woman, her magnificent haunches visible through a window, to finish her ablutions and do her toilet, and Joe is still here. He was in the arts, you know, and here's proof of it.

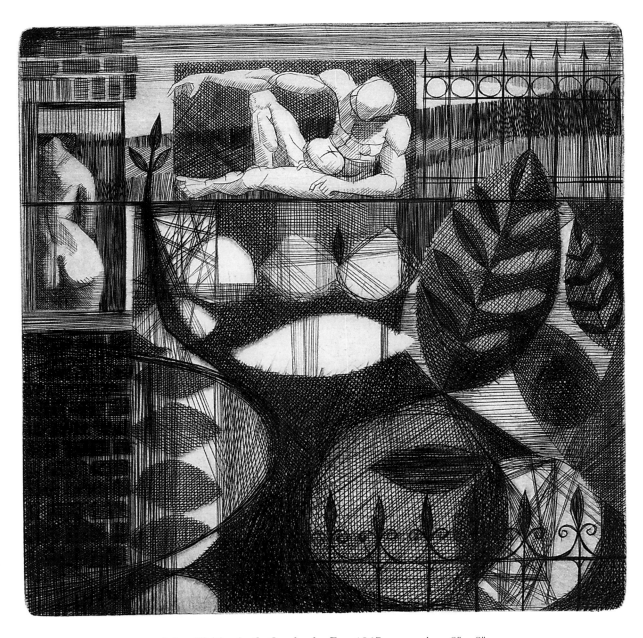

Adam Waiting in the Garden for Eve, 1967, engraving, 8" x 8"

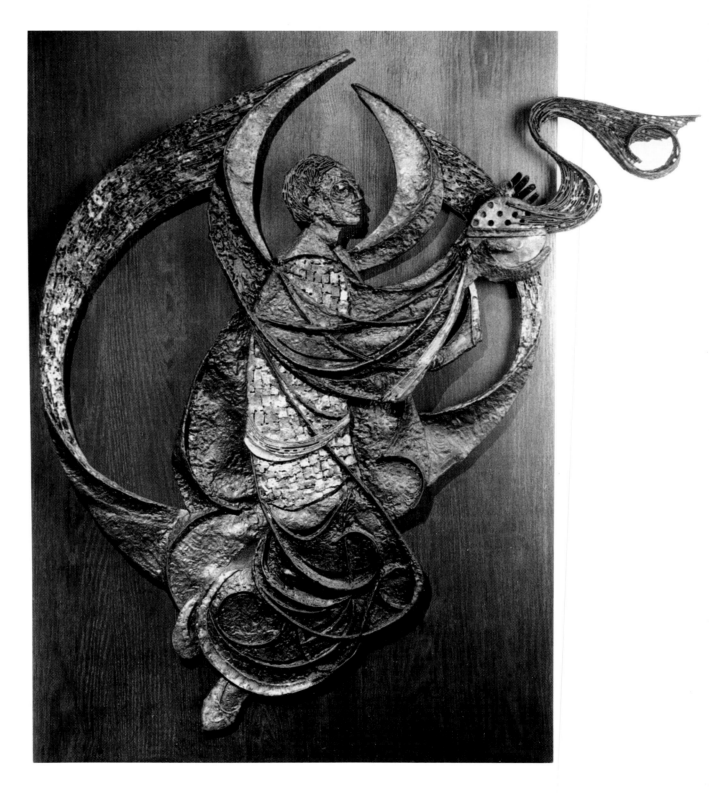

Saint Michael, 1964, welded steel and forged iron

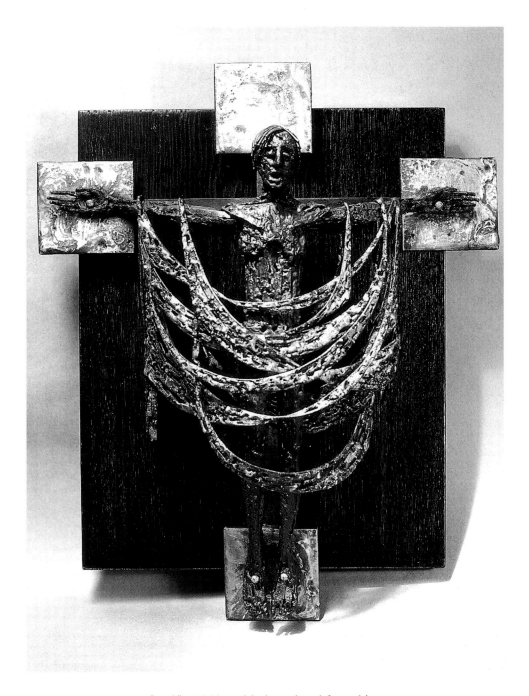

Crucifix, 1964, welded steel and forged iron

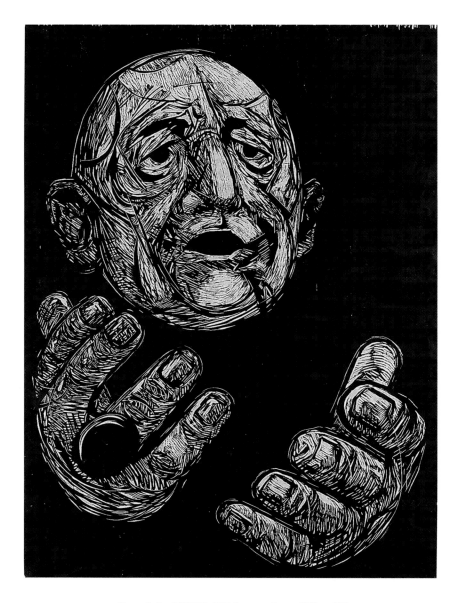

Pope John XXIII, 1963, woodcut, 29" x 20"

(Right) *Saint Francis*, 1954, limestone

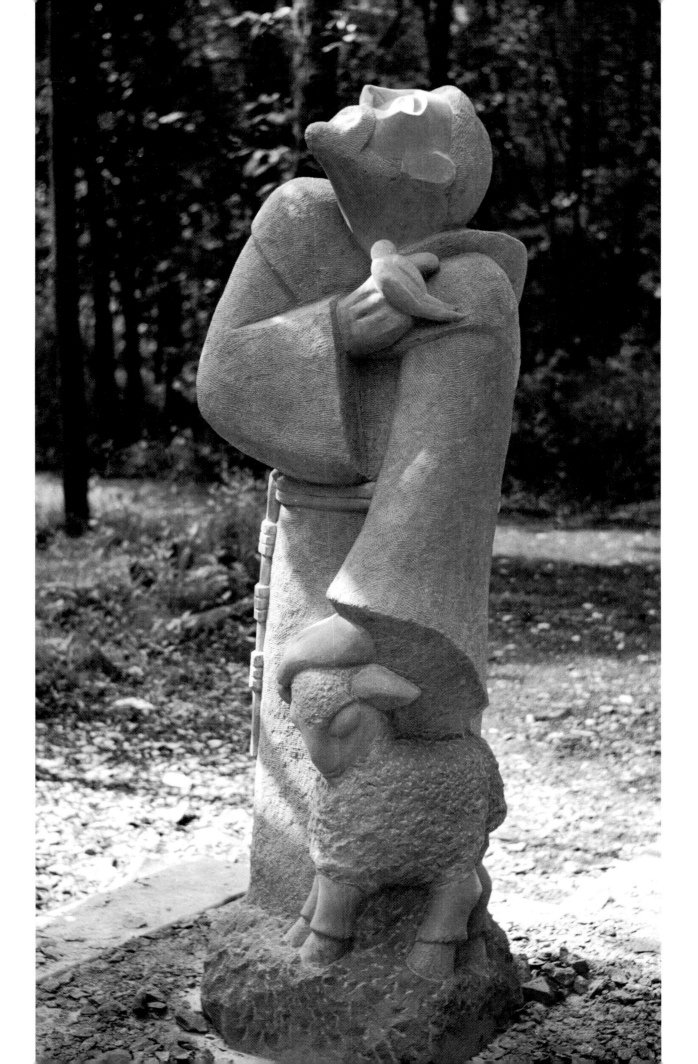

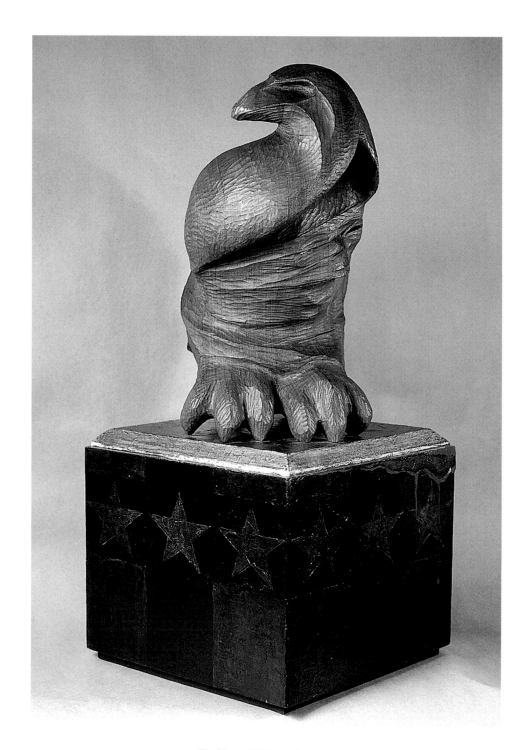

Emblem, 1980, mahogany

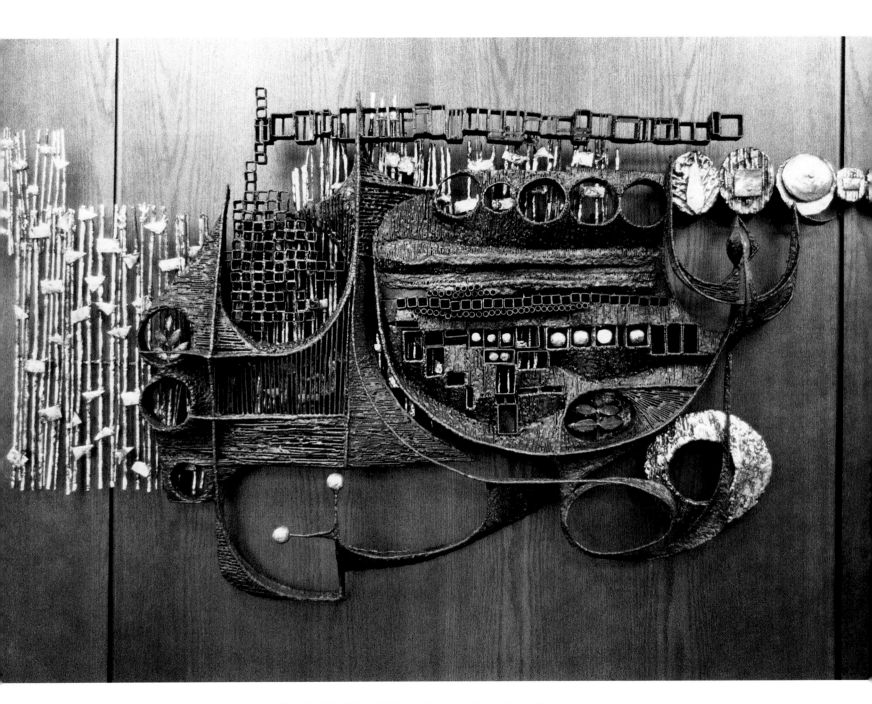

The Egg Machine, 1972, welded steel and forged iron

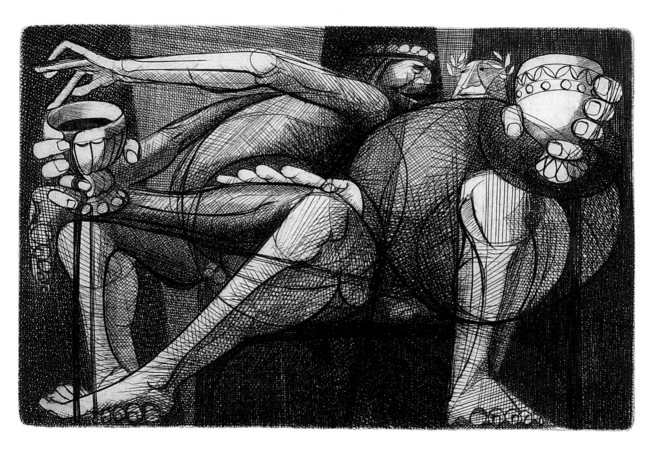

And That Day Herod and Pilate Were Made Friends Together, 1974, engraving, 6" x 8"

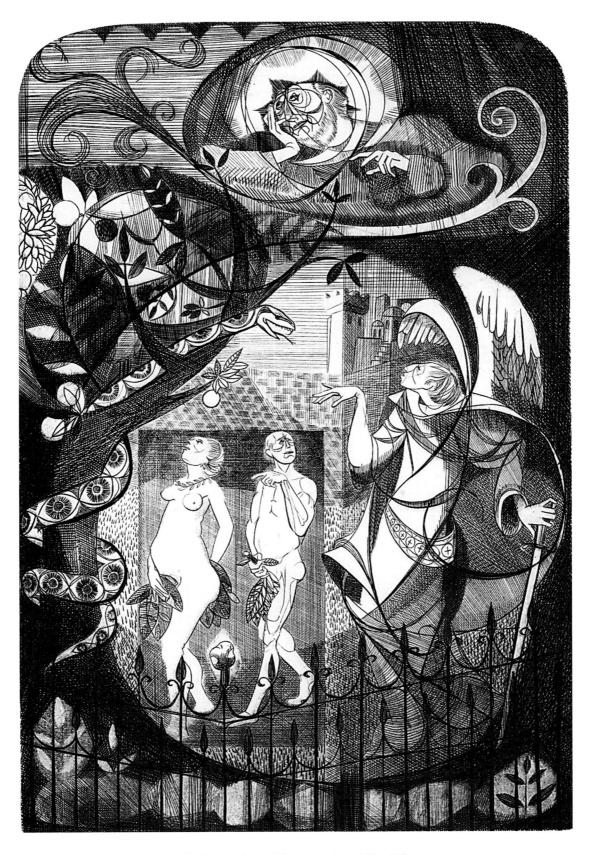

The Expulsion, 1967, engraving, 15" x 10"

Rear view: *Eve in Baroque*, 1990, marble

(Right): *Eve in Baroque*, 1990, marble

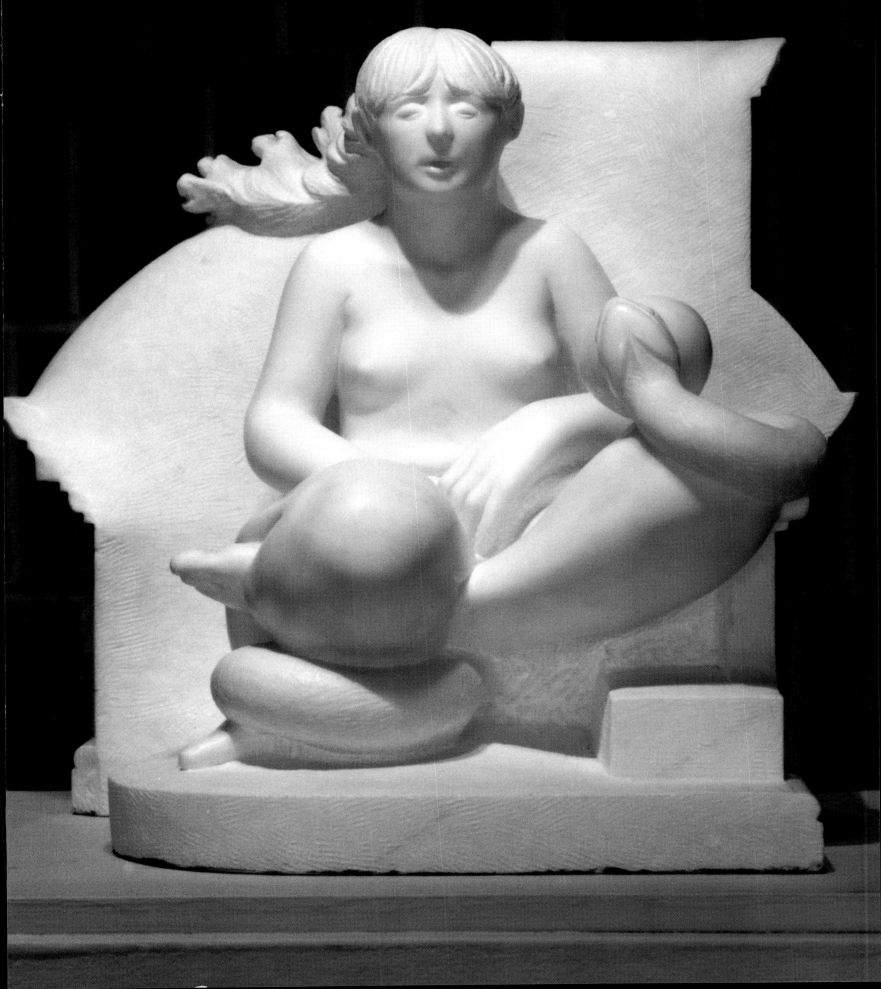

Unbecoming
A Look at *Eve in Baroque*

MARA FAULKNER, O.S.B.

Emerging from the softly shining marble that was once the communion railing in a monastery of Benedictine women, Eve balances the unbitten apple on a plump and polished knee. Her marble skin glows faintest pink as if washed by earliest light or lit by a secret she's holding inside. She has a teenager's face, hair cut in junior-high bangs in front and wild as sea waves in back, and half-closed, dreaming eyes. She takes for granted the snake curled blissfully around her, taking her warmth, her shape. Eve and the snake know each other, and are not afraid.

> It's taking my hands
> more than fifty years to unlearn
> one indelible summer lesson.
>
> This I remember: three little tow-headed girls
> wandering in the dusty pasture between our house
> and the woods
> breathing in the pleasant heat
> the sharp sweet smells of clover and of manure
> drying in the sun.
> We found a treasure
> a burnished curve in the dust
> a silky rope
> mysterious and delightful to hand and eye
> and picked it up and ran
> to where my father worked in the field.

Almost blind, his hands
grown huge with the effort of seeing,
he held it close to his one good eye.
A silky rope? The snake's eye
open in death
caught his.

Thinking to protect his little girls he flung it far
across the summer pasture
a coppery arc shining in the sun.
In its place grew a stale terror
as twisted as the tale of Eve
and the snake
the first unmaking
the breaking
of communion.

I've touched snake skins since then
dry and papery as words
and followed snake trails through poems
but my hands are lonely for the silk
of scales placed just so
and my body
like Eve's
imagines its sinuous
friendly
coil.

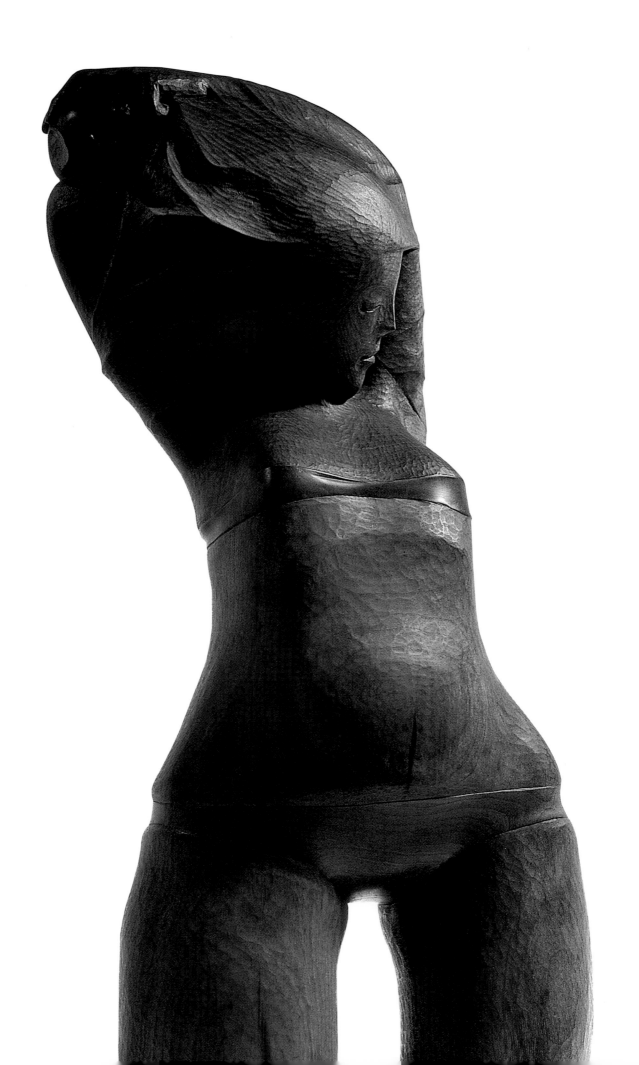

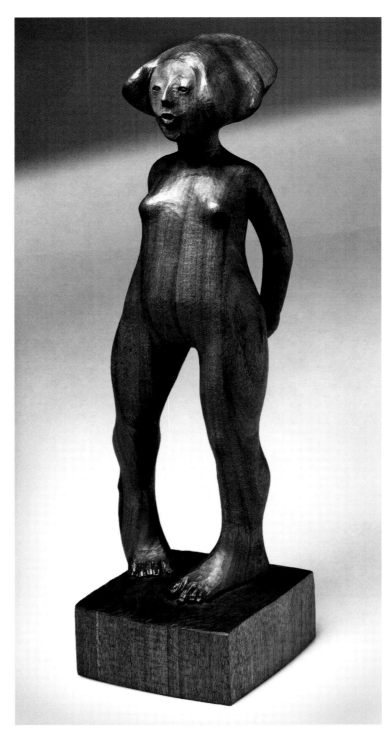

Eve, 1980, mahogany

(Left) *Eve* (detail), circa 1984, mahogany

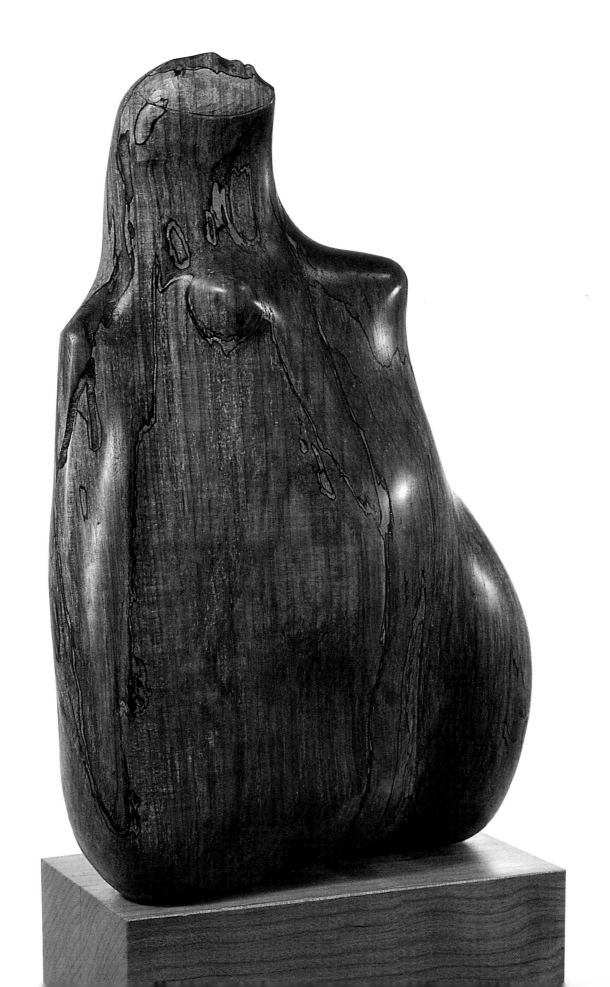

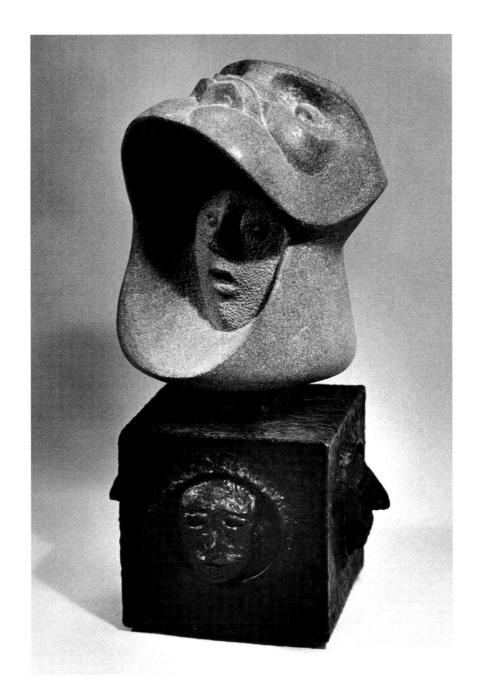

Helmet, 1977, limestone and forged iron

(Left) *Torso*, 1981, maple

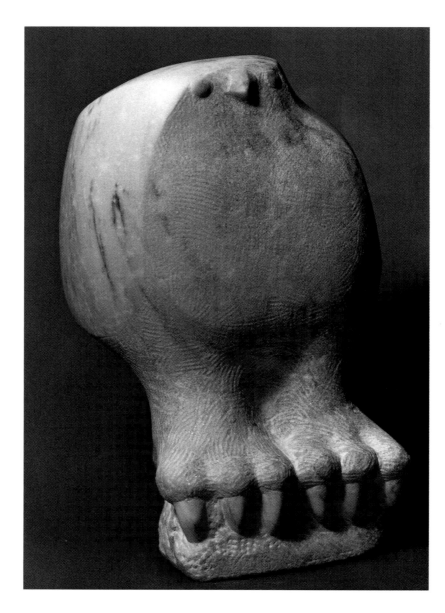

Owl, 1973, marble

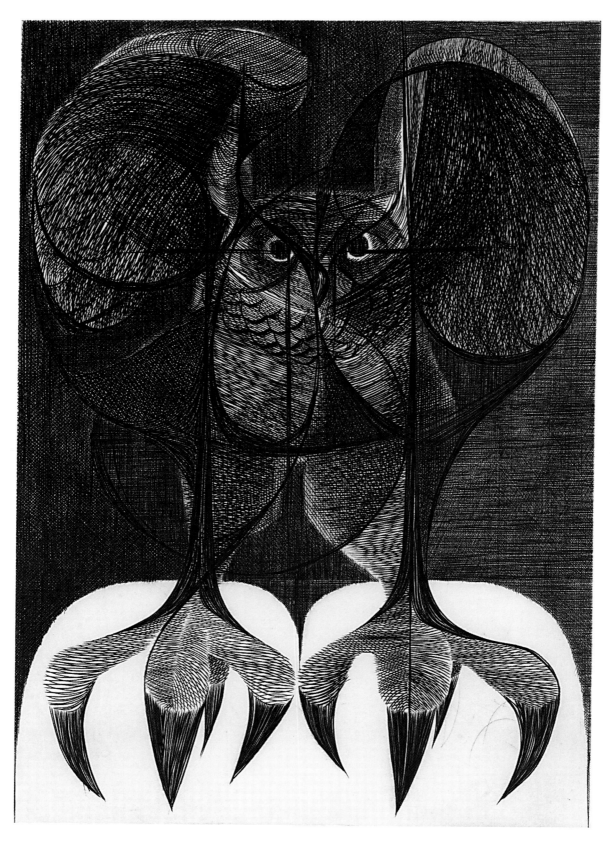

It Is Not Always Wise to Bend Over Naked in the Night, 1971, engraving, 13" x 9"

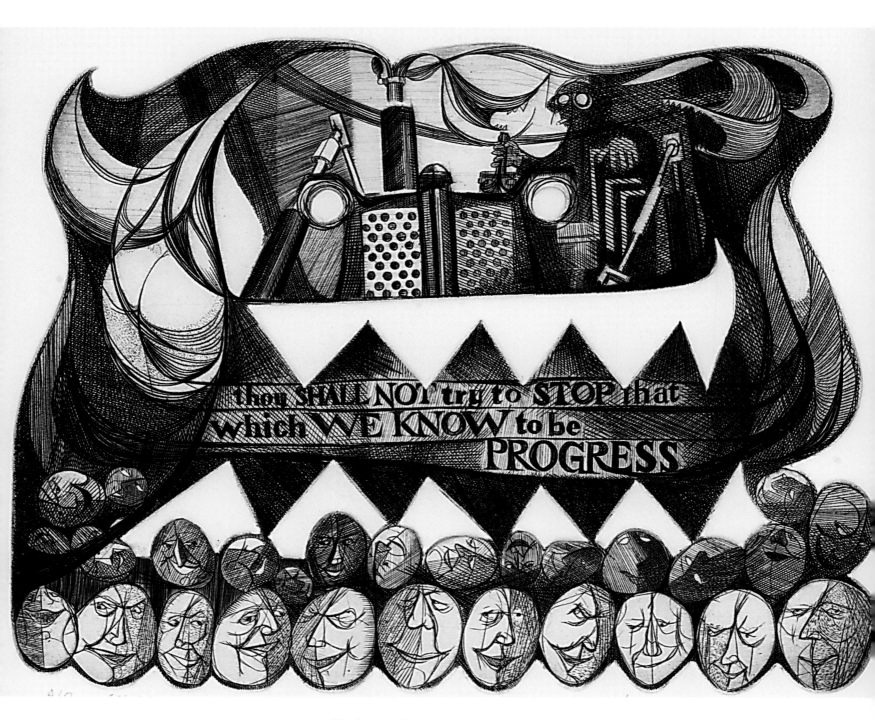

The Commandment, 1978, engraving, 11" x 18"

A Bead on Human Folly

HILARY THIMMESH, O.S.B.

When old Highway 52 was made into I-94 in the late 70s, a frontage road to serve the people on Collegeville Road became necessary. It cut through the countryside just north of the O'Connells' house, eating up most of the lawn and a few nice evergreens that Joe had planted. Joe did not think kindly of this development but in the end couldn't prevent it, so he did the next best thing and produced a commentary on it in his 1978 engraving *Commandment*.

In the picture, about 10" x 17", a monster bulldozer wreathed in swirling black emissions from its exhaust stack bears down on a double row of ovoid heads rolling on the ground like so many jack-o'-lanterns or Easter eggs with painted faces. The eleven heads in the front row all face forward and are unaware of their peril. They variously smile, smirk, look wise, cast conniving glances. The row behind them is already overshadowed by the jaws of the great machine that will swallow them up and is in some disarray. They tumble, grin inanely, become hollow eyes in blank masks.

The machine is one of Joe's wonderful inventions. Its radiator comes almost straight at the viewer from the center of the composition, blank white headlights in relief printing at its upper corners, hydraulic pistons and rods connecting indistinctly to a giant set of pointed teeth, also in relief, where the blade should be. The operator's gloved left hand rests idly on the tallest in a set of three vertical levers; the right hand grips a control stick. The hands are the only human features of the operator, who is dwarfed by the machine and appears only as a shape with goggle lenses for eyes. A cigarette projects from where the mouth must be. Across the lower half of the picture the monster teeth frame a legend bearing the commandment: "thou SHALL NOT try to STOP that which WE KNOW to be PROGRESS."

In the hands of another artist this work might have been no more than a bitter cartoon—sarcastic, cynical, ill-tempered. In Joe's hands it becomes a

commentary on fallible humanity. I have asked myself how he manages time after time to draw a bead on human folly and still telegraph to the viewer that God hasn't quit loving the world. I don't know Joe's secret, but I know that after living with his "commandment" for nearly twenty years I find it more reassuring than threatening.

Maybe it's the very exaggeration that makes me smile—the demonic fumes like flickering evil tongues, the big teeth filed to stiletto sharpness, the capital letters profiling the overweening arrogance of those who know best. Maybe something about the balance of the composition holds out hope for ultimate sense and stability. Maybe sheer technical mastery cheers the beholder unawares. Whatever the secret, this is one of Joe's masterpieces and to me one of his most characteristic works.

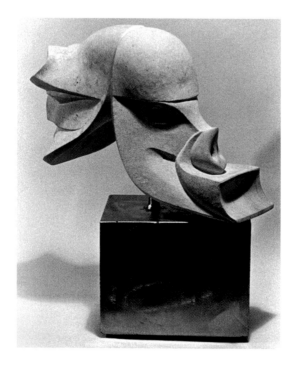

Portrait of the Highway Department,
1977, limestone

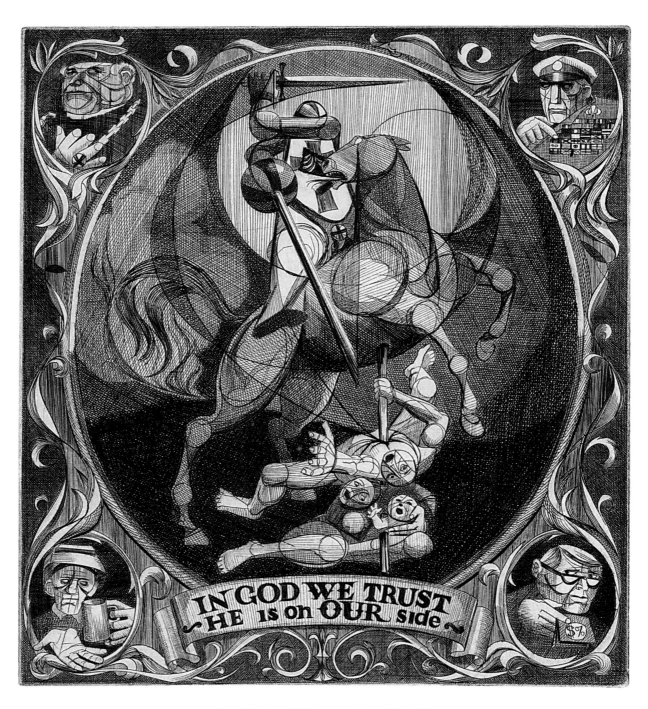

Our Warrior, 1968, engraving, 12" x 10"

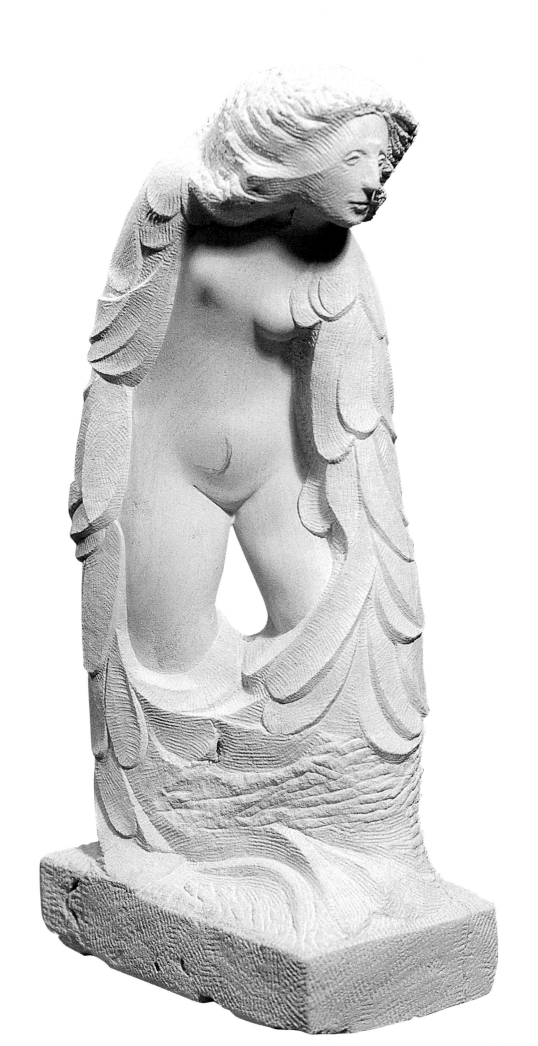

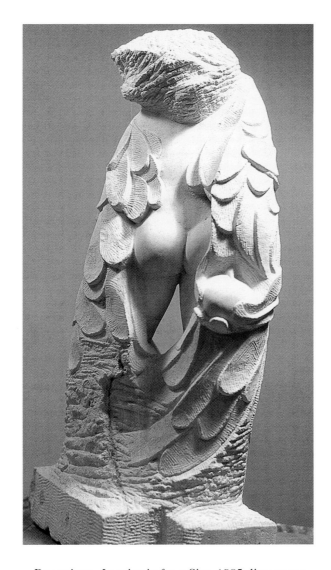

Rear view: *Leaning in for a Sign*, 1985, limestone

(Left) *Leaning in for a Sign*, 1985, limestone

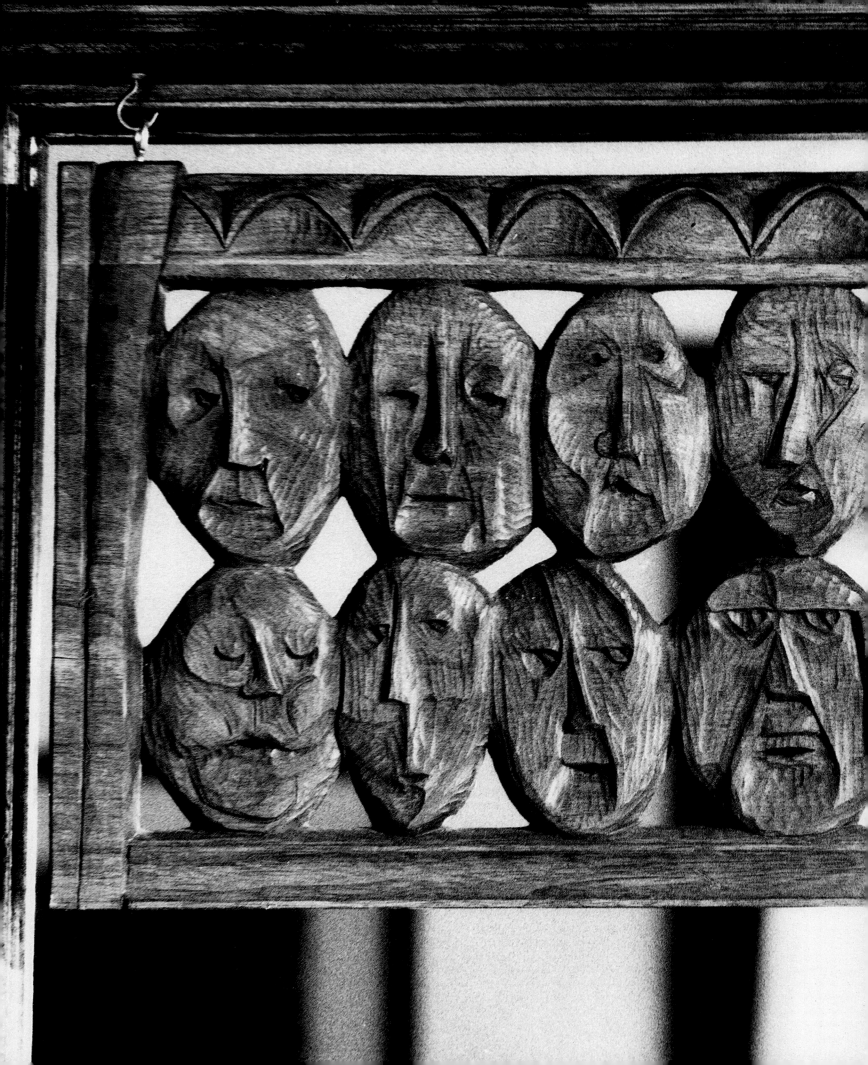

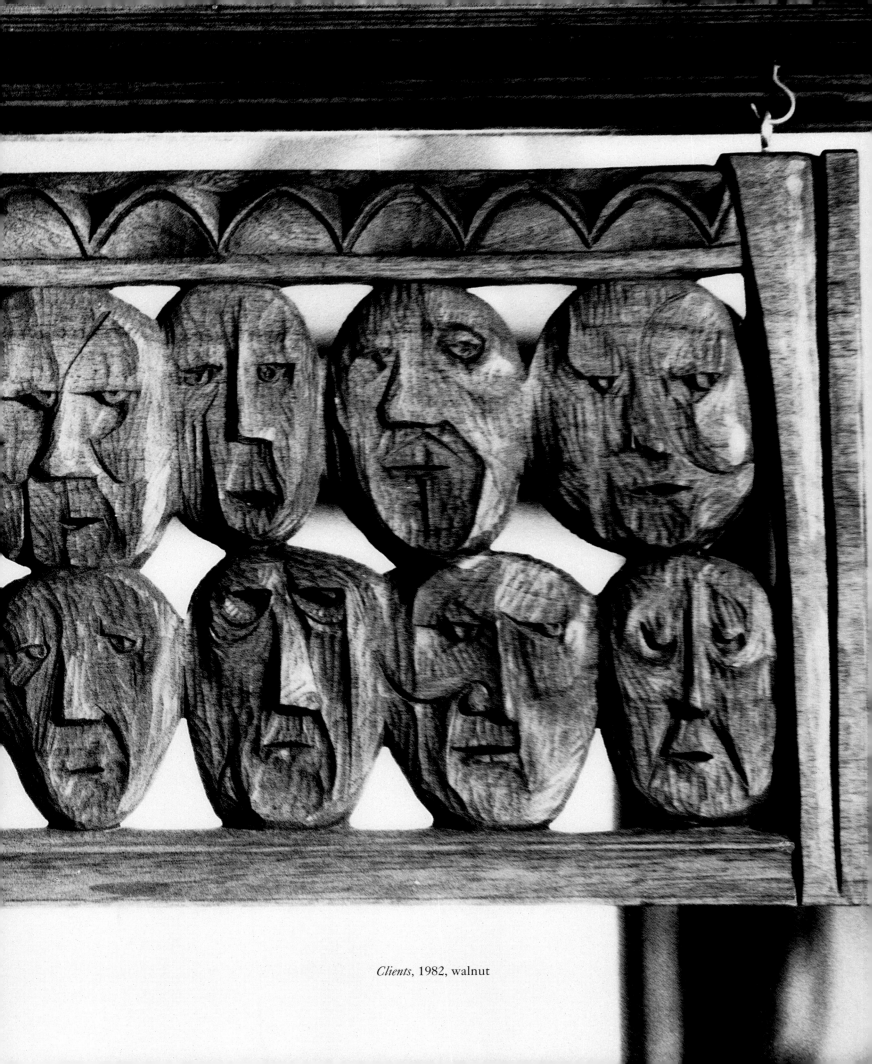

Clients, 1982, walnut

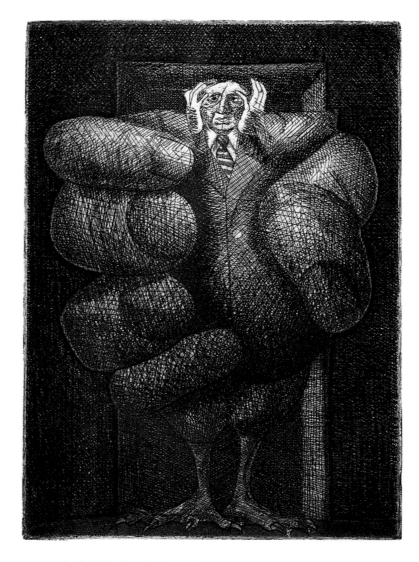

And If His Eye Is on the Sparrow, 1972, engraving, 7" x 5"

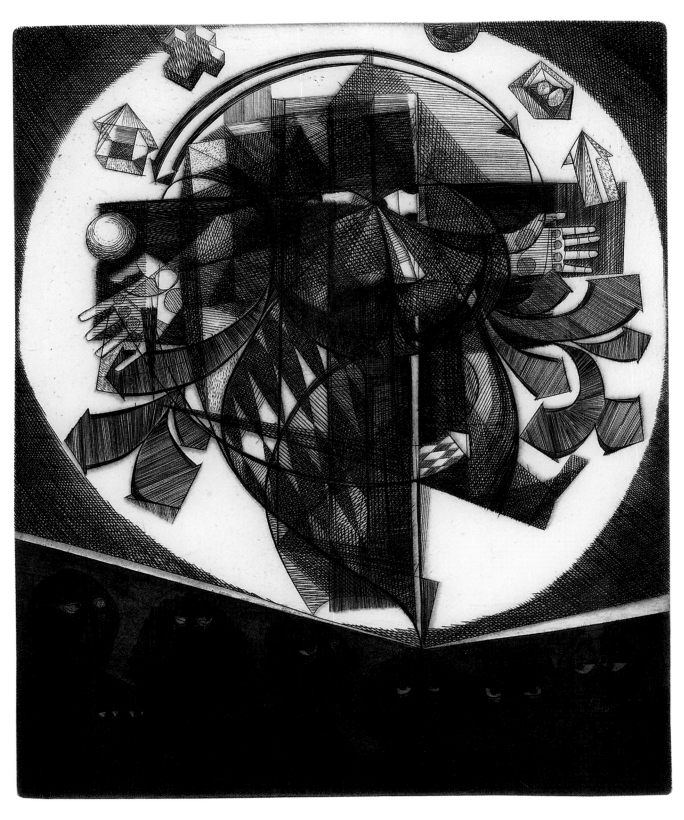

The Artist Before the Arts Committee, 1979, engraving, 12" x 10"

Transfiguration of the Commonplace

ALAN REED, O.S.B.

A single gesture of Mary in the sculpture of the Madonna and Child by Joe O'Connell is for me emblematic of all of Joe's art. Mary presents her child to the world by holding him away from her body, but the presentational gesture is never completed. She holds her thumb and fingers against the side of Jesus' cheek and neck in an unconscious touch where it rests or even caresses. It does not grasp onto Jesus, it would not support him or hold him back. But it touches, makes physical contact in the most gentle manner. This simple gesture is, borrowing the title of a book by Arthur C. Danto, "the transfiguration of the commonplace."* The need to express the power of religious experience, like the parables of the Gospels, is best accomplished in the ordinary. Mary touches the cheek with the side of her thumb. The meaning of the work of art is accomplished through the perfectly selected detail. A common, even unconscious gesture makes visible and real the entire significance of her relationship to him who is to become meaning itself. I think it was Joe's gift to us, to make visible the invisible.

*Danto, Arthur C. *The Transfiguration of the Commonplace: A Philosophy of Art.* Cambridge, Mass.: Harvard University Press, 1981.

Mary and Child, 1989, mahogany

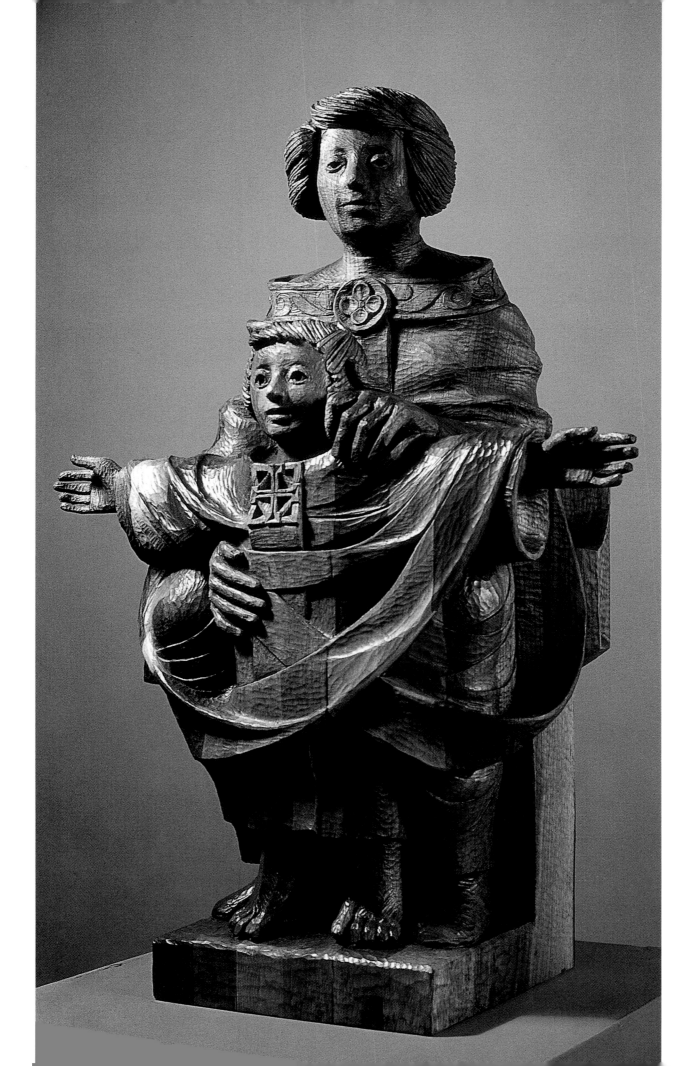

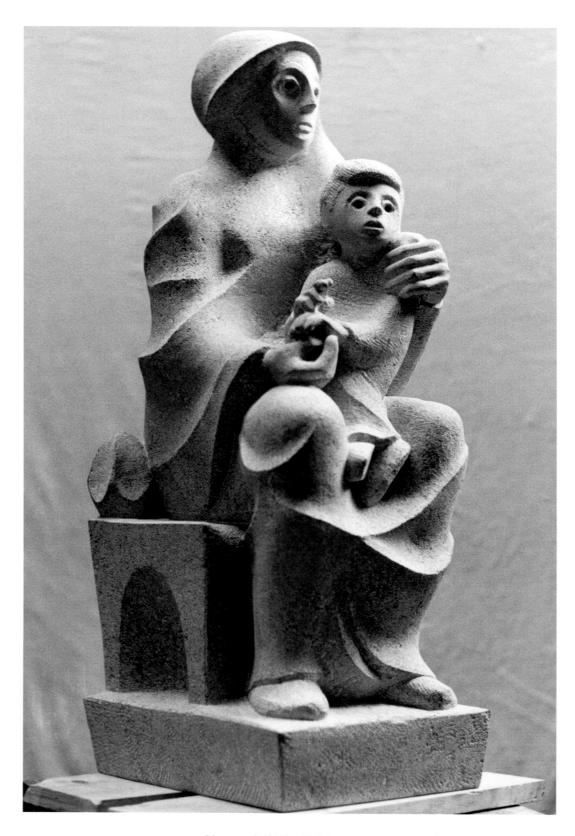

Mary and Child, 1966, limestone

(Right) *Mary and Child*, 1963, welded steel and forged iron

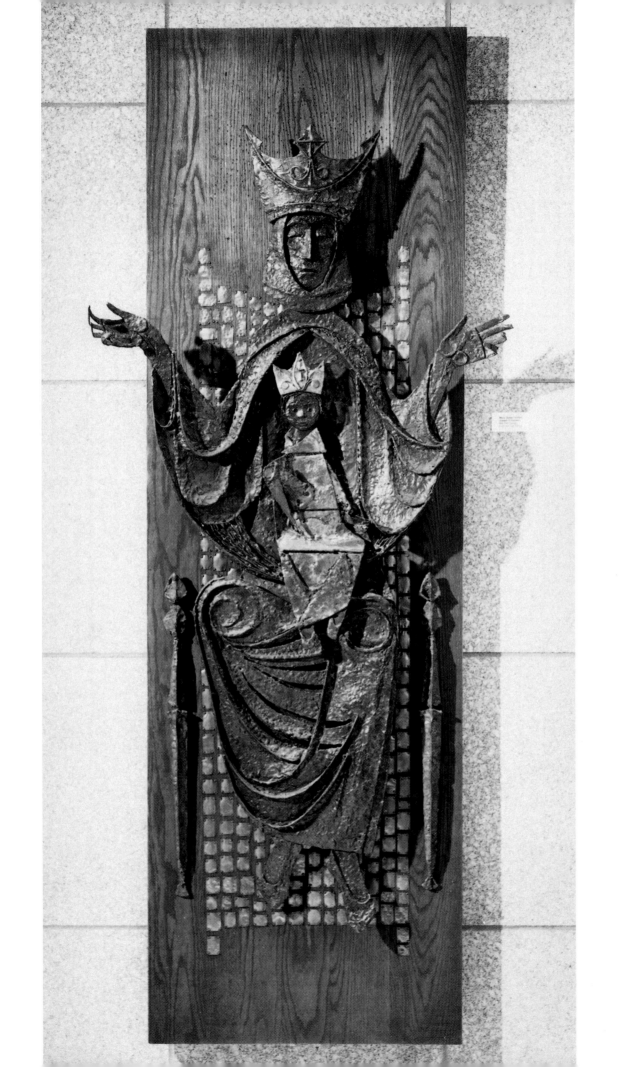

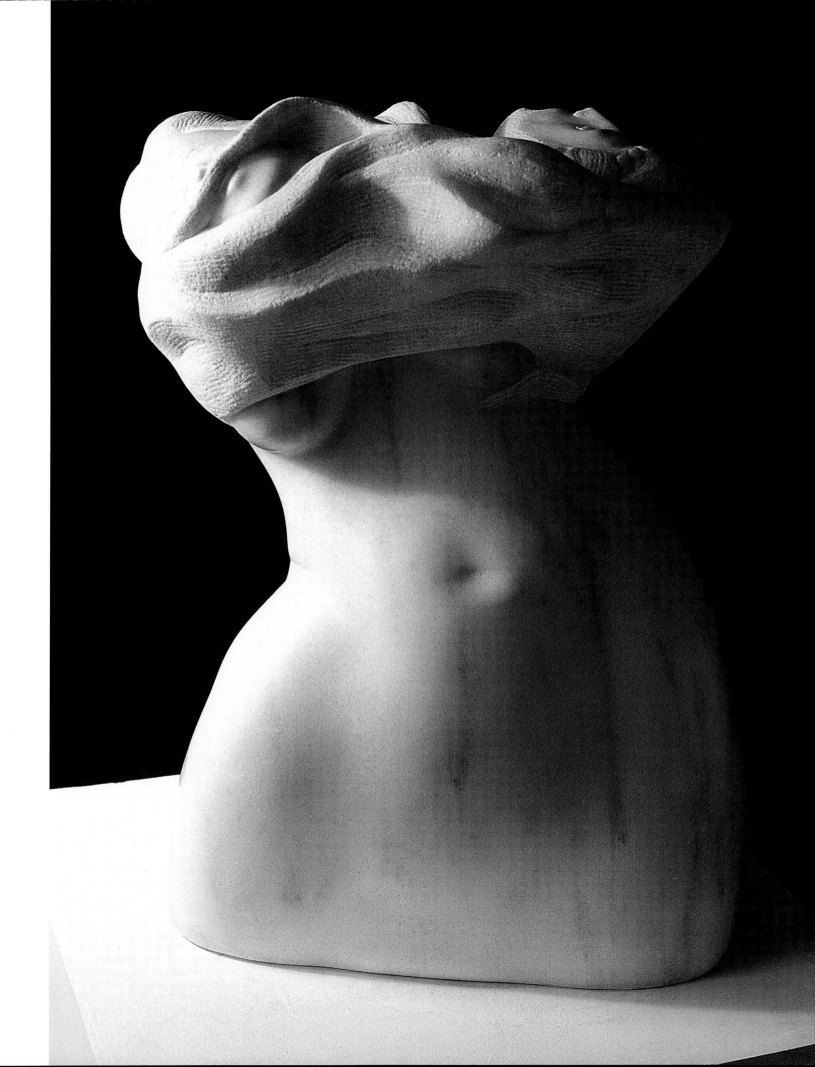

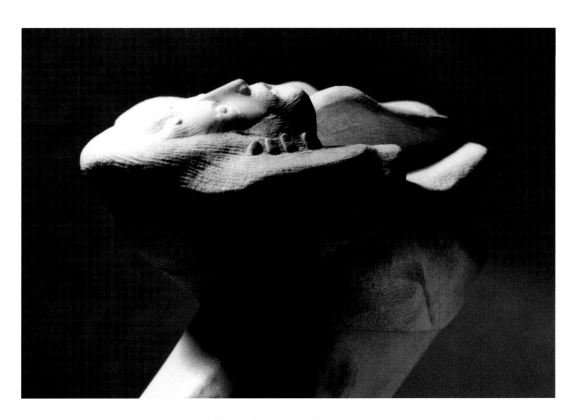

Torso (detail), 1977, marble

(Left) *Torso*, 1977, marble

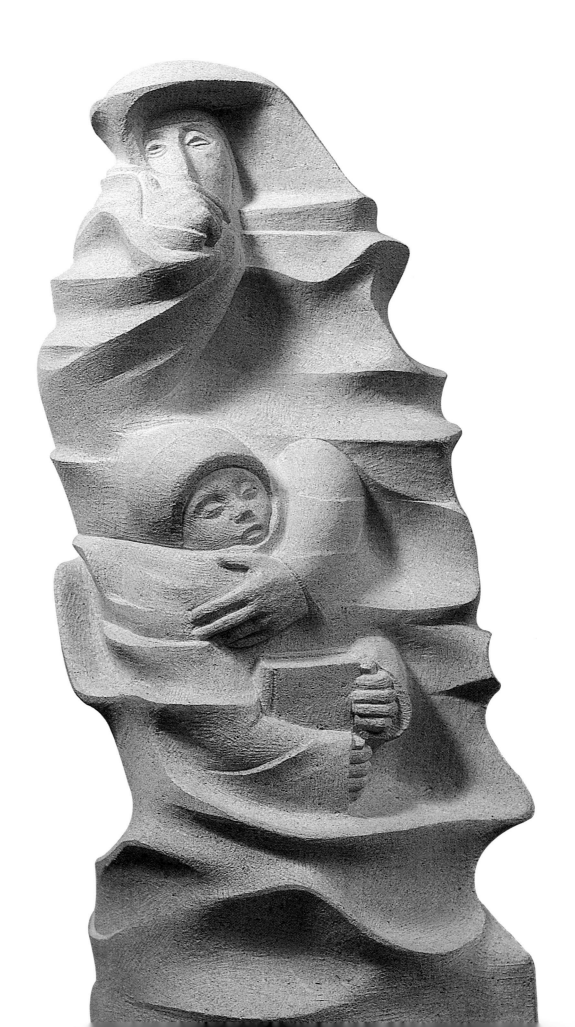

A Degree in Theology and Fine Arts

PHILIP MORSBERGER

During two deeply happy years as Visiting Artist at the College of Saint Benedict and Saint John's University (1984–1986), I was given, daily, the extraordinary privilege of watching Joe O'Connell discover, within three large blocks of limestone, the figures of early Benedictine sisters living missionary lives as pioneers in nineteenth-century Minnesota. I was astounded to see, gradually emerging under Joe's hands from the rock in which they'd been hidden, a contemplative sister in *lectio*; another sister buffeted by bitter winter winds even as she shields a small child from the gale; and a group of sisters gathered prayerfully around one of their own who has died.

Watching Joe during the course of two years patiently "freeing" these figures from blocks of reluctant stone was one of the great experiences of my life—spiritually, artistically, and in the realm of profound friendship. My deep happiness at Saint John's and Saint Benedict's was Joe's gift to me. I see him still, black knit cap pulled down over his boyish haircut, lovingly chipping away at his stones in the Benedicta Arts Center as New Orleans jazz blares from a nearby loudspeaker. Watching him at work was worth a dozen degrees in Theology and in Fine Arts.

Conceptually, Joe was somehow able to create images of visionary spirituality and, at the same time, of acutely knowing artistry. The trio of sculptures whose creation it was given me to watch, manage—I still think miraculously—to be both "realistic" and, not less, thoroughly modern, demonstrating an impressive understanding of Cubism and even of Italian Futurism. Henry Moore. Eric Gill. Umberto Boccioni. Joe knew his stuff! And finally, of course, his work is absolutely his own. Who can explain it? Not I. I look. I marvel. And I believe.

Work, 1985, limestone

Community (detail), 1985, limestone

(Right) *Community*, 1985, limestone

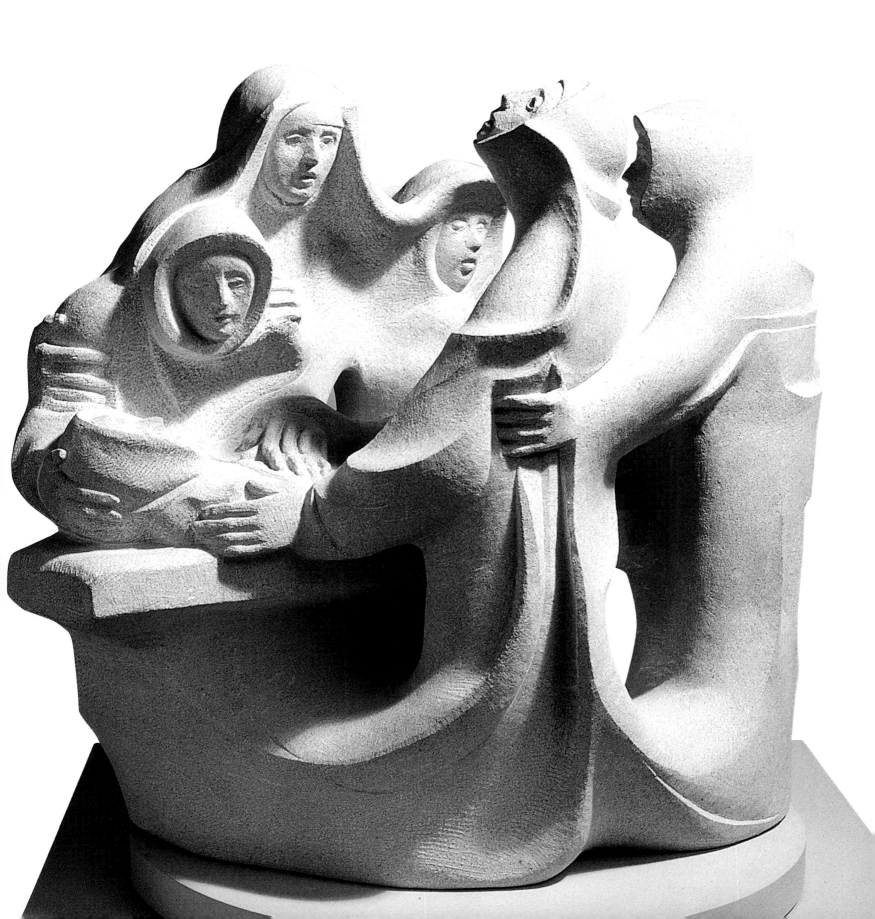

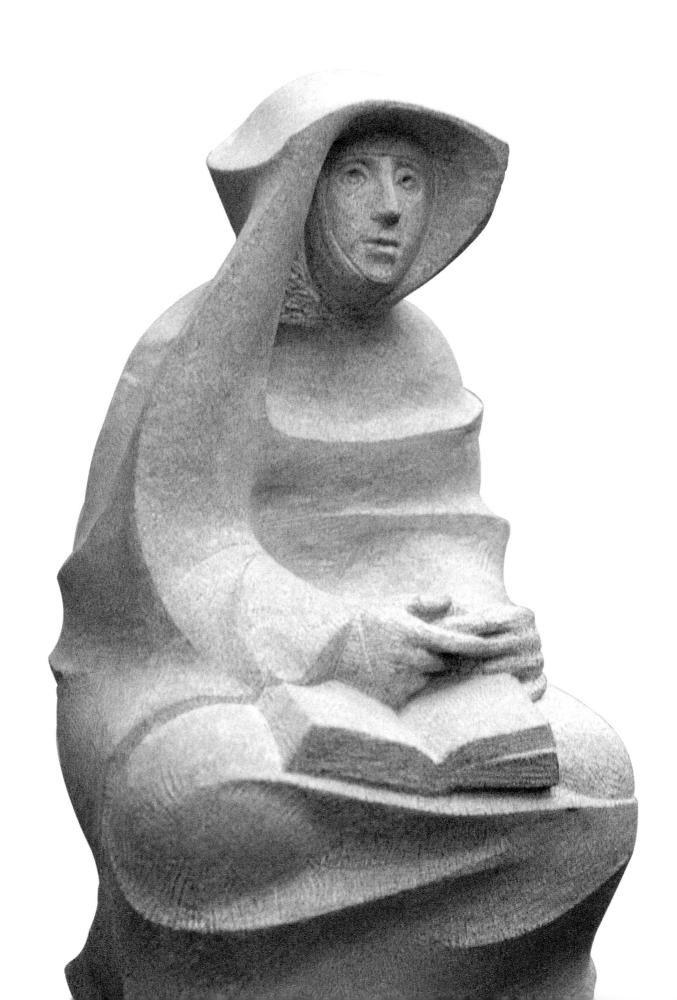

Joe's Questions

NANCY HYNES, O.S.B.

Five sisters mourning their first to die
Four touch, lean into, comfort
Each other.

One huddled, wrapped in self,
Staring into space

"Joe, why is she alone?"

"You know that better than I do.
In community,
Isn't there one who always walks alone?"

Deep-set eyes
Seeing *that which is unseen*
Fingers marking two places
in the Word.

"Who's to know
If she's praying
Or thinking how to make
The sauce for the goose at supper?"

Prayer, 1985, limestone

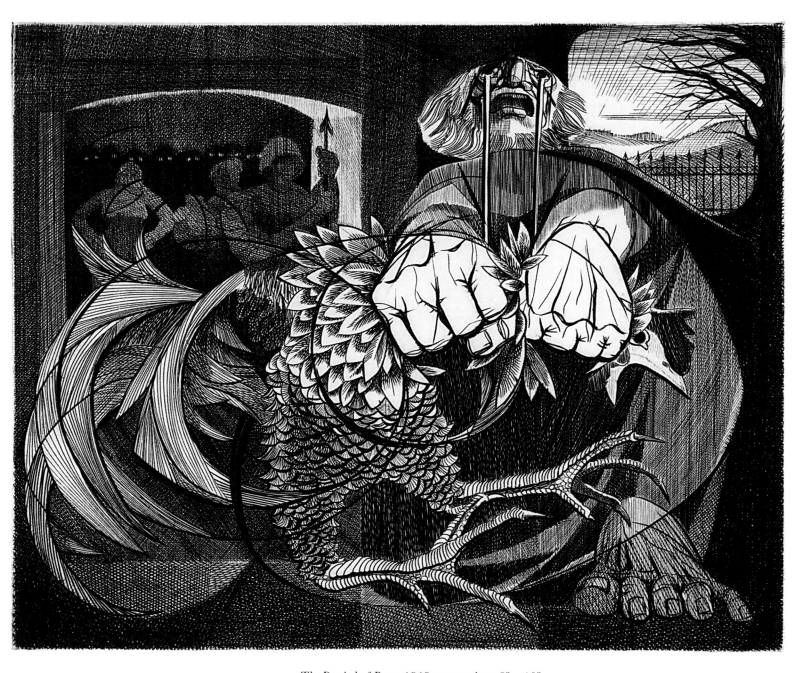

The Denial of Peter, 1969, engraving, 8" x 10"

A Meditation on Peter's Denial

As Imaged by Joseph O'Connell

MARY HYNES-BERRY

Isn't it just like denial?

A vortex.

We see the circles within circles within circles spiraling away when we falsely protest. *No . . . It wasn't . . . I didn't . . .*

And afterward, when it dawns upon us what we have done, we are caught in a whirlwind of denial, crying our eyes out, we protest again.

I didn't . . .

I didn't . . .

I didn't mean

But the dawn has already crept away from the blessed confusion of night. The authorities have come. They are leading away Him whom we know to be our best chance at salvation.

No matter how heartfelt, our protest grows fainter in the ever clearer light.

So we do what we can in an effort to keep from being sucked down in sorrow and guilty despair. We wring the stupid cock's neck—if he had just been quiet, it would have been all right. The darkness would have understood our fear, hidden it, forgiven us the consequences. But oh no, that rooster, preening in his role, not once, not twice, but three times trumpeted to the world the dayspring from on high. Everything is his fault we tell ourselves righteously. Crowing in triumph, he betrays our denial of denial. So, wringing his neck, wringing our hands, eyes streaming with tears of guilty regret we stand at the center of that vortex. And yet, as faint as the dawn, we hope.

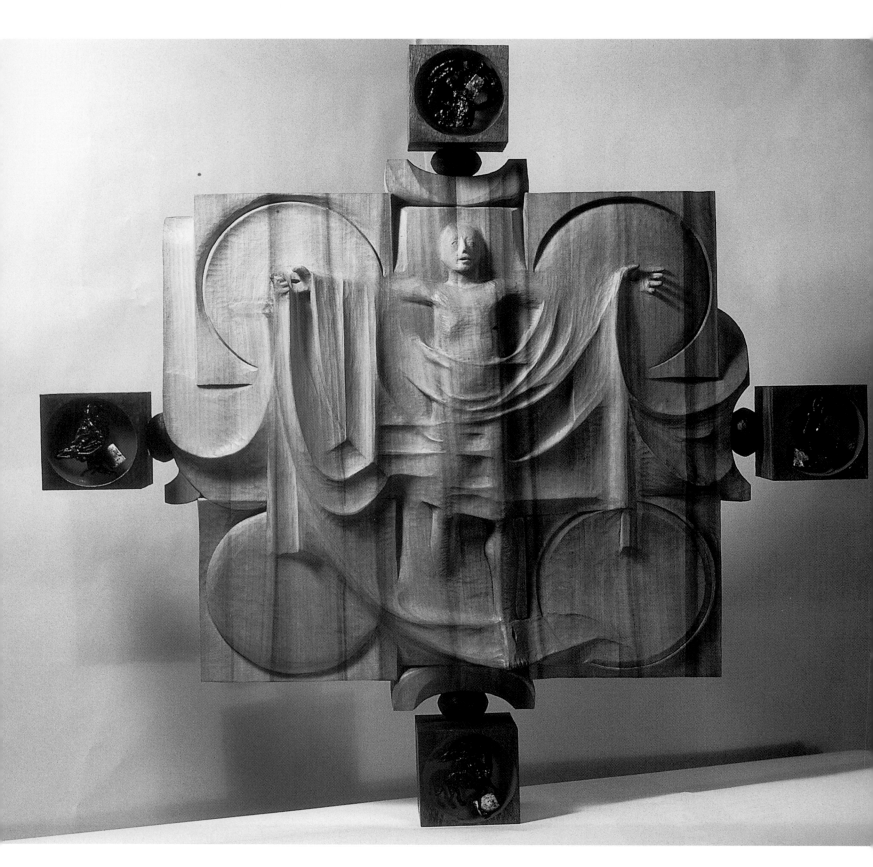

Cross and Figure, 1981, poplar

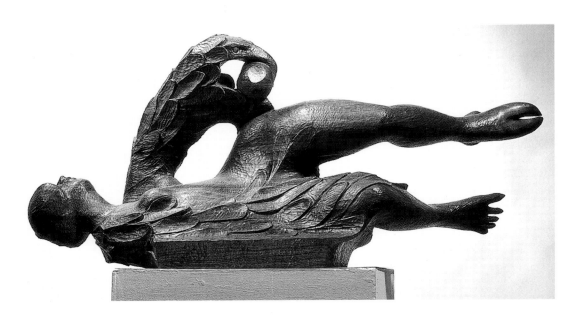

Fallen Angel, circa 1985, walnut

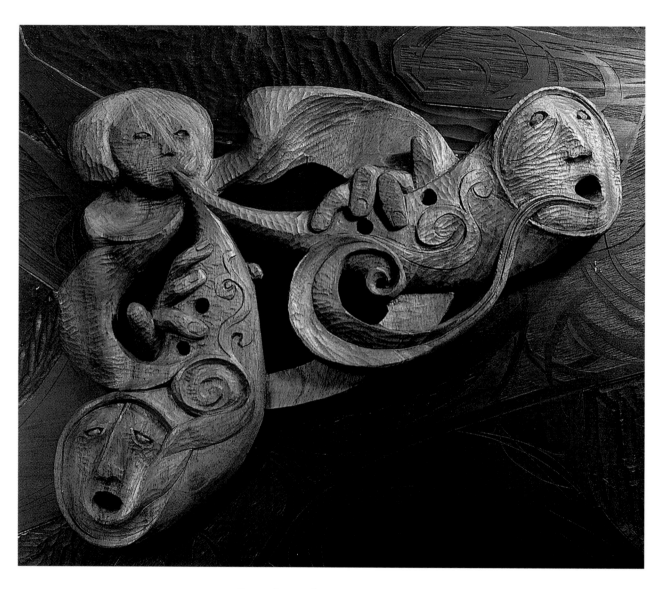

Organ Decorations, 1981, mahogany

Organ Decorations, 1981, mahogany

(Next page) Brustwerk doors for Organ, 1981, mahogany

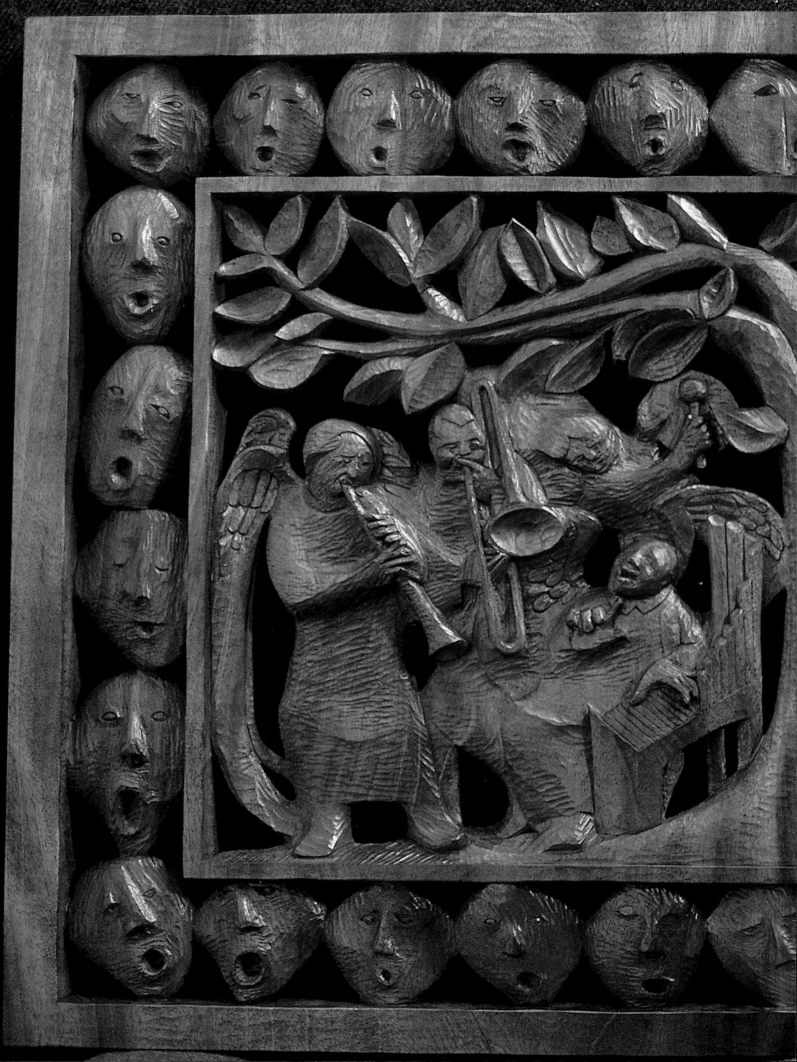

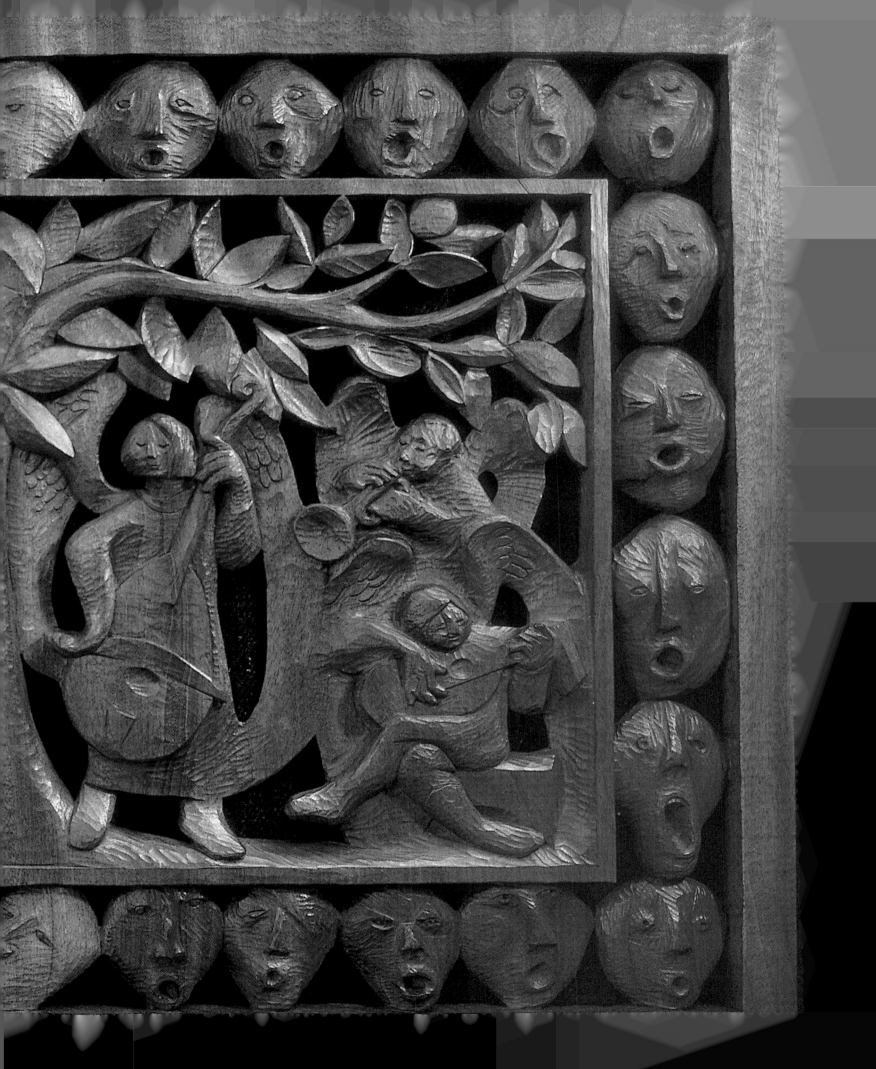

Warrior, 1968, engraving, 10" x 8"

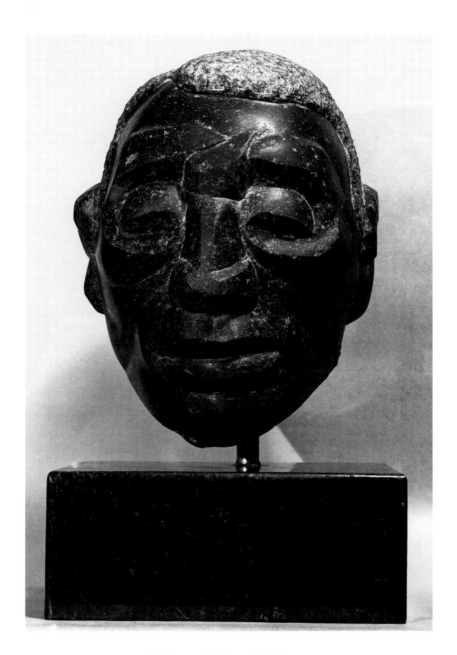

Fighter, 1954, basalt fieldstone

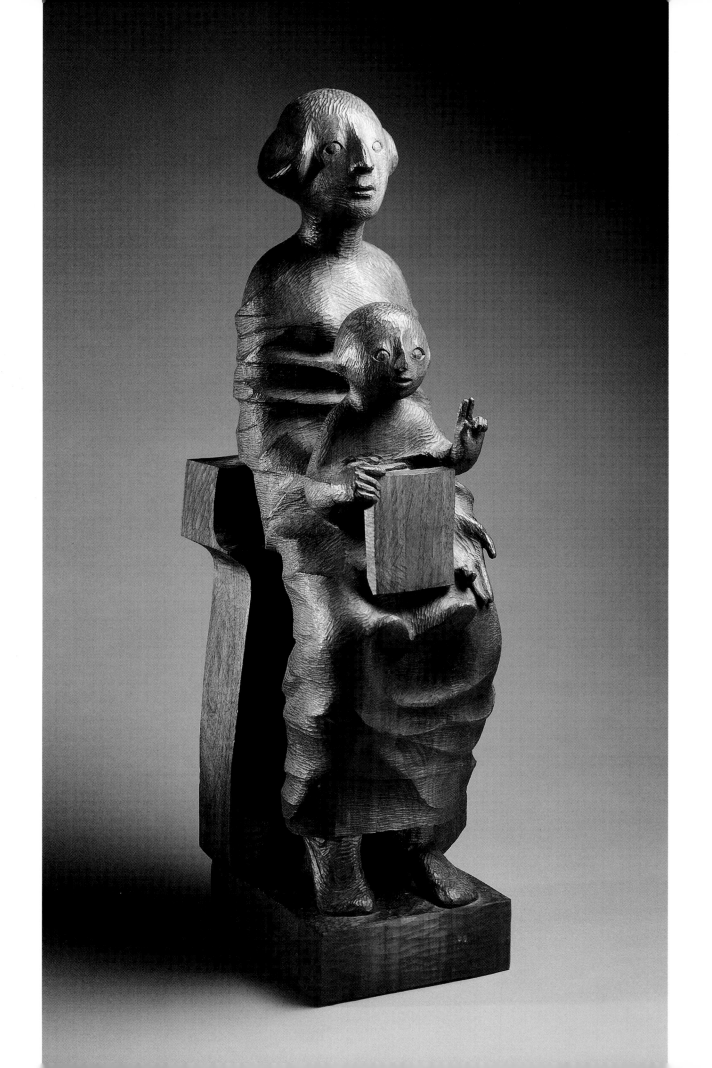

The Gift of Joe

ROSEMARY BOYLE PETTERS

I was in a rage—a parental rage.

The shaky bridge between one of my teenage children and me had
been mended back together again, amid tears and hugs and mutual
 regrets.

And now, just this morning, the bridge had crashed, exploding into a
million pieces, having been built on air, the air of a new lie.

This was it! I was finished! Why even listen? Why care? I couldn't
do it anymore! How could I when the ground crumbled
off the edge of the world
when I walked on it?

From the kitchen I saw Joe's car coming down the driveway.
Storming out the door to meet him, I suppose I showered him with
 the venom of my new abnegation of motherhood.

I remember the way he opened the car trunk, carefully folded back
the protective cloths, and there, shining out like the sun, was that most
exquisite madonna!

I was shattered by its beauty, melted, overcome, sobbing.

I remember the lovely autumn breeze that sent more yellow-tissue
 leaves
drifting down around us from the trees above.

I remember Joe, just standing there. Knowing.

And I, like a crazy lost cat falling from the sky, landed—right side up—
 back on the earth.

Mary and Child, 1973, walnut

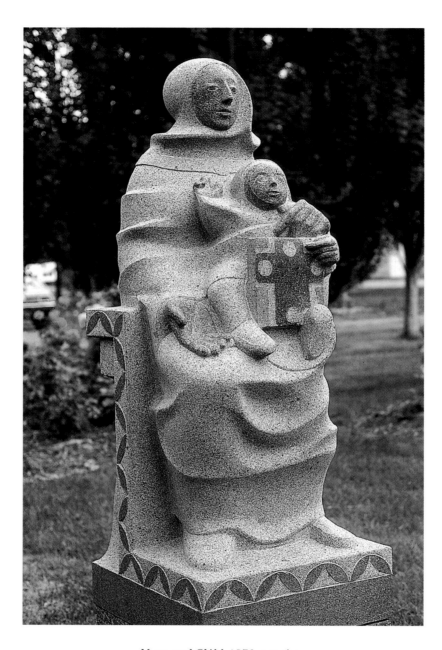

Mary and Child, 1973, granite

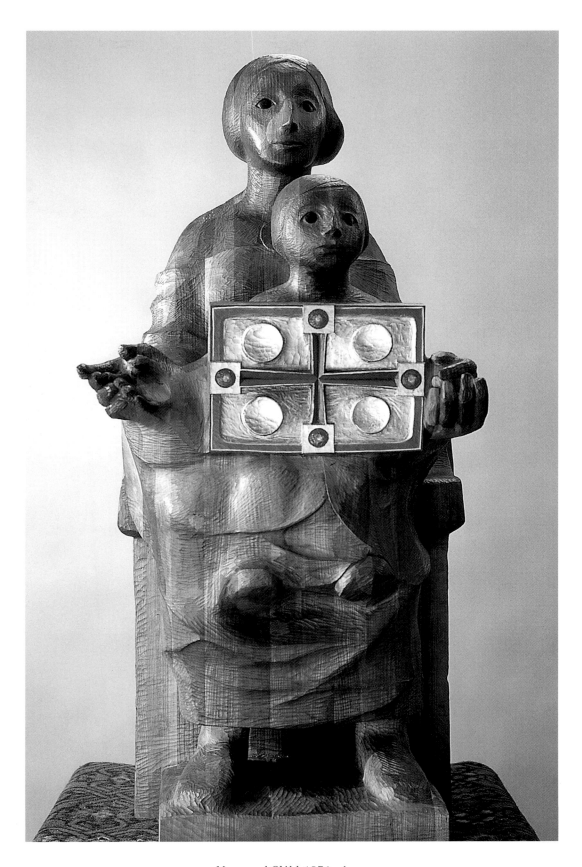

Mary and Child, 1976, cherry

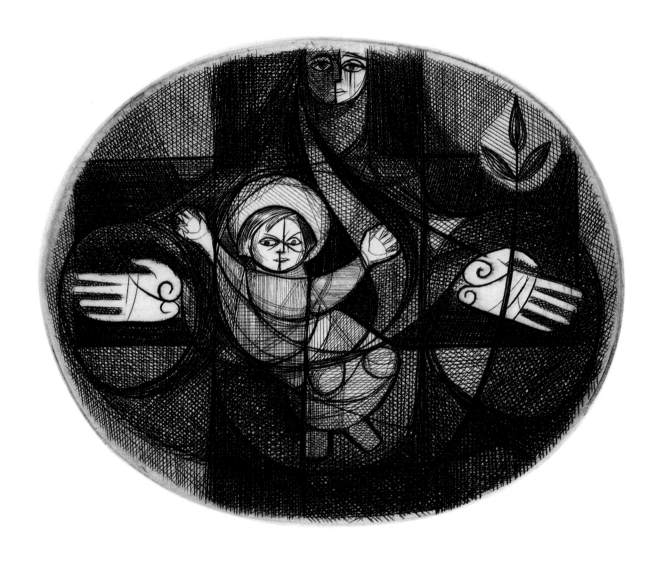

Madonna, 1968, engraving, 6" x 7"

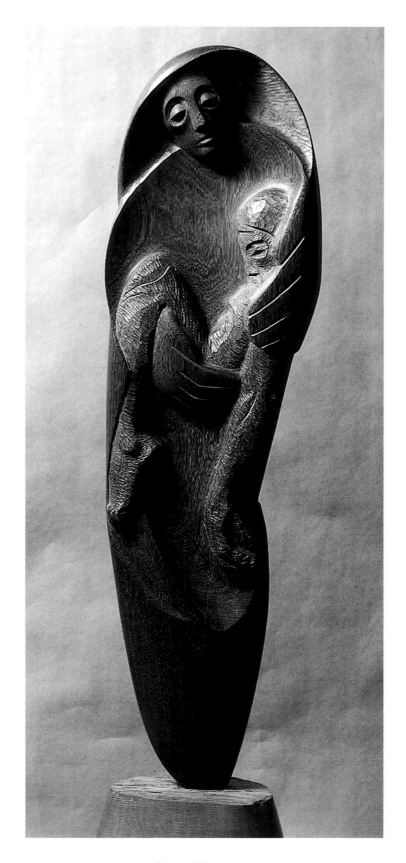

Pietà, 1975, walnut

Wall Panel, 1978, mahogany and forged iron

THE WORLD IS CHARGED WITH

THE

THERE IS
FIAT BY WHICH
ALL THIS WORLD IS
PERVADED

IN SPITE
EVERYTHIN
I STILL BEL
THAT PEOP
ARE REA
GOOD
HEA

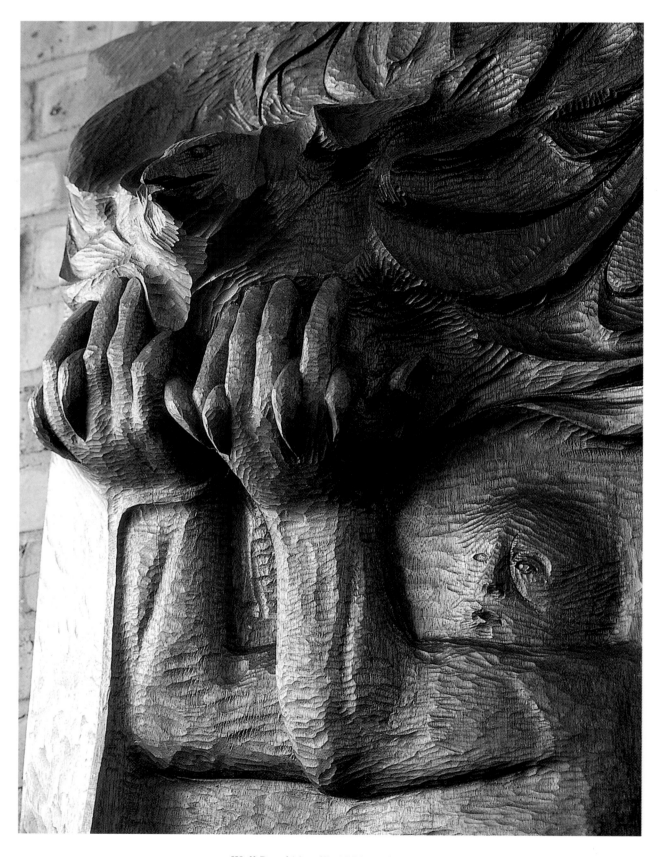

Wall Panel (detail), 1978, mahogany

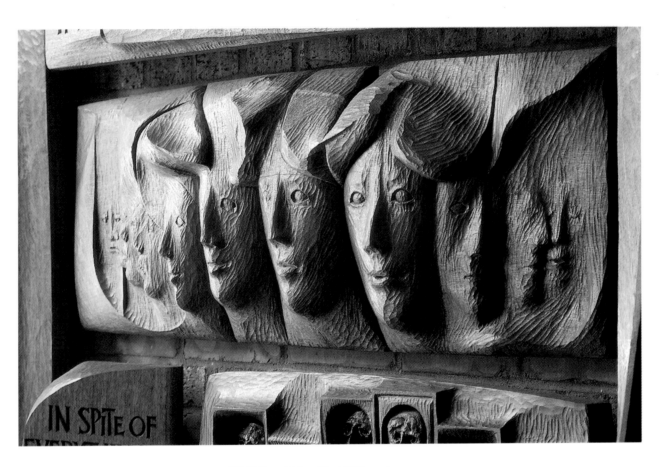

Wall Panel (detail), 1978, mahogany

Eve on Pedestal, 1971, forged iron

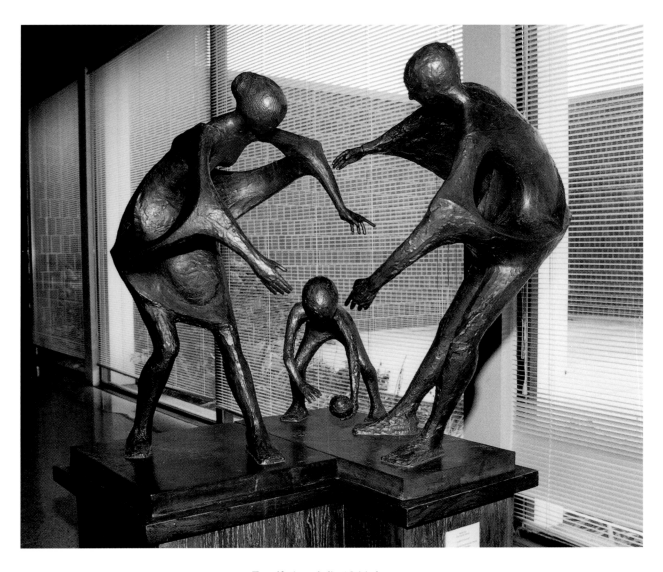

Family (model), 1966, bronze

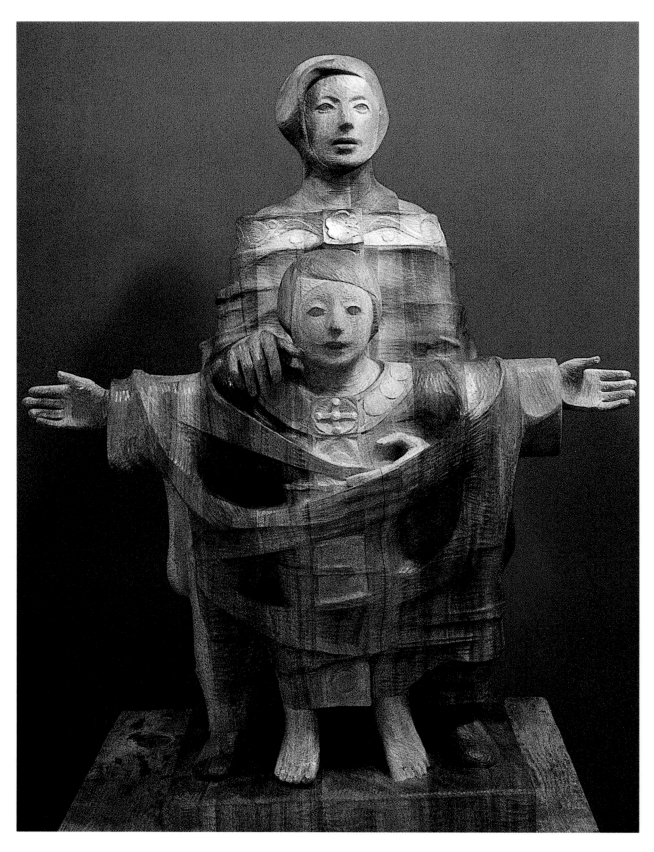

Madonna, 1984, mahogany

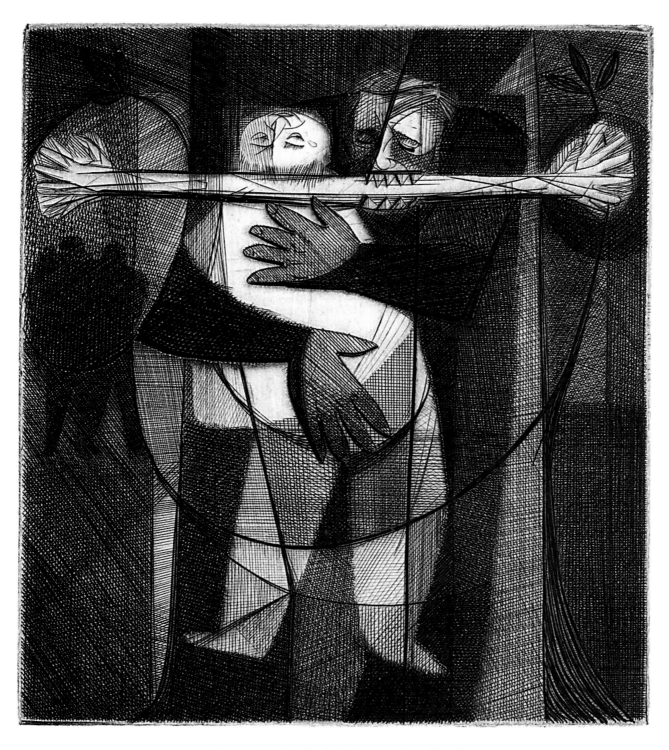

Return of the Prodigal, 1969, engraving, 7" x 6"

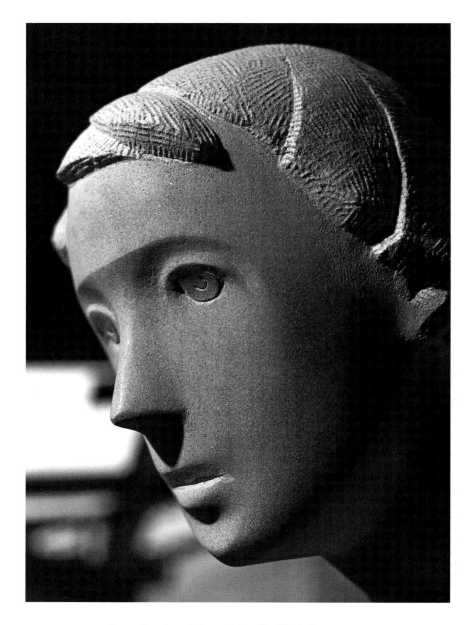

Guardian Angel Group (detail), 1960, limestone

(Right) *Guardian Angel Group*, 1960, limestone

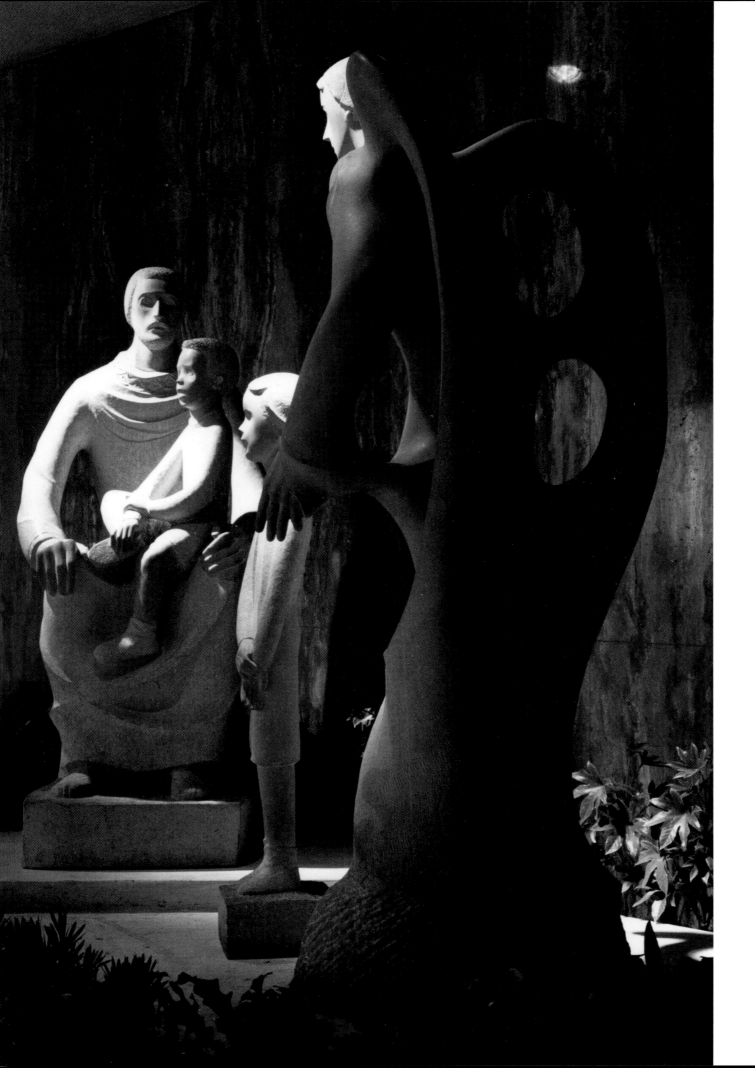

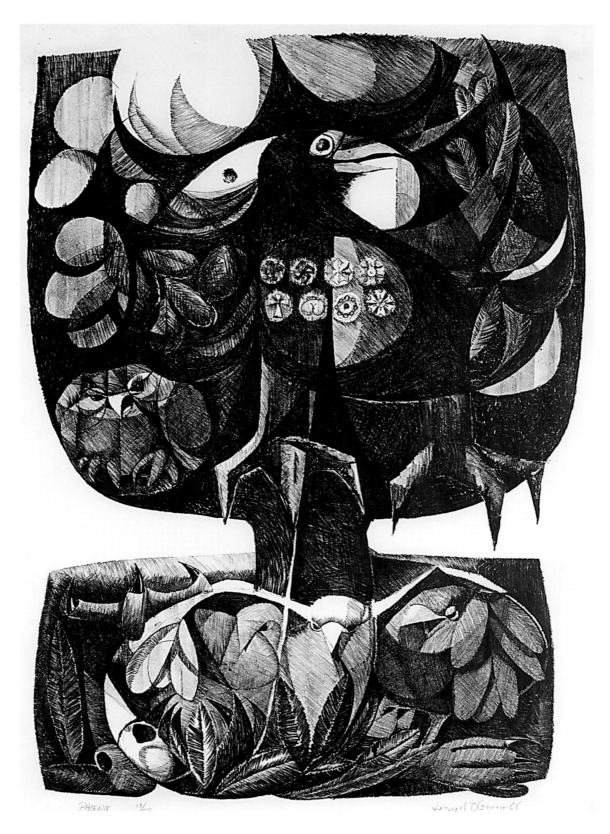

Phoenix, 1979, lithograph, 26" x 18"

(Right) *Young Owl*, 1977, limestone

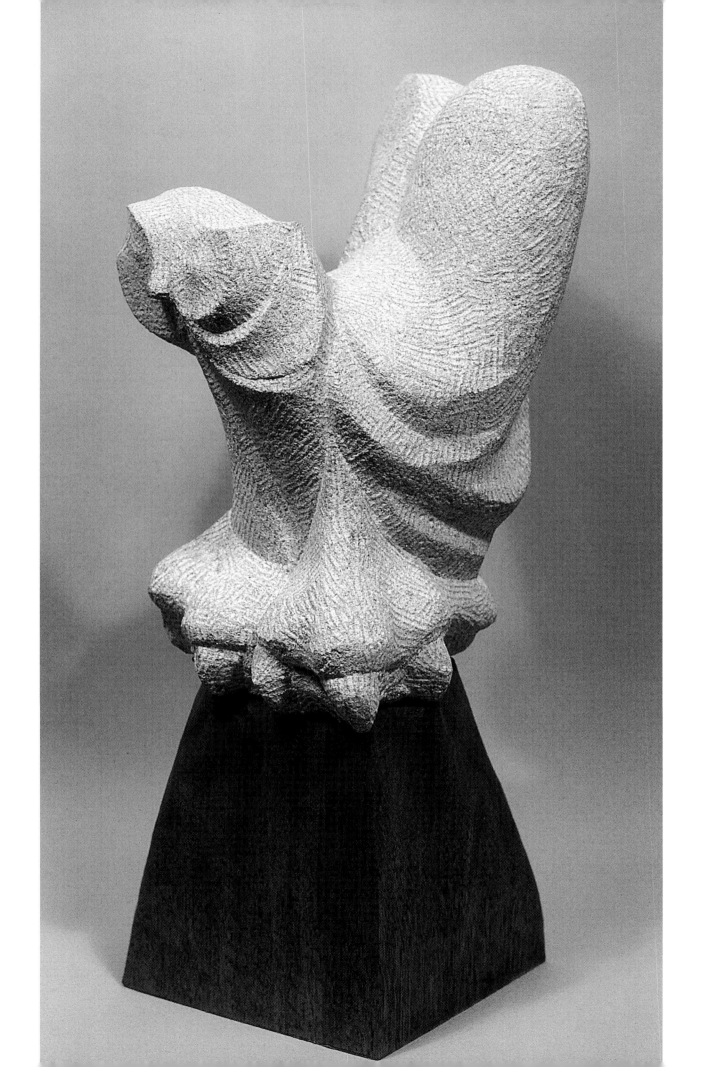

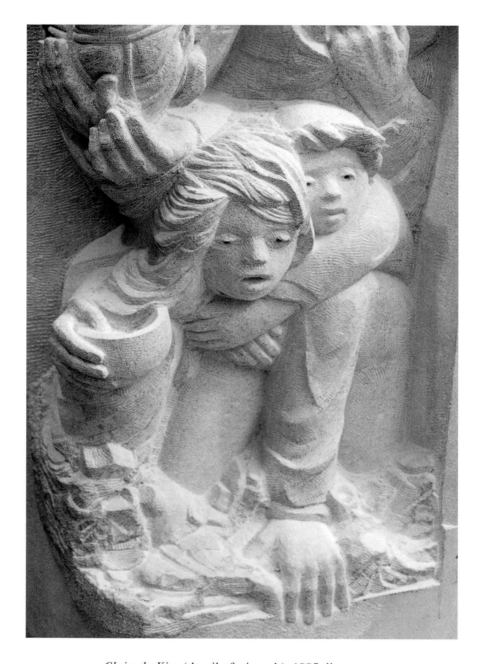

Christ the King (detail of triptych), 1995, limestone

Tapping

DENNIS FRANDRUP, O.S.B.

There was a rhythm to Joe's way of working, a rhythm that reached far beyond the confines of his studio. I could hear the gentle, careful tap of chisel and hammer on delicate stone fingers, and then in contrast, the crashing sounds of large chunks of falling stone. The gentle tap and heavy beat were enriched by the music that came from Joe's dusty tape deck. Jazz was Joe's favorite music, music that complemented and gave momentum to the rhythm of his hourly tapping. There were times when his tools became drumsticks as he joined in with the beat of the music.

A dusty black leather chair supported some of his silent moments as he studied his work, did further drawings, or napped a little. Always the tapping would resume with renewed energy and determination.

His studio is silent now. The rhythmic tapping has ceased. Yet there are times when we hear their echo and remember Joe.

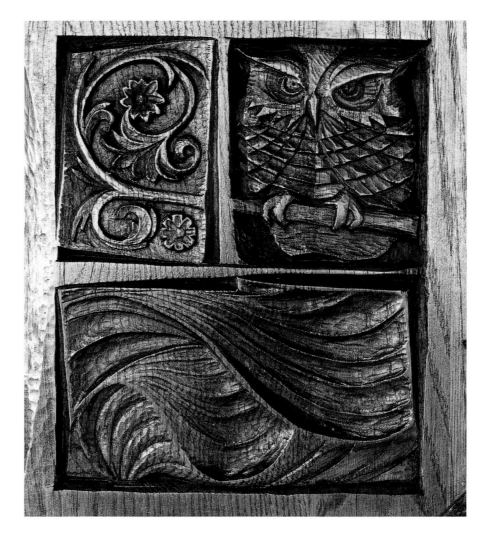

Door and Frame (detail), 1970, oak

(Right) *Door and Frame*, 1970, oak and forged iron

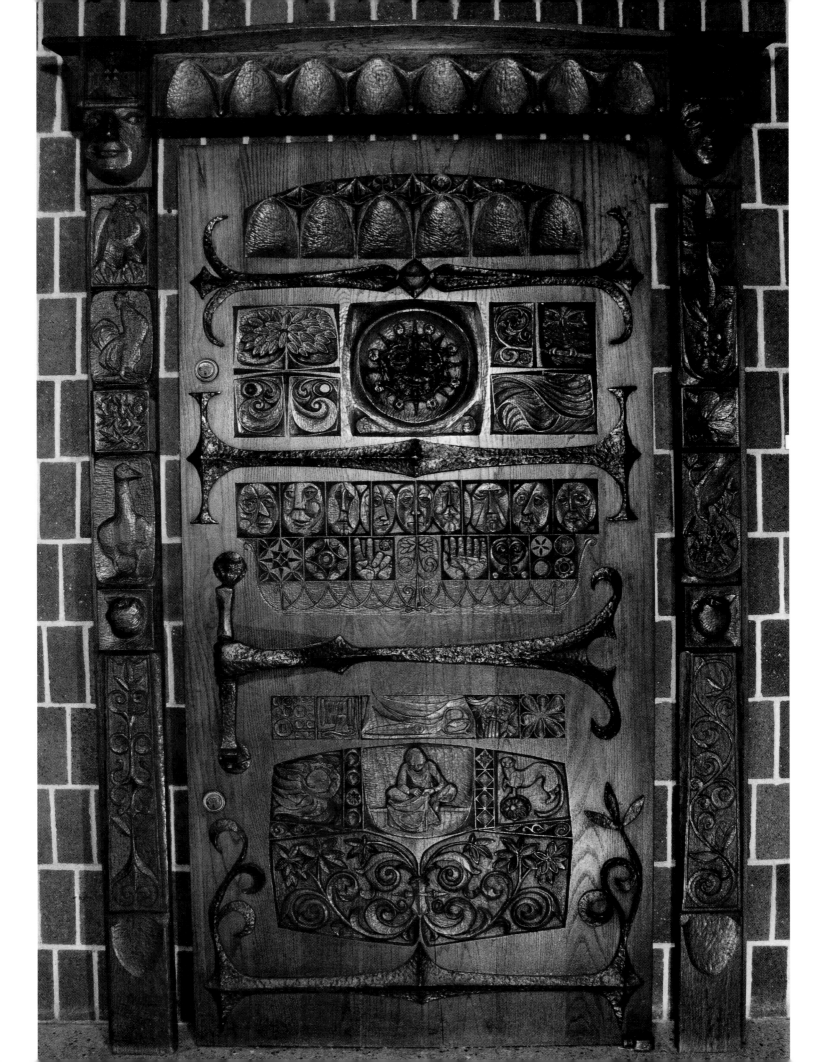

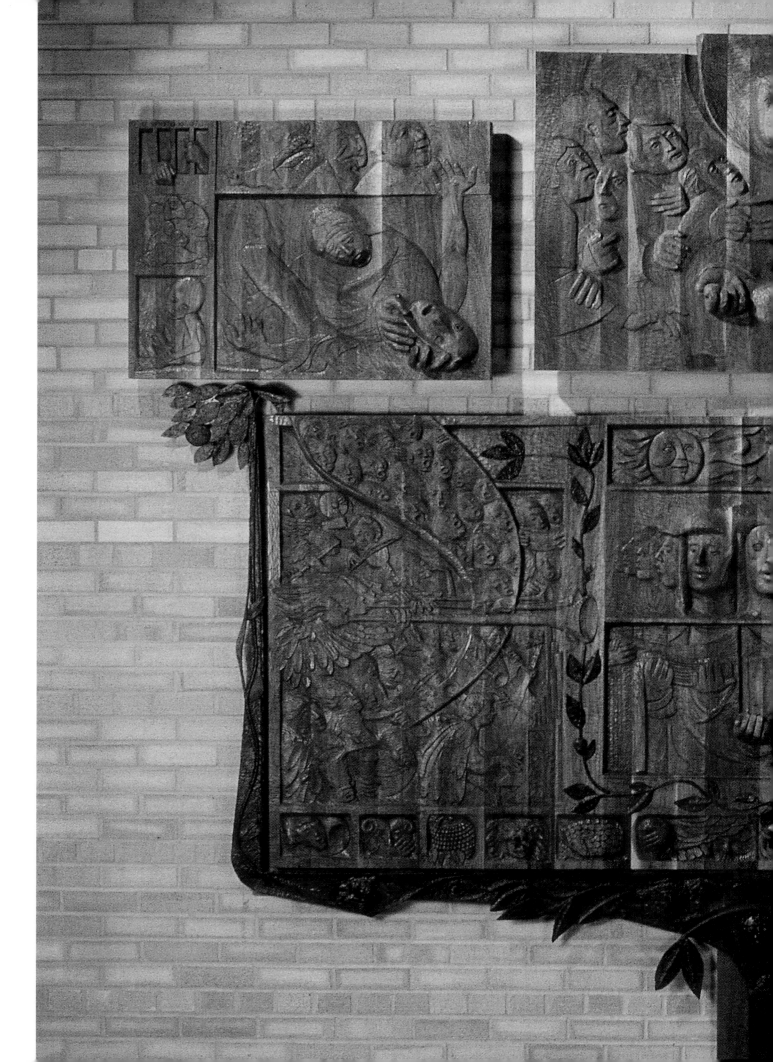

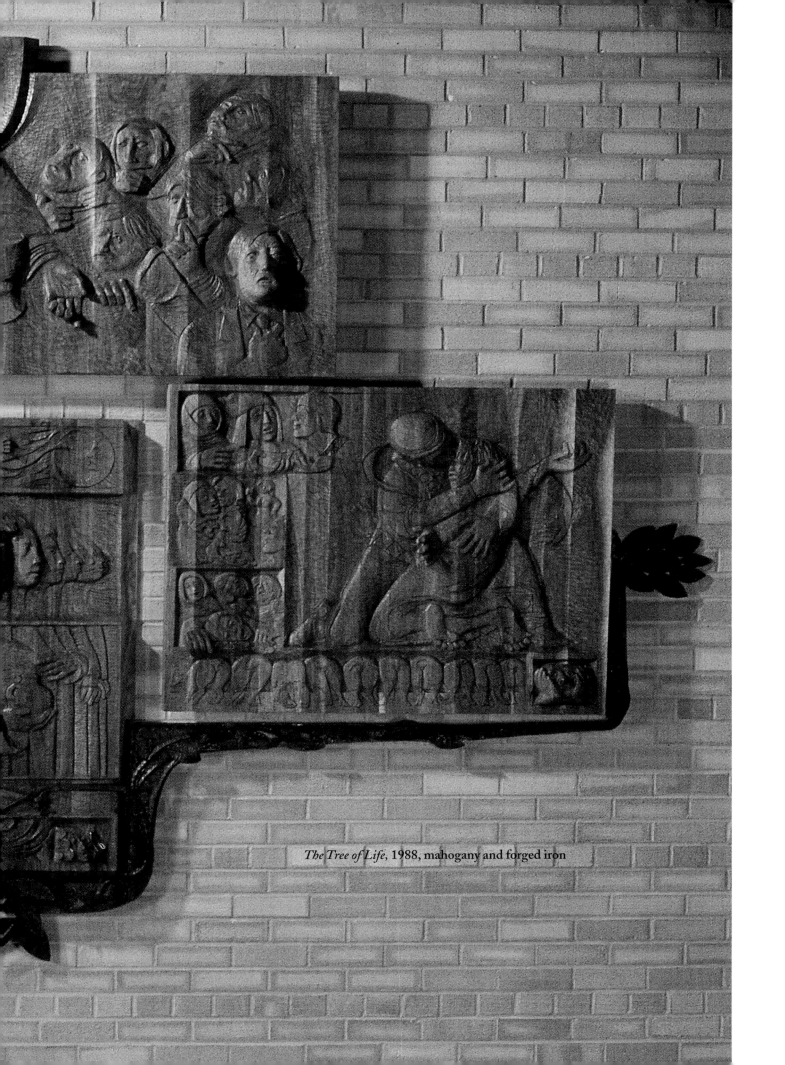

The Tree of Life, 1988, mahogany and forged iron

The Tree of Life

MARK CONWAY

The only time I recall getting direct advice from Joe—despite the fact that I often stopped by to angle for his opinion, his guidance—came some time after my first son was born. I was telling Joe a story about how badly some parental strategy had backfired, when he stopped me, put his hand on my arm. "Remember," he said, beginning to smile. "Whatever you do—it's wrong."

I take great pleasure in passing this advice on to new parents. I've come to think of it as the O'Connell Doctrine of Original Sin—there's been an awful mistake, and the least we can do is laugh.

Joe's last major work in wood, *The Tree of Life*, is filled with this irony. The heavenly hosts play music—most likely jazz—here in the earthly kingdom, but we hear it only rarely. The Prodigal Son sets off on his willful adventure only to discover the world is not as he imagined it. In the scene that dominates the panel on the right, the son submits to being saved by his family. He's welcomed back home by a crushing embrace, a hug which brings him to his knees. His arms are out-thrust in a gesture showing both gratitude and second thoughts.

Joe's comic vision, though, did not mean that Joe simply overlooked the darker aspects of humankind. The prevailing attitude of *The Tree of Life* is gently humorous, but it does contain the whole of life. Horrors occur that can't be explained away by misunderstanding or by simple human frailty.

At the upper reaches of the tree, a child sits alone, starving. Above this child, an infant is held in its mother's arms surrounded by a group of onlookers. There's an air of sorrow; it's clear the baby will die. The two large figures that dominate this panel are cast down on the ground, one nursing

the other in a final agony. At the top of this panel, next to the pair of hands holding prison bars, two prosperous burghers chat. They look off into the distance, in a good mood after enjoying a big dinner.

The top of the tree presents Christ's passion. But even at the Last Supper, the human comedy sneaks in. The apostles are gathered around Christ, except for the figure of Judas in the corner. He stares out at us with a look of practiced innocence, straightening his tie. As you notice Judas's big ears, you come to see that it's a portrait of the artist, the artist when he was younger and still had his beard.

Joe completed this work after returning from a long-awaited trip to Italy. One of the things he noticed in his careful inspection of the Baptistry in Pisa is how the artists included figures in relief, too low for most people to see. These figures were usually of animals, placed there so that the children would find them as they were playing, while the grown-ups admired the work of art.

Joe worked this motif into *The Tree of Life*. Ideally, as people gaze at the tableau carried away by grand themes, they will hear children giggling. They walk over to see what the kids are laughing at and they're shown a row of pigs' backsides, one of the repeating patterns, the laughter that frames the darker branches of Joe's *Tree of Life*.

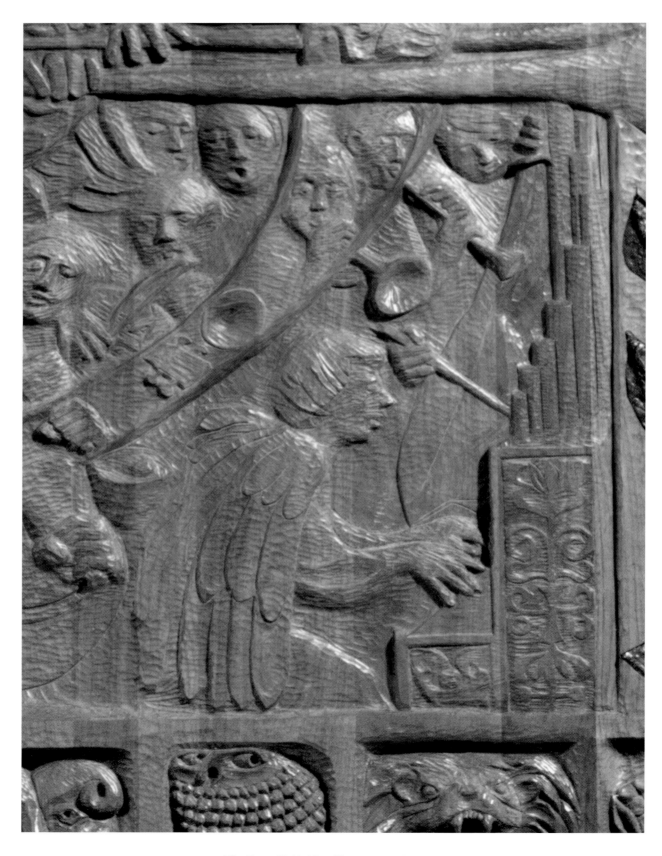

The Tree of Life (detail), 1988, mahogany

The Tree of Life (detail), 1988, mahogany

Saint Benedict, 1965, welded steel and forged iron

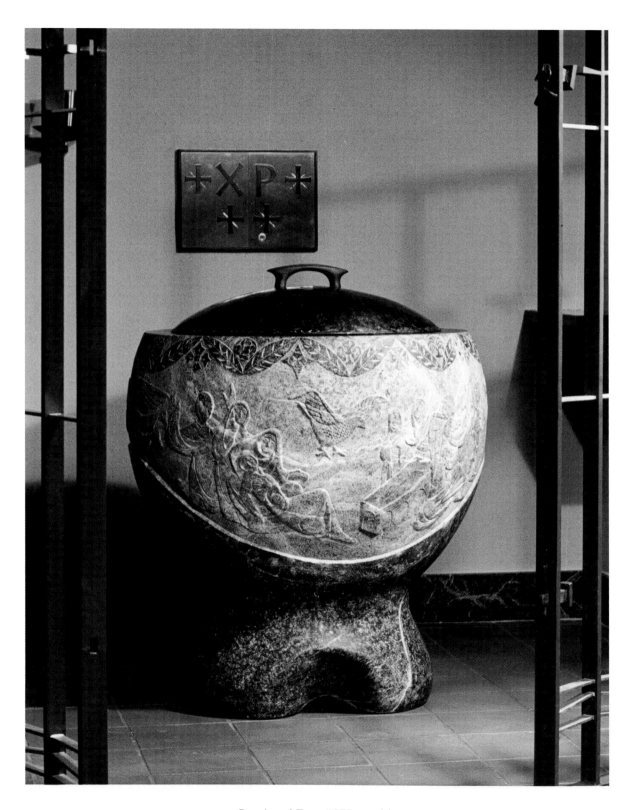

Baptismal Font, 1958, marble

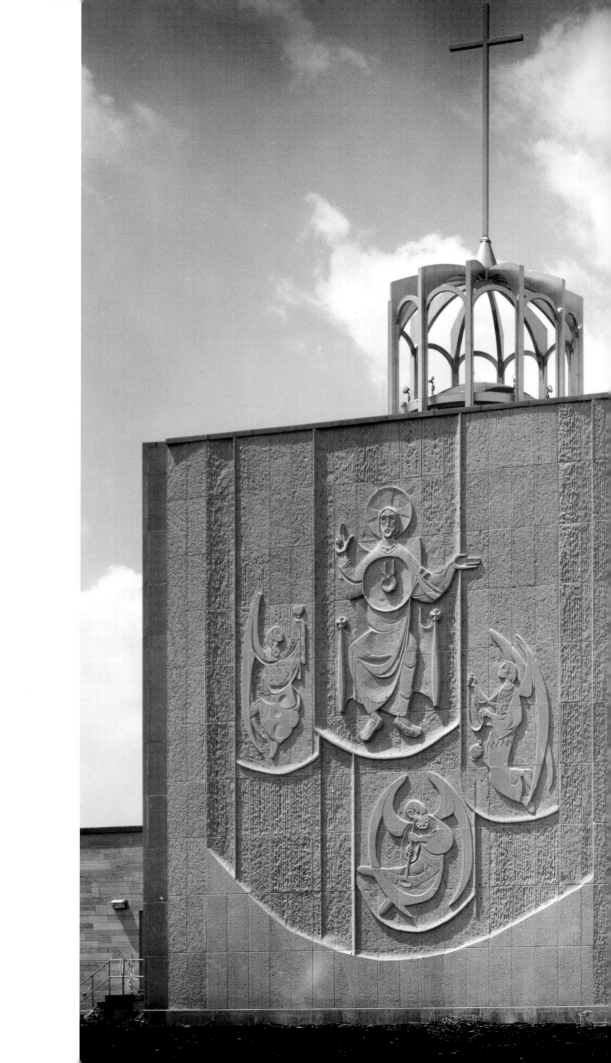

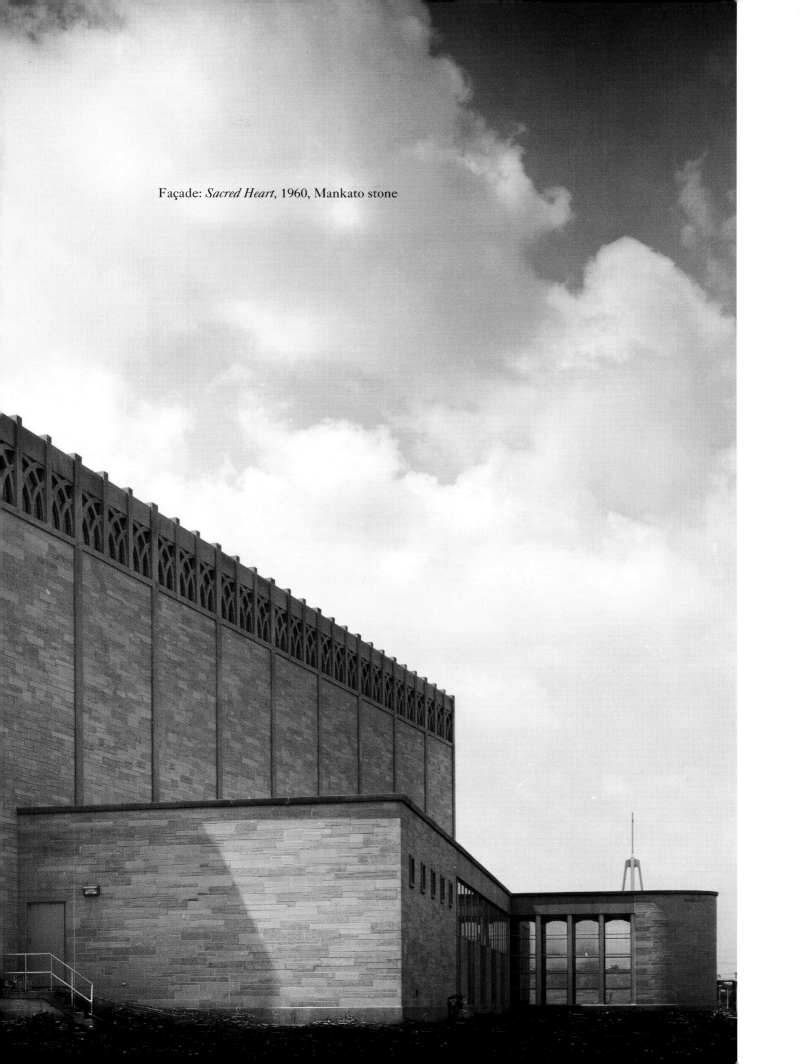

Façade: *Sacred Heart*, 1960, Mankato stone

Jazz and the Coming of the Kingdom

MARY SCHAFFER

Enticed by the curious polyphony of Jellyroll Morton and chisel tapping Indiana limestone, I walked into Joe's studio. Perhaps like me, Mr. Morton would have been amazed to see the crowd of figures his muse was helping Joe coax out of three huge blocks of stone. Joe was portraying Christ the King for a parish in Las Vegas, Nevada.

"What if you make a mistake?" Stone carving looked like a terribly irreversible process to me. "I don't make mistakes," Joe smiled, "only design changes." Well then, I thought to myself, that explains Jellyroll. Jazz Improvisation. Take a good melody, then stretch it. Make it move. Make it sing. No mistakes, just creative alterations sending that tune where it never expected to go.

I stood between two long, horizontal rectangles and faced a tall, vertical one in the center of the triptych. The middle panel depicts Christ with large, open hands, sitting astride a donkey. Joe chose a most difficult, strictly frontal perspective in order to show them entering the city and heading straight down what might be called the Avenue of Lost Hope and Broken Dreams.

Quite a sorry lot of folk emerges from the two side panels. One could hardly say they are gathering to welcome anyone; they are just a press of dismal humanity, each overwhelmed with his or her own burden. A hand reaches through iron bars to touch the shoulder of a woman who stands erect and tight-lipped against the prison wall, her children clinging to her

skirts. Two lovers steal privacy in a storm sewer. A prostitute and her child, drained of interest or expectations, stare into the street through the broken pane of their upstairs window. A bony child fingers his smooth, empty rice bowl. A teenaged runaway hunches in a cubbyhole, open to anything because nothing matters. There are still others: a knot of homeless people with glinting eyes—half wily, half wild—search for a scrap of space. A column of heads, each blindfolded or gagged or bound in some way, hem in another man stretched on a rack. Finally, a Christmas nativity in dreadful reverse: a couple grieves over their dead baby, attended only by a cat, a rat, and a mangy dog.

Not one of these is company I would choose, yet there I was in the midst of them all, closing the circle. I looked across at the donkey, which seemed to mirror my reluctance and dismay. Yet that beast's burden is the King of Kings, and Christ's reign takes a most difficult perspective indeed: whatever you do to the least of my family, you do to me.

I looked again at the face of Joe's Christ, turned fully and irreversibly toward all of us tragic people lining the avenue. There's not a trace of pity in that face, and not compassion either—simply joy: sheer, radiant joy. It's as if to say, "I am so *glad* to be here, so very happy I could come"—as if he were saying, "No discards, no mistakes, only design changes."

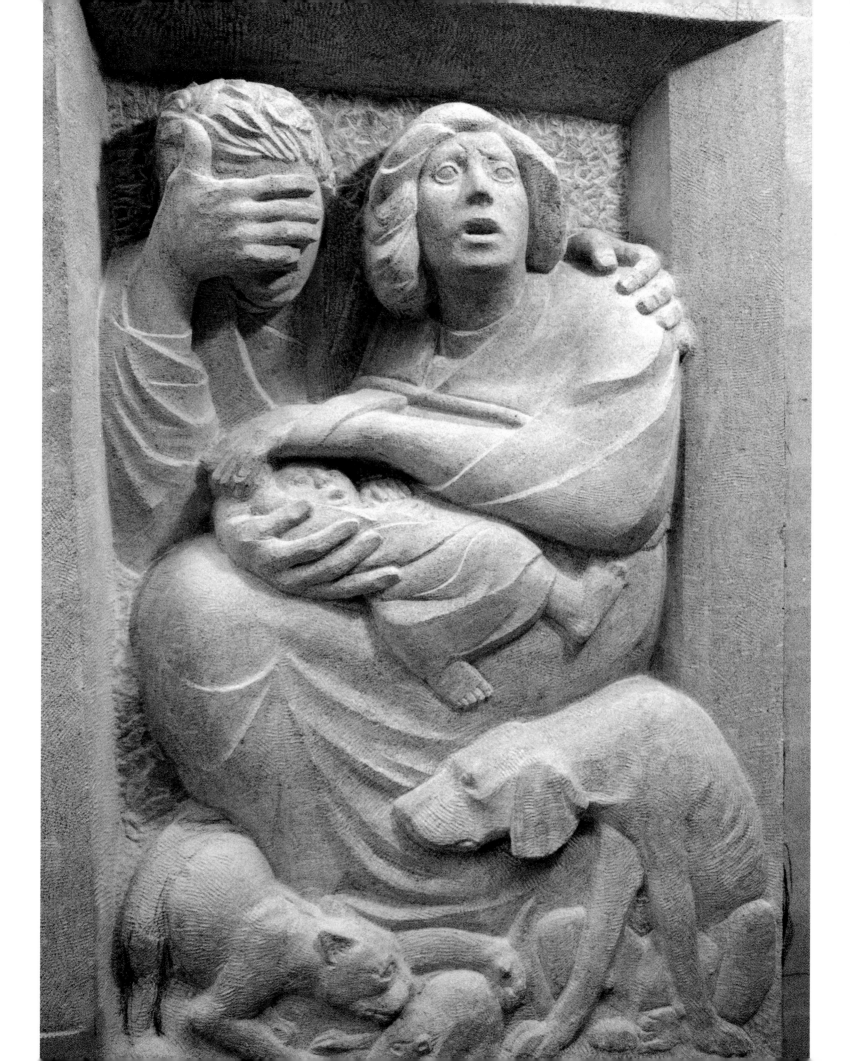

Christ the King (detail of triptych), 1995, limestone

(Left) *Christ the King* (detail of triptych), 1995, limestone

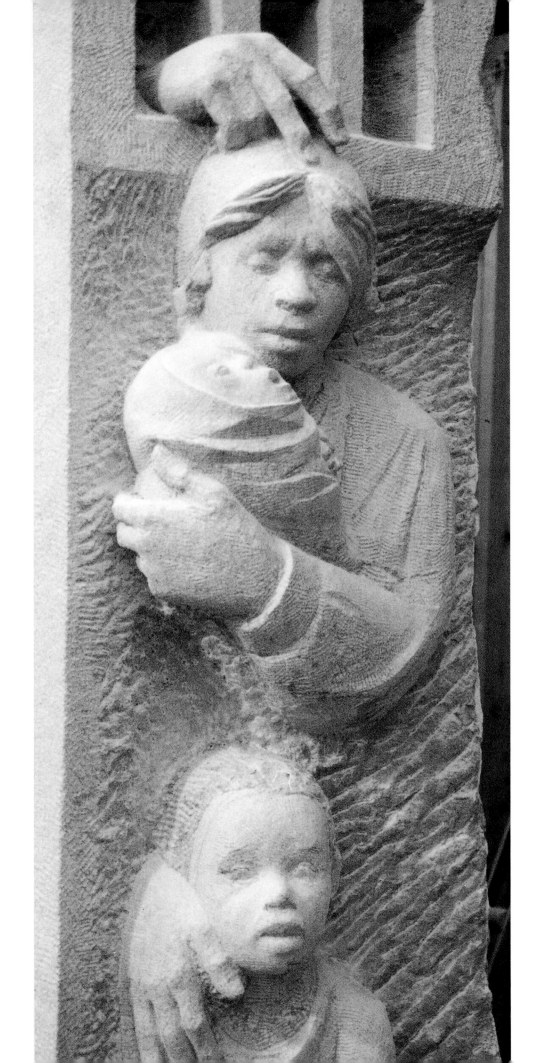

A Work in Progress
(for Joe O'Connell)

LARRY SCHUG

A beggar's hand reaches from limestone,
holding an empty bowl.
The stone faces of the imprisoned,
the silenced and the mute,
the blind and blinded face me;
homeless, widowed, orphaned people,
refugees and prisoners of conscience,
those emaciated of spirit and flesh;
the least of our brothers and sisters,
but our family just the same,
stare from limestone eyes
at whoever crosses before them.

Limestone chips litter the floor,
the husks of the sculptor's prayer.
The sculptor, breath barely squeezed
through a cancerous esophagus,
asks only for enough breath
to finish this work.

Christ the King (detail of triptych), 1995, limestone

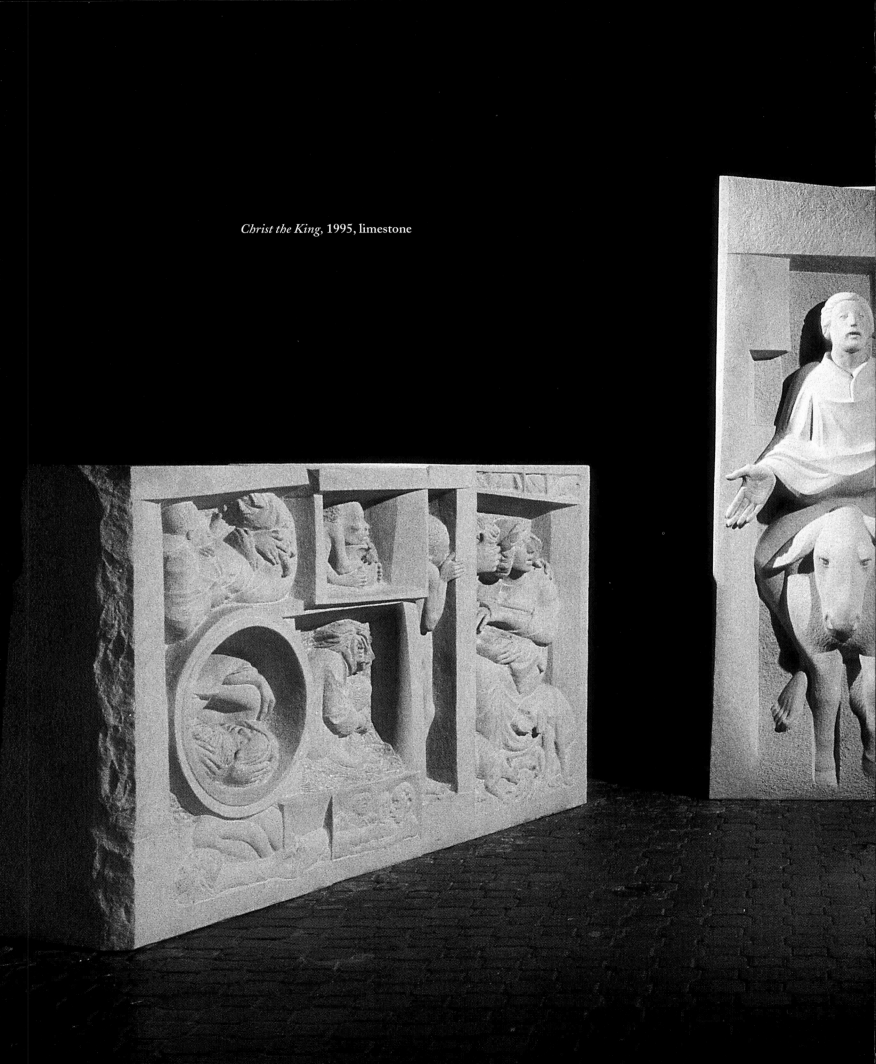

Christ the King, 1995, limestone

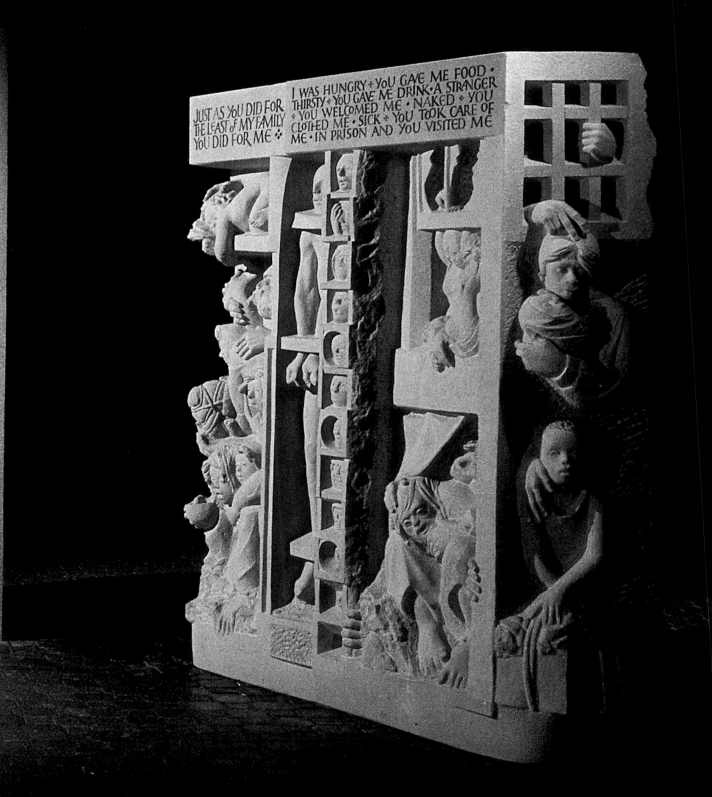

Joseph O'Connell, 1995

The Moses Man
1927–1995

───────────

MARY WILLETTE HUGHES

I tell you, the very stones would cry out.
<div align="right">

Palm Sunday Gospel

Luke 19:40
</div>

You stand before thirteen tons of gray Indiana
limestone. For four long years we watch you,
sculptor, set free a triptych in deep bas relief
as you listen to the radio's soul-blue-beat of jazz.

You choose hammer and chisel to follow lines
sketched on rough, textured stone. Strike and
chip, strike and chip. Dust shards enter your
lungs, wrists gone to pain are cloth bound.

A young Christ emerges from the center block,
riding a sad-eared donkey. You chisel his mouth
and open his hands to touch, to feed, to heal
his father's world. Our fingers trace curved cold

faces, the gaunt figures. Your ageless poor speak
with stone mouths that echo our idle, hollow hands.
Like a Moses man come down the mountain,
your stone becomes the word.

Chronology

of Principal Events in the Life and Work of Joseph O'Connell

1927 January 15: Joseph John O'Connell born in Chicago, Illinois.
Eldest son of Cecile DesMarais and Joseph O'Connell, diverse
craftsman and head teacher at Hancock Vocational School.

1941–1943 Attends Lane Technical High School; works as apprentice
typesetter for Edward Muraski, his uncle.

1944–1947 Enlists in U.S. Air Corps. Uses G.I. Bill to take art courses at the
University of Illinois, the American Academy of Art, and the Art
Institute of Chicago. Decides to abandon formal education.

Is offered studio space in the apartment of Francis "Muggsy"
Spanier and his wife, Ruth. Begins personal and serious study of
art with the support of the Spaniers and their stepson, Buddy
Charles Gries, a jazz pianist.

Works as typesetter, cab driver, and office worker while attending
night school.

1951–1952 Influenced by the autobiography of Eric Gill, especially his sense
of craftsmanship. Decides that direct carving is his vocation.

Travels in Mexico for one-half year and, while there, starts his first
carving: *Saint Francis*, a gift for the Spaniers. Meets his future wife,
Joann "Jody" Wylie, an art student at the American Academy.

1953 Has first one-man show at Esquire Theater Gallery, Chicago, in
July. Exhibit contains the Saint Francis statue begun in Mexico
and a number of paintings and water colors. Reviewed by
Copeland C. Burg in the *Chicago Herald American:*

> One of the most satisfying shows of the younger artists we
> have seen in a long time. It reflects a genuine talent and an
> earnest approach to many phases and facets of the environ-
> ments to which this artist has been exposed: war in the
> Pacific, peace in this country and in Mexico, and the timeless
> and placeless aspects of religion.

The exhibition and review bring commissions to do *Three Pilasters*
carved in oak for the Swedish Club of Chicago, a *Saint Joseph*, and
a carving of *Aesculapius*. These in turn bring other commissions.

Marries Joann "Jody" Wylie, Glencoe, Illinois, in September. Is apprenticed to J. Norbert Smith as a commercial artist. Moves to Valparaiso and then to Chesterton, Indiana. Commutes to Chicago with Smith. At Smith's urging, seeks sculptural commissions. Contacts Monsignor Hillenbrand, architects, and others connected with the liturgical reform movement.

1954–1955 Through architectural firm of Gaul and Vossen, gets first of several commissions: a life-size stone carving of *Saint Francis of Assisi.*

Through the University of Notre Dame, meets Reverend Cloud Meinberg, O.S.B., and is offered a teaching position at Saint John's University, Collegeville, Minnesota. Joins the faculty and rents an abbey-owned house in Collegeville.

First child, Thomas, born in August 1954.

Executes twenty-one sculptures, nine of which are commissions. Noteworthy are: *Mary and Child,* his first work in welded metal; *Madonna and Child,* which wins first prize in the Minnesota Sculptors Exhibition, Saint Paul Museum; and *Baptismal Font,* commissioned by Saint John's Abbey for its centennial and presented as a gift to Holy Spirit Church, near the site of the first landing of the Benedictine monks in the Saint Cloud area.

Second child, Lauren, born in October 1955.

Meets J. F. and Betty Wahl Powers and Don Humphrey; learns from them the importance of commitment to art.

Work at this time is influenced by Eric Gill and those associated with *Liturgical Arts* magazine.

1956 Joins art faculty at Siena Heights College, Adrian, Michigan. Visits regional museums. At Cranbrook, encounters the sculptures of Henry Moore for the first time. Is impressed by Moore's organic, tactile forms and his treatment of materials.

Receives three commissions and decides to leave formal teaching to devote full time to sculpture.

1957	Returns to Collegeville, Minnesota; buys house and land from the abbey. Builds plastic tent in yard and begins work on the *Angel Guardian Group* sculpture. At one point large segment of stone breaks due to uneven temperatures in the tent. Has to reproportion the parts and radically change the form of the angel. The decision increases his desire for perfection.

Third child, Eric, born in June 1957.

Influenced by the ideals and the dailiness of Benedictine community life in Collegeville and Saint Joseph.

1958–1961	Completes *Angel Guardian Group* sculpture. Sees it as a synthesis of work to date. Conscious of Moore's influences in voids and treatment of stone.

Commutes to Mankato quarries, where he carves *Sacred Heart Façade* for the Quigley South Seminary, Chicago.

Executes ten commissions. Noteworthy are: *Crucifix*, which he sees as more "human" in form while conveying the spiritual serenity that comes from victory over human nature; and *Water Font* and *Bride*, which evidence change and development of a personal mature style.

Fourth child, Brian, born January 1960.

Builds permanent studio/shop on secluded part of his land.

1962–1969	Completes sixteen commissions. Noteworthy are: *Mary and Child*, commissioned for Mary Hall, College of Saint Benedict; and *Saint Benedict*, Benedicta Arts Center, College of Saint Benedict, executed on campus while serving as artist-in-residence. Does first woodcut print and first engraved print. Sees both processes as extensions of carving.

In late 1955 contacted by American Dental Association and Al Carrara of Chicago architectural firm Anderson, Prost, White to present sketches for a sculpture group. Chooses the theme of family; executes model of *Family Group*, Benedicta Arts Center, College of Saint Benedict; receives commission. In 1966–67, working with student assistants, executes 13' plaster sculpture in Art Court at Benedicta Arts Center. Work cast in bronze; installed in court of new American Dental Association Building, Chicago, 1969.

Fifth child, Juliann, born April 1965.

1970–1972 Completes fourteen sculptures, twelve of which are commissions. Noteworthy is the commission for the *Door* for Petters Fabric and Fur Shop, Saint Cloud. Sees the commission as one which allowed growth in the work itself and in the friendship and rapport between artist and patron.

1973–1977 Engaged by Minnesota Department of Corrections as consultant/teacher at the Home School, Sauk Centre, Minnesota. Works with children 13 to 17 years old, using basic tools for direct carving.

Executes fourteen works, eight of which are in stone.

Accepts commission from Saint Joseph Parish, Saint Joseph, Minnesota, to do *Mary and Child*.

Reflects on idea of commissions; realizes importance of making a sculpture which is wanted and will be used, especially in his own community.

Group show, Osborne Gallery, Saint Paul, 1975.

1978–1981 Executes ten sculptures, six of which are commissions. Of these, two are collaborative: *Sacred Heart Organ* with K. C. Marrin, organ builder, and Judith Goetemann, batik artist; and *Crucifix/Risen Christ* with Jean Matske, weaver. Sees communal traditional aspects of such projects as important in modern world.

1981–1995 Three sculptures (*Community, Prayer,* and *Work*) for Saint Benedict's Monastery, Saint Joseph, Minnesota; *Eve in Baroque; Christ the King,* triptych for Christ the King Catholic Community, Las Vegas, Nevada.

1995 Joseph O'Connell dies at his home October 7, 1995, in Collegeville, Minnesota, at the age of 68.

Second Round:
A Return to the Ur-Bar

Edited by

Patricia Bray
&
Joshua Palmatier

Zombies Need Brains LLC
www.zombiesneedbrains.com

Copyright © 2018 Patricia Bray, Joshua Palmatier, and
Zombies Need Brains LLC

All Rights Reserved

Interior Design (ebook): April Steenburgh
Interior Design (print): ZNB Design
Cover Design by ZNB Design
Cover Art "Second Round" by Justin Adams of Varia Studios

ZNB Book Collectors #11
All characters and events in this book are fictitious.
All resemblance to persons living or dead is coincidental.

The scanning, uploading, and distribution of this book via the Internet or
any other means without the permission of the publisher is illegal and pun-
ishable by law. Please purchase only authorized electronic editions of this
book, and do not participate or encourage electronic piracy of copyrighted
material.

Kickstarter Edition Printing, August 2018
First Printing, September 2018

Print ISBN-10: 1940709180
Print ISBN-13: 978-1940709185

Ebook ISBN-10: 1940709199
Ebook ISBN-13: 978-1940709192

Printed in the U.S.A.

Second Round:
A Return to the Ur-Bar

Purchased from
Multnomah County Library
Title Wave Used Bookstore
216 NE Knott St, Portland, OR
503-988-5021

Other Anthologies Edited by:

Patricia Bray & Joshua Palmatier

S.C. Butler & Joshua Palmatier

Laura Anne Gilman & Kat Richardson

Troy Carrol Bucher & Joshua Palmatier

COPYRIGHTS

Introduction copyright © 2018 by Patricia Bray

"Honorbound" copyright © 2018 by Russ Nickel

"Forest Law, Wild and True" copyright © 2018 by Rachel Atwood

"The Wizard King" copyright © 2018 by K.L. Maund

"A Favor for Lord Bai" copyright © 2018 by Jean Marie Ward

"A Lawman, an Outlaw, and a Gambler Walk Into a Bar..." copyright © 2018 by Jeanne Cook

"Make Me Immortal With a Kiss" copyright © 2018 by Jacey Bedford

"Bound By Mortal Chains No More" copyright © 2018 by William Leisner

"Welcome to the Jungle Bar" copyright © 2018 by Garth Nix

"But If You Try Sometimes" copyright © 2018 by Diana Pharaoh Francis

"The Whispering Voice" copyright © 2018 by David Keener

"Ale for Humanity" copyright © 2018 by Mike Marcus

"West Side Ghost Story" copyright © 2018 by Kristine Smith

"Thievery Bar None" copyright © 2018 by Aaron Michael Roth

"Wanderlust" copyright © 2018 by Juliet E. McKenna

Table of Contents

SIGNATURE PAGE

Patricia Bray, editor:

Joshua Palmatier, editor:

R.K. Nickel:

Rachel Atwood:

Kari Sperring:

Jean Marie Ward:

A.E. Stanton:

Jacey Bedford:

William Leisner:

Garth Nix:

———————————————————————

Diana Pharaoh Francis:

———————————————————————

David Keener:

———————————————————————

Mike Marcus:

———————————————————————

Kristine Smith:

———————————————————————

Aaron M. Roth:

———————————————————————

Juliet E. McKenna:

———————————————————————

Justin Adams, artist:

———————————————————————

Introduction

Patricia Bray

They say you can't go home again. But you can return to your favorite bar, the place where the bartender knows your favorite poison and the regulars know you by name. In that spirit we are pleased to present a brand-new collection of stories set in the Ur-Bar.

Back in 2010 a group of science fiction authors came up with the idea for an anthology of stories set in a bar. Not just any bar—the Ur-Bar, the ultimate watering hole. At any time throughout history, there is always one place that is closest to the ideal of what a bar should be. That place is the Ur-Bar, where you'll find the immortal Gilgamesh pouring local beverages and the occasional mystic potion.

Unlike most ideas that authors have while drinking at science fiction conventions, this still seemed like a good idea in the light of day. Tekno Books and DAW agreed and AFTER HOURS: TALES FROM THE UR-BAR was released in 2011.

The first anthology set the tone for future projects, containing a variety of stories from humor to horror, and mixing bestselling authors with those seeing their print debut. Joshua Palmatier and I had so much fun with this project, in 2012 we followed it up with THE MODERN FAE'S GUIDE TO SURVIVING HUMANITY, also published with Tekno Books and DAW.

When Tekno Books scaled back their operations, Joshua Palmatier took the next leap forward, founding Zombies Need Brains, a small-press

publishing original genre fiction anthologies. The first release from ZNB was CLOCKWORK UNIVERSE: STEAMPUNK VS ALIENS. This was quickly followed by a half-dozen other projects, with a wide variety of themes, from temporally malfunctioning objects to aliens, were-creatures to robot invaders, life under the sea and a collection of stories featuring Death as the central character.

Over the years, authors kept asking, "When are you going to do another Ur-Bar collection?" Seven years and eight projects later, we decided it was time to return to our favorite place. So pour a glass of your favorite beverage and get ready to enjoy fourteen new stories featuring the Ur-Bar in all new incarnations from the past to the near future.

Happy Reading!

Honorbound

R.K. Nickel

A wounded Gaul stepped up to the bar, then extended his mug with his good arm. The other, Gilgamesh noticed, ended in a stump that still oozed into a fresh bandage.

"Another," said the Gaul, looking up to meet Gilgamesh's gaze.

"You certain that's wise?" asked Gilgamesh.

"If it's all the same to you," said the Gaul, "I'd rather die drunk."

Gilgamesh shrugged and poured the Gaul a korma. The man lifted his mug in thanks and returned to his table. The entire bar was filled with the weary, the weak, the wounded. Missing limbs, bandages, scars—the true spoils of war.

Gilgamesh didn't pity them. One of the greatest strengths of being human was the ability to grow accustomed to anything. Live a hundred lifetimes and there was little one wouldn't see. Gilgamesh had already lived through dozens of sieges; this one was no different. He'd watched cities burn, seen children slaughtered. He'd held dying friends in his arms. He'd loved, and lost, and loved again. He'd pitied. Once. But no longer.

The true curse he'd accepted all those years ago was not immortality, but rather … apathy.

These men would live and die, and he would go on. After their children were born, and their children's children beyond. On, and on, and on, always enduring the motions: sweep the floor, wipe the bar, pour the ale.

The door flew open, tearing Gilgamesh from his thoughts.

"Gilgameus!"

Vercingetorix strode through the doorway. The only man who could come close to matching Gilgamesh in strength and stature—in this time, at least—Vercingetorix's lime-washed hair reached his shoulders and his thick mustache flowed past his chin. Longsword at his side and cloak over his shoulder, he played at general as well as any of the other fools Gilgamesh had seen slaughtered upon the battlefield.

"What is it?" asked Gilgamesh.

Vercingetorix looked behind him. "Exapia," he called, and a woman followed him into the bar. "Gilgameus, this is my wife."

She nodded her head slightly—acknowledgement, but not deference. Most people gaped when they first laid eyes on Gilgamesh; her façade of authority was nearly as good as her husband's.

"Men," said Vercingetorix, clearly attempting to sound commanding. "Return to your loved ones. The time for battle draws near."

To his credit, the men obeyed, shuffling past Vercingetorix and saluting as they went.

"So kind of you to clear out my customers," said Gilgamesh.

Vercingetorix stepped in close. Something about him forced Gilgamesh to stop his work and meet the man's gaze—a frustrating quality.

"I have waited as long as I can for reinforcements," he said. "Those who have come have come. Tomorrow, we lead our full force against a weak point in Caesar's circumvallation. Our allies will strike from the surrounding countryside. If we can make it through their lines, we may yet win this war."

"And how does this affect me?" Gilgamesh asked, turning back to the bar and cleaning a glass.

"I have faith in my men, but this is the greatest risk the Gauls have taken in generations. I would not see the Arverni people bent under Caesar's will without a fight, but ... there is a chance that we will fail." Vercingetorix took a breath. "If we do, the city will fall."

Gilgamesh didn't reply. Why bother? If he were not in Alesia, he would be in some other city, with some other desperate leader. Humanity bled desperation, year after year.

Vercingetorix ground his teeth, displeased. "I know your secret," he said

"Oh?" said Gilgamesh.

"I trade in myth and legend. Whatever may give me an edge over the

Romans. And while I am willing to risk my life for my people, I will not risk my family."

"Every choice brings risk," said Gilgamesh.

"And I am doing my best to diminish it by asking of you a favor: protect them."

"Why should I?"

"Because it is the right thing to do."

"Ah, a moral argument," Gilgamesh said. "It is right to kill Romans then? In trade for your wife's life?"

"They are the aggressors."

"Boys who grew to men in Roman cities, who knew no future other that that of legionnaire. Had they been born Arverni, they would fight beneath you instead. If you know my secret, then perhaps you'll understand that morality grows subjective over time."

Vercingetorix paused before speaking, a faraway look in his eye as he stroked his long mustache. Finally, his expression hardened. He locked eyes with Gilgamesh. Then uttered the most welcome words Gilgamesh had heard in ages: "I will take your place."

Gilgamesh tried to suppress the surge of hope that beat suddenly in his heart. It pulsed so strongly he nearly had to steady himself with a hand. How long it had been since he'd felt an emotion break through the chitin that had grown inside him?

"You would bear my curse?"

"If the Romans break through the walls, and if you protect Exapia, then when I return, I will take your place."

"Words," said Gilgamesh, afraid to let himself trust this man.

"Please," Vercingetorix implored. "Our child shelters not far from here, in Meclodunum. I will not allow him to grow up an orphan."

"What if you fall in battle?"

"I may," he said, "but I have lived thus far."

The chance to leave this gods-forsaken bar. Gilgamesh could not pass that up.

"Give me your oath."

"You have it. I swear by the thunder of Taranis and the serpent of Smetrios. If I return, you shall have your freedom."

Gilgamesh extended his arm and Vercingetorix grasped it, grip strong. The pair stared into each other's eyes, an understanding passing between them. He was a good man, this Vercingetorix, willing to sacrifice himself to

save others.

Good men died much the same as bad.

Finally, they broke apart. "Here," said Vercingetorix, unclasping his sword and handing it to Gilgamesh. "I'll requisition another."

Gilgamesh felt its weight in his hands. He'd conquered with a blade, killed so many with the biting embrace of bronze. But that had been a different time. A different man.

"Good luck," he said.

"I welcome it," said Vercingetorix. The Gaul crossed the room and spoke a few words to his wife. They embraced, then he left, the door slamming shut behind him with the dull thud of finality.

* * *

The sounds of battle carried through the air. Though distant, screams and whinnies rode the wind, conjuring images of blood and death. Exapia stood tall, facing away from Gilgamesh, muscles tense.

"Perhaps some korma would settle your nerves," Gilgamesh finally said. She turned and looked up at him, bitter anger in her eyes.

"I think not."

"Fine," said Gilgamesh, then took a long drink of korma himself. Any joy the frothy ale might have brought had worn off a few thousand revelries ago, but still, if that woman was going to stand there like that the whole time, he might as well get drunk.

"I tried to counsel my husband not to bring me here," she said. "I would rather stand and fight than play royal ward, hidden behind the arms of an ancient statue."

"You pay me a compliment," Gilgamesh replied. "Are statues not revered?"

"Perhaps, but the bright paints quickly wear off, leaving chalky, cold stone beneath."

"I, for one," said Gilgamesh, taking another swallow, "admire the passivity of stone. Stone, for instance, doesn't seethe with hatred for the Romans."

"I do not hate the Romans. I love the Arverni. I love riding wild with the boar, smoothing bark into homes, standing beside my husband on the war council. Each tribe has its own unique way of life. The Romans ... the Romans consume everything they touch, creating a network of roads paved with blood, a spider's web that connects all people and flattens them into a single entity. Caesar would make the whole world Roman."

"Your husband would do the same."

"My husband is more man than you and Caesar put together. Caesar does not risk himself for his people. He simply commands at a distance, letting his men take the risks, then returns home and brags of his valor to any who will listen. My husband fights not just for the Arverni, but the Carnutes, the Bituriges, the Lexovii, and all the rest who have banded together with us. And when this war is won, each tribe shall continue to be who they are, not who the Romans want them to be."

Gilgamesh could not remember the last time he'd been so reprimanded. And the chastisement came from Exapia, small enough that the winds might pluck her into the sky.

In the silence that followed, the screams seemed louder, and was that the scent of death on the air, or was it merely a lingering memory? Flashes of times past tore through Gilgamesh's mind: the feel of an axe in hand, the spatter of hot blood onto his face, Ekidu falling into the underworld, endless darkness.

Exapia drew in a sharp breath and Gilgamesh had the sudden, bizarre desire to reach out to her, but he extinguished the thought.

"It is unfortunate," she said, "that someone stronger did not inherit your position. Think of the good that could be done with all your knowledge."

Who was she to judge him so? She did not understand, could not possibly understand. Gilgamesh gritted his teeth and his earthen cup shattered in his massive grip, clay shards slicing into his hand.

Yes, let her see his strength. There was fear in her eyes now.

But how well she controlled it.

He would not let her stoke admiration in him. He had excised that feeling.

He forced a laugh. "I was a king, akin to a god. I built great walls, slew great beasts. I accomplished more in my first lifetime than any who have come since. I have glimpsed the underworld and denied it. You think you know death because you have seen battle? You think you know life because you have birthed it? I've witnessed a thousand thousand lives. I have borne the death of all who've known me. Life is the curse, death the blessing."

"I am sorry you feel that way," she said, unfazed by his outburst. "I can believe you were a good man once. For your sake, I hope you can be again."

She turned her back then, once more facing the door.

Gilgamesh drowned himself in drink, letting it muddle his thoughts. At some point, he would blink and she would be gone, the bar in some new place. He would sigh, someone else would step through the doors, and he

would sweep the floor, wipe the bar, pour the ale, and the entire cycle would begin anew. Exapia was no more than a fleeting dream, and soon enough he would wake.

Eventually, a Gallic soldier burst through the doors awash in sweat and blood, armor scored in a dozen places. With him, the sounds of battle poured in, far too near to be contained to the siege lines.

"Catacus!" cried Exapia. "What news?"

Why was this man here? Why some trusted aide rather than Vercingetorix?

"Our plan failed," the soldier said. "We nearly broke through Labienus' lines, but Caesar himself led his elite squadron and repelled us. I'm sorry, Exapia."

"My husband?"

"Lives," said the soldier, and Exapia breathed with relief.

There was still hope then. Gilgamesh's mind raced with possibility. To hear the songs of birds, to hunt, to ride.

"Roman troops harried our retreat," the soldier continued. "Nearly six cohorts followed us through our walls. Your husband leads the resistance. He will expel them."

Gilgamesh stepped toward the man. "Bring him here. Now."

Exapia moved to intercept him. "He will come," she said.

"He fought. I guarded. Our deal is done."

"Thank you for your message," Exapia said to the guard. "Please, tell my husband to do what he must."

"Bring him here!" Gilgamesh roared. He would not let this moment slip by.

"Barkeep, calm yourself," said the soldier.

Gilgamesh growled in reply. "Exapia, tell him."

Exapia stepped close. He could hear her breath, though she didn't even come to his shoulders. "And what will you do," she asked, "if I refuse?"

Images of his hands wrapped tight around Exapia's soft throat flashed through his mind. It would be simple. Despite her bravado, she was a frail thing, and a single hand could surely crush her windpipe.

Gilgamesh withdrew, shaken. He had not realized how strongly he lusted for freedom. Too long had his heart lain dormant, and now that it beat, the blood coursed through him deadly hot.

"Do what you will," he said, retreating to the bar and pouring himself another drink.

When the soldier finally left, Exapia bolted the door behind him.

How long they sat and waited, he did not know. The sounds of fighting grew louder, closing in on the bar, but not breaching it. Not yet.

Until suddenly the door shook. The bolt that held it closed was rusty, frail from countless years of use. The door shook again. Dust fell from the rafters.

"Will you do nothing?" asked Exapia. The venom in her words was sharper than the gash in his hand. Gilgamesh looked down. The gash was already healing. Of course it would be.

He owed these people nothing.

He had helped before.

He had failed before.

The door shook.

He had felt for people, cared for people, loved. He had defended, and aided, and bled. But not one life he'd saved had changed anything. Not one life he'd ended had altered the flow of time.

Yet there she stood, defiant, her eyes a challenge to him, to the Romans, to any who would threaten her people.

"Your choice matters," she said, as if reading his very thoughts.

The door shook.

And Gilgamesh lifted the sword from behind the bar. The weapon felt good in his hands. It was no axe, but it would do.

"Get behind me," he bellowed, shocked by the strength of his voice.

The bolt snapped and the door thumped to the ground, dust echoing through the bar. Gilgamesh stepped forward.

A Roman lieutenant stepped in … and stopped, taking in Gilgamesh's hulking form. A flicker of fear crossed the man's face, but then he comported himself. A handful of soldiers fanned out behind him.

"My name is Titus Labienus, lieutenant to Julius Caesar himself. Step aside and my men will be gracious enough not to slaughter you where you stand."

"No," said Gilgamesh. He preferred simplicity.

"My quarrel is not with you, but I will kill you if I have to." The man held his head high, though his bearing bespoke compensation rather than confidence. His face was thin, with eyebrows scrunched too close together. Still, his short sword dripped blood.

"No," said Gilgamesh. "You won't."

Labienus' face reddened and he spat his words through clenched teeth.

"I said stand aside! I have battle-hardened legionnaires with blood-whetted blades against what, a woman and a simpleton?" Labienus rounded on Exapia and extended his sword toward her. "You! You're the one I want. Your ridiculous husband nearly overtook my cohort! But his men spilled the secrets of your whereabouts quickly enough when I squeezed their still-breathing lungs in my hands. Honorless curs who lessened my standing in front of Caesar. But history will know the name Titus Labienus. My sword sings a song of valor. My men ride with death by their side. And once I raise your head up in view of your precious Vercingetorix, he will fall to his knees and all will know that I was the one who ended the Gallic rebellion. I was the one who spread Rome's glory and stamped out the last embers of resistance."

"Your posturing does little to increase your manhood," said Exapia. "When Caesar himself comes to the door, perhaps I will quiver, but not before. Maybe you should fetch him."

Labienus growled, then leapt forward, his blade blindingly fast. Gilgamesh lifted Vercingetorix's sword to meet the blow.

But he was too slow. Years had passed since he'd wielded a weapon— eons, it seemed—and now he paid the price.

Labienus' blade bit into Gilgamesh's shoulder, spilling blood as Gilgamesh bellowed in pain, turning with the blow to keep it from cutting him too deeply. Smirking, Labienus sent him stumbling to the ground with a kick. Gilgamesh tried to rise, but again, his muscles betrayed him—the warrior within him had atrophied, buried long ago.

"Kill them," said Labienus, and the first of his men stepped into the bar.

From the ground, Gilgamesh watched Exapia draw two long, thin daggers from her sleeves.

Gilgamesh pushed himself up with his good hand, pain searing through him. Pain meant life. Pain meant choice. He switched his sword to his other arm, barely able to hold the blade for the blood slicking the pommel. Labienus, who had his back to Gilgamesh, must have sensed something, for he spun as Gilgamesh struck, blocking the weak, left-handed blow.

"You should not be standing," said Labienus.

"You should not be breathing," replied Gilgamesh.

Labienus thrust at him again, and though the angle was awkward, Gilgamesh barely batted away his attack.

Gilgamesh tried to parry Labienus' next strike, but the short sword opened a gash along his side. Gilgamesh dropped his sword and grabbed

the blade, using all his strength to keep it from digging into his gut. Blood poured from his hand. He tried to throw a punch, but Labienus grabbed Gilgamesh's wrist with his off-hand and pulled him close, their faces a hand's breadth apart. Gilgamesh screamed and blood flecked from his mouth, spattering Labienus' cheek. The kick must have broken a rib.

"A giant you might be," Labienus hissed, "but you fight with neither skill nor fire." Labienus cracked his helmet into Gilgamesh's forehead and let him tumble to the ground, then turned to face Exapia once more. "If you come willingly, your husband will surrender."

"Excellent idea. Once you've brought me to your camps, I'm certain Caesar will be pleased to learn that his lieutenant went behind his back to steal glory for himself."

"Your fight is lost," Labienus growled. "Your city will burn. Your people will be sold as slaves. Why add your body to the pyre?"

Gilgamesh locked eyes with Exapia. There was resignation there, yes, but also somehow hope, a stalwart stubbornness. "Because the fight itself is worthwhile."

"So be it," said Labienus. "I probably would have killed you anyway."

Gilgamesh tested his shoulder. The initial wound wasn't as bad as he'd thought. How easily he'd grown used to his impotence. He switched his sword back to his right hand and, with a grunt, heaved himself to his feet, keeping his left hand over the wound in his side to staunch the bleeding.

Labienus turned. "You …" he said, growing pale. "You should be dead."

"You don't know how right you are," replied Gilgamesh, lunging forward. He swung with everything he had, and it was Labienus who stumbled this time, combating both the blow and his shock.

"Men," he shouted, fear tinging his voice. "To me!"

Gilgamesh hammered down blow after blow, a relentless force, and with each pounding connection a thrill coursed through him. The fierce joy of the fight, but more than that: the thrill of purpose. He would protect these people, this woman.

Roman soldiers tried to surge past him, but he struck at them, pushing them back toward the door. Exapia stepped to his side, her daggers finding weaknesses in armor, opening flesh. Where he was a hammer pounding against the anvil of oncoming soldiers, she was a buzzing mosquito, drawn to the sweat, too fast to catch, yet always drawing blood.

Gilgamesh ran a soldier through the chest, his nearly inhuman strength piercing leather, deflecting off bone, and punching out the other side. He

ripped the blade free, taking a kick to his leg. As he fell to his knees, he grabbed the attacking soldier's throat and crushed it between his hands.

Soon the bar ran with blood instead of ale, so slick that the fight became as much a contest of balance as of strength. Yet half the soldiers remained, and the pair of them slid backward along the blood-slicked wood.

But Gilgamesh would not let them have her. He was King of Uruk, ruler of the Sumerians, descended from the gods themselves, and he would kill any who stood in his way.

He and Exapia slew together, a comingling of spirit and action and death, and never before had Gilgamesh felt so connected to anyone. As they struck, they sometimes caught each other's eye, and it was as if some spirit flowed between them. They were as one soul, born of one purpose. Her limbs were an extension of his being, her heart thumped in time to his.

But even still, he was just one man, and the precariously mortal Exapia had to dance away from oncoming edges. Through it all, Labienus played coward, watching for his moment, pressing only when it was safe.

Gilgamesh could not defend forever and Exapia's breathing was heavy. She slipped, falling into the path of a blade, and Gilgamesh leapt in front of her.

The soldier's sword cut into Gilgamesh's left leg, forcing him to lean against the bar. The pain exploded in him. He screamed.

But still he fought.

"Demon," shouted Labienus as Gilgamesh killed another soldier.

"Not exactly," said Gilgamesh.

Another sword struck his left arm and he roared in pain. He stared. The arm hung uselessly at his side. Never in all his years had he been so grievously injured.

His flesh was torn, his blood spilled, his body broken.

But not his will.

After all, he had already endured lifetimes of pain. What did these wounds matter?

Gilgamesh focused his will, closed his eyes, pushed aside pained, clenched teeth. This would not be the end.

"The woman!" shouted Labienus. "Get me the woman!"

Gilgamesh's vision grew darker as he poured all his energy inward, and in the haze, a man burst through the door, a blur of Gallic armor and purpose.

Vercingetorix.

"Exapia!" he shouted, joining the fight even as he sagged from exhaustion.

The pair of them fought together as Gilgamesh watched. They were beautiful, even more synchronized than he himself had been with her. A perfect match. Gilgamesh could only imagine what kind of man their child would grow into. The son of these two would be an indomitable force.

Soon the last of the Roman soldiers lay dead and only Labienus remained.

Gilgamesh rose once more. As he had time and time again, albeit light-headed and unsteady. "Labienus," he called. "You cannot defeat me. I am Gilgamesh, slayer of thousands, wielder of blades, the undying, the merciless, the cruel. I have broken walls."

Gilgamesh took a lurching step toward the trembling man. "I will not hesitate to break you."

Labienus' sword wavered in his hand, then he turned and ran.

Exhausted, Gilgamesh slumped into a chair, surveying the carnage around him. He would not have thought men contained so much blood.

"Your wounds," said Exapia, stepping up to him.

"Would have killed anyone else," he replied.

"I'll send for a healer," Vercingetorix said, stepping outside.

Exapia took his hand. "Thank you," she said.

Gilgamesh did not have the strength to respond.

Shortly, Vercingetorix returned and someone Gilgamesh did not recognize began to treat his wounds.

Vercingetorix stood tall, once more becoming the commander he had been when he'd set foot in the bar that morning. "You have my gratitude."

"I think Exapia could have handled things on her own," Gilgamesh said.

"Perhaps," mused Vercingetorix, smiling, then turned to Exapia. "Caesar will not be pleased with his subordinate's failure."

"Is the city lost?" she asked.

"We drove out Labenius' cohorts," he replied, "but Caesar has repelled our best effort. Gilgamesh. I apologize, but I must break my oath."

"What?" Gilgamesh roared, suddenly alive once more.

"I have spoken with the surviving leaders of the other tribes. Caesar demands recompense for the damage we have caused. My surrender can buy the lives of our people."

Break his oath? Break his oath?! Gilgamesh would not allow it.

"I understand," said Exapia, taking her husband's hands.

"I'm sorry," said Vercingetorix.

"Don't be," she said. "I love you."

"You gave your word," growled Gilgamesh.

"I know," said Vercingetorix, "but before that, I gave my word to protect my people, and that oath calls to me now. If I surrender, our people will carry on. Under Roman rule, yes, but Caesar will allow us to continue our ways of life."

"I do not care what Caesar will 'allow,'" snarled Gilgamesh. "What of what I will 'allow?'"

"The lives of eighty thousand Gauls supersede my personal honor. Would you truly force me to remain?"

Gilgamesh glared at the man, then turned to unleash his vitriol on Exapia—but when he met her gaze, he once more found himself staring into resolve.

Before he could open his mouth, she spoke: "I will take my husband's place," she said.

"Exapia, no," said Vercingetorix.

"You have made your choice," she replied. "Now let me make mine. Did you not marry me for my bullheadedness?" she continued, cutting him off before he could protest again. "I will take your place, Gilgameus. Will that satisfy you?"

Stunned, no answer came to his lips. "And who would lead the Arverni?" Gilgamesh asked her.

"We are a strong people," she said.

"This will be a time of great pain and transition," said Gilgamesh.

"We have weathered much. We will weather this."

"And what of your son?"

She choked on her words, then took a breath and managed to get through them. "He will grow strong."

How could she remain so calm? How could she care so much? For so long, Gilgamesh, builder of the great walls of Uruk, had used his skill to encircle his own mind, but somehow this woman, this family, had found a weak point in his defenses. Somehow, she'd helped him remember how it felt to have purpose. The feeling was intoxicating. To be human was not to grow accustomed, but to claw against darkness, fighting with every ounce of your strength for what you loved.

Finally, Gilgamesh spoke, hardly believing his words. "I have no doubt that you would manage the curse better than I," he said, "but the simple truth is that you have lifted it already."

"What?" she asked.

"The real curse is not eternal life, nor the prison of this place, but apathy, and of that I am cured."

Exapia frowned.

"As he has said," Gilgamesh continued, "your husband must surrender to the Romans, and I cannot leave your people without a leader. I cannot allow your son to grow up without a mother. Perhaps my choice will change nothing. But it is my choice."

"Gilgameus—" she said, stepping toward him.

"I have made up my mind," he said, then turned to Vercingetorix. "I would ask only one thing in return."

"Name it," said Vercingetorix.

"Save your surrender until morning. A handful of hours will make no difference. Once you have spoken to the leaders of the tribes and made all the necessary arrangements, there are rooms upstairs. Share one last night together. In the meantime," Gilgamesh said, "I will keep watch."

<p style="text-align:center">* * *</p>

Gilgamesh awoke slowly, then forced himself out of bed, muscles aching, back cracking. Getting up in the morning was no easy task, especially after so many years. But underneath the weariness, Gilgamesh could feel a lightness to his motion that hadn't been there before.

He looked outside.

Before him, buildings of stone stretched across a tan desert. Men and women clothed in headdresses and glittering jewelry bustled through a market square, a surprising number of cats weaving between their legs or lounging lazily in the setting sunlight. In the distance, a massive pyramid loomed.

So this was to be his next stop.

Gilgamesh smiled. One day, he would find someone to take his place—someone truly willing. In the meantime, he would make a difference.

He headed downstairs. After all, it was nearly dusk. Time for him to open up shop and see who stepped through the door.

ⅎorest ℒaw, 𝔚ild and 𝔗rue

Rachel Atwood

The fifteenth day June, in the seventeenth year of Our
Reign:

*Neither We nor Our Baliffs shall take, for Our castles or for
any other work of Ours, wood which is not Ours, against
the will of the owner of that Wood.*

Magna Carta Clause #31.

~ ~ ~

*All forests that have been made such in Our time shall
forthwith be disafforested; and a similar course shall be
followed with regard to riverbanks that have been placed in
defense by Us in Our time.*

Magna Carta Clause #47

~ ~ ~

"The Sheriff of Nottingham is taking wood from our forest!" Little John
banged his wooden tankard against the rough table by the hearth in the pub-
lic house at the edge of Windsor Village.

"Do we have title to the forest, or do we merely claim the land through centuries of common usage?" I asked. "To whom does the forest truly belong?" Damn all that legal training Tuck, or rather Abbot Mæson, force fed me. He made me question everything, including the foundation of a statement. Someday I would succeed him at Locksley Abbey in Nottinghamshire. Not soon I hoped.

I enjoyed my current apprenticeship at Windsor Castle as scribe to Archbishop Langdon. His Grace currently presided over meetings with King John and his Barons, drafting a peace treaty among them. So far, they addressed more pressing matters than the forest laws—like whether King John would be allowed to survive the signing of the treaty.

"Doesn't the sheriff need the king's permission to fell trees in a royal preserve?" Robin Goodfellow asked. He maintained his guise as a tall archer with no overlay of the ugly gnome that he sometimes used.

I was hard pressed to know for certain which was his original appearance.

"Sir Philip Marc wrote a petition to cut wood. I do not know if permission was granted," I told my drinking companions.

"It is ours!" The tables shook as Little John pounded out his response.

"By who's word, who's law?" I asked again, in different words. "Why is it yours?"

"Don't speak to me of your written laws. We are the forest folk, the Wild Folk. The woods were ours long before humans began taking our trees," Robin Goodfellow said quietly. His human features slipped a bit, elongating his nose nearly to his chin and pointing his ears above his cocked hat. Then he shook himself and once more became human.

My ability to see their true selves was a gift from Elena, an ancient spirit who dwelled in a tiny three-faced pitcher. At first, I'd only seen beyond the obvious when I secreted her in my pocket. Now I need no longer carry the pitcher to have true sight. Little John, to those who knew him well, looked like a tall, well-muscled villein. Beneath this, I saw the forest giant clothed in leaves and twigs. Will Scarlett sang as sweetly as any bard or bird. The red feather in his cocked hat was the only token to his true avian heritage.

Father Tuck should have joined us for a tankard or two, but the Archbishop kept him close. Our good Abbot had not fled England seven years before along with the rest of the senior clergy when the Church in Rome broke with King John. Instead, Tuck, his youthful nickname, had taken up residence with the Woodwose—those who lived in the forest illegally—ministering

to their needs as well as to the wild folk. He knew more about what England needed than King John, or Innocent III, the Holy Father in Rome.

I, Nicholas Withybeck, was an orphan; fetched up in the abbey at the age of three. Ten years later, in a moment of need, with the help of Elena, I had stumbled upon the Wild Folk one May Day. And now, in honor of their aide, I help them from time to time. This was one of those times.

My hand automatically went to the pocket in the front of my cowled habit, where once Elena's gift had rested. It was a fleeting gift, for Elena gave nothing of permanence to anyone. The ancient pagan goddess of crossroads, cemeteries (the ultimate crossroad), and sorcery had taken herself and her three-faced pitcher back into the crypt of the abbey where she awaited the next young student willing to be guided by her wisdom and her laughter. There was emptiness in more than the pocket; my heart and my soul were yet to fully mend.

"The Sheriff of Nottingham has greater reasons than firewood," Will said. He whistled a sprightly tune with hints of raucous laughter underneath the notes.

"And what might they be?" Little John demanded.

"To rob us of our home once and for all," Robin replied. A sharp edge buried in the words, anger a hidden blade.

"His plans call for enough wood to heat his castle and repair the beams in his Hall three times over," I grumbled. "His petition is tangled and obscure. It could mean many things. Or nothing at all. But he did request permission."

"Human lies are given power when scrawled on parchment." Robin growled out the words. He had no love of writing.

"True," I said. "But there is more. What is his real reason? His darkest purpose?"

Little John snorted.

Robin held up a hand to quiet him.

I looked at each and finally Robin spoke.

"He still lusts after Herne's water sprite Ardenia. He'll destroy the entire forest to capture her spring."

The words held anger deep and strong as only truth can. We all loved the gentle nurturing and healing powers of Ardenia's spring. It nourished the forest. And all of those who lived there.

"Calm down." The publican placed a heavy hand upon Robin's shoulder, forcing him to remain seated.

"We'll make certain he keeps his arrows in his quiver and his bow unstrung, Gilga," Little John promised. "But pray bring us another round of ale."

"Who's paying?" the man who near equaled Little John in size asked. He looked me in the eye, as if he knew I was the only one of the group likely to have any coins.

I sighed. My debt to these folk came with many obligations. And of course I was the only one with coins. The others had no care of or need for money, except here at the Boar's Head Inn. Gilgamesh often bartered ale for information, but not tonight apparently.

"So how do we stop Sir Philip Marc?" Will Scarlet asked as he held his tankard up for a pour from the freshly arrived pitcher.

I replenished his drink and moved on to the others.

"Can we inform the king of his perfidy?" Robin asked.

I choked on my laughter. King John had deeper problems than one patch of forest.

"First we'd have to catch the attention of His Highness," I said. "Lately he listens to no one but Archbishop Langdon. He trusts no one but Langdon, and him only slightly."

"Could his ear be bent by the words of Father Tuck?" asked Robin. "He has risen far in the church."

I was about to form a protest when Gilgamesh caught my gaze and beckoned me to the bar.

I pushed my bench away from the rough table and approached the man of indeterminate years. He looked to be on the far side of forty but his eyes betrayed more experience than could be crammed into one lifetime. My special gifts told me to look deeply. *Listen to the wisdom of the ages*, Elena whispered to me, as she did from time to time, even though I no longer carried her with me.

"You heard her." Gilgamesh fixed his gaze on me.

I gulped. He'd heard. No normal person could hear her unless he had carried the three-faced pitcher for a few years.

Both Elena and Gilga laughed, hers high and gentle like tiny crystal bells, his deep-throated and rumbling akin to thunder right on top of us.

"Common Law is giving way to Written Law," Gilgamesh said. Where had he learned such things? I knew about them because I'd studied them in various scriptoriums throughout England.

"I suspect this Charter that King John and Langdon discuss will become

the foundation of a new way of thinking about the law," I said. "It's a way to bring peace among the Barons, the king, and the Church."

Gilgamesh stared at me until I returned his glare. His brown eyes opened wide and I … fell.

New images streamed from his mind to mine. Signed documents. Men arguing in a gathering place assigned to them to form our laws. Men with the authority of the Crown and the community capturing law breakers. Twelve good men, honest and true, announcing a verdict …

I closed my eyes to break his contact with me.

"Enough," I said. "I understand. I can see."

"It will only be enough when you use the law to save the forest home of your friends," Gilgamesh said in low solemn tones.

And I knew that I must somehow use the law to stop Sir Philip Marc, the Sheriff of Nottingham, from declaring his own laws. And I had to do it before he finished cutting every tree. I already composed in my head a letter to the Sheriff to cease cutting until the king had time to address his petition.

Would he obey a command signed by Abbott Mæson?

Who could enforce the written law when the Sheriff was supposed to be the king's deputy?

As I asked myself these questions, Little John clutched his chest over his heart. His left arm hung limply. "He's taken an ax to my tree," he gasped. Not just any tree, John's personal tree, the place from where he took his strength. A refuge when he tired of his human guise. The place from where he watched the world and watched over the humans he loved.

Gilgamesh filled a different pitcher, a small pewter one, with liquid from a tiny barrel in a back corner of his domain behind the bar. The aroma wafting through the pub reminded me of spring rain, summer flowers, crisp autumn apples, and the bite of the first winter snow.

I found myself plodding blindly in Gilgamesh's wake as he marched over to the settle where my friends sat. He poured a measure appropriate to the customer's size and need. Will received only a few drops, Robin about three fingers, and Little John a nearly full cup.

"Get him home, now," Gilgamesh ordered the Wild Folk, as if one of them.

I held my own cup out for some. Gilgamesh surveyed me from toe to brow and back again. "I suppose you need a bit to do what you have to do." He tilted the pitcher over my cup and transferred the feeble stream to me.

Hastily I tipped the cup up and spilled the special brew onto my tongue.

The flavors burst free, flooding every surface and crevice with incredible sweetness that would put honey to shame. At the same time, it satisfied my craving for salt—like cheese but better.

I blinked in astonishment. Strangely I wanted no more of the brew. My mind cleared and I knew what I had to do and how to do it.

By the time I swallowed and nodded my appreciation to the publican, my friends had vanished, undoubtedly sharing with Little John bits and pieces of their travel magic to get them home in time to stop the Sheriff's woodsmen. A tiny part of me pitied the axmen.

I ducked out of the pub and ran back to the castle. By the time I arrived the sun had set and the gates had been pulled closed. For me this was an inconvenience, not a challenge. I'd been sneaking in and out of locked and guarded buildings for as long as I could remember. Keeping the ramparts of the Keep to my left, I inched around the curtain wall, counting my steps.

One hundred paces. I knelt and ran my hand along the next to lowest line of building stones. The rough texture changed slightly. I found the deeper crevice where mortar had never been. A gentle push on one corner and the stone slid inward. At the same time, an almost invisible door—wooden panels cleverly painted to look exactly like stone—swung outward.

That was the last of the ease. I had to shove hard to move the door enough to squeeze my tall body through the opening. Then I had to move quickly before it swung shut again, silently. Clerics had been using this portal for generations and we knew how to hide our passage as well as keep it secret.

I emerged into darkness behind St. George's church. I paused a moment to assess the shadows, considering what they might shelter.

"Returning a little late, aren't you?" Abbot Mæson said flatly.

I knew that tone, meant to quail bold novitiates and arrogant students. I had faced it many times over the years.

"Our friends from Nottinghamshire needed my advice," I replied, also keeping my tone even to hide the thick lump in my throat, fearing their demise if they could not counter the woodsmen before I could dispatch trusted knights to enforce the king's law.

"What now?" The Abbot shifted in the gloom so that I could see he straightened from a lean against the back wall of the Lady Chapel.

I repeated our conversation *verbatim* as he'd trained me, stopping the narration when I had moved to the bar and talked to Gilgamesh.

"And what did the publican Gilga say to you?" His voice shifted to a note of humor. He sounded younger than his many obvious years, more like

the Tuck who had wandered the forest with his great-grandfather Herne, the huntsman.

"We spoke of the nature of law."

"Ah." He scratched his chin.

I wished we could move into the torchlit courtyard so I could read his expression and posture as well as his voice.

"Come, we do not have much time. Tonight I am tasked with transcribing the final agreements into a fair hand to receive the king's seal tomorrow on neutral ground at Runnymede." He beckoned me toward the steps to the church sacristy.

My mind circled around the problem, finally settling on one issue. "Will the document be read aloud before the signing?" Or rather how many in the audience could read and not notice the insertion of an item or two? Or four?

Northumberland and his allies would not agree to any document that did not call for King John's immediate arrest and execution—without the benefit of the trial outlined in the charter. Making the king subject to the law was not enough for them.

"Yes, someone appointed by Archbishop Langdon will read the entire document," Tuck replied. "That should be me ..."

"Or me." The Northumberland alliance would not suspect me, a lowly novice and scribe, of adding things to the charter. I could alter a clause or two without rousing suspicion. Those who accepted the king's seal would have to abide by the entire document.

I lit oil lamps and wax candles for better light while Tuck brought forth pages of notes and fine parchment. I blended ink and sharpened quills. I'd need many of them before the night was through.

By dawn I had written out, in a fair hand, the complete text that would become known as *Magna Carta*. With Tuck's help, I managed to word the phrases innocuously enough that no one could object to them. And so they were read aloud the next day on the field of Runnymede, a boggy meadow between Windsor, the king's bastion, and Staines, the encampment of his rebellious barons. Though we tried to limit the weapons carried onto the field, honor dictated that every knight and baron be allowed to carry his sword and dagger. William the Marshall would make certain that no weapon came within six feet of the king.

No matter how hot the tempers, this stretch of land on the banks of the River Thames was not big enough or stable enough to become a battlefield.

While Tuck read aloud the entire charter, I moved silently and unnoticed

through the crowd. And so did many of the Wild Folk. Not the friends I had sent back to Nottinghamshire, but others who called the woods, the rivers and springs, and the broad meadows home. They came by the hundreds, in human guise. I pointed them toward those most likely to cause trouble. Every time a man touched his sword, one of the Wild Folk restrained his hand by gentle force, a moment of confusion, and the hand would drop again.

And so, all the forests that had been reserved to the crown since the crowning of King John's father, Henry II—the first of the Angevians—reverted to the original owners, and no one, not any of the barons, knights, foreign mercenaries, or even the king himself, could cut or burn the wood without their permission. The forest my friends called home reverted to Locksley Abbey. Sir Philip Marc, Sheriff of Nottingham, trespassed if he tried to cut any wood there, and Abbot Mæson of Locksley Abbey could bring down the wrath of the Church on any who so dared.

Sorting out the tangle of Forestry Laws and who had originally owned those lands, after so many decades, was a problem for later. I knew I'd be part of another charter designed specifically to protect the forests and the wild folk, but not today. The village of Woodwose—peopled by those who had no other home and thus lived illegally by their wits and the bounty of the forest—by custom owned their village as long as the Abbey ignored their presence. Little John's tree was safe from the woodcutters.

The vision that Gilgamesh had granted me with his special ale had showed me that the forests would not last forever. Eventually, as England became more and more populous, people would till the land and take the forest. But not now. For now, Little John, Robin Goodfellow, Will Scarlet, and Father Tuck could live safely in their wooded home, and live on in the memories of those who came to love their freedoms as embodied in the great charter.

Historical Note: The document we call Magna Carta was renewed by King John's son Henry III in 1216 after John's death from dysentery. Some clauses were eliminated but the forestry references remained. Henry III reissued the document again in 1225 with a few more revisions. Alongside those revisions, he commissioned a special committee to map and document ownership of all the forests and set out new laws that applied to all of them uniformly. The Charter of the Forests has entered the historical record and become part of the British Constitution.

𝕿𝖍𝖊 𝖂𝖎𝖟𝖆𝖗𝖉 𝕶𝖎𝖓𝖌

Kari Sperring

Every year, on the eve of the longest day, Father Elyas led his flock round the whole circuit of the parish. From the town gate to the waystone at the crossroads, where the two old roads met; down the line of the river to the furthest corner of Earl Thomas's private wood; up the line of the hedge to the ivy-wrapped bole of the old thorn; from the thorn along the lesser brook to where the old ditch crossed in from the south; up the ditch, up and up the flank of Caer Ogyrfan and to the left, following the line of the lowest of the covy of ancient banks that wrapped about it; down from the hill back towards the river; along the narrow edge where water-meadow became marsh; back onto the old west road as far as the toll gate and the corner of the earl's manor house; then again to the waystone; and finally back to the town gate. They sang as they walked, and Father Elyas blessed the land. Last of all, they came back to the church-gate. Then Wat Miller would begin to play his reed pipes and his son struck up a drum, so those who wished might dance, and the priest's housekeeper handed round fresh bread and honey and Gil the brewer handed new ale and old cider through the door of his inn, and the children ran about shouting, and the young people danced while the older folks gathered to talk over times gone. It was one of the two greatest days of the year in Mared's eyes, along with Harvest-tide, every year renewed in the spring and praised in the autumn.

"And seeing our joy in his works, and hearing our praise and gratitude,

the Lord helps our crops grow and our beasts thrive and blesses our hearths and families," said Nain, lifting Mared, out of breath from games and laughter, into her lap as she sat outside the inn. "He likes to hear us happy."

"And the priest knows to the penny what tithes he can require from each of us," said Da.

But, "Hush," said Mam. "Father Elyas is a good priest and a kind man who takes only what he needs."

Their village of Meresbury was bigger than most of the villages in the surrounding area, with its stout walls and an old stone church and a small market every Wednesday. It lay close by the border between England and Wales. It was, though, smaller than the towns of Penwern, to the east, where the bishop lived, or Rhiw Fabon, over the border to the west. Da sometimes took Mared with him when he went to one of them, and she stood open-mouthed watching a silver-smith at work, or gazed enviously at the bright pottery beads for sale. Meresbury had no cookshops and only the one inn, though Gil's ale was famous all along the border and brought traders in by itself. According to Nain, acrobats and players sometimes performed in the towns at festival tide.

At home, at the festivals, they had only Wat Miller and his pipe, and Alaw, whose father was a ploughman and who had a true voice, and Gil and his ale, and the sweet cakes given by the priest. And every year, Old Wyn came by at Midsummer and Harvest, and told stories that were even better than Nain's, about dragons and magic cauldrons and talking beasts. As he talked, he whittled animals from scraps of wood, which he gave away to the children. He gave Mared a ferret scenting the air, no longer than her shortest finger, which she kept with her treasures—one length of rather grubby ribbon, a lock of Mam's hair, and a strange-shaped stone which she'd found at the old fort. Old Wyn did not live in the village—indeed, as far as Mared could tell, he did not live anywhere in particular—but he was no beggar, for all that. Sometimes, when she rose early to carry eggs down to the village, she saw him slipping out of Father Elyas' house, or, once, the inn.

"A good man, and a wise one," said Nain, though Mam and Da were impatient if Mared or her brothers repeated his tales. "Your Nain fills your head with enough nonsense," said Da, but for all that, he spoke with courtesy to Old Wyn, and sometimes brought him ale or bread.

Father Elyas spoke Latin to God and English or halting Welsh to his congregation, but within their house Mared and her family spoke only Welsh to each other. "Our tongue," said Nain, "that we spoke before these Norman

lords came, and before the English, and before the Romans, too. We were
here first, Mared *bach,* and this land knows us. This land remembers."

To listen to Nain, every stream and stone in the borderlands had its own
particular history. She told Mared and her brothers tales of the great days of
the kings of the Britons—Bran who stood as tall as a tree, and his brother
Manawyddan, who made shoes of gold; Vortigern who built a great castle
and was the friend of St Garmon; Arddur, who married the daughter of King
Gogyrfan, who lived in the fort above Meresbury itself. "Great kings, great
days," said Nain, "and not over yet. When you were no more than a babe,
Mared *bach*, didn't the wizard king himself come here, to Meresbury, in his
triumph over the Norman lords? And he'll come back, mark my words, like
Arddur himself, one day."

Mam hushed her, when she spoke like that, and cast anxious looks to-
wards where the neighbors lived; Da muttered behind his beard and sug-
gested Nain would do better to remember trampled crops and slaughtered
livestock and burnt homes. But of all Nain's stories, Mared loved those of
the wizard king the most. He had come here, not only to Meresbury, but
to this very house. "He came under our roof," Nain said, "and stood right
there, by the fire, tall and bold. You were no more than two weeks old,
Mared *bach*, and your brothers not even born. He wanted a shoe for his
horse, you see, and your Da is the best blacksmith for miles around. He
came in here while he waited and saw you in your Mam's arms. He blessed
you, *cariad*, the wizard king himself, and said you were pretty." He had rid-
den away again within the hour, his horse new shod, to the next of his bat-
tles. ("Leaving trouble behind him," said Da, but Mared paid him no heed.)
"He defeated them all, the great Norman border lords," Nain said, "and all
the Welsh flocked to his standard and proclaimed him king. Even the French
king sought his friendship." But that same French king had proved fickle,
and stage by stage, the lords took back what had been theirs, and drove the
wizard king back and back, until he had vanished somewhere into the hills
of central Wales. "He's gone for now," said Nain, "but he'll be back. You'll
see, you'll see."

He was Mared's king, her wizard king who had blessed her, though her
brothers preferred Bran and Cadwallon. "Did he have a daughter?" she
asked Nain.

"He did, more than one. They were great ladies, too, and married lords."

"Perhaps he missed them and so he liked me."

"They were women grown," said Da.

But, "Perhaps he did," said Nain. "And perhaps he missed more than that. His wife was named Mared, too."

"That has nothing to do with it," said Mam, but her eyes did not meet Nain's. And Nain whispered—and Mared believed her with all her heart—that the wizard king had given her the name along with his blessing.

"She was strong," Nain said. "Almost as much a warrior as her husband, and his men all called her Yr Arglwyddes, the Lady. Your name is a blessing in itself."

And she was blessed: Mared Latimer, daughter of the best smith in the border, and a member of one of the few families locally who held their land free and clear of both lord and church and might do with it as they pleased. Most of the villagers owned nothing, lived and worked in homes and fields that belonged to Earl Thomas, and must plough and sow and reap, build and mend, at his pleasure and for his profit. "And that," said Nain, "is why the wizard king chose this house to shelter in, and why your Da's forge was spared when the village burned."

"He wanted his horse shod," said Da. "And he paid me nothing for the work. And cost me more, too." For the lord's steward, who lived in the manor and looked after the earl's property, had ordered the villagers to take their business to the smith six miles away after that, and for a year or two Da must take his axe blades and nails and spits to sell at the markets in Penwern or Rhiw Fabon.

That lasted no more than two years. The earl remained absent and the steward was indifferent and the neighbor smith charged more for worse work. And then, to the villagers, Da was one of their own. ("And so is the wizard king," said Nain, though never where Da might hear her.) Most of the villagers spoke the same Welsh as Mared and her family, and looked west, not east, for the bulk of their ways. But the Norman lord and the Norman king and even the bishop over to Penwern labelled the wizard king rebel and traitor and viewed anyone who spoke well of him with distrust.

Mared had no memory of him herself. But as she grew, Nain seemed, year by year, to shrink, and her memory grew faded and jumbled. It seemed that as she faded, so did the wizard king. The year Mared was nine, some of his men came over the border into her county, but were driven back, and their leader was not with them. Later that year, Yr Arglwyddes, his wife Lady Mared, fell into the hands of the Norman king and was sent to his great Tower prison. The few tales that made their way to the village were somber, now, and spoke of losses. No one, it seemed, saw or met the wiz-

ard king any more. "He's gone under the hill," said Nain, in a rare flicker of clarity. "He's gone to join Arddur and his warriors till they're called again. Under the hill."

Mared and her friend Siwsan, daughter of the miller, hunted all over the old ring fort looking for the entrance, for a way inside to see the sleeping king and his men, but they found nothing more than rabbit warrens and fox burrows and the narrow tracks made by goats and sheep. On the way back, too, Mared caught her foot in a rabbit hole and took a tumble into a bank of thorns. Mam smeared one of Nain's soothing ointments over her scratches, then made her sit quiet and mend the rip in one sleeve of her shift.

Two years later, Nain died. Mared, at eleven, was old enough by then to understand in full what that meant, though the littlest of her brothers went on asking for months when Nain would come home. She was old enough, too, to cook and spin and mind her brothers. Mam made Nain's potions and poultices, now, and gave them to her neighbors, but they did not smell as good nor did they work as well. Father Elyas had died the year before, and for a year there was no priest at all. His funeral was conducted by the neighboring priest, and the whole village turned out for it, save only those too young or too infirm to attend. Several of the travelling traders were there, too, and Old Wyn, standing at the back in the shadow of the yew tree. When Father Elyas' replacement, Father Dominic, did arrive, he proved to be a watchful man whose round girth and rosy cheeks belied a nature given to spite and vinegar. He begrudged every service he must do for the villagers and took as little time as possible over them, often delegating them to the overworked priest from Witham, the next village over. "A wicked woman, who gossiped and did not know her place," said Father Dominic, when Da went to him about Nain's burial. Then he turned his back and stalked away. So Nain was buried at sunset in the furthest corner of the churchyard, with only the sexton to murmur prayers, and no more than Mared and her family gathered by. But some of the villagers came, over the next days, on this apparent errand or that, and offered condolences and kind words. Not that the priest refused the burial fee, of course, though he skimped on the prayers for Nain's soul the following Sunday. He knew his rights inside and out, for all he avoided as many as he could of his responsibilities. He was Earl Thomas' man, and high in favor with the bishop. He knew full well how little store he needed to set by his lowly charges.

The summer after Nain died was short and wet, hurrying shabbily into a dank chill autumn. Great skeins of geese swept in from the north and west

to feed on the marshes that spread to the west of the village. Eadric's war-
riors, Nain used to call them, after the mad English lord who had resisted
the Normans and who had married a woman who could change into a swan
or a goose. "She taught him her secret," Nain whispered, "and he and his
men flew away before King William could find them, and still fly around the
world. They bring winter and war." There was no midsummer celebration
that year, nor yet the next. Father Dominic preferred to dine with the earl's
steward. "And that is why we've had two summers in a row that were so
poor," said Mam, when Da was out in his forge. "These things matter. Your
Nain knew that, and so did Father Elyas. Your Da should remember it, too."
Then she shook her head and turned back to her spinning. "And I'm talking
almost as much nonsense as she did. Don't you go repeating it, mind, not
here or outside."

"But he will celebrate the harvest, won't he?" Mared said. "He takes his
tithes then, surely?"

"He takes his tithes anyway," said Mam, "but we'll see."

"The harvest isn't worth celebrating," said Da, later that night, when
Mared asked him. "Nothing but rain and cold all year." But others in the
village muttered about the lack of a Midsummer blessing and cast dark
looks at Father Dominic's back. They would all be on tight rations, once
winter came, and, unlike Father Elyas, Father Dominic was unlikely to stint
his demands for their sakes. The next Sunday, the atmosphere in the church
was sullen and the responses slow to come. A priest who disdained his flock
made a poor intercessor with God: there were those in the village, Mared
knew, who preferred to make their real prayers in private. Gil the brewer
never came to church, but then he was a foreigner, for all the villagers liked
him. Now, others started to stay home on Sundays, too. The steward did
nothing; the earl had sent him no directions. And, come harvest-tide, Father
Dominic glared at the congregation and spoke of God's punishment via
want for those who sinned.

The next morning, as Mared made her round with the eggs, Gil called
out to her from the door of the inn. "The blessings must be given. Mind you
tell your Da that."

Da said nothing when Mared passed on the message, but looked thought-
ful, and spent the whole day alone in his forge. But that evening, as the fam-
ily ate their scanty meal, he said, slowly, "It's a long way to Midsummer."

"That's so," Mam said.

"The priest over to Witham has his own harvest and bounds to bless."

"A priest or a king, to bless the bounds; that's what your mother would have said."

"Well, I'm neither," and Da fell into another long silence that lasted until bedtime. But the following morning, he set off early for Rhiw Fabon and returned late. Mared heard him whispering to Mam in their bed but could not make out any words. And the next day, he seemed much as usual, and the day after that, and the day after, as the days counted down towards midwinter. Mam took to leaving a crust of bread and a splash of ale on the hearthstone each night, making the sign of the cross as she did so. Da, who had grumbled at Nain for such ways, said nothing.

"No summer blessing and no autumn thanks," Mam said. "We need as much help and fortune as we can come by."

Two weeks after that, Father Dominic demanded the best layers from Old Cati's ducks in tithe, saying she'd shorted him over the summer. She denied it in her limited English and he pretended not to understand her. Her neighbor spoke up for her and was rewarded with a blow and heavy penance. The Father overheard Rhodri, the six-year-old son of Sion Plough-man, singing on the sabbath and ordered his mother to whip him. A week later, three of the steward's servants came down into the village and took away three men, saying they had been heard in an inn in Penwern speaking ill of the earl. The wife of one of them, great with child, knelt outside the manor all through the cold night and took a chill of it, so that her babe was still-born. That evening, coming in from shutting the hens into the barn, Mared caught Mam standing on a stool to place half a raw onion on the roof beam. "To soak up the ill-luck," she said.

As a free man, Da owed no service to the earl. But in these days, that was no guarantee of safety. Father Dominic distrusted any low-born man who had, in his eyes, too much liberty. And then, "There's a rumor the wizard king has been seen in the borderlands," Da said, one evening. "So no telling tales of him where anyone you don't know well and trust can hear you." That latter was directed at Mared. "Both the priest and the steward have only suspicious eyes for anyone whose family is more Welsh than English."

"I won't, Da," Mared said. Since Nain had died, and without the feasts and the visits from Old Wyn, she had become the closest thing the village had to a story-teller.

There had been rumors before. But this time, it seemed the earl took them more seriously. He did not come in person—he had not done so in Mared's lifetime—but in the first week of December soldiers in the earl's

livery arrived at the manor and the village, taking over the manning of the gate from Awstin the porter and requiring yet more renders in kind from those who lived there. "And what we're to eat now, I don't know," said Mam's friend Carlyn. "Dirt and twigs, I daresay. If there's no blessing come next Midsummer, we're all sure to starve. I wish the wizard king had burnt us with the village and that's a fact."

That was treasonous talk. Mared threw an anxious look at the door. But Mam said, "He'd not treat his own people like that. It was only the earl's property he burnt. He was good to the Welsh. Better than these Norman lords and their king."

Mared drew in a breath and Mam looked at her. Her brothers were in the forge helping Da; Mared was busy with her spindle. Mam nodded to her, as she might once have nodded to Nain, then turned the conversation away. Da rarely spent evenings at the inn, but late that afternoon he went down into the village with a spit he'd mended for Gil and did not return until just before curfew. The following day he was up early and away to Rhiw Fabon before Mared had finished milking the goat. He was gone for close on three days, returning so late the family were long abed. Mared woke to hear him conducting a rapid low-voiced conversation with Mam, before disappearing out to the forge with a covered bowl and a leather jug. Yet when Mared woke, all the utensils were in their familiar places and no food was gone, so she wondered if she had dreamt the whole thing. Da was already at work in his forge, whistling as he mended the rim of a cart-wheel, and full of stories about the market at Rhiw Fabon. The smith there had taken ill, he told her, and Phylip Ddistain, who stood for the lord there, had sent for him to shoe the lord's horses. Da showed Mared the three fine silver pennies he'd been paid and promised she would go with him the next trip.

Later the same day, Wat Miller came by the forge with a knife Gil wanted sharpening and Da sent Mared's brothers out of the forge to watch the goat at her grazing. Mared made to take ale to the men and Mam called her back sharply; that too was strange. And then, Wat left without stopping to greet Mam. He'd had a basket with him when he came, but leaving he carried only the knife, wrapped in a cloth. "Wat's left his basket," Mared said to Mam. "Shall I run after him with it?"

But, "Wat's old enough to look after himself," said Mam. "Get on with your spinning."

That night Da told the children that the forge was out of bounds to them for now. "I've a commission for a merchant over to Rhiw Fabon and it's

delicate work. I don't want any accidents." The eldest of Mared's brothers grumbled a little at that, considering himself slighted, but Da would not be swayed and Mam spoke sharply to all of them.

Her brothers were all still young enough to regard their parents' words as law, but Mared at twelve was almost a woman grown and old enough to know when there was something hidden. That night, a rattling by the hearth woke Mared. She peered out from under her blanket to see Da, fully dressed, holding the close-lantern in his hand. He glanced once about the room and Mared hastily shut her eyes. A moment later, she heard the door creak open and then close. She counted slowly to ten under her breath, then crept out of bed. She took her shoes in her hand and Nain's old scarf for a wrap, and slipped to the door. Was Da going to the forge? She put her eye to the latch-hole and peered out. No, instead, he crossed the yard and headed out the gate and the track towards the village. Mared waited until he was out of sight round the first bend, then slid quietly outside herself. A frost had come down and the hard earth was chill under her feet. Hastily, she tugged her shoes on, then set out after Da. The sky was clear and a thin slice of moon provided enough light to see by. At this hour, the gate would be closed: where could Da be going? She ran until she could see Da again, then followed him at a careful distance.

As he neared the village, he turned right, away from the gate. Was he going to the mill? It seemed a strange hour for that. But he passed that turn, too, and instead carried on along the line of the wall towards the river. But just before it came into sight, he stopped and looked around him. Mared ducked behind a bush and held her breath. Da moved a square rock to one side, then knocked twice on the ground—at least, that was what it looked like—and then a beam of light sprang up at his feet.

The king under the hill ... For a moment, Mared was inside one of Nain's stories. Then she realized it was a trap-door of some kind. Da bent down and disappeared though it. The light vanished as the door shut behind him. Again, she hesitated. Then, once she was fairly sure no-one was watching, she crept after him.

The trap-door was closed and barred from within, and there was no latch string, but a faint line of light rimmed it and there were a few cracks in the wood here and there. Mared peered through one of them. She could see stone flags and the edge of what looked like a barrel. A tall figure stood near the door. It was far too tall to be Da: the figure shifted and she caught a glimpse of a hand. It was Gil; this must be the cellar of the inn. Gil was

talking, something about old laws. Mared bent closer and her elbow knocked against the wood.

She whirled, ready to run, but behind the trap door clunked open. A heavy hand came down on her ankle and she gasped. A voice—Gil's—said, "Now then, Mared, no need for panic. Turn round, now, and tell me what you're doing here."

"I …" Mared stammered.

"Better you come inside." Gil reached up his arms to her.

She could hear Da behind him, sounding cross. She was in so much trouble now; it would only get worse if she ran. Mared slipped down through the trap door. Gil caught her, set her gently on her feet.

He looked down on her from his great height. King Bran himself could not have seemed taller in that moment. The shadows themselves appeared to drape themselves around him like a nobleman's robe. Mared made to speak and he put a finger to his lips. Then he drew her after him, toward the main part of the cellar where Da stood, frowning. His face promised consequences later.

Gil said, "Don't scold her, Iestyn. She's a bright girl and she's helped us already by carrying my message."

"We'll see," Da said, but the frown faded.

Gil nodded, then went on, "All's well. It's just the smith's daughter."

"Mared," a new voice said, and a new figure formed out of the darkness. Old Wyn. But if Gil looked more like Bran than his familiar self, then Old Wyn was even stranger. His gray hair was combed back off his face and tied with a leather thong: in place of his familiar woollen tunic, he wore a shirt of mail, every bit as fine as that worn by the bishop's brother, who stood higher in England even than the earl, and who Mared had seen once when she was a small girl visiting Penwern with Da. Old Wyn came forward into the light shed through the door and smiled at her. "I remember her well. You were a babe in your mother's arms when your Da shod my horse, child."

Nain's story of the wizard king … But this was Old Wyn, who told stories of his own, and made animals out of scraps of wood. Mared stared at him, trying to read lines of mystery in his familiar face. He went on, "I chose the name after another Mared. She was the wisest person I knew, and the bravest." He looked at Gil, then continued, "She was the whole of my heart, but King Henry's soldiers took her and imprisoned her and tried to break her, but they never did."

Mared did not know what to say. She was not wise—she was too young

for that, surely? She did not know if she was brave. She did not know what she would do if the earl's soldiers took her and tried to make her harm Da or Mam or her brothers. Old Wyn looked back at her, and said, "She was kind, too, my Mared. She always said that was the most important thing."

"She's rash, that's certain," Da said. Mared looked at her feet.

"This Mared is kind," Gil said, "and clever, too. And she knows right from wrong."

"I remember," Old Wyn said, nodding slowly. "She always brought me food from her Nain. Her name becomes her."

Mared did not know what to say to that, either. Gil reached down and ruffled her hair with his big hand. "Go back home, now. All's well here."

Mared looked over at Da, who nodded. "Go straight home, mind. Don't wait for me."

"Yes, Da," Mared said. Then Gil lifted her up to the trap door, and she climbed back outside.

Mared ran all the way back to her home. No one stirred as she crept back inside and slid back into bed. Her feet were so cold … She meant to stay awake till Da returned, but somehow sleep took her, and when she woke it was morning and Da was making up the fire. He caught her eye and put a finger to his lips. She nodded. It was almost as if she had gone to bed a child but woken as someone more grown up. Da had a secret and he was trusting her with it. Something to do with Gil and Old Wyn. Something to do with Father Dominic and the steward and their behavior towards the village. Neither Gil nor Old Wyn nor even Da had made her promise to keep silent, and the lack of that meant more than anything. They trusted her and she would be worthy of their trust.

Later that morning, Mam took the eggs down to the village and returned with a grim face. "There's royal soldiers in Penwern," she said. "A peddler came through and told Wat Miller. He said they're likely headed this way, what's more. The king in London is worried about rebellion again and angry still that he never caught their last leader. And the earl's men are already here."

Da said, "We'll deal with that when we have to." But he spent longer than usual in the forge that day—Mam took him food and would not let any of the children help her—and came back to the house late, long after the moon was high and Mared and her brothers were abed. She heard him whispering to Mam as he undressed for bed. "The fire is out. The rest … We shall have to wait and see."

The following afternoon, Da went off to work on one of the fences, taking Mared's brothers with him. Mam kept Mared close to home, at her spinning. It was a gray, lowering day. Towards midday, it began to snow, in slow heavy flakes. It went on snowing through the night and all of the following day, until the land around Meresbury was an expanse of rolling white, studded with frosted hedges and sparkling trees. The old fort rose up to the west, its ditches marked out by the snow. On the marsh, geese pecked at the ice that covered the shallows, and rose in protesting arcs over the village. "Well, the snow will slow the king's soldiers," Mam said, looking out towards where the road should run.

"Midwinter is here," said Da.

That was Sunday: the family wallowed their way down into the village for church and stood in a chilly row to listen to Father Dominic growl and accuse. There was no stopping to talk in the churchyard outside: rather, the villagers hastened to their homes, hunched against the cold. Mared had to break the ice on the water trough twice that day, so the goat might drink, and her eyes turned over and over to the forge, wondering how Old Wyn was faring. The days were at their shortest: the snow clouds only helped to usher in the night sooner.

Mam woke Mared in the depth of that night. She put a finger to her lips as Mared blinked and began to sit up. Mared hurried back into her outer dress and shoes, then helped Mam with her younger brothers, who were bleary and unsure. Da waited for them by the door. Outside, the snow had finally stopped, and the land lay silent and strange under its coverlet of white. A half-moon hung over towards the western highland, its light turning the snow to silver and gleam. The family followed Da down towards the village, the children stretching their legs to try and step in the marks made by his feet. Mared's littlest brother slipped and staggered and Mam lifted him up into her arms. There were no sounds, apart from their breath and the slow deep crunch of the snow. Even the goat did not stir as they passed her byre. They made their way, step by slow step, right down to the shadowy line of the town wall. Mared held her breath. The steward had declared no curfew, but the earl's men still held the gate and they would surely look harshly on any villager caught out at this hour. As they approached, shadowy figures stepped forward and she bit down on her lip to stop herself crying out. But Da was not afraid. He kept on walking and the figures slowly resolved into the familiar forms of Wat Miller and his family. Wat held a close lantern: he nodded to Da and to Mam. Then he reached under his cloak and pulled out

a small leather bottle. He handed it to Mared, and said, "Gil gave this to me and told me to ask you to carry it. He told me to tell you that, hopefully, we won't need it, but if we do, your Nain's wisdom will guide you." Then he led his family to stand behind Mared's. Da turned and began to walk along the line of the wall towards the gate. Every few yards, more shapes joined them—Carlyn and her husband and children, Siwsan and her mother, on and on until almost all the village were with them. They walked in silence, their breath steaming in the night air. Da led them past the gate, which stood stolid and closed, with no sign of the earl's soldiers. They must be huddled round the fire in the guardhouse. Da walked on down to the waystone at the crossroads. Siwsan wriggled her way up the line to walk next to Mared and caught hold of her hand. "We're doing the bounds!" Her whisper was an excited rush. "Despite Father Dominic."

"Winter bounds," Mared said. Nain had never told a story about this. Midwinter night was for inside, for hearth-fires and quiet times. They did not sing or dance or tell stories outside the inn. And yet … they came to the crossroads, and it seemed that the waystone had somehow grown magically in size. It loomed up towards them, arms outstretched and crowned with a great ring. Mared squeezed Siwsan's hand. Wat opened the door of the lantern and a beam of yellow light leapt out. The stone resolved into the shape of a man, tall and strong, dressed in a fine brown cloak and wearing a crown of holly. For a moment, Mared was sure that Arddur himself had returned from under the hill. And then the man—the winter king—spoke, and his voice was rich and deep and familiar. Old Wyn, old no more, but proud and upright, his eyes as bright as those of a hawk. He spoke in Welsh, rolling words in praise of God and the saints and the rich green growth of spring. He seemed to need no lantern to light his way. He strode forth boldly and the snow melted under his feet. He led the villagers—at first astonished, then awed, and finally joy-filled—along the line of the river to the far corner of the wood, up along the hedge to the thorn-tree, along the lesser brook to the old ditch, up the ditch to climb the flank of Caer Ogyrfan, following the lines of its banks. As they processed, birds woke in the trees and hedges and raised their voices to praise the spring. Here and there, small buds became apparent on the twigs of saplings. Wyn's voice—but he was not Wyn, not now; he had thrown off the mantle of the old man and walked instead as he had been in the year of Mared's birth, the great Welsh king, the king from the west, Owain Glyndŵr, the wizard king—*Owain's* voice soothed away the pains of winter and hunger and filled the earth and the air with the glory

of nature and of God. It seemed to Mared that she could almost hear the earth itself singing, a low warm rumble beneath the soles of her shoes.

They came to the crest of the old hillfort and Owain raised his arms to the heavens. Moonlight poured down over him, so that he glowed like light through the colored windows of the great church in Penwern. Overhead, the wild geese circled and called. Wat came to stand at the king's right hand, and Da at his left, both of them likewise bathed in silver light. There were three heroes in many of Nain's stories. Three golden shoe-makers. Three fair princes. Three brave men. Wat and Da joined their voices to Owain's and one by one, the villagers joined in.

"Stop this heresy!" The voice was thin and bitter, a twist of bramble beside the bole of a mighty oak, yet somehow it cut through the singing like a sword through flesh. Mared felt her words catch in her throat and stumble to a halt. There, coming up the hill from the village, red-faced and screaming, was Father Dominic, flanked by six of the earl's men. "I will not permit this! Blasphemy and treason!" The soldiers held spears or bows; as the priest shouted, they levelled them towards the nearest villagers, who drew backwards. There were more villagers than soldiers, but none of them were armed. One by one, the villagers fell back, until the priest and his soldiers stood before Owain, Wat, and Da. "That man," Father Dominic said, pointing at Owain, "is a traitor. The other two are his allies. Take them."

Four soldiers stepped forward: the others kept their weapons pointed at the villagers. Mared swallowed hard. This must not be. It could not be. Owain had brought the blessing Father Dominic had refused. She remembered how she and Siwsan had hunted for the secret way into the hill and failed to find it. She remembered Nain's tale of the wild earl who learnt to fly away with the geese. She slipped her hand free from Siwsan's and began to wriggle forward through the crowd. All were silent now, save for Owain, who continued to speak in slow soft words, too low for Mared to hear. Her fingers closed on the bottle Gil had sent to her. He had trusted her with this, as he and Da and Owain had trusted her in the inn. He had said she would know what to do.

Father Dominic knew no Welsh. Nor, most likely, did the soldiers. Her eyes met Da's and he nodded. She took a deep breath and threw the bottle, calling out as she did, "*Vrenhin!*" King!

Time seemed to slow. The soldiers' feet stumbled as they tried to step forward. Father Dominic's voice was washed away by the thunder of Mared's heart in her ears. Owain raised a hand and caught the bottle. For a moment,

he looked down at her and smiled. Then he pulled the cork and drank the contents and cried out in some tongue that Mared did not know.

A heartbeat. Another. Father Dominic gave a strangled cry. His arm—pointing at the three men on the crest of the hill—began to twist and darken. The soldiers stopped, their weapons falling slack from their hands. Owain's shape, too, began to change, great white wings springing forth from his back, his neck lengthening as he threw his head back to look at the sky. The wild geese swooped, down and down, their wings beating at the heads of the soldiers until they cried out and began to run. Not one villager was touched, though many cowered. Then they leapt upwards, led now by one great white bird about whose neck ran a dark line, like the memory of a crown.

And then they were gone, leaving Wat and Da and Mared standing, gazing at each other, and the villagers, and, where Father Dominic had stood, a twisted knot of gorse. Da stooped and picked something up, then held it out to Mared. A single white flight feather. He said, "Well done, *cariad.* You merit your name."

The next summer was warm and generous; yes, and the next four after that. The villagers walked the bounds, led by their new priest, and danced on the green before the inn. But no more was ever heard of the wizard king.

Author's Note: I have played fast and loose with geography for this story and, to a lesser extent, with history. Meresbury is Oswestry, on the Welsh border, but while it does have an ancient hillfort (associated with Guinevere's father) it is not normally thought of as one of the places where Arthur sleeps. Owain Glyndŵr did invade it in 1400, and burnt it, but he did not take any care to distinguish Welsh from English tenants. His rebellion peaked by 1406, though his men did raid Shrewsbury (Penwern in this story) in 1408, which I have left out. He was last heard of in around 1412: tradition suggests he was buried somewhere near his family lands in Corwen or Sycharth, or at his daughter's estate at Kentchurch in Herefordshire. I've adapted another border legend, that of the Anglo-Saxon lord Eadric *Cild*, for the story about the wild geese and the wild hunt. Owain's wife really was called Mared (which is the Welsh version of Margaret).

𝔄 𝔉𝔞𝔳𝔬𝔯 𝔣𝔬𝔯 𝔏𝔬𝔯𝔡 𝔅𝔞𝔦

Jean Marie Ward

The immortal Gilgamesh closed the folding doors of the Nanjing bar behind the last of the morning's human patrons. He turned to his remaining customer, a dragon masquerading as a tall, well-dressed, Han Chinese youth. "There's a fresh coffee in it, on the house, if you'll move that barrel of black powder to the storeroom."

The prospect of more coffee—the musky, mysterious, exhilarating elixir served in tiny porcelain cups usually reserved for hard liquor—propelled Lord Bai, White Dragon of the West, to his feet. Then his mind caught up with his taste buds. He frowned at the wooden barrel wedged between the front table and the wall.

"You keep gunpowder in the bar? Isn't that …" Bai hesitated. "Dangerous," "daft," or the dozen other adjectives that sprang most readily to mind might offend his host. Bai was angling for a look at the glamoured artifacts concealed beneath the bar. The shelves above the bar displayed a number of rare curios, most notably a bronze, canister-shaped, Zhou Dynasty wine vessel. If Gilgamesh left such valuable items in plain view, it stood to reason any item he chose to hide must be precious indeed. Bai hoped the cache included something he could use to lift the restraining spell imposed by his tutor, the old sorcerer and new mandarin Li Lao—a remedy Bai was desperate to find. He settled on: "… illegal?"

"Not for fireworks. The head of the local gunpowder guild owes a favor

to our neighborhood merchants association. He's paying off the debt by creating a special fireworks display for the Harvest Moon Festival. I'm storing the powder until he gets around to it." He grinned at Bai's dismay. "It's perfectly safe. I'm not using the kitchen for anything except boiling coffee."

"What about your cook?"

"He left for Beijing this morning."

"What!" Bai squawked. "Why?"

"His family needed him," Gilgamesh said. "His father owns a restaurant not far from the Yongle Emperor's new palace. Between the crowds who came for the palace consecration and the repair crews brought in after the fire, the business exploded. His oldest son and family couldn't keep up. So he summoned his younger sons to help."

Bai's dismay morphed into horror. "But what will you do for lunch?"

The laugh lines fanning from Gilgamesh's green eyes deepened. "There are enough restaurants in this neighborhood to feed an army of dragons—assuming those dragons have the cash and their flashy scales aren't just for show."

Bai reared. The spirit of his dragon tail flicked in indignation. He wasn't like his tutor Lao. He always paid his tab!

Gilgamesh chuckled and ducked behind the bar. Hidden from his human customers and other potential troublemakers, he moved slowly, almost stiffly. The watery light streaming from the glass panels set above the front doors—a refinement as rare and outlandish as Arabian coffee, Frankish wine, or porridge-like Sumerian beer—emphasized the gauntness of his features. Exhaustion shadowed his eyes. Six months of single-handedly running the bar's public room from dawn until the second hour after midnight taxed even a demigod's vigor. But it appeared no restaurant worker in town wanted to work for a foreigner. Gilgamesh's former cook was the only one willing to give him a chance, and now he was gone.

This troubled Bai. He wasn't just the bar's best customer. Led by his dragon nose for magic, he had been the first person to cross the threshold. In the beginning, he had taken pains to ingratiate himself solely in the hope of discovering something to break Lao's spell. But over time, he had grown fond of the immortal himself. It was rare for the young dragon to meet anyone who viewed him as something more than a superfluous junior heir, a recalcitrant student, or the sum of his saleable parts. Instead, Gilgamesh acted the part of an indulgent uncle—often amused, occasionally exasperated, but never denying his hospitality. As far as Bai knew, the immortal never

denied anyone his hospitality. It was wrong for people to take advantage of his generosity, then declare him unworthy of service because he was born elsewhere.

"The bar—and you—can survive the loss of a cook," Gilgamesh continued. He drew a sheet of yellow paper from under the counter and slid it across the age-darkened surface. "This, on the other hand ..."

Bai approached the bar. The paper was crumpled and smudged by shoe prints. But it was unquestionably the same shade and weight as the paper used for official government documents. The precisely drawn script accused the proprietor(s) of the premises at the bar's current address of failing to pay their taxes for six consecutive quarters. To retain the license, and forestall confiscation of the property and its contents, the proprietor(s) of said property was/were hereby ordered to personally deliver the full amount due to the Nanjing Directorate of Entertainment Licenses and Revenue no later than the last day of Seventh Month—tomorrow. Bai glanced at Gilgamesh.

Instead of reaching for the small spirit lamp used to prepare coffee, the demigod set a thin, kettle-shaped, porcelain wine pot and two matching cups on the counter. The glittering crystal liquid he poured from the pot's narrow spout infused the closed air with the razor tang of lightning. It was *baijiu*—hard white liquor—and more potent than most.

Gilgamesh tossed back the contents of his cup. "I found the notice under the door when I opened this morning. I don't understand. The bar always takes care of these things. The day after I arrived, the Director of Licenses showed up with his secretary. I paid a year's taxes in advance and thanked them for their trouble with a few jars of my best wine. I thought they were happy. The director and some of his friends even dropped by after work a few times. No one mentioned any problems, much less that I owed taxes for a year before the bar opened."

"It's probably an error," Bai said. "The city revenue clerks are only human. They must make plenty of mistakes."

"It doesn't matter if it's an error or not. The problem is visiting the office to put things right. My curse won't let me leave the bar."

The ghost of Bai's dragon ears perked like a cat's at the squeak of a mouse. Only instead of a rodent, he heard an opportunity. Dragons were the best shapeshifters under heaven. "Maybe I can help."

The demigod's smile returned. "Thanks for the offer, but no one could mistake us for twins."

"They might," Bai purred silkily.

Bai's long, straight hair liberated itself from its bun. It contracted and curled beneath his soft-sided black hat before pinning itself close to his scalp in accordance with the dictates of court protocol. His smooth, youthful features rearranged themselves into the weathered, olive-tinted crags of Gilgamesh's face. Drawing on the spectral mass of his true form, Bai's muscles thickened until they assumed the broad, hard contours of a veteran soldier. His fashionable silk and linen garments transformed themselves into the mirror of Gilgamesh's baggy trousers and belted wool tunic, which proved surprisingly comfortable despite the warmth of the day. His beard, on the other hand, was a trial. Bai's cheeks, neck, and the top of his chest felt like they were being smothered under a blanket of ants. But he could hardly impersonate Gilgamesh without it.

New respect gleamed in the demigod's eyes. "I stand corrected—and in your debt."

That was exactly what Bai had in mind. He offered a brief prayer to Caishen, the god of fortune, whom even dragons worshipped. If Caishen smiled upon him, Gilgamesh would grant him the favor of revealing his treasures. Then Bai would get to work on breaking Lao's infernal spell.

* * *

The director's secretary kept the ersatz Gilgamesh waiting precisely long enough to demonstrate his employer's consequence without causing offense. Once the pecking order was established, he escorted Bai to a pleasant, white-washed office with a garden view.

The director, a heavy-set man with an oblong face and a prominent nose, greeted his visitor with the bow reserved for equals. He invited Bai to share fragrant oolong tea at the small table next to the window. As Bai eased Gilgamesh's bulk into one of the round-backed chairs flanking the table he tried to reconcile his reception with the harsh tone of the tax notice. The director seemed to be extending an unusual level of courtesy to someone who was, to all human appearances, an ordinary barman. Did the director share the Yongle Emperor's high regard for Arab scholars and merchants, or did he merely wish to give that impression to a possible associate of the emperor's Moslem favorites? There was only one way to learn the truth. With more delicacy than the rough-hewn westerner would have employed, Bai broached the reason for his visit.

The director's elegant silver nail guards clicked softly as he steepled them in front of his well-groomed goatee. "I wouldn't call the notice a mistake." Mildly spoken, it was still an order. "My secretary informs me it is

indeed legitimate. But it was sent to the former proprietors: Cheng, Feng, and Cheng."

He made a noise in the back of his throat, which in a less august gentleman would have been taken for a growl. "Good-for-nothing morons. Cheng's was an institution. The bar was owned by the family for over four hundred years. It survived the Song Dynasty. It survived the Mongol Horde. But it couldn't survive *them*. Less than two years after those stooges got their hands on it, the city was forced to confiscate the property for non-payment of taxes."

He took a deep breath, then smiled apologetically. "Forgive me. This is no reflection on you. You're a man who respects tradition. You even left the Widow Cheng's famous counterfeit pot in its place of honor behind the bar. I only wish her heirs had shown the same consideration."

Counterfeit? Hiding his disappointment, Bai asked in his best imitation of Gilgamesh's resonant bass, "Can you think of anyone who might benefit from sending me their bill?"

"If the bill was for supplies or services rendered, I could name a dozen. But taxes?" He waved the question away with a graceful fan of silver-sheathed nails. "Put it out of your mind. People are always finding odd bits of paper in abandoned properties. You never know what might turn up."

He hesitated. The stubby wings of his round-topped official's hat seemed to quiver. The movement echoed the flutter in his pulse detected by Bai's inhumanly acute hearing. His equally sensitive nose caught the subtle shift in the scent he associated with human unease.

"I don't suppose you found anything else?" the director asked.

What was he afraid Gilgamesh might find, and how was it connected to the note—the note whose sole purpose appeared to have been luring the demigod from the bar? Was the sender after something the former owners left behind? Did they, like Bai, covet one of the bar's more esoteric artifacts? Gilgamesh would hardly reward the dragon for dealing with a tax hoax if something worse happened while he was gone.

Bai needed to return to the bar quickly, even if it meant postponing lunch.

* * *

Bai rushed past the red banners and brightly painted signs lining Eight Treasures Avenue. He steeled himself against the ringing blandishments of the avenue's restauranteurs, shopkeepers, and peddlers. He refused to be distracted by the savory aromas blooming in the clement, turquoise-capped afternoon. He resisted the urge to fly to Gilgamesh's rescue in dragon form.

It would have been faster and more impressive, but he couldn't risk shifting in a crowd. A dragon, living or dead, would fetch more on the Middle Kingdom's magical black market than any treasure secreted in the bar.

A top-heavy, two-wheeled pull cart drew up beside him with a clatter of pounding feet and grumbling wheels. Without warning, the driver swerved. Bai barely jumped back in time. The driver bolted down the high-walled alley to his left and parked next to the kitchen entrance of the restaurant on the corner.

Steam hissed from the sides of Bai's mouth. His foot could have been crushed, an injury which would have lamed him in dragon form as well. Regardless of the urgency of his mission, he could not allow this affront to his person to go unpunished. He needed to put the fear of fire into the offender. It would only take a moment. He stormed into the alley.

Somewhere in heaven, Caishen was laughing. The first thing Bai saw after his eyes adjusted to the dimness was the logo of Hu's Pastries emblazoned on the side of the cart. Hu's—the peerless, Old Town confectionary located on First Street. It was said the Jianwen emperor refused to flee his burning palace without a dozen of Hu's cream buns for the road. Though how the fugitive royal could forgo Hu's crunchy sesame seed balls, their almond biscuits and water chestnut squares, their autumn mooncakes, their …

The driver unlatched the backboard of the wagon and used it as a ramp to reach the tall, fabric-draped box which filled most of the cart. He flipped back the cover to reveal a tower of four open bamboo shelves. Fitted into each rack was a large basket packed with an assortment of Hu's celestial pastries. The driver balanced the topmost basket on his right shoulder and trotted toward the kitchen door. A red-faced man in a cook's cap and stained white apron hurried him inside. The door slammed behind them, propelling the aroma of stir-fried garlic shoots and seared meat in Bai's direction.

The fragrant cloud washed over him. Bai moaned. His human toes curled inside Gilgamesh's outlandish socks. It wasn't fair. He'd been so good. He'd steadfastly ignored every gustatory temptation set in his path and what did it get him? A near maiming, a restaurant close enough to smell, a truck of Hu's pastries close enough to touch, and he was starving. He'd only eaten two breakfasts all day.

No. He could eat his fill after he checked on Gilgamesh. The bar was only a few blocks away. He could have marched halfway there in the time he's spent transfixed by baked goods. He should leave. But his feet refused to move.

Shouts from the thoroughfare behind him broke his trance. He emerged from the alley in time to see two burly men in aprons and cooks' caps eject two smaller, grubbier men dressed like day laborers from the noodle shop across the avenue. The larger cook bellowed, "And if I ever see you hanging around my place again, I'll call the City Guard!"

The pair scurried across the street, precipitating several near collisions, including a three-way between an ox cart, a water seller, and a sedan chair. They ducked into the alley and huddled next to the wall opposite the restaurant. The man closest to the avenue sported the shaved head of a Buddhist monk over a round cherubic face and even rounder belly. His companion was thinner, with a narrow face and beaky nose. He owned enough hair to gather into a messy bun at the nape of his neck, but his crown was bald and shiny with perspiration. Chests heaving from exertion and possibly fear, they peered into the avenue, ignoring the six-foot-plus foreigner standing less than six feet away.

Bai's eyebrows drew together over his nose. They seemed remarkably oblivious, even by human standards. Then again, they had no reason to be afraid of him ... unless they caused him to miss lunch *and* dinner. The tubby one's funk carried a delectable whiff of piglet in the sty. A groan of longing rolled up Bai's throat. He moistened lips suddenly gone dry.

The characters of the spell imprinted on his back flared to life. They itched worse than Gilgamesh's beard. Lao claimed the spell's only purpose was to protect him from Bai's pique. But the damn thing was turning into a surrogate conscience, pricking him at the most inconvenient times. Bai needed to leave now, and not just to help Gilgamesh. If he grew any hungrier and started thinking—quite innocently, without ever dreaming of acting on the thought—how splendid humans could taste, he might scratch off his skin. It would be worth it if he could scratch off the spell in the process, but he knew from experience he couldn't. So he searched for an opening in the crowd.

The chubby guy huffed in a high, unlikely tenor: "The nerve of that guy, Jingxi. Imagine, kicking us out of his shop just because we hadn't ordered in three hours."

"Yeah, and we didn't see Gilgamesh, either," his companion, aka Jingxi, replied in a hoarse, nasal voice. "You don't suppose we missed him, do you?"

Bai froze mid-step. *They couldn't mean ...* But as far as Bai knew, there was only one Gilgamesh in Nanjing. Bai lowered his foot and approached

the pair. He stopped less than an arm's length from both men. Still, neither one turned in his direction.

"We'd've seen him," Chubby averred. "The guy's a giant with a bushy beard and hair out to here." He spread his hands in front of his shoulders.

"I dunno, Juanqu," Jingxi, fretted. "He should've passed by ages ago. Every time I paid the bar tax, the clerks gave me the bum's rush."

The two clowns knew about the bar tax. They must have sent the notice—or knew who did. In a growl worthy of his dragon form, Bai demanded, "What do you want with Gilgamesh?"

"Nothing," Juanqu chirped. "We just need to keep him busy until Ma gets Auntie Cheng's pot back."

That pot again. Maybe the director was wrong. Maybe it was genuine after all. The thought flashed through Bai's mind as Juanqu finally, *finally,* turned to face him.

"Nyah-ah-ah!" Juanqu squealed. "Hey, Jingxi, over here!"

"Quiet, Juanqu. I'm concentrating."

"Well, concentrate over here!"

Face twisted in an exaggerated show of annoyance, Jingxi made a production of turning around. His eyes widened, but his gaze was fixed on the avenue, not the dragon version of Gilgamesh. He flattened himself against the wall. "Oh no! Ma!"

Before Bai could ask why Jingxi was scared of his mother, a third man burst into the alley, panting hard and ripe with primate sweat. As short as the other two, he vaguely resembled Juanqu. But the likeness was obscured by his fierce scowl and the kerchief tied pugnaciously low over his forehead. Surpassing even the mind-boggling obliviousness of his confederates, he stomped past Bai, caught Jingxi by the hair, Juanqu by the ear, and cracked their heads together.

"What's the big idea letting Gilgamesh beat me to the bar?" he snarled in a voice harsher and lower than those belonging to his associates.

"But Ma," Jingxi and Juanqu protested in unison.

Ma slapped them quiet with a single swipe of his hand. "No buts. I escaped the bar by the skin of my teeth. Then Mother Pan Pan's boys caught up with me. It took me an hour to give them the slip. Now we gotta come up with a new way to get Gilgamesh out of the bar and I'm all out of tax notices."

"Ma!" Bai snapped.

"What?" Ma groused, still not bothering to glance in Bai's direction.

"Can't you see I'm busy?"

Bai yanked off his hat, releasing Gilgamesh's distinctive curls. He thrust his hand between Ma and his comrades. "I don't believe we've been introduced."

Ma jumped. "Gilga-a-a …"

Jingxi's head whipped from side to side, searching for a way to escape. Juanqu hooted, teeth bared in the desperate grin of a monkey in a trap. He patted the air over Bai's head. As Bai stared, bewildered, Juanqu retracted his hand and formed a fist. Bai instinctively ducked. But Juanqu never threw the punch. He belly-slammed Bai into the cart.

Bai yelped. The cart shook. Its forward struts groaned. Bai grabbed the cart to steady its precious cargo and himself.

The trio ran into the avenue. Crashes, shouts, and curses erupted in their wake.

Bai shook his head and rubbed his thigh. He hadn't hardened his skin before impact. Nothing felt broken or damp, but from the way it smarted, the bruise promised to be spectacular.

Still, the afternoon was looking up. He had solved the mystery of the tax notice. Better yet, Juanqu's cannon gut had knocked a mooncake and several cream buns into the bed of the cart. Cracked and squashed, they couldn't be sold. Hu's discerning clientele would never accept damaged goods. Bai's karma would hardly suffer if he prevented them from going to waste. A Neo-Confucian might even consider eating them an act of merit. All the same, he checked the alley and the avenue to make sure he didn't get caught.

A distant roar reverberated along the gray brick canyon of the shopping street. It grew louder as Bai listened—a bestial sound, born of many voices, which spanned the aural spectrum from guttural bellows to furious screeches. Only one mortal animal possessed such a range. Only one raged in packs. War band, gang fight, or riot? Bai couldn't say. He couldn't see the source of the clamor. He only knew the humans who created it were getting closer.

Despite who and what he was, Bai felt an atavistic shiver ruffle phantom spines along the back of his neck. This was how the first humans exterminated the mastodons and other giant beasts of the Last Age. Massed together, their mingled screams rending ears and minds, the puny hairless apes drove those noble animals into pits lined with sharpened sticks. Dispatching them with clubs and rocks, the humans cooked their victims where they died and reveled in the gore. But that was before dragons took to the sky, before

humans learned to herd grass-eaters, before the apes civilized themselves.

They weren't that civilized. A part of them never forgot what they were capable of.

Somewhere in the distance, someone shouted: "Run!" Dozens, maybe hundreds took up the cry. Run!

Run!

RUNNNN!

Pedestrians scattered. Mounted riders wheeled and galloped east, barely outpacing the frightened citizens charging up the pavement behind them. The multitude rushed toward Bai like a tsunami. The carts, displays, and street-side tables were tossed aside. They shattered against storefronts or were crushed in the stampede. Broken sign boards leapt into the air like flotsam at high tide. The noise was indescribable—cracking wood, booming feet, the howl of hell wolves, rapid-fire shrieks of rage—and the cause was still unknown, still too distant to be identified.

It didn't matter. The panic was infectious. Overwhelming. Bai retreated to the cart in a mindless quest for cover. He had been pursued by humans singly and in groups. He had faced mortal danger in a hundred different forms. But he had never been caught in a mob. The sight, the sound, the sheer mass of humanity triggered something deep within his dragon brain, something primitive and scared, from a time when even his kind were prey.

Ma, Jingxi, and Juanqu burst into the alley. Bai opened his mouth to croak a warning. Before he could remember words, Ma pulled to a stop.

"Wait!" he cried. "We need ammunition. You boys take the yoke. I'll handle the artillery."

Ma turned to the cart. Bai stood between him and the ramp. Ma flinched, then stabbed a finger at the dazed dragon's chest. "You! Lead, follow, or get out of the way!"

A woman shrilled over the din of the avenue, "They're in the alley! The alley next to the bookseller!"

Bai leapt onto the back of the cart and pulled Ma up behind him. "You load. I'll throw."

He flipped the backboard into place and shot the latches. Ma yelled, "Mush!"

"I wish we had a horse," Jingxi whined.

Juanqu whinnied, and the cart rocketed forward. A lane opened to the right. The cart sheared into the turn as their pursuers barreled into the alley they left behind.

Bai, Ma, and the contents of the baskets flopped to the side. Ma whipped upright and shoved pastry at Bai. The cart lurched and slid, jounced and juddered. Bracing himself against the cab, Bai didn't try to compensate. With so many targets, he didn't need to aim.

The motley rabble on their tail was just a small riot, not the army of his fears, but the numbers were bad enough. Eight roaring bruisers marked by broken noses, docked ears, and various sinister scars manned the poles of an aristocrat's red sedan chair. In the wider streets and intersections they plied it like a garden roller, trampling anything in their path. In the narrower alleys and passageways, they wielded it like a giant scythe. The two liveried chairmen caught between the poles struggled to keep the cab level as the vehicle careened from side to side.

Behind the chair, Bai glimpsed another four thugs and the crested helms of two city guardsmen. A flat-faced, middle-aged woman wearing the black coat of an entertainer harried the brutes from the rear. Mother Pan Pan, he presumed. Three black-coated young women flew in her wake. They might have been pretty when their features weren't scrunched around feral yowls. A lucky spray of cream buns reduced the din and forced the pursuers to fall back, but only for a moment.

"Faster!" Bai yelled. He grabbed another round of baked goods. "They're gaining on us!"

A fresh volley of sesame seed balls splattered against the dust-clouded sedan chair and its bearers. Black bean paste bled into eyes and cheeks. Speeding feet skidded on jellied water chestnut squares and the lotus paste hearts of mooncakes. The sedan chair shook harder but kept coming.

From somewhere in the depths of the crowd Bai heard a plaintive cry. "My cart! Help! Police! They stole my cart!"

Bai shared the deliveryman's pain. A little piece of his soul died with every bun and biscuit he threw. He would never eat them now. If the mob caught up with him, he might never eat again. He reached for more pastry.

"It's empty," Ma shouted as the cart plunged from a relatively bright side street into a high-sided, tunnel-like alley.

"There's more," Bai assured him. "Get the basket. Hold for 'go.' I want to take out the chair."

"Say, you're all right!"

Bai grinned. The ersatz Gilgamesh was still grinning when he shouted, "Go!"

The large, square basket rushed toward the lead thug's face. He yanked

his pole to the left. The basket bounced off his shoulder and dropped to the ground. The man behind him stumbled over the hamper. Struggling to keep his balance, he threw his weight onto the torqued pole. The wood splintered with a sound like artillery fire.

The chair crew staggered, nearly dropping their burden. The remaining pursuers jammed up behind them. For an instant, Bai thought the pastry cart was saved. Then the lead thug heaved the remains of the broken pole on his shoulder and resumed the chase.

Bai reached for more baked goods.

"Just a sec," Ma said. "The last batch is on the floor."

"Shouldn't there be two?" Bai could have sworn he saw three baskets when he jumped in the cart.

He glanced at the teetering shelves. The number of baskets was the least of their problems. They were running into a trap. The street at the end of the alley was blocked off with sawhorses and building supplies. Scaffolding fronted a large, jagged gap in the tall gray brick wall across the street. Workmen swarmed the cordoned area, stirring mortar, laying courses, and ferrying supplies.

Bai shouted, "Stop!" as Ma hollered, "Damn the construction, full speed ahead!" Jingxi and Juanqu surged forward.

They were going to die. Hardening his skin until it resembled his natural hide, Bai jumped from the cart. He landed in a patch of mud near the alley wall. With no time and no place to run, he curled his arms over his head and fell to his knees.

The human tide roared past. A terrible crash reverberated from the end of the alley. The yelling grew louder. He covered his ears. Wait, he wouldn't be caught dead in the afterlife with human ears. He must still be alive. Yes, he was breathing. The alley stank of trash and piss. He risked opening his eyes. Lurching to his feet, he struggled to comprehend the scene playing out in the wrecked construction site.

Mother Pan Pan and company were fighting the construction crew. They appeared to have forgotten the original objects of their wrath, who were nowhere in sight. A richly-robed walrus of a man girdled in an ostentatious silver belt shouted threats from the sidelines, while the deliveryman tried to free his cart from the ruins of the scaffolding.

The red sedan chair had run aground against a mortar tub. As Bai watched, the chairmen hoisted a tiny old woman from the battered cab. She was gowned in the rich crimson silk reserved for dukes and their immediate

family. Gold combs bedizened with jade, emeralds and pearls glittered in the coils of her unnaturally black hair. She jabbed her gold-headed cane toward the melee, and the chairmen dutifully supported her doddering steps in that direction. For one mad instant Bai wondered if he should stop them. The lady was the oldest non-magical human Bai had ever seen. Then she took out the nearest bruiser with a single blow to the head. Her withered lips stretched in a triumphant grin.

A steamy chuckle burbled up Bai's throat. Then another.

The deliveryman kicked the tumbled scaffolding poles and started cursing, quickly proving himself a master of the obscene. A bricklayer locked under a bulky guardsman's arm flailed at the guard's backside without connecting. Bai couldn't tell if the cop was trying to strike back or reaching for the helmet bouncing from foot to foot like a *cuju* ball.

Bai laughed aloud. This was funnier than a *Nanxi* operetta.

The helmet's progress drew Bai's attention to something—three somethings, in fact—worming through the mud. The authors of this mayhem belly-crawled between the legs of the crowd, stealthily working their way toward the alley.

Bai was tempted to let them escape. No longer worried about what was happening at the bar or tearing across the back alleys of Nanjing in fear for his life, he realized *they* were funny. If they had been actors in a play, he would have paid good silver coins to see them.

But the reason Ma, Jingxi, and Juanqu were in this fix was because they wanted to rob Gilgamesh. Bai could not allow their crime to go unpunished, not if he wished to retain the demigod's favor.

The trio scuttled closer to Bai. Backlit by the sky over the street, he couldn't see their eyes. But their thrust-back shoulders, thrust-forward chins, their wide elbows and fisted hands made their intentions plain. Bai's Gilgamesh was as bedraggled as everyone else and the odds against him were three to one. Juanqu *woofed* and jogged in place, pumping his arms like a boxer in a play.

Bai snickered, not bothering to mask the smoke of his amusement. No one else in the street paid any attention. The four of them could have been alone in the world—the perfect circumstance for what Bai had in mind.

His snout extended and his lips pulled back from the white-fanged death of a dragon's smile. His eyes shifted from brown to their natural golden amber. Their pupils went from round to pointed ovals. Smoke and vapor wreathed mighty serpentine coils with scales the color of thunderheads. His

belly was hammered silver. His talons glittered, as sharp and long as Imperial swords.

He shifted again, devolving into human once more. But instead of a bear-like western barbarian, he stood before them in the guise of his self-appointed tutor, Li Lao—master sorcerer, restrainer of dragons, and the newest mandarin in the Department of Rites. Admittedly, Bai improved a little on the original. He gave the old scarecrow his own imposing height and dressed him in a rich violet-blue silk robe befitting the badge of office stitched to its front. But the fringe of hair rolled under his black-winged scholar's hat, the jug ears, the wrinkles, and the (blessedly) wispy beard were all Lao.

Bai's smooth transition from fellow fugitive to dragon to mandarin was too much for the threesome's tiny primate brains to grasp. They fainted. Their bodies dropped like so many trees in the forest, which no one seemed to hear.

This presented a problem. The young dragon had many natural gifts. In his true form he could fly, spit lightning, and weather the fiercest winter storm. He could transform into the perfect image of any human he had ever met. In every form, he was preternaturally strong, a master of all languages, aware of ambient magic, and a collector of treasure. But there was no way he could haul those three clowns before a magistrate all by himself. Time to put the city guardsmen to the use the Emperor intended. He took a deep breath.

"Silence!" His dragon voice resounded in the closed space like a mighty Shang bell.

All the conscious humans froze. They were indeed a sorry lot, especially the senior of the two guardsmen. In addition to losing his helmet and being covered in muck, the buttons on his regulation quilted vest had popped all the way to his collar. The front panels spread in an equilateral triangle around a decidedly non-regulation paunch. The knots of gray hair dribbling over his shoulders were as stringy as old Lao's. But damned if he didn't manage a smart salute.

"Sir! Who do I have the honor of addressing, sir?"

"Li Lao, mandarin of the fifth degree, Department of Rites." Bai pointed to his badge with a hematite-tipped nail only slightly shorter than his corresponding talon. This was another improvement on the original, who pared his nails like a common artisan. "What is the meaning of this commotion?"

Several people spoke at once. Bai raised his hand and unfurled his claws. The humans gaped. A few blanched. More to the point, they all shut up.

"You." He pointed to the deliveryman. "Why are you swearing?"

"Those crooks stole my cart and ruined my pastries," he sobbed. "My boss will never understand. I'll lose my job."

Having so few wits to recover, Ma, Jingxi, and Juanqu were already trying to crawl away. Bai pinned the hem of Ma's tunic in place with his shoe. Ma tried to pull free. Bai fixed the threesome with an amber-eyed glance and slowly shook his head. They meekly pressed their foreheads against the ground.

"Stop whining," Mother Pan Pan said. "Your cart's under there somewhere—and you got two guards who saw the whole thing. Those morons ruined my best girls."

Remembering the speed, agility, and ferocity the young women displayed earlier, Bai couldn't imagine how.

"I hired those guys as hairdressers. I felt sorry for them, all right!" Mother Pan Pan snapped in response to Bai's disbelieving stare. "The city took their bar and everything in it. They told me they used to take care of the Widow Cheng's hair. Her hair always looked good, so I figured I'd give them a chance. What harm could it do? *What harm could it do?*" She giggled maniacally. "Let's see!"

Mother Pan Pan stalked toward the young women. The former furies trembled like baby birds at her approach. She snatched their coiffures from their heads, revealing three pates as slick and naked as a serpent's egg.

The workmen gasped. Several of Mother Pan Pan's thugs grimaced in what looked like sympathy.

A small, imperious sniff broke the horrified silence. "And you call yourself an abbess," the scarlet-gowned dowager interjected in a surprisingly firm voice. "You wouldn't know a business opportunity if it smacked you on the nose. Dress those girls in orange and say they're Buddhist nuns. They'll be a sensation. You'll have every noble and official in the city vying to pollute them. How do you think Wu Mei got to be Empress Wu Zetian?"

"Carts! Hair!" the man in the silver belt bawled. He flung his arms wide. "What about my wall? That crash destroyed two wagonloads of supplies— and the crew is paid by the hour."

"You can afford it," the dowager and the deliveryman shot back. She added, "You don't hear me complaining about my chair."

Surprisingly, the construction workers agreed. They chorused: "Yeah!" "The old tightwad!" "You tell 'im!"

Boosting his voice to compete, Bai said, "These are serious accusations.

Do you three have anything to say in your defense?"

Ma sat back on his haunches. "We're sorry, your honor. We never meant to hurt anyone. We were only trying to get enough money to open a new bar. We spent our whole lives working at Cheng's Bar. It's all we know."

Lao's old man eyebrows crawled up Bai's forehead. Indeed! His new favorite comedians had worked in their aunt's bar—a bar the Director of Entertainment Licenses and Revenue described as an institution and implied was well-run until they took over the helm. The wyrm of an idea began to turn in his brain. He addressed the senior constable. "Do you have anything you wish to add concerning the character of these men?"

"The Chengs and Feng Jingxi aren't career criminals, if that's what you mean."

Bai gestured for him to continue. "They went broke, because they made lousy beer—not that it was any surprise," the constable said. "Their aunt served the worst beer in town."

"Why you …" Juanqu sputtered. "Auntie Cheng made great beer! She was the most popular hostess in Nanjing!"

The constable snorted. "The Widow Cheng was the fourth-most ruthless information broker in town. She had the dirt on everybody. The government couldn't afford to let her fail."

Ma leapt to his feet, fists raised. "Take that back! Our auntie was a saint!"

Juanqu barked, and Jingxi shouted, "Yeah! Take it back!"

Another flash of hungry dragon eyes accompanied by a trickle of smoke from both nostrils crushed their momentary rebellion. Unfortunately, once they started talking, so did everyone else. Since the crowd was only human, Bai was tempted to give them a taste of the medicine that worked so well on Cheng, Feng, and Cheng. But he refrained and shouted for silence. Even Lao's dry, old man's cackle resonated nicely against the alley walls.

"You all want to press charges—and you should. At the moment, however, I'm afraid the magistrates would not treat them with the seriousness they deserve."

In their current, custard- and mortar-daubed condition, the judges would laugh them out of court. But the humans wouldn't appreciate it if Bai said so. He opted for a commiserating nod. "Therefore, I want you to go home"—*clean yourselves up*—"gather your evidence, and report to my office at the Department of Rites in the morning. My secretary will take your statements and assist you in preparing your case. Meanwhile, I will take charge of the accused. Guardsmen, restrain them."

The three knuckleheads whimpered as the guards produced their shackles. Bai thrust his hands into his sleeves to keep from rubbing them in glee. Untangling this business would keep Lao out of Bai's hair until well after the Harvest Moon Festival—longer, if Bai obtained what he needed from Gilgamesh.

The junior guard urged the prisoners to their feet. His senior sidled next to Bai. He whispered, "Pardon me, sir, but isn't this a little *irregular*?"

He said it the same way Bai had said "illegal" not so many hours before. Bai's cheeks split in one of Lao's most alarming grins. "Absolutely. But look at it this way: do you really want to write up the report?"

<p style="text-align:center">* * *</p>

Bai bid the two guards a gracious farewell and closed the folding doors of the bar behind them. Turning to the bar's remaining occupants, he resumed the form of a tall, handsome, smartly-dressed young man.

Gilgamesh crossed his thickly-muscled arms over his massive chest and glowered. Bai suspected he was still annoyed at being caught cleaning. An abandoned mop leaned reproachfully against the bar. A bucket stood nearby. Sodden rags stretched across the passage leading to the kitchen. The air burned with the scent of top-shelf *baijiu*.

Caught between the dragon at the door and the demigod by the bar, the newly unshackled Ma, Jingxi, and Juanqu tried to make themselves very small. Bai hoped they wouldn't faint.

Gilgamesh cocked his chin at Ma. "That guy tried to rob me today. Thanks to him, I lost three stools and two jars of my best *baijiu*."

"He and his associates were also the source of the bill under your door—which I took care of at no cost to you. Now they wish to make amends by working for you. Meet your new employees: Cheng Ma, Feng Jingxi, and Cheng Juanqu." Bai gestured to each man in turn.

Gilgamesh's thick eyebrows drew together over his nose. "Cheng? Any relation to the former owners?"

"That's us," Jingxi said proudly.

Ma wrung the hem of his tunic. "I'm really sorry about the mess. I was just trying to get back our auntie's pot." He glanced at the embossed bronze canister now sitting in the middle of the bar. It could have been the light, but it looked newly oiled. "She begged us to keep it safe. It came with her dowry. It was never part of the bar."

"Yeah," Juanqu chirruped. "Those tax boys had no right to take it. That's where Auntie Cheng kept all her recipes. We'd have never gone bust if we'd

known how to read."

A curious expression crossed Gilgamesh's face. He murmured in Arabic, *"No, they would've been killed. I wanted to know why Ma grabbed the pot instead of the cashbox, so I took it apart. The lower relief hides a false bottom filled with notes, markers, and IOUs. The late Madame Cheng had something on every major criminal and government official in town, including the Eunuch of the Emperor's Wardrobe."*

"So that's why the director was worried," Bai remarked in the same language. In answer to Gilgamesh's upraised eyebrow, he added, *"I'll explain later."*

"You'd better." Reverting to the common tongue, Gilgamesh said, "I'm not interested in your aunt's pot or her recipes. What I need is someone who knows their way around a bar."

"You mean we're off the hook?" Jingxi asked hopefully.

Gilgamesh thought about it, absently massaging his lower back. Bai held his breath.

"As long I like your work," Gilgamesh said.

"You'll love it!" Jingxi promised. He reached for the mop.

Ma grasped his cousin's arm. "Not so fast. What's in it for us? We got debts."

"Big debts," Bai confirmed in Arabic. Gilgamesh shot him the kind of fisheye Bai normally associated with Old Lao.

"But there's something bigger at stake here," Ma continued. "The Chengs have been in the hospitality business since the Song Dynasty. Our ancestors will haunt us something awful if we don't have a bar to pass along to our descendants."

A small smile threatened to part the forest of Gilgamesh's beard. He hid it by finger combing his moustache. *Yes*, Bai thought. *They make you want to laugh. Just think what that talent could do for business.*

"You'll get a fair salary … minus breakage, of course." Gilgamesh gazed meaningfully at the rags. "As for owning another bar, I never stay anywhere very long. If you do a good job, there's no reason why you can't take over this address after I leave."

"Do a good job!" Ma rushed to the bar and pumped the demigod's hand. "We'll do the best job you've ever seen. Jingxi, lift that mop. Tote that pail!" He pointed at Juanqu. "You, get in the kitchen or we'll land in jail."

Juanqu saluted. He jumped to the right, hopped over the rags, and headed down the passage.

"Is Juanqu a good cook?" Bai asked hopefully. After all, he *had* missed lunch—and several snacks.

"You've never seen anything like it," Ma promised. "Just wait."

With a satisfied sigh, Bai joined Gilgamesh at the bar. He leaned his elbows on the counter and confided, "They come with a floor show. Now about those favors …"

"What favors?" Gilgamesh asked. His brows lowered. His eyes narrowed in suspicion.

"You said you would be in my debt if I took care of the taxes," Bai reminded him. "I did, without costing you a single copper cash. Then I found you three experienced employees who are about to owe a lot of people a lot of money and therefore have no objections to working for a foreigner. One plus three equals four. But before we get to that, I want that coffee you promised."

Gilgamesh cast a martyred gaze heavenward and grumbled in Arabic, "*Dragons.*" He switched back to the common tongue. "Coming up."

Perhaps Bai should ask for coffee beans and a long-handled brewing pot as one of his favors. Permission to examine Gilgamesh's magical treasures shouldn't cost more than one favor. Persuading the demigod to part with an artifact might take more, but he should still have enough good will left for coffee. It wasn't as if coffee constituted a *big* favor.

The sound of banging pots and cupboard doors echoed from the kitchen. A moment later, a patter of feet approached the storeroom. A puff of celestial laughter, so faint he might have imagined it, intruded on Bai's thoughts. He tried to dismiss the prickle of misgiving it provoked. Cooks often added liquor to their dishes.

But Gilgamesh, like the other barmen of the Middle Kingdom, stored his wine and hard liquor in large ceramic jars with bowl-like caps. There was no reason why Bai should hear the creak and pop of a lid being pried from a wooden barrel, or the *thunk* of that same lid hitting the floor. If Juanqu wanted beer, he would have tapped the bung. Slowly, almost fearfully, all senses alert, Bai straightened.

"What's this?" Juanqu's chirped. "Oooh, pepper! I think I'll make Szechuan!"

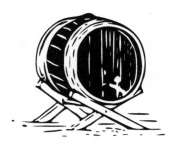

A Lawyer, a Gambler, and an Outlaw Walk Into a Bar ...

A.E. Stanton

James Conason rode into town slowly, paying attention to everything. The way his horse's hooves kicked up the dust. The slight breeze that was blowing. The smell of sage and, somehow, honeysuckle, intermingled with the smell of impending rain. It was a nice scent. Nicer than he was used to.

The town was tiny—three buildings, one large corral for cattle, which was empty. He could just make out what might be a couple of ranches in the distance. Couldn't really call this place a town. Settlement wasn't right, either. It was just ... here. Someplace for the ranchers to come to, someplace for travelers to pass through.

No jail, though. Just a small general store, a stable, and a bar and boardinghouse, which was the biggest thing here. Gil's Place at Four Corners. Gil must be the one who ran this town. So to speak. No jail likely meant no law. Probably also meant no stage stop. That was fine. He wasn't looking for a stagecoach.

He looked around. No people he could see. Anywhere. Nowhere for them to live around here, either. No stage would bother with this so-called town, for certain. Meaning it was likely only here for the ranchers and their

hands, and possibly for travelers like him, those coming in on horseback. Whoever worked here probably lived at Gil's Place, too. Nice way to control your interests.

Two others were riding in, one from the east, one from the north. He was coming up from Mexico. He wondered who would be coming in from the west.

Conason dismounted and tied his horse loosely to the hitching post. He went onto the boardwalk and watched the others approaching. The one from the east was dressed like a dandy, the one from the north was all in black.

He decided not to wait. Better to see what was going on inside the bar, if anything. That way he could get into a safer position. Possibly.

Conason pushed the swinging doors open, stepped over the threshold, and surveyed the interior. It was plush—as if someone from San Francisco had moved one of their better saloons out here to the middle of nowhere. Red velvet covered the chairs and parts of the walls, all the wood dark and rich—if he had to guess he'd say it was Cherrywood—and the tables were many, some for drinking and eating, some for different forms of gambling. There was even a piano, the fanciest one he'd seen in many years.

The stairs to the second floor were at the left of the bar and they curved, just as he'd seen in truly fine houses. The rooms upstairs were numbered in gold plate or what surely looked like it. There was gilt all over the place, particularly around the large mirror that backed the bar. He'd seen a lot of frontier bars, but never one with this much opulence.

And it was huge, far larger than he'd have expected from the exterior, stocked with many bottles, far more than Conason had seen out West before. In his experience, if a bar had tequila and beer as well as whiskey it was a superior establishment. But this one had bottles that were slim and tall, round and short, and intricate works of the glass blower's art. Every color of the rainbow was represented, too, and some of the bottles had strange things floating inside. They reflected against the mirror behind them and looked almost otherworldly.

Not that there was anyone here to impress. Barring the man behind the bar and Conason himself, the room was empty.

Until he blinked. Then, the room wasn't empty anymore.

There were a variety of people—cowboys, gamblers, bargirls, ranchers, townspeople. There was a man at the piano, playing; card tables were filled, and drinks were flowing. The noise level was what you'd expect from a bustling establishment—only Conason hadn't heard any noise before entering

the bar, and he should have.

He looked behind him. His horse was still the only one tethered out in front. He looked back inside. Maybe there was a corral or stables he'd somehow missed.

His perusal hadn't taken more than a second or two, but it was enough time for the bartender to notice him. He nodded. "Need a drink, stranger?" he called out. A few people looked at Conason, but not most, and the few who did went back to their pursuits without incident or interest.

Conason went to the bar. "I do. You Gil?"

"I am. What'll you have?"

"I'd ask 'what have you got', but I can see that you have everything."

Gil grinned. "You want the same old or something special?"

Conason considered. "Your best whiskey."

"So, the same, but not the same old," Gil said, as he turned and grabbed a bottle from behind.

"Odd spot to start an establishment as fine as this one," Conason said as Gil poured a generous shot and put the glass down on the bar in front of him, though the bartender put the bottle back where it had been. Conason couldn't blame him—the bottle looked expensive and the liquid in the glass had a high likelihood of being the best whiskey he'd ever had in his life.

Gil shrugged. "Anyplace is as good as another."

Conason would have argued this, but he saw the doors swing open via the mirror's reflection. The dandy had arrived before the man in black. He was a smaller man than Conason himself, but he looked wiry and well-muscled under his fancy clothes.

The dandy examined the room just as Conason had, but his eyes lingered on the gaming tables and a flash of disappointment crossed his face. Then he blinked and suddenly smiled, looking far more confident than he had a moment prior. So, he was a gambler. Good to know. Conason had a mistrust of gamblers—the bad ones tended to create problems and the good ones tended to be excellent con artists as a side endeavor. Based on how this man was dressed, Conason figured him for a good one.

Conason also figured that the gambler had also seen the establishment as empty when he first walked in and now saw it as full, just as Conason did. Something to ponder and possibly discuss. And perhaps worry about. Possibly.

The gambler came to the bar, nodded to Conason, and smiled at Gil. "My good sir, you seem to have a plethora of libations beyond the norm for these

parts."

Gil grinned. "I do. What can I do you for, mister?"

"I'd like a glass of your finest."

"Finest what?" Gil asked.

The gambler shrugged. "Your finest whatever. I'm a man of many tastes."

Gil nodded, turned, and pulled a very intricately blown bottle down from the top shelf.

"Stanton," the gambler said, putting out his hand to Conason. "Gabriel Stanton."

Conason took his hand slowly. "I'm—"

"Marshal James Conason." Stanton grinned as they shook hands. "Your reputation precedes, Marshal."

"Yours doesn't," Conason replied. "Though if you're as good as your clothing and taste in alcohol insinuates, I should know who you are."

Stanton shook his head as they let go of each other and took a drink. "Delicious," he said to Gil. "Many thanks. As to reputations, Marshal, in my profession, the less renowned you are, the better."

The doors swung open again and the man in black stepped through. He did a very obvious perusal of the interior, blinked, did another perusal that was far less obvious and far more intent, and Conason knew that the man in black had also seen this place as mostly empty when he'd first stepped inside.

The man seemed ready to leave—Conason wondered if this meant that he was smarter than Conason or Stanton—but then he shook himself and walked to the bar. He ignored Conason and Stanton and made a motion with his hand towards Gil. "Two fingers."

Gil nodded and pulled a glass and bottle out from under the bar. The glass wasn't as nice as the ones Conason and Stanton had, and the whiskey was cheap rotgut, but the man in black tossed it back, put his glass onto the bar, and Gil poured another.

Holding the glass in his hand, the man in black turned to them. "Gents."

"Black Jack Riley," Stanton said with a nod. "I'm honored to be in your company."

Black Jack snorted. "Right. What about you?" he asked Conason.

Conason was about to reply when a woman appeared at the top of the stairs. She was tall, with a perfect figure a man could live and die against, and a face like an angel. She was dressed in a tight, low-cut dress, indicating that she was working the bar, and therefore might be his for a night—for a

price. He wondered if she had a price that would make her his forever.

She smiled and it was as if the sun had entered the bar. He felt her smile hit him in the gut, tie itself around his insides, and pull them towards her.

He heard Black Jack and Stanton both gasp and looked at them out of the corners of his eyes. They both looked like he was sure he did—enthralled.

Gil cleared his throat, Conason blinked, and suddenly the woman just looked ordinarily attractive. The men next to him relaxed as well. Maybe it had been the lighting, or the alcohol. Or they'd all blinked when Gil had cleared his throat and were now seeing something that wasn't real.

The woman came slowly down the stairs, nodded to the three of them, and stood at the bar. "All done?" Gil asked.

"For now," she replied.

Gil grunted. "It's moving day soon."

She shrugged. "That's as may be." She turned to the men next to her. "I'd offer you gentlemen something to drink but I see you're all taken care of." She smiled at Stanton. "I'm sure you'd enjoy a game, and none of the tables have openings. Would the three of you care to play poker with me?"

Stanton took her hand and kissed the back of it as he bowed. "Gabriel Stanton, at your service. And I would consider playing cards with you to be one of the highlights of my life."

She laughed. "I'm Missy, and you're a charmer, aren't you?"

Black Jack nudged Stanton aside. "Black Jack Riley, Miss Missy. And I'd find it right appealing to play anything with you that you'd like. Any kind of game, in any kind of setting."

"Classy," Stanton muttered under his breath.

Missy tinkled another laugh. "Oh, outlaws are always so exciting." She turned to Conason. "Lawmen can be, too. Can't they, Marshal?"

Conason nodded to her. "That depends, ma'am."

She laughed again. "Please, all of you—no formality. It's just Missy." With that, she turned and headed for a card table, one that, Conason was sure, hadn't been there when he'd come in.

"Eldritch," Stanton said quietly.

"Something's not right," Black Jack agreed, as they followed Missy. "Though with a gal as pretty as this one, I'm inclined not to care. I want to know if you think you're taking me in, though, Conason."

Conason sighed to himself. "Are you wanted?"

"You know I am."

"Are you in my territory?"

"Unsure."

"Are you going to cause me problems?"

Black Jack grinned. "Now, that depends."

"On what?" Conason asked.

"On whether or not causing you problems will be fun, or if that little gal decides she's interested in me and you try to stop her."

"She seems grown," Conason said. "If she's interested in you, fine. You try to force yourself on her? I consider that causing a problem I will definitely stop."

"I don't need to force myself on women," Black Jack growled.

"Keep it that way."

Stanton rolled his eyes, pulled out a chair for Missy, seated her, then seated himself next to her. Black Jack grunted, then hurried to the seat on Missy's other side. Conason didn't mind—this put him opposite her and that was a fair place to be.

Stanton produced a deck of cards and began to shuffle. "Those marked?" Black Jack asked.

Stanton heaved a sigh. "I don't need marked cards to win."

"He didn't ask if you did," Conason said. "He asked if this particular deck was marked."

Stanton flashed a grin. "Your reputation seems to be accurate, Marshall. And no, the deck isn't marked."

They played five card stud for a while. Stanton won most often, but all of them were in the game, Missy included. Bargirls brought drinks over for all of them and the bar remained busy, but no one else entered and no one left.

"No one coming from the west, then," Conason said absently, as he looked at another decent, but probably not winning, hand.

Missy cocked her head at him. "I came in from the west." She smiled. "I always do."

Stanton looked at her sharply. "*Do* you?"

Missy nodded. "I do. And I'll take two cards."

Conason considered the gambler's reaction. It meant something or indicated knowledge Stanton might have that he didn't. Conason had a feeling he was going to need that knowledge.

As another round arrived, Missy started asking them questions, saying she wanted to know their histories. Black Jack, apparently quite eager to impress, answered first, and at length.

They were on a third hand after Missy's question before the outlaw start-

ed to wind down. "… and so, I'm wanted in seven states and territories."

"Impressive," Missy said, sounding genuine. "And yet, you haven't killed all that many people."

"No, Missy, I haven't. I consider it a point of pride not to kill someone just because I can. I only kill them if I have to." He shot a glance at Conason. "Or if they force me to."

Conason sighed. "Law taking you in for crimes you've just gleefully listed isn't forcing you to shoot, Black Jack. That's all on you."

The outlaw shrugged. "Someone stupid enough to go up against me? I figure it's better I take 'em out quick, before they can spread that ignorance."

Stanton snorted. "You're a benefit to society, sir." He smiled as Missy. "I doubt you need the good Marshall's testimony, but let's have him give it to you before mine."

"Saving the best for last?" Missy asked in a teasing tone.

Stanton shrugged. "As I told the Marshall only a short time ago, I prefer to remain somewhat anonymous."

"Oh, but you're anything but," Missy countered. "Why, I'll bet you've cleaned out many a man of his life's savings."

Stanton nodded slowly. "I'm sure I have. I try not to turn anyone into a beggar or an indigent, however."

"Do you always succeed?" she asked.

"I have no idea," the gambler said. "I tend to not remain in one place too often."

"Ah." She smiled. "A traveling man, and one who prefers it that way."

Stanton's eyes narrowed. "May I ask why you're here, Missy? You seem far more educated and elegant than the rest of the young ladies present."

"Oh, I'd rather hear about you and the Marshall," she demurred.

"I'm with Stanton," Conason said. "I'd like to know how a lovely woman such as yourself happens to be here, in this nowhere town."

"But I'm not in the town," Missy said. "I'm in Gil's Place."

Stanton took in a long breath. "I see." He cleared his throat. "Am I free to leave?"

Missy put her hand on his wrist. "Now, what do you think?"

Stanton didn't speak but, for the first time, the gambler looked frightened.

Missy laughed softly. "You relax. I'll be right back." She moved to get up and Stanton quickly stood and helped her with her chair. The other men stood, too. Missy smiled at them, went to the bar, and started talking to Gil.

Conason and Black Jack sat, but Stanton didn't. "Gentlemen," he said as he gathered his winnings, "I believe I'm going to quickly take my leave."

"I don't think that'd be smart," Black Jack said. "I think we're all three in danger right now. Marshall, what's your take?"

"I don't think things are as we think they are."

"Or they're *exactly* as we think they are," Stanton said. He put his money away, looked up, went pale, and sat back down.

Conason and Black Jack both looked where Stanton had. The doors to the bar were gone. They were now in a room with no exit.

"Tell us," Conason said to Stanton. "I know you have an idea of what's going on here."

Stanton shook his head. "If you don't already know, I believe it would be dangerous to say aloud."

Black Jack played with his gun. "More dangerous than not telling me what I want to know?"

Stanton heaved a sigh. "Probably similar." He shot a glance towards the bar. Missy and Gil were still deep in conversation. "Fine," he said, turning back. "I can't speak for the Marshall, but I know that you, Mister Riley, like I, saw this establishment as empty when we first stepped in." Black Jack nodded.

"I did as well," Conason said. "And the table we're at wasn't here when I came in, and no one put it here. Missy wanted it and it appeared."

"Exactly. Well, when one is what she is, what one wants, one gets. At least, I assume."

"You'd better explain that," Conason said, before Black Jack could threaten the gambler again. "Because I know we're not following you."

Stanton nodded. "Perhaps not. In a great number of religions, it's considered that Death comes from the West. You, Marshall, murmured something about the West and Missy confirmed that's where she comes from. Always. It's not possible to always come from only one direction, unless you happen to be the personification of Death, and then, I imagine, you can manage it."

"I've heard that," Conason said slowly. "It's why I was still wondering who was coming from the west, since the three of us all were riding in from the other three directions. But I always took it to be a metaphor."

"Not all myths are false," Stanton pointed out.

"So, she's the Devil?" Black Jack asked, sounding far less frightened than most would when uttering that question. Then again, Conason wasn't sure that Black Jack didn't have a tight relationship with the entity in ques-

tion.

"No," Stanton said. "Though I place no bets on who or what Gil is. But Death isn't evil, and it isn't from the Devil. It's a natural part of life."

"This situation is as far from natural as you can get," Conason pointed out.

"Conason's right, and now we can't leave because the doors are gone," Black Jack said. "Think we can shoot our way out?"

"No," Conason replied. "I think we need to ask why we're here. And by here, I mean the three of us, in this location, at this time." He pulled out a telegraph. "I was told to come here, by the U.S. Marshall's office, in order to apprehend a criminal."

"Me?" Black Jack asked, sounding interested as opposed to aggressive. Meaning, Conason hoped, that the outlaw was more concerned with thinking than fighting, at least at the moment.

"No, actually." He nodded at Stanton. "I'm here to apprehend a known confidence man and gambler who stole three towns' treasuries. Didn't have a name, just the general direction he was coming from and the likeliest point where I could hopefully catch up to him."

Stanton grinned. "Guilty as charged." He looked at Black Jack. "I was told that Black Jack Riley was looking to add a man into his gang and I wanted the protection riding with a man such as yourself would provide, particularly since you've never been known to kill any man riding with you."

"Huh." Black Jack looked thoughtful. "I was told that Marshall Conason was going to be here and wanted to call me out on the draw."

"And you came?" Stanton sounded shocked.

Black Jack shrugged. "I know I'm faster. And that would have gotten a good lawman off my trail, legally."

"Not quite," Conason said. "But I agree that if I was the one calling you out and you won, the Marshall's Office would just think I was a moron who deserved to die."

"We, all three, appear to be morons about to die," Stanton said. "If we're not dead already. She's Death. I'm certain of it. She wants us listing our sins before she passes judgment or whatever it is she's doing. Mister Riley listed his, I have my share, and I'm sure you have them, too, Marshall. I have no idea if this is just a way for her to pass the time or if there's something more sinister afoot, but all of us are in grave danger, pun not intended, and unless we work together, we're all going to be together for the rest of our

now much shorter lives."

"She's coming back," Conason said softly. "What do you recommend?"

"I vote for us just asking her what her game is," Black Jack replied.

Stanton nodded. "We know. Why prolong it? We may already be dead and just not be aware of it. I agree that confrontation is the right course of action."

Missy reached the table. All three men stood and Stanton helped her into her seat. "Well," she said with a smile, "where were we?"

"You were having us tell you our life histories," Conason said, "in order, we suspect, to determine which one of us dies today."

"Not that you should need us to list anything," Black Jack added truculently, presumably because he'd already shared everything. "I thought Death knew all about us."

She shook her head and tinkled a laugh. "Oh, I'm not omnipotent. Besides—everyone sins."

"So, Gabriel's right? You admit to being Death?" Conason asked.

Missy laughed. "A lady never admits to anything against her favor."

Stanton sighed. "Until today, I didn't think this was how death worked."

She patted his hand. "I knew you'd figure it out, though I'm a little disappointed in the Marshall."

Conason shrugged. "Sorry. I was too distracted by you."

She smiled. "That's sweet."

"You were even more beautiful when I first saw you," Conason said.

"For me, too," Black Jack admitted.

"There has to be a reason," Conason said. "So, why?"

Missy smiled but didn't reply.

Stanton did. "She was the most beautiful thing I'd ever seen, too. I believe that might be because the three of us have been courting her for a long time. Most of our lives."

"A lady always likes to look her best for her admirers." She produced a deck of cards. "Let's keep playing."

"Why?" Stanton asked as she dealt the cards, slowly and carefully. She'd dealt as fast as Stanton during prior hands and Conason knew this hand was going to be very different.

"I enjoy it."

"Who are all the people in here?" Conason asked. "The ones who aren't really here, I mean."

"Oh, the only ones not really here are the three of you," Missy said. "One

of you will stay forever, two of you will go on."

"We're back to Gabriel's point," Conason said. "Death doesn't work this way."

"Marshall, how would you know how death works?" she asked.

"You shoot a man, he dies," Black Jack answered. "You hang a man, he dies. Someone takes ill, unless they're lucky, they die. Some get old and they die. How else does it work?"

"I thought Death was the great equalizer," Stanton agreed. "Something that comes to all, each in their own time. Not capricious."

"Children die, good people die while terrible ones live, and you don't find that capricious?" Missy shook her head. "Death is both predictable and capricious. Just like life."

"What's the game, then?" Black Jack asked.

"You're betting your lives," Missy said, as she finished dealing. "Seven card stud. Stakes are your crimes or your successes. Winner gets to choose."

"Choose what?" Conason asked.

"All in good time," Missy said as she looked at her cards. None of the men touched theirs.

Conason considered his options. "If I fold? Or refuse to play?"

Missy grimaced and Stanton's eyes lit up. "If we *all* fold or refuse to play, what then?"

Missy cocked her head at them. "Well, then, I'll simply choose who I want the most. So, it would behoove all of you to play."

"Or to play together," Black Jack said. "What do we get if we win, if we beat you?"

"You believe you can beat me?" Missy asked, sounding interested versus offended.

"Sure," Black Jack said. "The Marshall and I have beaten death a lot. I'm sure our gambler here has, too. That's why we're still around."

"And possibly why you set us up to be here with you now," Stanton added. "We've cheated you too much and you want to take one of us out of the game permanently."

"And you're *sure* I'm who you think I am?" Missy asked. "Not just letting you believe what you want to believe?"

The three men looked at each other. Conason concentrated and looked at things out of the corner of his eyes. There was a slight haze around them, and the others in the bar seemed insubstantial, as if made of gauze. Missy looked as beautiful as the first moment he'd seen her. "I'm sure," Conason

said. The others nodded.

Missy smiled enigmatically. "Say you're correct. How does that change anything?"

"I suggest a different game," Conason said. "Seems only fair, since it might be the last one I ever play."

Missy raised her eyebrow. But she put her cards down. "Oh? What game would that be?"

"Three-card monte," Conason replied before the others could speak. "With Stanton as the dealer. For all hands."

Missy smiled slowly. "You trust your life to his?"

Conason looked straight at the gambler. "I do."

Black Jack looked back and forth between the two men. "I do, too," he said finally.

Missy shoved the cards near her towards Stanton, but Conason reached across the table and stopped her. "Not that deck." He reached into his vest pocket. "This deck." He tossed the cards to Stanton. Who pulled them out of their box quickly and began to shuffle.

Missy laughed. "I like your style, Marshall. Fine, we'll use your deck." She leaned towards him. "But … this makes you very interesting now."

Conason shrugged. "Have to figure I was interesting to begin with. I'll take my chances."

Stanton laid out three cards in front of him but didn't show where the Queen they'd have to find was sitting. "Only one deal. This one. And only Missy plays. Those are *my* terms."

Missy's lips quirked. "I see. You're more interesting now, too, Mister Stanton."

"If you win, you get all of us," Black Jack said. "And if you lose, you get none of us. And those are *my* terms."

Missy sat back. "Well. I accept those terms, Mister Riley. The game just got more interesting. For me. I know it's already fascinating for the three of you."

Stanton turned over the middle card. "The Queen of Hearts. Follow her properly and take us all. Fail, and the three of us leave here, unharmed, quite alive, and with the rest of our years still to live."

Missy nodded. "Agreed."

Stanton turned the card over and started to move the cards around, slowly at first, then faster and faster. He spoke a typical gambler's patter the entire time—Conason had heard this kind of vocal distraction often over the

years. "Midway through—here's the Queen, did you follow her properly so far?" Stanton turned over the righthand card.

"I did," Missy said, sounding amused. "As if there was any doubt."

Conason noted that the others in the bar, even Gil, were taking an interest. Meaning there might indeed be some doubt. He was counting on it, and so were the others. As long as she was truly not omnipotent, they had a chance.

Stanton grinned, turned the card over, and moved them again, even faster than before, patter going at the same speed, moving his hands and his mouth faster than any other gambler Conason had seen. Conason stopped trying to figure out where the Queen was—either Missy would find her or she wouldn't. There was nothing he could to do affect this outcome.

"Test your luck," Stanton said finally, hands off the cards and away from the table. "Choose the lady or lose the prize."

Missy smiled widely. "So well played. You tried so hard, too." She pointed to Stanton's right sleeve. "It's there. You palmed it right after you showed us where it was."

Black Jack slumped in his chair. "Dang it," he muttered.

But Conason only looked at the gambler. Whose eyes opened wide. With outrage. "My dear woman," Stanton snapped. "Are you calling me a *cheat*?"

"I am. Show me your sleeves."

Stanton unbuttoned his shirtsleeves, ranting about the lack of faith in the world and how he'd make sure that he was compensated for this slight. There were no cards there. "You lose," Stanton said calmly.

Missy gaped. "But … but I saw you do it. I *felt* you do it!"

Gil started to laugh. Conason hoped that he was laughing with them.

Stanton turned the middle card over. "There she is, the Queen of Hearts. And you, madam, as I said, have lost. Now, I and my companions will, as agreed, be taking our leave of you and this so-called fine establishment. Be happy that's all we're doing, as opposed to demanding recompense for your insult to my character." He gathered the cards, put them back in the pack, and put them in his pocket.

Conason and Black Jack both rose, nodded to Missy, who was still gaping, and, with Stanton, headed for the door that was there again. Conason looked back over his shoulder as they crossed the threshold. Gil nodded to him. "Be seeing you, Marshall, sometime in the future."

They were back on the boardwalk and then, they were just there, in the middle of nowhere, with their horses. Gil's place and everything around it

was gone, as if it had never been.

"Gotta say, that was a hell of a thing," Black Jack said. "How'd you do it? And how'd you know he'd do it?"

Conason chuckled. "I had some information I didn't share. The way Stanton here robbed three municipalities was by rigging a three-card monte game in just this fashion, then threatening to call the authorities regarding the outrage of them accusing him of cheating. He was working with a partner who pretended to be law. The towns panicked and paid up. Wasn't until they checked with the Marshall's office that they discovered the lawman wasn't carrying a real badge and calling a man a cheat wasn't a new law passed by Congress."

"What happened to your partner?" Black Jack asked Stanton as they all mounted up.

"Took his part of our take and headed for California to dig for gold. It's why I was looking to meet up with you."

"I'm willing to ride with you," Black Jack said.

"Thank you. Now, however, I would like to ask the Marshall to ride with us, too."

"Why's that?" Black Jack asked, sounding suspicious.

Stanton pulled Conason's deck out of his pocket and gave it back. "Because this is a deck made up of only Queens of Hearts."

Black Jack stared at Conason. "I thought you were a good and decent lawman!"

"And I thought you were a killer who'd try to leave me dead in that bar. Nice to know we're all still able to be surprised, isn't it?"

Stanton chuckled. "I believe, gentlemen, that the best years of our lives lie ahead. In what direction shall we head?"

Black Jack shrugged. "I'll leave that to the Marshall."

"Oh, call me James," Conason said. "Men who are riding together should use their given names. And I say we go north. I think the west might not treat us well for a while."

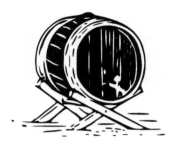

Make Me Immortal
With a Kiss

Jacey Bedford

Amelia Pentney-Knowles stared at the blood under her fingernails, so tired she could barely recognize what it was, and certainly didn't remember to whom it belonged. Some young man whose life had been cut short or changed forever, she supposed. There were too many of them. Their faces blurred, their names were always Tommy or Fred or Walter, with the occasional Hugo or Bertram from the officer-ranks. The officers cried out for their mothers or their sweethearts just as loudly as the privates and the corporals and bled just as much as the boys under their command.

Rivers of blood.

Oceans of it.

Never neatly on the inside where it was supposed to be.

Always dripping on the floor or spurting up the walls or soaking through bandages. When it was congealing in a chest wound, you knew that it was already too late, but you tried anyway.

The British bombardment of the German trenches had begun on 24th June. Chateau de Couin was a main dressing station. Nurses at the forward dressing stations got the raw wounds, but they never saw the results of their patching and bandaging. Those at Couin had to try and turn emergency first aid into a permanent solution; repair broken bodies and help the boys

to live as close to a normal life as they could. Some returned to the front, others were shipped to hospitals back home. Some—too many—went to their graves.

Today's wounded had been unlucky enough to be in the wrong place when the German guns barked back at British lines, leaving bodies mangled and torn. Many were beyond the skill of any surgeon, but others might survive if gangrene or infection didn't set in.

As a volunteer Amelia wasn't supposed to change dressings, let alone help with surgical procedures, but distinctions melted away in the mud, and those with the stomach and the nerve for it learned on the job. She'd started by cleaning floors, changing sheets, and swilling out bedpans, but that had been two years ago. The work was exhausting, unending, and often disgusting, but she'd ceased to be squeamish about men's bodies and the damage done to them.

"Miss Knowles, have you finished?"

"Almost, sister."

She scrubbed her nails one more time and dried her hands.

"Get some sleep." Sister Sweeney's voice softened. "You did well today, but I want you back on duty at six a.m. sharp."

"Yes, sister."

Sleep. Yes, she needed sleep, but right now she'd kill for a stiff gin. It wasn't allowed, of course, and the bottle she'd smuggled back into her quarters after the wonderful three-day pass to Paris had vanished. She couldn't openly accuse anyone of taking what she wasn't supposed to have, but she had her suspicions. She shrugged off the thoughts of Ida Langley swigging her gin. Ida had lost two brothers to this war already. If the gin comforted her, perhaps it didn't matter.

Amelia was so tired that she staggered into the corridor wall with her shoulder and bounced off it again on her way to the staircase. Her quarters were in the attic, a tiny room shared with Ida and two other VADs.

She looked at the steps. They went in both directions.

Instead of heading up, her feet took her down to the front door of the once-grand chateau. She stood on the broad top step breathing in the June air, feeling the tiredness lift with each breath. The sweet scent of the climbing rose around the doorway fought with the acrid smell of gunpowder blowing in on the breeze. Birdsong was subsumed into the constant bang and boom of the artillery just a few miles away.

"Our boys are giving 'em a pasting, miss, make no mistake." Private

Henry Grimshaw appeared behind her, struck a match on the door jamb and lit a Woodbine, inhaling deeply, holding the smoke in his lungs, and then exhaling with a satisfied sigh.

She moved sideways and turned to him.

"Pardon my rudeness, miss, would you like one? My mum sent them in a care package with some of her fruitcake. I never cared for her cake, if I'm honest, but these smokes are just the thing."

"No thanks, Henry, I never got into the habit. But you enjoy them while you can. When are you re-joining your regiment?"

"Next week. Doc says he'd have sent me back today, but there's a big push towards the Somme tomorrow. Said I'd be better off waiting a few days until it's all over."

"He's probably right. Dysentery's not to be taken lightly. You could have died, and you're still weak."

"I couldn't have died with you looking after me, miss. Saved me, you did."

She smiled. "I think it was teamwork."

"If you say so, miss."

She let a few seconds pass, still yearning for the sharp taste of gin, or maybe cognac. Something to numb her senses after a day wallowing in blood and shit.

"You're the sort of man who might be in the know. Where can a young woman get a drink? Purely medicinal, you understand."

Henry Grimshaw raised both eyebrows, then slowly tapped his index finger to the side of his nose twice.

"There might be somewhere I've heard of, miss, though it wasn't me what told you."

"I understand."

"Round the side of the house, there's an overgrown path through the shrubbery. Follow it right to the end and you'll see a potting shed. It doesn't look like much, but knock on the door and wait a moment and … well … you'll see."

She nodded her thanks and stepped down to the gravel driveway, rutted by the wheels of ambulances. She followed Grimshaw's directions around the house to the shrubbery. The light was beginning to fade now. Long shadows had given way to that magical hour between sunset and darkness. There was the path—more than overgrown. She pushed her way between rampant rhododendron and azalea, wondering if she'd taken a wrong turn.

Just as she was about to retrace her steps, she spotted an old shed. Grimshaw was right, it didn't look like much. In fact, she felt quite stupid knocking at the door. Of course, it was deserted. Who would be waiting inside an old potting shed?

Before she could turn away, the door creaked open. A waft of warm, beer-laden air hit her in the face like a drunkard's belch, and the echo of a chorus floated up from the depths beyond a stone stair.

She blinked twice and craned her neck to look inside. A flickering lantern hung above her head and there was a warm glow at the bottom. Thinking herself a fool, she stepped inside and the door swung closed behind her. The chorus grew with each downward step.

> *Pack up your troubles in your old kit bag*
> *And smile, smile, smile …*

A jaunty song for grim times.

At the bottom of the steps, around a corner, was a vaulted cellar. The potting shed must have been built on the remains of a building long since demolished; perhaps the old house which had preceded the chateau. She could almost imagine she was in some medieval building. The whole place glowed with the soft light of candles and lamps and there were maybe thirty or forty men sitting at tables or leaning against the bar. They seemed to be an odd assortment of ranks. Captains drank with corporals and, from the badges on their caps and their uniforms, they were all from different regiments. Some she didn't even recognize.

A trestle stood at the far end of the room. She'd never been in a pub alone before. She giggled at the thought and then cleared her throat, realizing it sounded more like hysteria than jocularity. She could strip a wounded man and give him a bottle to piss in, but she'd never ordered her own drink at a bar. Did she even have any money? It wasn't normally the sort of thing she carried on the ward.

"Welcome." The woman behind the bar waved her over. "Gil's busy right now, talking to some of the young men, but I can help you." She wore a blouse that might have been stitched from a sack. The apron that topped it was none too clean, but her smile made up for that.

Amelia snatched off her uniform cap, releasing her fair curls, cut short for convenience. "I'm sorry, I didn't think … I shouldn't be here."

"If the door opened for you, then you're exactly where you should be.

What'll you have?"

"I don't have any money."

"That doesn't matter. What you do every day pays your way here."

Suddenly emboldened, Amelia said, "I could murder a gin and tonic."

"I have something better than that—a cocktail."

This hardly looked like the kind of establishment that served cocktails, but the barmaid winked at her. "How about a *French 75*?"

"A what? No, it's all right. I heard you the first time. I just didn't expect it."

She'd drunk a *French 75* with *him* at the New York bar in Paris, and for one night had forgotten the stench of ruptured guts in favor of gin mixed with Champagne, lemon juice, and sugar. He'd told her that it got its name because it kicked like a French 75mm field gun. It had gone straight to her head, of course, or maybe that was the second one.

She'd found herself sharing confidences with the young lieutenant. Kisses followed confidences, and then a walk along the banks of the Seine, holding hands in the warm spring evening.

He'd smuggled her into his hotel room. They'd stood beside the bed looking at each other. She knew all about men's bodies, but not in this context, and she suddenly found herself feeling awkward.

"Don't be afraid," he'd said, and he'd pulled her into his arms, laid her gently on the bed and held her close. They'd talked all night long and never removed even one stitch of clothing, but it felt like the most intimate encounter she'd ever had.

She took the *French 75* from the barmaid and sipped it, thinking of one stolen night with Alastair Gaunt.

A tall man rose from a table in the center of the room, slapped one of the corporals heartily on the shoulder, and stepped behind the bar. He had fierce black curls and a remarkable plaited beard. He frowned at her drink. "I would have offered you beer. We have the finest beer in all of history."

He had a slight accent, but she couldn't identify it.

"That's a big claim."

"Only if it can't be upheld. I'm Gil."

"Amelia." She offered her hand and he took it.

"Why are you here, Amelia?"

"I needed a drink and Henry—Private Grimshaw—told me—"

"I mean why are you really here? What do you want most in the world?"

Such a direct question. She meant to dissemble, but Gil's gray-green

gaze locked with her own and the truth slipped out around the *French 75*.

"I want to be able to help the poor boys who come into our field hospital. I would make them all immortal if I could."

"Ah, sweet Amelia, so selfless. I do like that in a woman. Your intentions are good, but immortality is not always a benefit. Believe me, I know."

She shrugged. "It's impossible anyway."

He simply smiled.

* * *

A brief silence fell as, against all odds, the barrage of artillery stopped. Alastair Gaunt halted his pacing and looked up, ears ringing. A bird chirped.

Then a single desultory bark from a field gun, and the whump as one of Jerry's whizzbangs landed in another trench, kicked it all off again.

Alastair flinched.

He should be used to it by now. The British guns and howitzers had been pounding Jerry's lines for a week, softening them up for the offensive. Each boom and bang ate into Alastair's calm and reminded him that by seven-thirty tomorrow morning he'd be leading his men over the top.

Unless there's been another change of plan.

The offensive had been postponed once due to bad weather. He didn't see how a few more inches of rain mattered. The trench was already a quagmire. No Man's Land looked like Hell, if Hell were mud, craters, and barbed wire.

He thought it might be.

Maybe the extra two days of shelling would make a difference. Jerry would be crushed, his wire defenses flattened, and tomorrow's surge into No Man's Land, towards the town of Serre, would be a walk in the park.

Or not.

He pressed his lips together.

Lieutenants: too low down the chain of command to be told anything useful; too far above the enlisted men to be included in the rumors. Cannon fodder of a higher class leading cannon fodder of a lower class. As if class mattered now. They were all expendable.

Alastair's hands trembled. He clenched them. Did everyone feel like this on the eve of battle? Surrounded by thousands of men, he felt utterly alone.

He wasn't made for war. He should never have volunteered, but most of his friends had been joining the new Pals regiment. Victor Ratcliffe, who had already accepted a commission in the Prince of Wales' Own, had looked down that long, straight nose of his and said, "My dear chap, you'll be the only young man left in Leeds if you don't join up."

So he had.

He didn't regret it immediately.

The few months of training in Colsterdale Camp had been—dare he think it?—fun, but it had been games for boys. The Leeds Pals had eventually shipped out to Egypt to protect the Suez Canal from the Johnny Turk, but aside from a few skirmishes, the threat had never developed. After three months of sun and sand they'd been ordered back to Port Said, and the Asconia had brought them to France. The Somme would be the first offensive—first proper offensive—they'd faced.

Their real test.

His real test.

His feet slowed of their own accord and he leaned against a pile of sandbags, thinking of Paris and Amelia. He'd only known her for a night, not even a night of unbridled passion, though God only knew how much he'd wanted to tear off her clothes and plunge himself into her until he forgot all his fears, but she was quite tipsy and not that sort of girl, so they'd talked instead, lying close together in the darkness. He'd confessed his fears to her—that he wouldn't be able to lead his men into battle—and she'd understood. It wasn't cowardice, she'd said. Sometimes she was afraid to get out of bed in the morning, put on a clean uniform and a sunny smile, and face the wounded men in her care. What if she let them die when she could have saved them? She'd made doubts and fears seem normal. Just his luck to meet his perfect woman on the very last day of his leave.

He'd told her of his boyhood in Yorkshire and how he'd joined the Leeds Pals on the same day as the Bennett boys—boys he'd grown up with and who were now obliged to call him sir. Even though their easy friendship had withered, their father had cornered him the day before they all shipped out to Egypt. "Look after my boys," he'd said, and Alastair had promised that he would.

A promise he hadn't been able to keep.

Freddie Bennett had died in a skirmish on the banks of the Suez Canal. Alastair had sent the inevitable letter home. *A brave soldier,* he'd written. *Died in the service of his country.* He didn't write about the attack from behind, the blade in the darkness, the slit throat, and Freddie Bennett gurgling out his life on Egypt's unforgiving sands.

What would he give now for Egypt's dry sand beneath his feet? He trudged the trench, boots weighed down with the cloying mud of France. His stomach churned. God! He could do with a drink. Brandy, to settle his

stomach. Purely medicinal of course.

A shadow resolved itself.

"Evenin' to you, sir."

Private Tommy Bennett. Of course. The remaining Bennett lad seemed like his own personal spirit come back to haunt him on a night such as this. He looked so much like Freddie. He couldn't save one brother. He mustn't let the other one die tomorrow.

"Good evening, Tommy. What's the word?" he asked.

"The lads aren't happy, sir. No rum ration again. SRD."

SRD—Seldom Reaches Destination.

"Are you thinking what I'm thinking?" Alastair asked.

"About the rum, sir? I'm thinking it's in some sergeant's mess, sir."

"About the war. About tomorrow."

"That it's going to be a bloody one, sir? Yes, sir."

"All this shelling is supposed to clear the way for us across No Man's Land."

Tommy made a disparaging grunt.

"What's in your canteen, Tommy?"

"Water, sir, just like it's supposed to be."

Damn. He'd been hoping it might be something else. Tommy always knew where to get hold of contraband, even when the rum ration didn't arrive.

"If you fancy something a little stronger ..."

"Yes?" Alastair turned his affirmative into a question.

"There's a place ..."

"Where?"

"I can't really describe it, but I could show you."

Alastair waved Tommy forward, then followed him down the cut-through to a secondary trench. A young man with old eyes sat sharpening his bayonet on a whetstone by a makeshift door draped with canvas. Tommy nodded at the young man, then jerked his head sideways at Alastair.

"Knock," the young man said, without breaking the steady rhythm of steel upon stone.

The light was fading fast. Alastair turned to Tommy, surprised to find his childhood companion already turning away. "Aren't you going to share a drink with me for old time's sake?" Alastair asked.

"Not today, sir. It's not my turn."

Alastair wanted to say that he wouldn't be long, but right now, if given

the chance, he'd make a run for it. That would only get him a firing squad. Would that be a cleaner end? Not really, but it would end the torment of wondering whether he'd let himself down, let Tommy down, let Tommy's father down—again.

He didn't know whether he was more afraid of dying or of failing the men who relied on him.

"Knock," the young man said again.

Feeling a little foolish, Alastair knocked on the door post and waited.

The canvas curtain twitched back. Alastair couldn't see anyone behind it, but in front of him was a set of steps dug into the earth. He looked at the young man with the whetstone.

"Go if you're going," the young man said. "Or don't. I couldn't care less. But make your mind up. It won't wait all day."

"What won't?"

"You'll see when you get there."

Alastair trod on the top step and the curtain closed behind him. There was a warm glow at the bottom of the stair, but he couldn't see whether he was descending through hewn earth or whether this was some sort of old cellar or root store that the trench diggers had uncovered.

The sound of men's voices in convivial conversation gave him his first inkling of what he might find. He reached the bottom and turned left into a vaulted stone space with tables and benches, some of them in nooks for privacy. He guessed someone had found a cellar by accident and made good use of it. Alastair tried to guess its age. It looked like the undercroft of a Gothic church.

At the far end was a trestle table. A man was setting out tankards and a woman was wiping the bar. Half the tables were occupied and a blue cigarette haze was already adding a curtain of privacy.

"Welcome, my friend."

The man behind the bar was tall, taller than Alastair, who was built like a beanpole. This man was well-muscled, evidenced by his arms showing below his short-sleeved tunic. His curly black hair, long around his ears, marked him as a civilian, as did his beard, oddly oiled and braided. Alastair wanted to take off his cap and run his fingers through his own short-back-and-sides stubble. He settled for rubbing his chin instead, only slightly rough with today's whiskery shadow.

"Come in, have a beer. I'm Gil, and you would be ... ?"

"Alastair." He offered his hand and Gil took it, his grip warm and pow-

erful. "Do you have anything stronger than beer?"

"The beer first, eh? I brew my own to an ancient recipe." He nodded to a red-clay tablet about eighteen inches square hanging on the back wall behind the trestle that served as a bar.

Alastair screwed up his eyes to read the writing, but the figures seemed to squirm in the flickering lamplight. He shrugged. "I'll have a beer, then."

"Good choice. A beer for my friend."

The woman, middle aged with a kindly face, poured beer from a jug into one of the tankards.

"You're expecting more customers." Alastair nodded to the tankards.

"We always get a lot of customers on the eve of a battle. Men's needs suddenly become more urgent when they stare death in the face."

Alastair knew. He took a gulp of his beer so he didn't have to reply. It tasted slightly odd, though not unpleasant. The bitterness of the brew was offset with a honeyed sweetness. He took a long pull.

"Ah, so you like my beer."

Alastair's head felt as though it was full of bubbles. He'd only downed half the tankard. He couldn't be drunk already.

"Sit yourself down, my friend, while there's still a table free. I suggest that one, over there."

It was in an alcove, a table just big enough for two, with a three-legged stool at either side of it. Alastair nodded his thanks, carried his beer across, and sat down.

He took another swallow. When his nose emerged from the tankard, two more tables had been occupied. How had the men come in without him noticing? Where had they come from? He took another pull of his beer. Gil the barman had crossed over to sit with half a dozen infantrymen, not one of them more than nineteen years old, his hands describing some action or other. They all stared at him as if entranced, their faces serious, until he nudged the one to his right and laughed. The tension was broken; they all laughed with him. Six small clay cups materialized on the table. Gil took a flagon that had been tied around his waist and poured a few drops into each cup with a drink-up gesture. He watched each one of them raise a cup and left them to the rest of their beer. They'd been subdued, but now they were animated.

One began to sing and they all joined in.

Mademoiselle from Armentieres, parlez-vous,
Mademoiselle from Armentieres, parlez-vous
Mademoiselle from Armentieres, she hasn't been kissed for forty years
Inky-pinky parlez-vous

They followed that song with another and another. Each time Alastair turned around, more and more of the tables were filled with soldiers, by their accents, some of them Canadian volunteers.

Another table of regular British Tommies had arrived while he was wool-gathering over the Canadians. They started singing in opposition:

Here we are! Here we are! Here we are again!
Pat and Mac and Tommy and Jack and Joe ...

Alastair began singing along under his breath. He'd never been able to carry a tune, but he was happy to join in the chorus.

Gil came over with another tankard of beer and sat on the stool opposite. "Why are you here, my friend?"

Caught by the intensity of Gil's gray-green stare Alastair felt compelled to answer. He tried to say, *Because I wanted a drink*, but ended up telling the plain truth. "Because I'm afraid."

"Take a look around you."

Gil sat back while Alastair took in all the tables. Not one stood empty, now, yet he'd seen no one enter.

"Everyone's afraid, but they're all trying to hide it."

"Is it worth it, this war to end all wars?"

Gil sighed and shook his head. "Worth it? That's for you to say. But let me tell you, in all the wars throughout history, there have been men on the eve of battle wondering if they would be a hero or a coward."

Alastair took another swallow of his beer to wash down the lump forming in his throat.

Gil leaned forward. "It's not about winning and losing, you know. It's about courage, about being terrified, but still doing what you have to do."

"I'm not sure I have that courage."

"Would it be your greatest wish to have that courage?"

"To know that I'd not disgrace myself tomorrow, and not let down my men? Yes, I could wish for that, but also ... there's a woman. I only met her once. But I'd like her to know that I found my courage."

"What if you could tell her yourself?"

"I'd like that more than anything, but she's stationed at Couin. She's a nurse at the main dressing station. If I had a car or even a fast horse, I might be able to make it there and back by the morning bugle call, no one any the wiser, but … Ah, who am I kidding? I can't leave. Not tonight of all nights."

Gil raised his eyebrows and looked smug. "Look over there."

Sitting at the bar, her back to him, was a slim figure in a nurse's uniform, her cap in one hand and blonde curls catching the lamplight.

"Amelia," he breathed.

Gil ambled over to the bar, tapped Amelia on the shoulder, and whispered something in her ear. She turned and her face lit with pleasure. She hopped down from her stool and threaded her way through the now-crowded room, placing both hands in Alastair's extended ones and sitting down in the nook. Their fingers twined across the table and for a minute neither spoke, then they both spoke at once and laughed.

"I never thought …"

"I didn't expect …"

"How have you been?"

"All right. And you?"

"Perfectly bloody if you want to know the truth, but much better for seeing you."

"That uniform suits you. Makes you look like an angel."

"I think that's what it's supposed to do. Or a nun."

"Perhaps it's to stop your patients getting ideas."

"It's good when they do. It means they're getting better. Usually they're too weak to do anything about it." She laughed. "Don't worry, my virtue isn't in danger."

"If I had my way it would be."

She blushed and giggled.

Gil came over to them and set two small clay cups on the table. "You two children seem to be getting along splendidly."

Alastair grinned. He couldn't recall being happier since their stolen night in Paris.

Gil poured a few drops from his flask into each of the cups. "You both told me your hearts' desires. Do you remember?"

"Impossible desires," Amelia said.

"Do you each know the other's greatest wish?"

Amelia looked Alastair steadily in the eyes. "He wants to be a good offi-

cer and lead his men well."

"And she wants to save every poor soldier who enters her hospital."

Gil huffed out a breath. "Close enough. These two cups, my children, will give you your heart's desire, but only for one day. Alastair, your gift is bravery. Amelia, yours is compassion. One kiss bestows the gift of immortality for twenty-four hours. You may use it once. Think carefully. Use it wisely. A second kiss releases the spell."

Amelia looked dumbstruck,

Gil was bonkers, but Alastair didn't want to offend him. "Dutch courage without the rum." He raised the cup to his lips and tossed the liquid down his throat. It burned. Then a delicious warmth spread through him. He wasn't sure he believed what Gil said, but a tot of something powerful couldn't hurt.

Amelia touched the cup but didn't pick it up. Alastair nudged her foot under the table, jerked his head towards the cup and then sideways to Gil.

"Yes, you're right. It would be rude not to. Thank you, Gil." She drank the contents down and gasped at the ferocity of the liquor.

Gil patted her on the back and left them to talk.

"Do you believe him?" Amelia asked.

"I don't know. Maybe."

"Well, here you are, then." She leaned across the table and kissed him full on the lips. The sweetness took his breath away. When he came up for air he tried to kiss her again, but she turned her head away.

"Just once. You have twenty-four hours of immortality."

"It's time, children," Gill called.

Alastair looked around. All the other tables were empty and the barmaid was sweeping up. "Have we talked all night?" He asked Amelia.

"I believe so."

"Exit one at a time, please," Gil said. "Amelia first."

She squeezed his fingers. "You know where to find me."

"I do."

She gave him one backward glance before rounding the corner. He heard her feet on the cellar steps.

"And now you, my friend," Gil said.

"Will I see her again?"

"You're asking me? Do I look like an all-knowing god?"

"You're a kind man."

"I wasn't always, but occasionally I have a soft spot for a pretty face.

Hers, not yours." He laughed. "Now get out of here while I'm still feeling benevolent."

Alastair climbed the cellar steps, lifted the rough curtain, and stepped out into a French July dawn. The roar of the guns seemed muted, though he was sure it was just the way he was hearing them.

"All right, sir?"

Tommy Bennett's voice startled him as the guns had not.

"I am." He looked around. "You didn't see a young woman leave here, did you? About two minutes ago?"

"No, sir, no one else came out or went in. I've been here all night in case the captain came looking for you. I've got your back, sir."

"And I've got yours, Tommy."

By seven o'clock Alastair stood in line, pistol in hand, ready to go over the top.

Seven fifteen came and still the guns and the howitzers pounded Jerry's trenches

His heart thundered in his chest. His mouth was too dry to spit, but his hands were steady.

Seven twenty-five—twenty-six—twenty-seven—twenty-eight—twenty-nine.

At seven thirty precisely the shelling stopped.

"First man over the wire gets a three-day pass," Alastair yelled.

"Make it seven days and you're on," Tommy said by his left elbow.

They leaped for the ladders together.

* * *

Amelia thought she knew what bloody was, but she'd seen nothing like the casualties coming in on the morning of the first day of July 1916. Man after man was stretchered in from the forward dressing stations, swathed in blood-soaked bandages. Some had head wounds, others had limbs shattered to bloody pulp or guts spilling out. Some poor devils had multiple wounds. Those with single bullet wounds were the lucky ones. Amelia's white apron was soon red with blood, her uniform soaked through beneath it, but each time she tried to snatch a minute to go and change, someone called to her. Press here. Twist there. Clamp that. The operating theatre looked like a butcher's shop. The corridors and treatment rooms were no better. The waiting room looked like hell.

Orderlies left men on stretchers, in corridors, on truckle beds. The hospital was drowning in blood.

"Miss, help, please!"

Amelia turned.

"You've got to help him, miss." A young man had heaved himself off his stretcher and crawled to the man lying next to him, leaving a trail of red across the already sticky floor. "He saved my life. Bravest thing I ever saw. He pulled me out of the wire, right from under a Boche bayonet. And he was already covered in his own blood. Said something about my dad."

She looked down.

Alastair.

"You're Bennett."

"Yes miss. How'd you know?"

"He did it."

"This one next." Dr. Lennox paced through the lines of stretchers and pointed at Bennett.

"No, not me. The Lieutenant's hurt worse than me. See to him first."

Dr. Lennox glanced at Alastair, bent over him, and lifted a corner of the bloodsoaked dressing on his chest.

"He's dead. Who the hell brought him in? We haven't got room for the living. Get this corpse out of here."

Alastair's eyes flew open and he clutched the doctor's arm.

Lennox gasped, shook himself free, and took a swift pace backwards, then pulled himself together. "Easy soldier." Lennox turned to Amelia. "Heart-shot. If he's not dead now he soon will be. Have the orderlies put him somewhere he can die in peace. See if there's a priest free."

"I know him."

"Christ, I'm sorry. It's hard enough when they're anonymous."

She nodded, unable to speak again.

"Take five minutes. No longer. The living need you more. Say your goodbyes. You'll do him more good than a priest anyway."

Bennett was still yelling that they should save the lieutenant as they carried him into a treatment room, blood dripping from his bandaged leg.

Amelia managed to get the attention of two orderlies and they carried Alastair into the room on the side of the house designated as the hospital's chapel. Lord knows, there were plenty who needed the solace, staff and patients alike. The chapel's French windows looked out onto the shrubbery and the shady greenery imbued the room with a gentle forest light.

"Alastair." She took his hand.

"Amelia." His word was barely a whisper. She felt for his pulse, but he

had none. His chest showed no rise and fall.

"I did it, Amelia."

"You led them over the top. You saved Bennett. You're a hero."

"I didn't want to be a hero. I simply wanted not to be a coward."

"You were never that."

"I'm not dead. I should be dead." He tried to laugh, but there wasn't enough air in his lungs. "You made me immortal … with a kiss."

She stroked a stray lock of hair off his forehead.

"Kiss me again, Amelia."

"Gil said—"

"I know."

If Gil really had given her the gift to make Alastair immortal, his twenty-four hours ran out at three. She needed more time. She had to go back, beg Gil for an extension. An extension that would last a lifetime.

"Wait here."

"Where do you think I'm going?"

She squeezed Alastair's fingers, let herself out of the French windows, and hurried to the shrubbery. The path was more overgrown than she remembered. By the time she reached the potting shed her arms and face were covered with welts from the whippy branches.

She rapped loudly on the door, but there was no answer.

She hammered with her fists.

Then she tried the door.

It wasn't even locked. It swung open to reveal nothing more than an old potting shed with an earth floor, swept clean. No steps.

Had it all been a dream?

No, Alastair had remembered.

She ran back. How long had she been away? They'd come looking for her soon, and Dr. Lennox was right, she had a duty to all the wounded, not just to one.

"There you are. Where did you go?"

"To find Gil."

"He wasn't there, was he?"

"How did you know?"

"By the look on your face."

"I'll think of something. I'll try to find Gil again. I'll ask Lennox to operate. If he can fix you before your time runs out—"

"Kiss me again, Amelia."

"I can't."

"I heard what Lennox said. Heart-shot."

"Are you in very great pain?"

"I was, for a few moments, but not now. I can't feel anything."

"Your heart—"

But Lennox was right. It wasn't beating. No surgeon could fix that.

She held Alastair's hand. "Can you feel that?"

"Yes."

But she thought he was lying to comfort her. It should be the other way around.

"Are you so very frightened?"

"Not anymore. I've done what I had to do."

"I don't want you to go."

"Dear Amelia. I wish we'd had longer."

"I wish we'd had a lifetime."

He smiled. "Kiss me now and let me go."

She couldn't, but she had to.

She bent forward and brushed her lips across his, feeling what breath he had left sigh away like a departing spirit.

She closed his eyes and folded his hands across his bloodied chest.

Then she stood and returned to the living.

Author's Note: The Leeds Pals Regiment was raised in 1914 by volunteers. They trained in Colsterdale, North Yorkshire, and in 1915 deployed to Egypt to guard the Suez Canal against the Turks. They were shipped to France in March 1916 to join the British build-up for the Battle of the Somme. On the first day, the battalion casualties numbered 24 officers and 504 other ranks, of which 15 officers and 233 other ranks were killed. Private A.V. Pearson, a survivor, later said: *"We were two years in the making and ten minutes in the destroying."*

Lieutenant Victor Ratcliffe, who has a walk-on role in this story, was a real person, a minor war poet and nephew of Edward Allen Brotherton, Lord Mayor of Leeds in 1913-14, one of those responsible for raising and equipping the Leeds Pals regiment. Victor also died on the first day of the Battle of the Somme, killed in action at Fricourt. He was twenty-nine years old, and left behind a fiancée, Pauline.

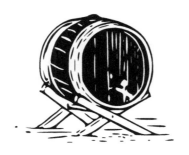

𝔅𝔬𝔲𝔫𝔡 𝔅𝔶 𝔐𝔬𝔯𝔱𝔞𝔩 ℭ𝔥𝔞𝔦𝔫𝔰 𝔑𝔬 𝔐𝔬𝔯𝔢

William Leisner

New York City, 1929

The guests were led into the small sitting room that had been prepared for the séance. The electric lights had all been extinguished and a trio of candles at the center of the circular table were lit. Lightning flashed outside the windows as the storm clouds came rolling in from across the Hudson and over Central Park. "The perfect spooky weather for a séance, isn't it?" asked the host, Walter Culyer, with a chuckle.

"Actually, no," Arthur Ford answered wearily. The medium was only ten years older than his host, his college pals, and their sorority dates, but he carried himself like a man who had lived a much, much longer life. "The electrical discharges tend to disrupt the balance of energies," he continued as he crossed to the windows and pulled the curtains closed, "and make contact beyond the veil more difficult."

"You're not making excuses already, are you?"

Ford turned from the windows. "Excuses?" he asked the young woman Culyer had introduced as his fiancée, Ginny Farrington, a lithe brunette with a pageboy haircut wearing a scandalously short frilled dress.

"In case the spirits are being 'unresponsive' or whatnot." Her lips were

curled into a tiny sneer as she pulled the cigarette from her overpainted lips. "I've read Houdini's book," she added, cocking her head and blowing out a long stream of smoke.

Cheeky little tart, innit she?

Ford ignored that voice from inside his head and held his gaze on Farrington as he moved over to the table. With the candlelight striking him from below, sharpening the contrast of his black tuxedo and white shirt, and flickering shadows over his face and his neatly trimmed van dyke beard, he knew he cut an imposing image. "I was told when you hired my services," he addressed Culyer, while still maintaining eye contact with the woman, "that this was to be a friendly affair amongst friends. I did not come here to be subjected to some sort of skeptic's inquest."

"That's not what this is," Culyer tried to placate him. "Ginny here, she's just cracking wise, ain't you?"

"Because if any of you are coming into this with your minds already closed and locked that way," Ford continued, taking in the rest of Culyer's guests, "then I see little reason for proceeding."

Finding every set of eyes in the room fixed on her, Farrington sighed and said, "Fine. I won't make another peep."

I wouldn't bet on that, Fletcher silently interjected again as the group settled in their seats around the table and joined hands.

Silence settled over the room, interrupted only by the muffled sounds of wind and rain outside. Ford relaxed his breathing and dropped his chin to his chest so that his deepened voice reverberated through the small room. "O, Spirits! We are gathered to seek you and beseech your wisdom and counsel. Let the veil between the worlds of the living and the dead grow thin, the barriers weaken. Hear us, O, Spirits!"

As he incanted, a vine-like tendril of spiritual essence, invisible to all but Ford himself, stretched out from the center of his chest. It curled like a wisp of smoke over the table, then expanded into the shape of a man's head. The candles guttered in reaction to the small but sudden dip in ambient temperature, to the gasps of a couple of Culyer's guests.

Ford raised his head again as the apparition began to speak through him. "My name is Fletcher. I am Mister Ford's liaison and guide to the spirit world." Though still Ford's voice, Fletcher gave it a somewhat reedy tenor, colored by the brogue of his Scottish home village. "The spirits are amongst us and they wish to be heard."

Ford then took back control of his own tongue. "To whom among the

departed do you wish to speak?"

"How about Rudolf Valentino?" asked another of Culyer's guests, a freckle-faced girl wearing a sorority sweater. There were titters from around the table, while Ford fought back a weary sigh.

"No, no," Culyer quickly overruled. "I would like to speak to my grand-father, George Culyer."

Ford looked to Fletcher. *What do you think?* he asked in the privacy of their shared thoughts.

A lot more likely than trying Valentino again, Fletcher responded. His spectral eyes closed and threads of spiritual energy distended out from the circle and into the aether. After what seemed like several minutes—although only a couple seconds on the physical plane—Fletcher was joined by a second presence. "George Culyer, is that you?" Fletcher/Ford asked aloud.

"Yes, I am George Culyer." His words were conducted silently to Fletch-er, then to Ford, who gave them voice for the benefit of the rest of the gath-ered living. They came slow and gravelly, sounding like a bad cliché from some radio horror play. "Who calls upon me?"

Fortunately, Walter Culyer found the voice credible. "Granddad? Is that really you? It's Walter … Wally."

"Wally, my boy!" the spirit responded through Ford. "Yes, it's me, your grandfather."

Ginny Farrington huffed noisily, but before she had the chance to voice her skepticism, her fiancé asked, "Do you remember the gift you gave me for my thirteenth birthday?"

How in hell am I expected to remember something like that? the late Mr. Culyer asked.

Ford, of course, withheld that profane outburst from the rest of the circle. *All the knowledge you ever had in your lifetime is available to you now,* Fletcher explained to his fellow spirit. *You just need to concentrate a bit …*

The old man's image scowled, but after a moment said, *That was the year I gave you my old Bowie knife, wasn't it?*

Ford channeled his words to the circle and the younger Culyer's face lit up. "Yes! And the note you gave me with it?"

The fucking note, too? What is this?

They can't see you or hear you, Ford thought at him. *They need proof you are who you say you are.*

Christ, George Culyer hissed. *The note said something like, Wally, today you become a man, don't let your mama keep treating you like a boy.*

"That's it!" Walter Culyer confirmed with a high-pitched laugh. "That's exactly right!"

Seems that advice went to waste, the grandfather grumbled.

"Seems that advice went to heart," Ford amended aloud.

No, I said 'waste,' George Culyer told Ford. *Look at this milksop, with his Ivy League tie and his clean fingernails. When I was his age, I was using that knife to fight Indians out West, not sitting around playing parlor games like some old biddy!*

"Did I ever tell you about how I fought against the Indians out West when I was your age?" Ford said instead. When young Culyer answered no, he continued, "Well, we were out on patrol, heading for Fort Buford ..." Everyone in the circle, Miss Farrington included, listened to the unwinding adventure, enraptured.

George Culyer, though, was far less beguiled. *I thought you called me here because my grandson wanted to hear from me, not you!*

Yes, that's what he thinks he wants, too, Ford said inside his head. *But I'm getting paid to give them what they really want.* Aloud, he continued to regale his audience, to their appreciative gasps and cheers. Not a one of them, not even Ford, noticed when George Culyer withdrew in disgust and slid back beyond the veil.

* * *

The rain was pouring down in sheets when Ford emerged from the Culyer's brownstone. He clutched his overcoat around his neck with one hand and held his silk top hat to his head with the other as he dashed down the steps and across the sidewalk into his flivver. "Well, that was a grand success!" Ford crowed as he cranked the starter and brought the engine to life.

Was it? Fletcher countered.

"You don't think so?" Ford pulled carefully into the empty street, one hand on the steering wheel while he used the other to crank the windshield wiper back and forth. "Young Mr. Culyer seemed to think so. And that shrewish fiancée of his certainly lost the chip off her shoulder."

The irony being, you used the same deceptions Houdini filled that book of his with in order to do it.

"Fah, deceptions!" Yes, he had stolen the story of another soldier, one of George Custer's ill-fated cavalrymen, but that was merely flourish. "I called forth the spirit of the dead—"

Who *did?*

"Oh, let's not have that row again," Ford huffed. "Whomever you credit,

Grandfather Culyer's spirit was present. The trouble is, these juveniles consider spirits the same way they do their movie-house idols: colorless flickers that amuse them for an evening and then are gone as soon as the house lights come back on! So I had to do the lion's share of the entertaining for Culyer this evening; does that detract from my—our—ability to do what we do?"

Fletcher's response was lost when a thunderclap boomed overhead and lightning illuminated a trash barrel that had been blown into the street, no more than three feet ahead. Ford tried to swerve around it, but the car skidded and bounced over the flooded cobblestones and the barrel exploded against the engine hood. Ford heard a scream and wasn't sure if it came from him or Fletcher. The automobile spun in a complete circle, then jolted to a sudden standstill.

The engine was dead, and the only sounds inside the car were from the rain and Ford's racing heart. Fletcher muttered what Ford recognized as a Gaelic profanity. After a moment to settle his nerves, Ford unlatched the door and stepped out to survey the damage. Both headlamps were shattered and broken slats of what remained of the barrel stuck out from the radiator grille and the front fender. Both right-side wheel rims were bent from where they'd hit the curb, their rubber tires deflated. Ford could do nothing but stare at the wreckage, heedless of the rain continuing to beat down on him.

He was jolted from this stupor when a hard gust knocked the hat off his head and sent it tumbling down the street. He started running after it, but after a block or so realized the effort was futile. He crossed over to the sidewalk, where some shop owner had left his storefront awning open overnight. He unbuttoned his overcoat and tried to flap some of the excess water off, then looked around to regain his bearings. The rain was falling hard enough that he couldn't even put his eyes on where he'd left his car.

He cursed under his breath again, trying to decide what there was to do next at this hour of the night. As he looked up and down the street, a flicker of light caught the corner of his eye and he turned his head just in time to see two shadows stepping in through a side door in a narrow alleyway across the street.

Ford sprinted across the roadway, reaching the opposite curb just as the last sliver of light disappeared. He found the door latch in the darkness and stepped inside a narrow stairwell leading up to the darkened floors above. To the right of the stairs was a door labeled BASEMENT—KEEP OUT. Ford pulled it open, discovering a faint glow—and what sounded like the muffled buzz of human voices—coming up from below street level. He

made his way down to the concrete floor, then toward a thin rectangle of light coming from beyond the boiler room. Only briefly did he question what he was doing—people who hid in basements didn't tend to welcome visits from strangers, after all—but he continued forward and knocked on the door.

A small slat above Ford's eye level slid open. He looked up, saw a pair of dark, intense eyes peering down at him from underneath a furrowed brow. "Yeah?" a deep rumbling voice challenged.

Ford cleared his throat. "Um, hello. I was wondering if you have a telephone, and if so—"

"No."

The opening slid shut with a loud clack. Ford knew he should have simply accepted that dismissal and gone to wait out the storm on the stairs, but something compelled him to try knocking again.

This time the main door swung inward, only far enough so that the man with the dark eyes could reveal the entirety of his imposing self. He stood well over six feet tall, with long black hair and a thick black beard that twisted into a number of long, wiry fingers. He looked like he'd just stepped out of a poster for some circus freak show, a cross between the World's Strongest Giant and the Boy Raised By Wolves. "Is there a problem, friend?" he asked, sounding anything but friendly. "This is a members-only establishment on private property. If you haven't got a good reason for being here—"

"Gil sent me."

The big man stopped short and raised one black thick eyebrow at Ford. Ford stared directly back at him, while inside his head asking, *'Gil?' Who the hell is Gil?*

You mean you don't know, either? Fletcher replied.

Before either could think any further, the doorman said, "You should have said that from the beginning," and stepped to one side. "Welcome to Connally's." Ford stepped past him quickly, avoiding his eyes.

The speakeasy was nothing like what he'd expected. Far from being a sordid, dimly-lit joint, this felt like walking into a friendly neighborhood pub, the type which had gone the way of the dodo once Prohibition became the law of the land. The lights, while not exactly bright, still served to make the space feel like something other than a basement. The dozen or so tables were occupied by nattily dressed men and women chattering away, as carefree as if in their own homes.

But the most impressive feature was the bar itself. Instead of a simple

table or makeshift wooden plank one might have expected in an illicit gin club, along the far wall stretched a beautifully-crafted mahogany bar, complete with gleaming brass rails that ran along its full length. The varnished wood almost gave off its own glow, like a well-cared-for piece of fine furniture.

Behind the bar, watching as he approached, stood a round-cheeked redhead wearing a white apron over a simple dress. "Evening," she said with a cheery, gap-toothed smile. "Aednat Connally, at your service. What can I get you?"

Ford took hold of the rail and pulled himself onto a barstool. "Whiskey neat, please." The barmaid nodded and turned to pull a bottle from the shelf behind the bar.

Do you feel that? Fletcher's voice asked, and before Ford could reply, his fingertips slid along the rail, and then over the dark wood.

Yes, Ford answered as an unearthly yet familiar tingle seeped into his skin. He pressed his palms down firmly and the hairs of his arms stood on edge. *An imprinted consciousness?*

Right-o. Fairly recent, I think ...

Before Ford could give that further consideration, Aednat turned back with a dark brown bottle in one hand and a glass tumbler in the other. Ford was surprised to recognize the label of a highly-regarded Irish distillery on the bottle, and even more so when, once Aednat had poured out a finger and he sampled it, that it was just as advertised. "Oh, heavens," he murmured appreciatively as the amber liquid burned over his tongue and down his throat. "Where did you manage to acquire such ambrosia?"

"Ask me no questions and I'll tell you no lies." Aednat winked and asked with a silent gesture of the bottle if he wanted a second.

Ford nodded eagerly; it had been too long since he'd had anything so fine to drink. "I must say, this is the most surprising speakeasy I've ever set foot in," he said as Aednat refilled his glass.

"Good, because nobody calls my place a speakeasy," she told him. "Connally's is a legitimate bar, one with a nearly forty-year history in this city. We've simply been required to relocate temporarily to this less conspicuous milieu."

"Forty years, you say." He took his refilled glass, while the fingertips of his free hand traced along the wood's grain lines, letting Fletcher extend his otherworldly perceptions outwards ...

"Mm-hmm." Aednat pulled a cloth from her apron and began polishing

the bar. "My da, he opened his first place in the Gashouse District, in a space even smaller than this. Did well enough that he was able to buy a bigger place, but never forgot the old neighborhood. Good man, he was. Best friend to every soul that stepped in his door."

"He sounds like a real stand-up fella," Ford said, now rubbing both hands back and forth across the bar. The imprinted psychical sensations intensified as the daughter's memories flowed …

"Indeed." A smile flickered across Aednat's lips, then faded with a sigh. "The Spanish flu took him back in '19. My brother kept the old place running for awhile, but with the country about to go dry …"

"His heart wasn't in it," Ford said, nodding. "He always had bigger dreams than running a tavern." The words were flooding out now, aided in part by the high-quality alcohol now warming his stomach and head. "So he sold the place and it sat vacant for a year. Then the night before they tore the block down to build another skyscaper, you and the neighborhood gang broke in and rescued this beautiful old bar, so it could be put back to its proper use."

Aednat stared bug-eyed at Ford. "Where did you get all that from? You some kinda detective?"

"Your father is proud of you, Aednat," Ford said earnestly. "He had trouble saying such things when he was alive. He could be as warm as anything with strangers who walked into his bar, but with his own family, it was different. But he wants you to know he loves you."

For a moment, she just stared at him speechless. Then her face hardened and she shot a look off behind Ford. "Gil!"

Ford spun on his stool and saw the bouncer look over from his post by the door. Aednat crossed the bar to speak with him in a tense whisper. *Wait, he's Gil?*

No, Fletcher said without certainty. *If he's Gil, why did he let us in when you said Gil sent us?*

I didn't say it! I have no idea where that name came from!

As they carried on their dialogue inside Ford's head, the bearded man finished talking with Aednat and made a beeline toward him. Then a huge hand wrapped all the way around Ford's bicep and Gil's lips were an inch from his ear. "I need to ask you to come with me, Mr. Ford," he said.

He found himself being led, not back the way he had come, but through a curtained doorway to the side, into a dim back room. Gil pulled him into a small storeroom of some sort, barely bigger than a closet, and dropped him

onto a wooden crate emblazoned with a Canadian maple leaf. "Listen…
I don't know what Miz Connally told you I said to her …" Ford babbled,
panicked, craning his neck back to look up at the giant.

"Ah, don't worry about it. Aednat's a tough gal; you just caught her off
her guard, is all." He added, with a small chuckle, "You seem to have a
knack for that."

Ford blinked. "I'm sorry?"

The bouncer sat opposite him on a neatly made Army surplus cot wedged
against the wall. Ford noticed, curiously, that he had brought the whiskey
bottle from the bar with him. "Well, seeing as how I'm the only Gil who
knows about this place, your claim struck me as … curious."

"I—I honestly have no idea why I said that."

Gil tilted his head. "Maybe your friend does."

"… My friend?"

I think he means me, Fletcher said.

Gil nodded. "Yes. I mean you."

Ford felt as if he'd just been punched square in the face. "You can hear
him?"

You can hear me? Fletcher asked in unison.

"Yes, Mr. Fletcher, now that I know to listen."

H-How is that even possible?

Gil shrugged. "I gave up trying to figure out 'possible' and 'impossible'
a long time ago. Let's just say that over the course of my life, I've gained an
awareness of things beyond the physical realm, though not quite like yours.
I knew there was an essence trapped in the bar, but I've never been able to
get anything stronger than a vague awareness." Gil paused and lifted his
head as if listening for something in the distance. "And now, you've freed
him. The message you gave Aednat was what he needed to say in order to
move on."

He's right, Fletcher confirmed. *I don't feel him anymore. He's gone.*

Gil then grabbed a pair of mismatched glasses from his bedside table
and poured some whiskey for each of them. "To Iain Connally, proud son of
Ireland," he said, raising his glass. "May your God forever keep you in the
palm of His hand, but never close His fist too tight."

Ford joined the toast and both threw their drinks back. Between the
top-quality alcohol, and the relief that this hulking brute wasn't about to
throw him out into the gutter, he was feeling better than he had in a long
time. Gil reached out again to refill his glass and said, "So tell me, Mr. Ford,

Mr. Fletcher: how did you two come to your present circumstance?"

That question instantly dimmed his mood. "It happened during the war," Ford answered after a long sip. "We were on patrol and came under Gerry sniper fire. In the confusion, I got separated from my men and hopelessly lost. I eventually found an abandoned trench to hole up in—except it wasn't quite abandoned."

There had been about thirty men in there when the bomb hit, no more than ten feet forward of us, Fletcher added. *The trench caved in. My entire squadron was buried alive, all except me. I tried ... I grabbed up my spade and started digging, but ...*

"When I found him, he was curled up on his side, clenching his shovel and talking to himself, shell-shocked. I collapsed into the mud next to him and talked to him for hours, hoping he'd snap out of it. Then, once darkness fell, I picked him up over my shoulder, carried him up out of the trench and away from the line. I crept through the dark for something like an hour, until I reached an Allied encampment, and collapsed. The next thing I know I'm in the medics' tent, but no Fletcher. I asked the doctor what had happened to him and he told me he was dead ... that he had been dead for at least a full day, that I had been carrying a stone-cold corpse with me."

In hindsight, I suppose I knew I was dead well before Ford's appearance, but hadn't accepted it. Then, when he started talking to me and I was able to answer back, I thought, well, I seem to still be alive after all. It wasn't until I watched them cart my body away on the meat wagon, while I was still right there with Ford, that I truly knew.

Gil listened intently, leaning forward with his elbows resting on his knees. "So, somehow you two were bound?"

"Something about the conditions at that location at that specific point in time. I've no idea what." Ford shrugged. "I started studying Spiritualism after I returned stateside, trying to understand it. Unfortunately, the field has far more questions than answers."

"The greatest mystery of life is death," Gil said, as he poured himself another whiskey, then handed the bottle to Ford. "Though it seems that the two of you are in the ideal position to finally answer some of those questions. I should think the American Society for Psychical Research would be eager to hear your tale."

Ford laughed as he refilled his own glass. "Then I have to assume you've never had any direct experience with the Society."

"That's true," Gil confessed.

Ford paused to take a long sip, then added, "In fairness, I do believe the A.S.P.R. was founded with the best of scientific intentions. However, with all the notoriety they and their allies like Harry Houdini have gained for uncovering hoaxes, I feel that now they'd reject even genuine evidence, so as not to undermine their own reputation."

"But there are people who are still willing to be convinced," Gil said. "You just mentioned Houdini. Isn't his widow offering ten thousand dollars to anyone who can reach him in the afterworld?"

Ford scoffed. "Yes, and that would be all well and good if Houdini were actually willing to be contacted. Most people think being a psychic is like being a telephone operator, that you can name any party you like and we simply plug wires into some ethereal switchboard. The fact is, the dead generally don't want to be disturbed, least of all by strangers and thrill-seekers. If the departed has an emotional tie to a person or location, like with Miz Connally's father, they tend to be more forthcoming. But I could no more compel the ghost of Houdini to speak to me than I could command King George to hop in an airplane and come for tea. Mrs. Houdini's only goal is to draw out a few foolish frauds, publicly humiliate them, and further her husband's legacy."

"That's quite a cynical view," Gil commented. Ford answered with a shrug and drained his glass again.

After another moment of wordless contemplation, Gil said, "I keep coming back to the question, why would you have said 'Gil sent me?' *Something* sent you, obviously, and wanted to be sure you caught my attention." He stood up, turned, and reached for the shelf that hung above his cot. "I think I have an idea why."

The shelf held a few personal items, including an old clay tablet scratched with some sort of ancient cuneiform and a small, intricately-carved, wooden box. "I believe this may help you," Gil said, as he removed the lid and pulled out a small silver object.

Ford had to stand to accept the gift from the tall man. At first glance, it appeared to be a key, but closer examination revealed it as an amulet in the shape of an Egyptian ankh, with a deep red ruby set in the open loop at the top of the cross. "Help me with what?" Ford asked as he examined it.

"It's never worked the way it was supposed to for me," was Gil's only answer. "I suspect it might for you, though. Good luck."

The big man then collected the glasses and the nearly empty bottle of whiskey and headed back out into the bar, forcing Ford to follow. Aednat

was back behind the bar. Ford caught her eye and, under her acid stare, decided not to wear out his welcome any further.

<p style="text-align:center">* * *</p>

Outside, the rain had stopped, allowing Ford to find his bearings and make his way back to his car. The damage somehow seemed worse now that he didn't have to squint at it through a downpour, though with the weather now cleared, he noticed a small hotel half a block away. After waking the night clerk, he was shown to a tiny plain room, where he stripped off his still-damp clothes before collapsing onto the threadbare mattress.

But despite his exhaustion, as well as being more than a bit zozzled, he found himself tossing and turning sleeplessly. After close to an hour, he gave up, turned on the light, and dug the ankh out of his trouser pocket. "Do you have any idea what this is?" Ford asked aloud to the empty room as he sat on the edge of the bed and studied it. The metal gave off a slight warmth, and the way the jewel caught and refracted the dim light of the room's single lamp was strangely hypnotic.

I'm not sure, Fletcher replied. *The ankh was the Egyptians' symbol for life beyond death. I feel like it has some sort of psychical powers ... like it's perhaps channeling energies between worlds.*

Ford pondered that, then he took the two "arms" of the ankh between the thumb and forefinger of each hand and focused on the gem. "O, Spirits," he started to intone, "we beseech thee. Let the veil between worlds grow thin and the barriers weaken."

The facets of the jewel seemed to melt then, shimmering like a large drop of blood. The entire room was flooded with an unworldly light that came from everywhere. Ford blinked instinctively, even though he had no trouble seeing what had just occurred.

The room was filled with ghosts.

Hundreds of incorporeal beings surrounded him, spirits of every shape and size, some having assumed their former bodily appearance, others as indistinct as a smear on glass. All of them concentrating their collective consciousness directly toward Ford.

The ankh fell from his fingers and he was just as suddenly alone in the near-dark again.

Though not entirely alone. *Jesus Christ,* Fletcher's voice inside his head quavered. *What did you just do?*

"I have no goddamned idea," Ford answered. He stared at the amulet laying on the carpet between his bare feet, the jewel once again solid.

The veil didn't just grow thin there; it was gone*!*

"Gone?"

Or at least it grew a great big gaping hole. That thing, it's like ... a key to a door.

Ford continued to eye Gil's relic, slowly working up the courage to pick it up again. As before, there was nothing particularly remarkable he could sense about it. He took it between both hands again and, on a hunch, recited a variation of his incantation: "O, spirit of Rudolf Valentino, we beseech thee, your counsel and wisdom."

This time, a single form coalesced before him, one who was instantly recognizable as one of the most famous men in motion pictures. *Hello? What is this?* he asked, speaking with a slight Italian accent.

For a moment, Ford merely gaped at the spirit. Then, he threw his head back and laughed. He kept laughing as he leapt off the bed and started dancing riotously around the specter of the world-famous Latin lover in just his underwear.

Che cavolo? Valentino muttered, just before Ford released his right hand from the ankh, sending the spirit back.

That was ... invigorating! Fletcher sounded breathless, despite his perpetual lack of breath. *All that agency and power ... Ford, let me try something. Take hold of it again.*

Ford did as requested, curious to see what else the amulet might be capable of. Another spirit took form before him, this time a willowy young woman Ford did not recognize.

Helena! Fletcher extended his essence across the room, taking on his former corporeal appearance.

Graham! the woman cried out. The two rushed together and embraced—not physically, yet with an intensity of emotion that no two physical beings could have equaled. Ford could not fully comprehend what he was witnessing, but he had enough apperception that he felt the need to look away.

After a few minutes of this, discomfort turned to impatience. "Fletcher!" Ford called, and when he got no response, he broke the circle he'd formed with the ankh. "Fletcher!"

The female spirit dissipated like the smoke from a snuffed candle. Fletcher started as if being awakened from a dream, then wheeled on Ford and shrieked, *No, damn you! Bring her back!*

Ford had faced plenty of angry spirits over the years, but Fletcher had never been one of them. "Easy, Fletcher!" he shouted, hands out before him.

"Who was that?"

That was Helena! My wife! he raged.

"Your wife? You were married?"

That's how one typically obtains a wife, yes, he said sharply. *We were wed shortly before I was conscripted; we barely had a month together before I had to ship out. She fell ill the following winter. Neither of us ever had the chance to say goodbye,* he said morosely.

"Get ahold of yourself, Fletcher," Ford berated him. "With this, you can reach her any time you like. For right now, though," he said, admiring his new prize, "we have much bigger fish to fry."

* * *

Bess Houdini was a small, tired-looking woman in her fifties, still dressed in black more than two years after her husband's funeral. Ford leapt to his feet as she entered the small sitting room where the housekeeper had left him to wait. "Mrs. Houdini, it is an honor to meet you," he said, taking her hand. "Thank you for inviting me to your home."

"You made some very bold claims in your letter, Mr. Ford," she replied, fixing him with a critical glare. "I don't believe I've even known any spiritualist to use words like 'promise' and 'guarantee' as freely as you."

"And I intend to show you that my confidence is justified." He had in fact conjured Harry Houdini's ghost more than a dozen times over the past two weeks, as well as a score of others, ranging from Socrates to John Wilkes Booth. He could not be more confident in himself than he was at this moment.

Mrs. Houdini, though, was far from convinced. "Of course. So, tell me, how do you intend to go about contacting my husband? What do you require?"

"Only your leave, ma'am," Ford said. "I'm prepared to do so right now if you like."

That brought the woman up short. "Now?"

"Or did you have another preference?" Ford asked.

"Well, I'm just surprised. Most of the other mediums have asked for time to prepare, or else insisted the séance needed to take place at night, in a room that met certain criteria."

"And all of them you discovered to be charlatans. Unlike myself."

She paused to reassess him. "Very well," she said, stepping around him and seating herself on the sofa. "Let's begin."

Ford pulled the ankh from his pocket and settled into the chair opposite

her. "Please take my right hand with your left, then take hold of this amulet with your right." Bess eyed the object curiously, then did as instructed. Ford closed his eyes, but Bess kept hers open and fixed on him, watching for whatever trick he intended to pull from his sleeve.

She gasped aloud when the spectral shape of another man emerged from Ford's body. She blinked hard, assuming that her vision had gone blurry, but the ghost persisted.

"You're not Harry," she said in a small whisper.

No. My name is Fletcher. I serve as Mr. Ford's spirit guide. Pleased to make your acquaintance, Mrs. Houdini.

Bess was speechless. Her eyes darted around the room, looking for mirrors or some other tool of the magician's trade that might explain this apparition. She had been Houdini's assistant since his earliest days touring small-town theaters and vaudeville houses. She would have been intimately familiar with his tricks and the tricks of the fraudulent psychics he had exposed. When she turned back to face Ford, he could see her shock in realizing this was no illusion.

"Shall we proceed?" Ford asked. Before Bess could respond, he continued, "O, Spirit of Harry Houdini, née Ehrich Weiss, we beseech thee. Return across the veil of death to share your counsel and wisdom with us, the living."

And then he was there. Misty wisps of light came into being and condensed into a stocky, slightly bow-legged figure, with a broad face and deep-set eyes. "Good God," she whispered. "Harry?"

The image glowed brighter as a smile stretched across its face. *Oh ... Bessie ...*

Bess nearly leapt to her feet, but Ford tightened his grip, pressing one of the talisman's sharp points into the flesh of her palm, and held her in place. "Harry, it is you, isn't it? You always said that if you could find the way back to me after death, you would."

Yes, my love, I did, Houdini said. *I'm only sorry that this son of a bitch found it first.*

"Mind your manners, Harry," Ford warned.

Fuck you, Ford—

Ford released Bess' hands, breaking their psychic circle and casting Houdini from the physical plane. Bess blinked at the empty space where her husband and Ford's spirit guide had just been. "What happened?" she asked Ford. "What did you just do?"

"Was he so foul-mouthed in life?" Ford asked, ignoring her question. "I know the dead tend to have a more relaxed sense of propriety, but …"

"Harry never minced words," Bess told him. "If he called you a son of a bitch, likelihood is that's just what you are."

Ford chuckled at that. "Then you do accept that I've called the spirit of Harry Houdini back from beyond the grave."

"I … I don't …" Bess shook her head, unsure just what she wanted to believe.

Ford sighed in impatience. "Rumor is that you and your husband agreed on a message he would relay to you if he were to come back, to prove he was who he said. Is that correct?"

"Yes," she admitted.

Ford grabbed hold of her hands again and a moment later both Fletcher and Houdini took visible form again.

—and the horse you rode in on, Houdini completed his earlier sentiment.

Ford gave him a patient smile. "Harry, your dear wife doesn't believe who you say you are."

How odd that she'd find you unworthy of her trust.

"Do you love your wife?"

The ghost's ire toward the medium grew even higher. *Of course I do.*

"Now mind, I'm speaking in the present tense. Do you, the ever-living spirit of Harry Houdini, continue to love this woman even from beyond the veil?"

Houdini turned his gaze to Bess again. *With all I am, yes.*

"And wouldn't you like her to believe that, without doubts?" Ford asked him. "Do you have anything you might say to her that would convince her of the truth of those words?"

Houdini winced and said to Bess, *That message was to protect you, so you could dismiss all of the shams who were sure to crawl out of the wood-work to take advantage of a grieving widow.*

"I know," Bess said. "And it's worked that way until now. But you need to tell me. I need to hear it."

Houdini sighed, then intoned in his booming stage voice: *Rosabelle, an-swer, tell, pray-answer, look, tell, answer-answer, tell.*

Ford looked from Houdini to his widow. "What was that gibberish?"

"It's a code," she explained. "When Harry and I were just starting out, we did a mind-reading routine. He'd be blindfolded, I'd have an audience member hold up an object, and he'd say what it was … after I used the code

to spell it out for him."

"So what does it mean?"

"'Rosabelle' is the key. I need to take off my wedding ring."

Bess tried to pull her left hand free, but Ford tightened his grip. "Why?"

"Because we haven't used the code in ages," she told him, wincing. "There's an engraving inside. It will let me decode it."

"Do not break the circle," he told her, as he adjusted his right hand's grip and started working the ring up her finger.

What does it matter if the circle breaks? asked Fletcher, who had been unusually quiet throughout the séance. *You can call Houdini back at will.*

"Yes, *my* will," Ford answered. "*I'll* decide when, or if, Mr. Houdini is allowed to escape." Taking care to keep his hand in contact with hers, Ford wrenched the ring up past Bess' knuckles and off her finger. With the nimbleness of a stage magician, he transferred it into her palm, then shifted his grip to her wrist.

Bess lifted her hand, rolled the ring so that it caught the light at the right angle, and then read—or rather, sang: "Rosabelle, sweet Rosabelle, I love you more than I can tell …"

Over me you cast a spell, Houdini joined in, and the two completed the verse in unison: *I love you, my sweet Rosabelle.*

"And so?" Ford prompted. "What does it mean?"

Bess let the ring fall from her fingers and drop onto the low coffee table between Ford and herself. "The song is the one Harry would sing to me while we were courting. But you mean the code. *Answer, tell, pray-answer, look, tell, answer-answer, tell* spells out the word 'believe.'"

Ford smiled and nodded at that. "So now you believe that I've truly brought your husband back from the other realm."

"Yes, I do," she said, looking pained. "And I believe that using Rosabelle is the right thing to do."

"Using Rosabelle? What is that supposed—" Ford started to ask, but then he looked down and saw Mrs. Houdini's ring spinning on the table, gaining speed, then actually rising off the surface. Ford stared dumbfounded, so absorbed that he barely registered the way the ankh was heating up in his hand. He tried to drop it, but his fingers were locked into a fist.

I love you, Bessie, forever and always, Houdini said. *Believe.*

The spinning ring rose higher and the artifact felt as if it was now burning into his palm. Then something like an electrical current shot up his arm and through his entire body, launching Ford over the back of his chair and

flinging him across the room, striking the marble fireplace head first.

* * *

Is he dead?

Not quite. He's hurt, but I trust Bess to take care of him.

Ford moaned. *What just happened?* He tried to rub his blurry eyes, but his arms refused to move. He couldn't even say for certain that he still had arms.

A true magician never reveals his secrets, Houdini answered him, *though in this case, I feel an exception to the rule is justified. When I first began my efforts to discredit false spiritualists, there were many who accused me of subterfuge, suggesting my motivation was to protect my own secrets.*

They said your escapes could only be successful with supernatural assistance, Ford recalled. *That you could only have survived so many brushes with death if you were in fact in league with spirits.*

Yes. And those people were correct.

Ford's vision finally cleared and both Houdini and Fletcher came into sharp focus. But somehow, Mrs. Houdini and her home remained disturbingly indistinct. *The ring ... it's another talisman ...*

Yes. A key to loosen any lock. Even one as powerful as Nefertiti's ankh. You've provided me, Mr. Ford, with my final and most impossible escape! Houdini beamed and bent forward in a deep theatrical bow. *And now, farewell ... and congratulations to you, Mr. Fletcher.*

The great magician's form dissipated as he slipped beyond the veil again. Ford then looked to Fletcher. '*Congratulations?*'

I wasn't ready to cross over that day you found me in that muddy trench, but I've been ready for a long time since. Gil saw my predicament; that's why he gave you the ankh. He knew lock would be drawn to key, Fletcher explained, then began to slowly fade away just as Houdini had.

W-what? Ford stammered. *Fletcher, come back here! You can't just ... you ca—*

* * *

"—kakkakk!" The wracking cough, triggered by the ammonia-soaked rag held under his nose, sent explosions of pain through Ford's skull.

"Thank Heavens!" he heard Bess Houdini's voice say from somewhere above where he lay on the floor. "Now, run, go fetch Dr. Neiderkorn!" A pair of feet, presumably belonging to the housekeeper, hurried off and faded away. "Mr. Ford? Can you hear me? Can you speak?"

Ford moaned and cracked his eyelids open a sliver. "Yes, Mrs. Houdini,

I hear you," he managed to croak … and then stopped. His head was throbbing, but he pushed the pain aside to search his mind.

"You're the only one I hear." It had been such a long time he had almost forgotten what it felt like to be alone inside his own head. "Fletcher? Fletcher?"

He tried to sit up, but was immediately overwhelmed by dizziness. The world faded to gray and he dreamt he was back in the army hospital in France, doctors poking at his body, the dead Scotsman poking at his thoughts. When he came to again, he saw it was Mrs. Houdini's physician doing the prodding, while his head was silent. The doctor said something, to which Ford nodded absently, then bid his farewell.

Moments later, the housekeeper helped him into his coat as Mrs. Houdini lead them to the front door. They stopped in the foyer, where Bess handed a slip of paper to him. He was shocked to see it was a check for ten thousand dollars. "You did contact Harry's spirit, after all," she said in answer to Ford's unspoken question. "And more importantly, you helped destroy the means of ever bringing him back again." With that, she handed him the ankh and opened the door for him.

Standing alone on the sidewalk, Ford continued to stare at the check in his right hand, dumbfounded.

This is what you wanted, isn't it?

It was own voice, asking his own rhetorical question, but still his eyes shifted to the ankh in his left hand. Its jewel was gone now and, he knew, running his fingers over it, that its power had been neutralized.

With a flick of his wrist, he tossed the relic down the nearest storm drain. *Yeah, this is all I wanted*, he assured himself as he dug both hands deep into his coat pockets and made his way down the busy city street alone.

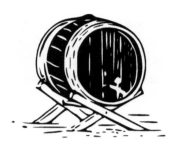

𝔚elcome
to the 𝔍ungle 𝔅ar
Garth Nix

Neville Westerley was having a beer—not his first, not even his fifth—in the Sergeant's Mess at Nui Dat when the Australian warrant officer felt someone standing next to him at the bar, way too close. So he detached his attention from drinking for the second or two it would take to work out whether someone needed a forceful reminder of the importance of personal space or to take other action if it was the beginning of a practical joke by one of his mates.

His raised almost-fist turned into a half-wave, half-salute as he took in the tiger-stripe camouflage, the flower-like rank symbol on the epaulettes, and finally the sardonic and once well-known smile of Cao Van Dzung.

"Who let you in here?" he grumbled. "Major."

"McLintock invited me," said Major Cao easily, pointing to a group of NCOs at a table near the door who were busy passing around a very large bottle of Bundaberg rum to spice up their own beers.

"I didn't mean the sergeant's mess," said Westerley. "I meant the base."

"Who'd want to keep me out?" Cao signaled the bartender.

"Anyone who knows you."

"Lucky I came in with General Vinh Loc then."

"What's he want here?"

"Who knows?" shrugged Cao. "A slouch hat? A passport?"

He took a sip of the newly-arrived beer, which came in a frosted glass, beads of condensation making it slippery. The mess was air-conditioned, but not as effectively as an American NCO's club would be, the air still humid, if not as hot as outside.

"A passport?" asked Westerley, surprised.

Cao shrugged.

"He thinks about the future a lot, the general. He worries. Maybe not so confident now it seems Nixon meant what he said about troop withdrawals. I hear your lot are following that lead." Cao indicated the room. "They're all going home next week, aren't they? And no new battalion here to replace them. Or coming out."

"Yeah, well," said Westerley. "There's no reduction in the Team's numbers."

He was talking about the Australian Army Training Team Vietnam, to which he belonged, as indicated by the fact he wore the same tiger-stripe camo as Cao, not Australian Army green. Westerley was on his fourth tour, this time around attached as an advisor to an Army of South Vietnam Mike Force special unit. With the unit just returned from a spectacularly unsuccessful search and destroy mission just short of the DMZ, the officers and advisors had been sent on a few days leave to get them out of sight of anyone who mattered. It was good timing for Westerley, who had managed to hitch several helicopter rides to get over to Nui Dat to say goodbye to some mates in the 8th Battalion, Royal Australian Regiment, who were indeed heading home very shortly.

After their inauspicious greeting, Cao and Westerley drank in silence. Westerley knew the Vietnamese officer would get to whatever it was that had brought him here in due course, and that whatever it was, he wouldn't like it. He and Cao had served together in the Central Highlands, where the Major (then Captain) had commanded a Montagnard special forces unit and he'd been their advisor.

They'd been through a great deal together, including various things that would never appear in any official report, though one mission that had made it on the record, big time, was the recovery of the crew of a downed helicopter which turned out to be the Divisional C&C craft of a US major-general, with him on board. Cao's reward for that, besides the promotion, was to be seconded to some snake-eating, super-secret unit run out of MAC-SOG. Westerley had got a bar to the DCM he'd been awarded in Korea and had been issued a similar invitation, but had refused it. He didn't want to go

down the assassination road, which was where he thought Cao was headed.

Where he presumably was now.

"We want to borrow you for a while," Cao said finally, leaning close, his voice low. He'd stopped drinking at his third beer, letting Westerley continue on alone, now well into his tenth or eleventh.

"Who's we?" asked Westerley. They both spoke in Vietnamese now, the better to keep the conversation confidential. There were two other advisors in the mess who were fluent speakers, but the regular grunt NCOs typically only knew a few words. A significant failing in Westerley's opinion, but then he wasn't in charge.

"You know," said Cao. He made a highly unofficial field signal, an undulation of his hand with two fingers striking, suggesting a snake with fangs.

"What does that theatrical crap ... look, I told you before, I'm not doing the shooting people in the back of the head in the night shit," said Westerley.

"This isn't ... it's not one of those jobs," said Cao.

"What is it then?"

"Hard to describe," said Cao. He hesitated, then said, "Basically we want you to check out a bar."

"What?"

Cao hesitated again.

"You remember that time in Polei Kleng?"

"What time?"

Cao gave him a look. There was really no question about which particular time he was talking about.

"Yeah, I remember," said Westerley reluctantly. "I'm not quite sure exactly what ... but I remember. What's that got to do with this bar?"

"Maybe a lot," said Cao.

The event was a single, ferocious attack upon an ambush patrol that had been led by Cao, with Westerley along to coordinate artillery and air support. Fourteen veteran Montagnard soldiers—all comparable in Westerley's opinion to the American Green Berets, if not quite to his own home regiment, the Australian SAS—were killed in the surprise attack, which was not a counter-ambush, was not conducted with firearms, and as far as he could tell, actually had nothing to do with the Viet Cong or the NVA or in fact any human antagonist.

Cao's ambush had been professionally laid to pin any passing enemy coming along a trail against the deep stream that ran alongside it, with claymores at each end to close the killing ground and the ambushers concealed

in the thick undergrowth on the rising ground above the trail that ran next to the stream. The jungle was much denser behind, so it would be very difficult for any counterattack to dislodge the ambushers or for a probe to detect them.

But no one had come along the path or out of the deep jungle. All of a sudden, a single attacker was just *there*, right in the middle of the ambush position. He—or it—killed three men in the first dozen seconds by biting their heads off and went on to kill eleven others in the same fashion. Cao was an early, non-lethal casualty, flung down the slope into the stream by something he could not or would not later describe.

Westerley wasn't sure what he'd seen either, though he was sure he'd emptied an M-16 magazine into it to no effect. His traumatized memory included a glimpse of something like an enormous rainbow-scaled snake that reared upright on its lower coils, but it moved so swiftly in the moonlight he really wasn't sure what he'd seen, and everything had been made even more confusing by the smoke grenades that had been wrenched—or bitten—off the webbing of one of the victims, red and yellow smoke billowing everywhere.

His rifle proving ineffective, and his radio operator falling headless next to him, Westerley had fired a hand-held parachute flare straight at where he thought the creature was moving to next, punching it straight in front. The burning magnesium had hit *something* and, unlike the previous richocheting bullets, had given the creature pause. Westerley didn't think it had actually hurt it at all, but he wasn't going to wait and see. He ran up the hillside, plunging into the dense jungle, worming his way through a network of tree roots and undergrowth he hoped the beast couldn't navigate.

Whether it could or not, it didn't.

Westerley and Cao were the only survivors, Cao found six hundred meters downstream at dawn the next day, Westerley staggering back into camp a few hours later. By mutual agreement, they had not discussed nor reported what happened in any detail. Both were in hospital for several weeks afterwards, feigning concussion and confusion to go along with their numerous minor injuries. Westerley did in fact have a potentially serious gunshot wound, someone's panicked fire having creased his back, leaving him with three long, parallel scars that looked like he'd had a red-hot pitchfork applied to his skin. Two inches deeper and he would have been dead.

"I'm not going anywhere near anything like … whatever that was," said Westerley. "In fact, I'm not going anywhere. I'm staying here and drinking

beer until I pass out."

"I don't mean there will be a … naga … involved," said Cao.

"Naga?" asked Westerley. He knew a little about nagas, or at least had heard about them from his Montagnard soldiers. After his personal experience, he had changed from a skeptic about such things to share their belief, though he kept quiet about it.

Cao shrugged.

"It's a good enough name for something we don't … can't … know. But I don't mean there will be something like that creature involved. I have come to you because we asked General Vinh Loc's astrologer what we should do about this bar, this strange bar where there should not be a bar. And she said, 'It is for the beer-drinker, the star-shooter, the man of gold, the naga's lost prey.'"

"Could be anyone," said Westerley, his face set in the expression he used to scare the shit out of new recruits.

Cao laughed and tapped the warrant officer's glass.

"Beer-drinker."

"Yeah, well, it used to be fun. Can't say I even like the taste that much now. Even the VB they fly in tastes … disappointing."

"Star-shooter. The flare you fired, that saved us both. It would have come for me in the water, you know. You drove it back … somewhere."

"That was pure arse luck. If I'd had a kitchen sink on me, I'd have thrown that. It just turned out to be a flare."

"So you're lucky," said Cao. "That is also good."

Westerley rolled his eyes and took a deep swallow. The beer, every beer, *was* disappointing. It was cold, but that was all. It didn't even seem to make him drunk anymore. He couldn't get lost in it, like he'd always been able to do before. He just drank and drank and drank and it didn't make him cheerful, or boisterous, or do anything damn else, until the moment he went from lifting a glass to unconsciousness.

"The man of gold."

"Well, that's the prime bullshit that explodes the whole thing," said Westerley.

"Is it?" asked Cao. He turned around and called out to the group of sergeants and warrant officers gathered around the now nearly empty bottle of rum. "Hey, McLintock. What's Westerley's nickname again?"

"Nugget," called out McLintock. "Cos he's a turd."

One of the younger sergeants started to laugh, stopping immediately as

Westerley and McLintock both stared at him savagely and he realized no one else was laughing.

"Turds of a feather," said Westerley. He raised his glass to McLintock, who gravely raised his back. They drained their glasses together, then smashed them onto bar and table respectively, broken glass going everywhere.

"Nugget," said Cao. "Gold."

"Oh, come on," spat Westerley, wiping some blood on the bar cloth. "I got called Nugget because I'm short and wiry, it's got nothing to do with gold."

"The naga's lost prey."

"That could be you," protested Westerley. He gripped the Major's wrist, tight around his watch, hard enough to hurt, though Cao didn't react. "You've got a gold Rolex. You're the man of gold."

"I don't drink beer," said Cao. "Not normally. Only with you."

"Fuck," said Westerley, his voice as tired as it ever got. "I just worked out why the General's really here."

"Yes," said Cao. He smiled his sardonic smile. "My general, your Australian general, they like to help each other out. But I explained that would mean nothing if you didn't agree."

"Nah, it means I don't have a choice," said Westerley sourly. He wished the beer *was* having an effect. In the old days, after a dozen beers, he'd happily deck an officer, no matter whose army they belonged to, particularly in the sergeant's mess, since everyone would swear blind the officer fell or whatever, with three or four equally ludicrous alibis for Westerley on offer from his fellow NCOs.

He just didn't feel like it now. Fatalism, he supposed, something he was aware had been creeping over him this last tour. Que sera, sera, like Doris Day sang. Whatever will be, will be. You put an eighteen-year-old boy into green in the closing year of WW2 and after twenty-five years fighting the Japs, the Koreans, various Malayan insurgents, the Indonesians in Borneo, then the Viet Cong and the NVA, even enemies he couldn't describe or comprehend, it was quite clear the boy would not be famous or rich.

He would just end up not knowing what else to do, having somewhere along the line lost the ability to have a civilian life, a creeping malaise that was now reaching into his military life as well, beginning with the lack of savor in the beer that had always been his reward and escape and philosophical booster fluid.

"So tell me about the mission—this bar you want me 'to check out,'" said Westerley, falling back on the one thing he did know, that he could always be.

A professional soldier.

Cao started to talk. Very quietly.

* * *

Sixteen hours later, Westerley was looking at the suspect structure from the ruined bank of a bombed-out rice paddy. Cao was with him, talking to his headquarters on the radio. He'd brought two of his smiling killers with him, as well as the radio operator; they were out on the flanks. The long, tropical dusk was setting in, bringing with it all the usual bugs and making sweat and the humid air seem to be pretty much interchangeable. They'd been dropped five kilometers back and had walked and waded in the hard way, staying off paths.

The whole area had been designated a free-fire zone by the Americans some months before, but even that didn't explain the quiet. Nugget had never experienced such an absence of people, not anywhere he'd been in his time in-country. Cao and his men were nervous, too, something Westerley hadn't seen before either.

"It looks like it's made of adobe," said Westerley. "Kind of out of Texas or somewhere. You sure this isn't some weird Yank thing? Psy-ops or something?"

"It is made of mud bricks, we know that much," said Cao. "But not local mud. Wrong color. And the Americans … the ones that know about it are worried. They sent in a team as well."

"What?" spat Westerley. "You didn't tell me that! Surefire way to fuck everything up is not tell me shit like that!"

"I didn't know," said Cao. He looked across at his radio operator, who was lying on his side against the earthen wall, making sure the folded-over bush-whip antenna of his ANPRC-77 stayed below the rim of the bank. "I just got word."

"I hate this fucking left-hand right-hand bullshit," said Westerley. "Who'd they send in?"

"Ranger lurp," said Cao. "Six men. Went in just before noon, none came out."

"And eight of your guys the day before? Went in, didn't come out?"

"Yes, eight."

"Got to be a tunnel complex below, but … no communication at all?

Nothing?"

"Both units confirmed they were about to enter, then nothing," said Cao. "I had two men to cover mine, a little closer than we are now. They heard nothing, saw nothing. They waited two hours, then retreated to the LZ and reported. That's when the General asked his astrologer and I came to find you."

"The Americans have anyone else here now?" snapped Westerley.

"No one has told me they do," said Cao.

"Find out," said Westerley. "I'm going to take a look. By myself."

Cao nodded and took the handset from his radio operator again. Westerley was a little surprised. He'd expected an argument, expected Cao would want to come along. But then this whole thing wasn't anything like normal.

A fucking two story adobe building in a destroyed village in a free fire zone with a flashing neon sign above the main door that said "Bar." It was either the most complex practical joke ever perpetrated in wartime—or it was even weirder than that night by the stream eight kilometers out of Polei Kleng.

Westerley took his time getting to the bar, moving from cover to cover, pausing to listen and watch. It was still strangely quiet and that was another oddity, since that flashing neon sign had to be powered by something and he couldn't hear the familiar chug of a diesel generator. Maybe they had big batteries and only ran the generator part of the time …

He was about forty meters away, prone in the dirt by the fallen corner of what might once have been the village temple, when he did hear a faint drone and for a moment was reassured that there was a generator here after all and the neon sign could be explained. But then he realized the sound was more distant and up high. Rolling on his side, he scanned the darkening sky until he saw it. A very faint speck of a silhouette, orbiting the village maybe nine hundred meters out and about two thousand meters up. An OH-1 Bird Dog, almost certainly American, with a forward air controller aboard, ready and more than willing to order in artillery or air strikes to support the Ranger LRRP who'd gone into the bar earlier today.

Or to avenge them, Westerley thought, and was grateful Cao spoke such excellent English and was very experienced working with American FACs and pilots. Cao would make sure there would be no unexpected rain of artillery, bombs, or napalm while Westerley was reconnoitering the bar.

He watched the building for twenty minutes, until the dusk gave way to real dark. Or what would have been the dark he knew so well if it wasn't

for the neon sign.

There didn't appear to be any way in apart from the front door. The windows were heavily shuttered and flush with the walls. There might be an entry point in the roof, but he didn't think he could climb up to it. The sign had looked promising from a distance, to be used as a handhold, but it was higher up than it looked, at least ten feet. The whole building was bigger than it had looked from the rice paddy, which was something else to give him pause.

All he could hear was the faint, distant buzz of the Bird Dog. No birds, no frogs, no livestock, no human noises.

The door opened a crack, light spilling out. Westerley shut one eye to preserve his night vision and settled his elbows and the CAR-15 into his shoulder, ready to take the shot.

"You coming in for a beer or what?" asked an unseen voice. A deep, male voice. In English, with an accent Westerley couldn't place. Maybe a mixture of accents.

With the man's words came the scent of beer. Real beer, like he used to smell when he was a kid growing up in the near-slum of Redfern. When the wind blew right, the yeasty, malty smell of the Tooth's brewery would wash across, often just before a summer thunderstorm. Fresh beer and humidity—the two were linked in Westerley's mind with childhood, the innocent time before his first war, though even that seemed like a more innocent time than now. Fighting the Japanese had been … straightforward.

Westerley's finger curled back—outside the trigger guard. He took another deep sniff of that amazing beer smell, hesitated, then stood up, stepping forward out of his partial concealment. He kept his carbine ready, squinting to see the shadows around and inside that door, where the neon light didn't reach.

"Reckon I'll try the beer," he said.

Whoever had spoken didn't come out, but the door yawed wider and the smell of beer grew stronger. There was noise now: bar sound, pub sound, people talking and drinking, stools or chairs shifting, glasses clinking, a knife scraping on a plate. Soft light spilled out, candlelight, not harsh neon or anything electric.

The man in the doorway was huge, six foot six or more, and hugely muscled. Dark-skinned, but not an African. He had a shaped beard, braided with little leather cords. He wore an odd white tunic and a sort of leather kilt. His large, thick-fingered hands were empty and Westerley saw no obvious

weapons.

"I'm Gil," he said. "This is my place. Welcome."

Westerley lowered his carbine, thumbed the safety. Whatever was happening here, he knew instinctively he wasn't going to fight his way out of it. This man had the same sort of ... feel ... aura ... he didn't know how to describe it ... as the creature Westerley had fired the flare at it in the jungle ambush the year before.

"Come on in," said Gil, turning to provide the broad target of his back. "There's some baskets just here, you can leave your weapons. Keep your knives. We don't mind knives."

Westerley followed him into a long corridor lit by candles in sconces carved out of the mud-brick walls. The floor was paved stone and looked very old. Halfway along, there were half a dozen tall wicker baskets with a wide variety of weapons protruding: M-16s, AK-47s, a Garand, a couple of RPG-7s, even a couple of old French MAS-49s.

"Grenades on the shelf at the end," said Gil, lifting a curtain to go into the bar proper. Scent, noise, and light increased for a moment, then the curtain fell back.

Westerley carefully put his carbine and .45 pistol in one basket and his two fragmentation and two smoke grenades on the low shelf he hadn't seen at first, beyond the last basket. There were already a lot of other grenades there, again, of all types: US, Russian, French, Chinese.

He unclipped the knife on his shoulder webbing before he drew back the curtain, went into the bar, and stopped, the curtain sliding down across the back of his neck.

It was the kind of place he liked. About twice the size of the sergeant's mess at Nui Dat—which was bigger than seemed possible from outside. Half a dozen long tables of old, dark wood, with benches of the same timber, ran through its center. Candles bunched in half-melted groups of five or six sat on platters of fired but unglazed clay. The actual bar ran the width of the room and it was made of the same stone as the floor. There were a lot of tankards on the bar, a varied lot, some glass, pewter, pottery, some even wood. And the shelves behind the bar were not lined with familiarly-labeled glass bottles, but clay jugs, stoppered with wooden bungs. Right in the middle, on a shelf of its own, there was a clay or maybe stone tablet carved with bird-scratch symbols. A tall white candle burned on either side of the tablet, as if it were a shrine or something.

There were maybe twenty people in the bar. Mostly men, though there

were some women. Everyone was in uniform, of one kind or another. He saw Cao's men, and the Rangers, and two women who were US Navy nurses, but there were also men and women in the black pajamas of the Viet Cong and the tan outfits of the NVA. Everyone, from all sides, they were all sitting together, mixed up, drinking beer, talking. Vietnamese and English, Korean too. A couple of men on the end were ROK "volunteers."

"Come and get that beer."

Gil was behind the bar, pouring a foamy brew from one of the clay jugs into a pewter tankard. In a daze, Westerley crossed the room and took up his usual stance, leaning on one leg, hip against the bar.

The beer Gil put down in front of him smelled truly wonderful. Westerley couldn't help but lick his lips. But still he hesitated.

"What is this place?"

"A bar. A once and future and always will be bar."

Westerley looked at the foamy head on the beer and swallowed, his throat dry. Still, he couldn't drink. Not yet.

"What's your bar ... doing here?"

"Serving beer," said Gil. He smiled. "You look like you need one. Or maybe two."

"Two won't even hit the sides," said Westerley, and gave in. He lifted the tankard and poured the beautiful fluid down his throat, washing away dust and grit and a few half-swallowed bugs, but even as he finished it, he knew it wasn't enough. Even the perfect beer couldn't wash him clean, couldn't carry him like a wave back into life, a proper life.

"Not bad," he said to Gil, with a smile that told a different valuation. "Can I have another?"

"One more," said Gil. "In a moment. Closing time, you see. Got to finish up before the B-52s unload."

"What? But Cao, he'll have told them I'm—"

"It wasn't up to Cao," said Gil. "His boss, the general. Lost his nerve, and doesn't want to know now, just wants us to go away, and he's convinced the Americans. But no harm will come to the bar. It's just that those Rangers, and your friend Cao's men, they have to go out the way they came in, in the village. So they need time to get clear."

"What about the others? The nurses, those two Koreans—"

"They came in a different door," said Gil. "They'll go out the same way. The main question is, what about you?"

"Me?" asked Westerley. "Uh ... I guess I'll go ... I'll go with the ..."

"You don't have to," said Gil. "You could stay here."

"Here?"

"Take over the bar. You understand beer. You're a warrior. And you'll live forever."

Westerley stared at him; not the recruit-scaring stare. This was the stare of someone profoundly misunderstood.

"I don't want to live forever," he said quietly. "I want ... I want to just live. I've fought four wars, at least, whatever you call them, and I ... I've had enough."

"You want to stop killing," said Gil.

"I want to stop my boys dying," said Westerley. He stopped leaning against the bar, stood straighter, almost at attention. "I'm twice their age, sometimes even more, and I can do so much, so little ... sometimes I can stop something stupid, sometimes I can get us all out of the shit. But never enough."

"Surely you can go home," said Gil. "You've done your time, and more."

"Yeah," said Westerley. "The only home I have is the Army. That's it. And the Army not at war is ... uh ... you wouldn't understand."

"I was a soldier," said Gil. "I know what you mean."

"How about that second beer?"

"In a moment," said Gil. He raised his voice, addressing the room.

"Time, ladies and gentlemen. Please pick up your weapons as you leave."

Westerley turned and leaned back against the bar to watch everyone go. Tankards were quickly drained, there was hand-shaking all around, everyone filed out through the curtained exit.

"I thought you said they'd go back where they came in," said Westerley, as the last customer left. It was one of the US Navy nurses. She glanced back and smiled—at Gil.

"Same door, different exit," rumbled Gil. "I'll get your drink now."

He reached under the bar and lifted out an even more ancient jug than the ones on the shelves behind him—and more firmly stoppered. Gil did not immediately open it.

"Tell me," he said. "You say you have no home but the Army. Have you tried to make one elsewhere?"

"Well, I got married after Korea," said Westerley. "That didn't work out."

"No children?"

"Nah. I wasn't around much. Suzy got tired of it. And the beer ... too much ... but I needed it."

"You expected your Suzy to make the home for you," said Gil. "Just as your Army does. But you have to work yourself to make a real home. Alone or together. If you want a life, as you say you do, then you must build it. Brick by brick."

He unstoppered the jug and the fumes of an even more potent beer flooded Westerley's senses. This ... this was the beer that might wash all clear, lift him to a bright future ...

"It isn't," said Gil, apparently in answer to Westerley's thoughts. "Everything you have done and been will still be with you. But it may clear your mind enough to build your new life, whatever it will be. If you make it happen."

Westerley drew in a deep breath, inhaling those wonderful fumes. Instinctively he knew that if he drank, no other beer would ever after tempt him. He would have to find something else to manage the demons within him. But the beer hadn't been enough anyway, this past year, so what would he be missing? And he *couldn't* keep his boys alive, he *couldn't* stop the killing, he *couldn't* alter the course of this benighted war by the slightest fraction.

He nodded. Gil poured. Westerley drank it down in a single, long swallow, set the tankard back on the bar, and released the longest sigh of his life.

"You have about twenty minutes to get clear before the bombing," said Gil. "It might be just enough."

"What about you let me out somewhere else?" Westerley asked thoughtfully. "Somewhere I might do some good? Can you do that?"

"Perhaps," said Gil. "It's not entirely up to me."

"So what do I do?"

"See what happens," said Gil. He extended one enormous hand. Westerley shook it and walked away.

When he lifted the curtain, the hallway was empty. There were no baskets of weapons, no shelf of grenades. The air smelled different, too, not so humid, and cooler, as if he were back in the Central Highlands, or maybe higher still.

Westerley paused for a moment, just a moment, then marched forward and flung open the door, disappearing into sunshine.

Back in the village, the bombs began to fall and the earth to convulse.

But the bar was already gone, vanished in the blink of several eyes; gone in the moment between the shutters opening and closing on bomb-bay cameras; gone as if it had never been there at all.

But If You Try Sometimes

Diana Pharaoh Francis

I was running from the Findlays when I plowed into a wall. Specifically, a cinderblock wall covered in peeling paint and mold.

Welcome to Moldton. This hellhole was named after Daniel Moldoviani, the guy who'd thought building a town between the forks of the Dismal River was a brilliant idea. Fact was, the place was hot and humid, even for Nebraska, and mold lay over everything like a diseased blanket. Take a clean shirt out of a drawer and, diamonds to nuts, there'd be mold in all the fold creases. You kept your furniture three inches away from the wall and hoped mold didn't grow on either. Rainbow Market's best-selling product was bleach. On a good day, the town smelled like wet socks someone had left in the cellar for a week. On a bad day—well, it plain old stunk.

The Findlays didn't like me. Truth be told, they didn't like anybody, but held a particular grudge against me ever since George Findlay had grabbed my ass at a church dance and I'd told him to fuck off and die. It wasn't the insult so much that made the family hate me as the fact that he'd woken up dead the next day and hadn't even known it. Not until breakfast when he bit off Me-Maw Findlay's hand. The rest of the family had had to kill him again, because you can't let undead folks walk around spreading disease and what have you and it seemed George was a little blood thirsty.

Ever since, they'd been looking for revenge. That's coming up on three months now and, so far, I've managed to keep out of their way.

I can't say for sure that I caused George's death. Or anybody else's, for that matter. But just in case, I'd kept my lips sealed since that day. Not a word passed them, not when I was alone, and not when three Findlay assholes were chasing me. I was pretty sure I wasn't going to like what they did to me when they caught me.

And they absolutely were going to catch me, because I'd run headlong into a wall. I bounced off it and collapsed onto the cracked pavement beside a steel door coated in faded orange paint. I lay there, my head spinning, big black blotches flying around me like moths. Blood dribbled down my face as I gasped like a catfish left high and dry on the bank.

The peeling cinderblock wall had not been there last night. It shouldn't have been there today. I lay there with my hands on my nose, trying to stop cascade of blood and catch my breath, all the while waiting for the Findlays to catch up and stomp my head to a pulp. They hadn't been far behind. I'd been leaving the post office when three of them had driven by. I'd shifted into a sprint as Josie and Lee had hopped out to chase me. Earl raced ahead to cut me off. Ha! Joke's on him. He'd be waiting awhile.

It wasn't much revenge, but you take your triumphs when you can.

I heard the rattle of the steel door unlatching and tensed. It swung open. The corner caught my shoulder and I swore. "Watch it, asshole," I moaned.

I was aware of someone standing in the doorway looking down at me. I tried to imagine what he saw: a scrawny chick with a giant lump on her forehead, dirty blond hair frizzed up from the humidity, and legs that could be tanned or could be dirty. For the record, they were both. Oh, and then there was all the blood.

"Looks like that hurt."

I was still gasping, so I flipped the owner of the voice the bird. Cuz right now, stating the obvious was really not helping.

"You going to lay there all day?"

I could hear some kind of accent, but it was faded, like threadbare fabric so thin it almost isn't there anymore.

"Nope." I managed the word, though my lips felt puffy.

"When do you plan to rise up?"

"Not going to."

Silence. The shadow moved and then the voice came from closer as the man crouched down. A big blunt finger ran down my cheek. "I am in-

trigued."

Bully for him.

"How do you plan to leave if you don't get up?"

"Pretty sure the Findlays will be along any minute to drag me off," I said.

"Friends?"

"Not so you'd notice."

"Enemies, then."

"That's closer." I was starting to breathe easier, but my vision still hadn't cleared up. My head ached like someone had cracked it with a sledgehammer.

"Perhaps they won't find you."

"If not today then tomorrow or the next day."

I couldn't keep ahead of them forever. I was getting tired of leaving the house before dawn and sneaking back whenever they weren't looking. Not that they put that much effort into catching me. Too lazy, thank God; every single one of them had the attention span of a gnat on an acid trip. When they saw me, they chased, and when they thought of it, they dropped by to graffiti my trailer.

On the other hand, they knew I wasn't going anywhere fast, and that they'd eventually corner me, and that nobody would bother to help me when they did. They'd noticed I hadn't been throwing any curses at them, so they'd stopped going out of their way to think up ways to trap me or knock me out, so I'd run myself into a rock wall just to show them.

"They're what you'd call tenacious. Rabidly tenacious."

"Come."

It might have been a command or an invitation or both, but it didn't matter how I might have responded because he grabbed the waistband of my jeans and dragged me close, then lifted me up and carried me inside.

The door closed and the light went from a harsh, steely sort of light, to a dim we-can't-quite-afford-enough-electricity sort of light. The bar—for it was a bar—looked like it had seen better days. Down one wall was a scratched and dented wood bar top with an array of part-full bottles huddled together on plywood shelves behind. Booths with cracked red vinyl seats and gray formica tabletops lined the walls and tables crowded the rutted and scraped oak floor. I could see a couple of quarter pool tables through a doorway into another room, along with a couple sagging couches facing a TV. Wood paneling slathered the walls and faded tin painted oxblood covered the ceiling. Spiderwebs clung to the corners.

"You need a new interior designer," I said as my rescuer—or kidnapper, depending on how this went—set me down in a chair at one of the rickety tables in the middle of the bar. He pulled some paper napkins out of the dispenser and handed them to me. I took them in a wad and pressed them against my nose to stanch the bleeding. That's when I got a good look at my companion.

He was a giant. I bet he barely had to hop to dunk a basket. Dr. J only wished he was that tall. The rest of my potential kidnapper was well formed—broad shoulders, slender waist, muscular thighs, taut forearms. He folded said arms, looking down at me, his gray-green eyes piercing. I didn't pay much attention, distracted by his braided black beard. The braiding was complicated, with gold, silver, copper, and bone beads woven through. The bottom was squared off like someone had taken a weedwhacker to it.

It looked positively Biblical. I wonder how many hours he had to sit in a beauty chair to get that done. No self-respecting barber would be caught dead braiding beards.

I opened my mouth to ask what the deal was, then snapped it shut. Shit. I'd been talking. I could have said something that hurt him. Even killed him, like George Findlay.

Thing is, as ridiculous as it sounds, I did curse George to death. I deserved everything I was going to get from his kin. Not that I'd meant to, and not that I'd ever done it before. But when the words left my lips, they went with a power that came from deep inside. The old country power, as my Nan would have said. I recognized it, though I'd never felt it. There was no missing the rumble of power through my body, the vibrations that trembled down into a place inside me I didn't even know existed.

The words stabbed into George like thrown knives. I saw them hit; saw his body flinch and his face turn pasty. Then I'd turned and run like my ass was catching fire.

I didn't know he'd wake up dead. Maybe it happened because of guilt. Telling him to fuck off and die, and then regretting the command enough to call him back to something like life. Either way, I killed him with words and I'd meant never to speak again. I had no idea how to control this ability and I didn't want to hurt innocent people. Or even the Findlays.

But bash my head once against a stone wall and I started blathering like an idiot. I raked my brain for what I'd said. It was all fuzzy, though I remember I'd flipped him the bird. I hadn't otherwise told him to go do anything like die or stick his head up his ass or anything else.

I looked around the bar. It smelled of beer and something savory and delicious. I realized a couple of patrons occupied the corner booth. Both wore dirty coveralls and ratty ball caps and I could smell the gas wafting off them from across the room. Other than that, the place was empty but for me and Mister Barbie Beauty Center, or maybe it should have been Mister Ken.

"Bathroom?" I asked after considering whether that single word could do any harm.

"I'm Gil," was not a helpful reply. His brows rose, prompting me to reply in kind.

I flushed. "Melissa. Missy."

"Which?"

"Pick one. Where's the bathroom?" I prompted again. I wanted to wash my face and take an account of the damage the wall had inflicted on me.

He eyed me a moment, then pointed me in the right direction. I stood up. Immediately my head started spinning and pounding, like a dozen Budweiser Clydesdales galloped in circles around the outside of my skull. I caught the back of my chair to steady myself, blinking hard to clear my blurry vision.

Taking a breath, I strode across the bar hoping I didn't bounce off any furniture or collapse in a heap.

I made it to the bathroom without incident. Like the rest of the place, it was a lesson in how-not-to-decorate-a-bar. The door was made of unfinished plywood and sagged from two pieces of chain looped through holes on the side of the plank and bolted to the jamb. I pushed it open and squeezed inside the tiny one-hole bathroom. A stained urinal on the wall indicated the bathroom might be the only one of its kind in the bar. Must make for long lines on a Saturday night. Or maybe not. The place gave dives a bad name. Probably one bathroom was enough for the handful of customers that ventured inside. I just couldn't imagine how or why Gil's bar had ended up in Moldton. You didn't build a place like this overnight. Except that's exactly what had happened. Either that or it had dropped out of a tornado like the house in the *Wizard of Oz*. To be honest, both seemed equally viable options.

I went to the sink and examined myself in the hazy mirror. I looked like hell. Blood had stopped flowing out of my nose, but I was going to have at least one black eye, probably two, and I had a bad feeling my nose was broken. Like I could afford to get that fixed. The scrapes on my forehead and chin had scabbed over already.

I washed my face and hands and did my best to clean the blood off my

clothes. My BeeGees shirt was toast. Not a bad thing. They sang like their balls were in a vise.

Once I was as cleaned up as I was going to get, I returned to the main room. Mr. Tall, Giant, and Weird stood exactly where I'd left him. He watched me cross back to the table, his face inscrutable. I resisted the urge to smooth my hair.

I stopped in front of him. "This place wasn't here yesterday," I said, my mouth taking over without any consultation with my brain.

My rescuer nodded. Was that a yes or a "No shit, Sherlock?"

"Why did you run into my wall?"

Like I'd meant to. Like he was somehow put out by my temerity in bashing myself headlong into his damned building. I hoped I'd left a bloodstain he couldn't get out.

"Seemed like a good idea at the time." I gave him a shit-eating grin. I expected the big guy to get irritated, but instead, the interest in his eyes sharpened. Not the lust kind, but the bug-under-a-microscope kind. What was wrong with him?

"Were you running to something or away?"

"Both." To home and away from the Findlays.

"Sit."

I don't know if it was a command, a suggestion, or a request, but it got my back up. I folded my arms, my chin jutting stubbornly.

Giant Gil just waited like he had all the time in the world. I mentally settled in for the long haul. I'm known to be that girl who cuts off her nose to spite her face.

After a couple minutes, it seemed to dawn on him that I was ready to wait him out. He frowned. "Why do you stand?"

"I don't take orders. Not from you, not from anybody." Which wasn't entirely true. I could take orders from bosses, as long as I didn't disagree with them.

He scratched his jaw. "I will get you a drink."

He walked off before I could say no or yes or anything else. But then, he clearly wasn't interested in whether I wanted anything or not.

Catching my bottom lip between my teeth, I contemplated the doors. The Findlays were probably still out there. Even if they weren't, it didn't really matter. They were going to catch me, sooner or later. What's the worse they could do? Maybe I could get away with a simple tar and feathering. On the other hand, the Findlays took family bonds seriously and it wouldn't hurt

their feelings to get some payback. I didn't think I'd like torture.

I sighed. Maybe I just needed to leave town. Walk out and start somewhere fresh. I grimaced. And maybe on my way, I could get raped while hitchhiking. Or Leatherface could cut me into cat food.

I had arrived at exactly no ideas or decisions when Gil returned. He set a pewter mug of frothy beer on the table and, beside it, a tiny glass no bigger than a thimble. He sat, pushing out my chair with his foot. A bottle joined the other two items on the tabletop. When I looked at it full on, its graceful curves seemed clear, but for the pink liquid inside. When I turned, it played at the corners of my sight—an aura of blue enclosing it, with a pulsing heart of warm, yellow light.

"What is that?"

"Sit. I will explain."

Since I'm naturally nosy, I decided to do as requested.

He leaned forward, bracing his elbows on the scarred tabletop. He tapped the rim of the beer. "This is ale. The recipe goes back thousands of years." His eyes flicked to a clay tablet hanging on the wall behind the bartop, then back to me. "It's *only* ale. This—" He tapped the stopper of the bottle. "This will give you what you need." He eyed me, waiting, his cryptic words hanging in the air between us.

"What do you mean—give me what I need?"

He smiled, a not entirely friendly expression, and steepled his fingers together like I imagined Darth Vader would, if he ever did anything as mundane as sit at a table in a bar.

"I can only tell you what it does. You may drink or not. The risk is yours to take."

"Risk? Is it poisonous?" I didn't think that's what he meant, but I didn't want to say what I'd begun to think, since it probably meant I needed to send for the men in white coats to haul me off to a rubber room.

He shook his head, then shrugged. "It will give you what you need. If that is poison, then it is poisonous."

Hell of a recommendation. I felt like Alice in Wonderland. Drink this. What had happened when she did? Shrinking into an ant or growing into a giant? I had a bad feeling those two things weren't out of the realm of possibility. Any more than a bar arriving out of the blue in a place it had never been before, or a girl accidentally killing and zombifying a groping scuzzball.

I looked at Gil again. He'd sat back to watch me.

"What do you get out of this?"

"Entertainment. I have been bored of late."

"Fuck-de-doodle. Glad I can help you out of a jam."

A smile. "I am as well."

I sat down, eyeing the two drinks. Either or. Maybe both, who knew? The question returned: what was I going to do about the Findlays? I still didn't know. Maybe drinking was the best answer. Just because it hadn't worked before, didn't mean it couldn't work this time.

"Fine. I'll try the mystery drink." Mostly because I desperately wanted to find out what it tasted like. I imagined it was out of this world.

Gil leaned forward and unstoppered the bottle. A scent like nothing I'd ever smelled before wafted out and seemed to fill the bar. Prickles ran uncomfortable down my body. I shifted uneasily. Was I really going to do this? The tiny little glass wasn't much, but a hit of acid was much smaller and packed an enormous punch. I'd heard.

I bit my lip, then reached for the glass. What did I have to lose?

I tipped the glass into my mouth and the liquid flowed over my tongue. Instead of nectar of the gods, I got sugary vomit, like supersweet cough syrup mixed with burned cabbage and fish. My stomach heaved and I put my hand over my lips. I was *not* going to lose it in public, especially not in front of Gil, who grinned at me and reached for the ale. I slapped his hand away. His brows rose, but he withdrew. Good, because I'd start with the ale to kill the taste in my mouth and then start licking the garbage can. It had to taste better.

"What the hell?" I demanded when I no longer feared puking. "That tasted like ass. You could have warned me."

He shrugged. "I have not drunk the elixir. The flavor changes for everyone."

I wonder if anybody else had ever tasted something worse. "What happens now?" I was waiting for something big—some kind of sign, like maybe a genie popping in to grant me three wishes, or a stampede of cows right down mainstreet.

"You have what you need."

"And what's that?" I drank some of the ale, swishing it around in my mouth before swallowing. It didn't help.

"I cannot know."

I glared at him. "That's not even a little bit helpful."

"I have given you what you need. I can do no more."

"Aren't bartenders supposed to give helpful advice?"

He tapped blunt fingers on the table and eyed me speculatively. "I don't know your problems."

He had a point. "I guess."

"Do you want to tell me your problems?"

Yes. Why, I didn't have a clue. Maybe it's just because bartenders were cheap therapists. "Not really."

The glint of interest faded from his eyes. He stood. "Good luck."

"I kind of maybe killed someone and brought him back to life except he was more like a zombie and the rest of the Findlays—his family—are out to get me." The words tumbled out in a mad froth. I didn't want him to walk away. I didn't want to leave. "I used magic. I cursed him."

I braced myself for derision. But then, why would he? His bar had appeared out of nowhere. More magic.

"They were chasing you."

"Yes."

"And you let them?"

What the hell? I was the victim here. "What was I going to do? They were going to beat the snot out of me and probably throw me off a cliff after."

"You didn't fight."

I couldn't tell if that was an observation or an accusation.

I decided it was the second choice. My chin jutted. "I couldn't win."

His head tipped. "Couldn't you?"

I knew what he was suggesting. Use the magic in my voice. "I don't know how to make it happen or how to control it," I said, folding my arms over my stomach.

"Learn."

"By practicing on who? And what would they suffer if I did?"

"If your enemies suffer, why do you care? It is the way of war."

"I'm not a soldier." I couldn't explain that I didn't want to use this power. I didn't want to hurt anyone. Not seriously, anyhow. I just wanted all the Findlays to forget about me and leave me alone. So why didn't I tell them to do that, let the magic in my voice make it happen?

Because every time I thought of doing that, I imagined all the ways it could go wrong. Like they forgot about me and how to breathe, too. Or maybe they'd forget to eat or drink or sleep. I'd read enough fairy tales in my life to know that making the wrong wish—wording something the

wrong way—always happened with magic. I couldn't bear the thought of killing another person.

I bit the inside of my lip until I tasted blood. Maybe I was just a coward.

"No, you're not a soldier," Gil agreed, considering me. I was small, but wiry. Fast. "That doesn't mean you can't fight."

I just shook my head. I'd stupidly hoped that drink would actually give me the answer. No such luck. But then, the fairy tales said that, too—magic was a curse, not a gift, and you couldn't trust it.

Right then's when I ran out of time.

The two front doors thrust open, letting in the thin, gray sunlight, along with three menacing silhouettes. I bit back the words that popped into my mouth before I accidentally killed them. Or worse.

The doors clacked shut and in the light of the bar the three silhouettes resolved into people.

Lee was the oldest. He stood a head taller than the other two, with a lean frame and the muscles that come from bucking hay and building fence. Standing next to Lee was Earl. He was stocky with curly brown hair and shoulders that stretched his shirts so hard I was surprised the seams held. Last was Josie. Towheaded blond and built like a brick outhouse, as most of the guys in town said when she walked by. A lot of male drool tended to drip in her wake. Of the three, Josie was the smartest and meanest.

"Time to face the music, Little Miss Muffet," she said, her lip curling. It always did, even when she smiled.

That was my nickname. Had been since kindergarten when Jack Findlay had pinned it on me. Jack and Josie were twins. He'd joined the army, or I'd be facing four instead of three right now. The rest of the Findlay clan—and there was an endless supply of brothers and sisters, cousins, aunts and uncles, great whatevers—did their part to torture me from more of a distance. Which is why I could barely find work and my car had a tank full of sugared gas and why most of the town shunned me. Half the time I couldn't decide if they wanted to run me off or just make me miserable.

Mostly I kept body and soul together by working odd jobs for people—under the table. That and working in the cornfields. Even the Findlays couldn't afford to pass up a pair of hands during detasseling season.

I glanced over my shoulder, only to discover that Gil had vanished. Great. I guess I was on my own.

I turned to face my three persecutors. I decided not to play defense, but to rush right into offense. Mostly because I didn't have much of a choice. I

knotted my hands into fists.

"You know, if you really thought I killed and resurrected George, then why aren't you worried about what I'll do to you?"

Lee and Earl glanced at each other and then at Josie-the-ringleader.

"If you could, you would have," she declared with absolutely no logic at all. Because I could've and I didn't.

I was still hoping the drink would work as advertised and miraculously give me what I needed, whatever the hell that was. I'd settle for a shotgun at this point.

Inwardly I snorted at myself. That was dumb cubed. What good would a shotgun do when I wouldn't use the weapon I *did* have?

"What do you want from me?" I asked finally.

"I want to put my fist through your face," Josie said. "Lee and Earl, here, they want to see how many pretty colors of purple they can turn you before they use you for target practice."

I opened my mouth to make a cutting reply, but I couldn't. Fear had me by the throat. I knew damned well she wasn't joking or exaggerating. The Findlays dealt out their own kind of justice and it was always bad.

That doesn't mean you can't fight. Gil's words galloped through my mind. I could tell them to go to hell. Did I really want to send them to endless burning torture? I could tell them to leave me alone, but they might just twist that into dumping me into a deep hole and leaving me to die.

So what could I do? I'd lose in a fist fight. They'd drag me out by my hair and I didn't think Gil or the two greasemonkeys in the corner booth were going to help me. *Think, Missy! Think!*

I looked down at the little glass. What did I need? Dozens of answers ran through my brain, not the least of which was help. *Please God, let somebody help me.*

Nobody answered, as usual, but I had been kinda hoping Gil might come out of wherever he disappeared to and have my back.

The drink hadn't done shit for me. I was all I'd ever had and all I was going to have. So now I had to decide—what was I willing to risk to be safe? No, the real question was—what did I have to lose if I didn't? And the answer was my life, which was worth something, at least to me.

I stared at my three foes, trying to sort out the best words, the best curse. I needed something that wouldn't bring all the other Findlays down on me and bring on a repeat of this situation.

I took a breath, feeling for the power that was always there, always wait-

ing. It surged, spiraling through me like hot stardust. I could do this. I was ready. Still, I had to force my mouth to shape the words.

"Lee—"

His named flowed out of my mouth on silver glitter. I felt my eyes bug and I slapped my hand over my mouth. What the hell was that? Earl and Josie stepped back, mouths hanging open. Lee had gone stiff, the silver sparkles swirling around him and fixing him in place.

The power pushed inside me, demanding to be used. But now that I'd seen it manifest, I was no longer so sure I should use it. On the other hand, if I didn't, Lee might be left standing there for a hundred years.

"You bitch! You *did* kill George!" Josie exclaimed.

I didn't mean to. I didn't say it. I didn't dare.

I chose my words carefully. "Lee, go home and study for college and get your degree, make a lot of money, and have a great life."

Without a word, he turned and walked away, a man on a mission. One down.

"Earl, you've always wanted to travel and see the world. Go become a photographer. Travel wherever your heart desires and take pictures. You'll win awards and have a wife and kids and be very rich and happy."

Like Lee, the sparks of my words whirled around him, winding him in my spell. Then he, too, turned around and walked out of the bar. That left Josie.

"Keep your damned magic to yourself!" she shouted, backing up against the wall, one finger stabbing the air at me. "Don't you dare tell me what to do!"

I debated. She'd never stop coming after me. She'd come worse now that she'd seen what I could do. I gave her a little shrug of apology. "Go to Hollywood. Be a famous movie star. Get rich, be happy, and enjoy your life."

The magic wrapped her and in a moment she left, too, doors clacketing closed behind her. I let out a sigh, letting the magic swirling through me settle like snow in a snowglobe.

"Interesting choice of curses," Gil said from behind the bar, where he was wiping a cloth over the already-gleaming wood.

Sure, now that the fireworks were over, he came back out of the woodwork. I wandered over to sit on a stool. "You think I should have done something different?"

"Not for me to say. Like I said, interesting." He paused, giving me a steady look. "I appreciate interesting people."

I flushed, but didn't look away. "I still don't know what that potion gave me that I needed. Or was it a *Wizard of Oz* thing? It gave me courage or a heart or something like that?" I couldn't keep the disappointment out of my voice. I'd hoped—I'd wanted—something more, something better than that. Something … magical. Life-changing.

Gil reached for a tankard, drew another ale, and slid it across the bar top to me. "What do you think?"

"I think that shit is about as useful as a sugar pill," I grumbled.

"Perhaps you need something else."

"I need lots of stuff."

"Like what?"

"I could use some new underwear. Maybe a new bra."

Gil laughed at that. "You do surprise me," he said, drawing himself a tankard of ale and sucking down half in one long drink. "What else do you need?"

I pushed off the stool. "I'd better go."

Disappointment flickered across his expression, then smoothed away. "Farewell, then."

I gave a little nod. "Thanks for picking me up out there." I turned and went to the doors. The two men in the corner booth watched me. I guess me using magic had caught their attention.

I reached the door and put my hand on one of the pushbars. I stopped. There was one thing I really needed, more than anything. But did I ask? God, I hated asking for anything. I supposed I could use my power and take what I needed, but just the thought made me nauseous. That was like slavery or rape or something. Evil.

I looked up at the ceiling, breathing in deeply. My hand fell to my side and I turned.

"There is one thing you could help me with."

Gil looked up from a newspaper he'd opened on the bar. "What's that?"

"I need a job."

I waited for him to answer, a hot flush rising up from my toes. I bit my lower lip and wrapped my arms around my stomach, watching him all the while.

"Are you sure? This place is … strange. And you might find yourself elsewhere with no warning. You would find the clientele unusual."

"I'm unusual. I'd fit right in"

Gil just kept looking at me.

I nodded. "I'm sure."

The corner of his mouth quirked. "I could use an extra pair of hands." He considered another moment, then tipped his chin toward a staircase I hadn't noticed before. "Pick any room you want."

A room? As in live here? But then, of course I'd have to live here. What if the place took off in the middle of the night when I was at home asleep?

"I'll be back. I have to get my things."

"You should hurry. The place has a mind of its own."

I nodded understanding, then fled through the door, feeling lighter than I'd been in a long time. The elixir hadn't helped me with the Findlays because I didn't need help. I needed something else, something I hadn't had my whole life.

A home.

Of course, it might not have been the elixir's fault at all. Maybe Gil just had a soft spot hidden deep, deep, deep—way deep—down. Then again, the giant jerk had left me alone to deal with the Findlays, so any soft spot was probably just a sign of rot.

No—I was going to give the elixir all the credit. *Something* good had to come from that horrendous flavor. It had given me the courage to recognize what I needed and ask for it. Maybe it had even looked into the future and brought the bar here in the first place, before I ever tasted it.

Not that it mattered. Whoever was responsible—the elixir, Gil, or just plain old me—I was finally home.

The Whispering Voice

David Keener

What she needed more than anything was a drink.

Anna Brodie knew it was wrong, knew that alcohol was the furthest thing from what she really needed, but old habits died hard. A drink, just one drink, and then she'd leave and do what needed to be done.

Liquid courage.

Driving down Frankford Avenue in her Toyota Camry, it was easy to convince herself that—she glanced over at the radio/clock to see the time—at 11:17 AM on a fine, sunny Monday morning, the best thing she could do in her situation was to walk into a bar. Yeah, right. And then reality obliged her; there was a new tavern up ahead where Linda's Cafe had been before it went out of business. The only thing that was odd was that it didn't have a neon sign like most of the other businesses around it, just a wooden sign with a design that seemed vaguely foreign.

She slowed down, turned right, and followed a narrow lane to the parking lot behind the bar.

Walking back down the lane to get to the establishment's front entrance, she had to move to one side as an old, battered sedan with more rust than paint rolled slowly past her toward the lot in back. The driver, a twenty-something man with long, lanky hair and a sallow face, gave her a lingering once-over as he went by. The way he looked at her made her feel dirty, like an object and not a woman. She was almost twice his age, with a

daughter and a husband waiting for her back home.

Waiting for her … and here she was, about to walk into a bar for the first time in eighteen years. Anna almost turned around, but then she realized that she'd have to face the man in the car again. A moment later, she was around the corner and pushing her way into the tavern. It was dim inside, with a few rough-hewn wooden tables scattered around and a bar with five or six mismatched stools directly opposite the entrance. The establishment was empty, except for a lone customer sitting on one of the stools

Approaching, she saw that her fellow customer was a man in what looked like a long, dark robe with the hood pulled up so that it obscured his face. That was weird, kind of gangsterish in a way, and not really something she recalled seeing in any bar except maybe around Halloween. Still, he didn't worry her the way the man in the car had.

She took a seat a couple places down from the robed man. Then the bartender came out of the back and drove any thoughts of her fellow morning drinker out of her head. He was tall, a head taller even than her husband, who'd once played college football, and broad-shouldered like he could wrestle a bull to the ground with his bare hands. She shook her head. She had no idea why that image had popped into her head.

Coming over, he said, "Name's Gil. What would you like?"

"Shot of tequila."

"Don't have tequila."

She frowned. What kind of bar didn't have tequila? "A shot of anything, then."

He looked at her inscrutably. "All right."

The bartender turned around and pulled what looked like a ceramic jar off a shelf. Not even a bottle, a jar. She didn't know of any alcoholic beverages that came in ceramic packaging. Still, it looked clear and dangerous when he poured a measure into the shot glass he'd placed in front of her.

Behind her, she heard somebody come into the bar, though she was too busy contemplating the drink in front of her to turn and see who'd walked in. Besides, if it was the man from the parking lot, somehow she wasn't the least bit worried with Gil here. She barely noticed as the bartender walked away.

"You going to drink that or just look at it?" The voice came from the man sitting a few seats down from her. She glanced sideways, but still couldn't see his face because of the hood.

"Drink it," she answered. "At least, I think so."

"Trying to work up your courage, eh?"

"Yeah."

"I know how it is," the man said. "You've got a problem you can't figure out how to solve, so you reach for the thing that will at least make you feel better." The man turned towards her and pulled back his hood. He had penetrating blue eyes, an olive complexion, a roughly trimmed red beard, and what looked like an afro that was just as red as his beard. Whatever ethnicity he was, she'd never beheld the combination before. "Except that you know that it won't really make you feel better. And it won't solve your problem, either."

Anna couldn't help it. The tears started flowing. In a moment, she was hunched over her shot glass, shoulders shaking with the force of her sobs. As she cried, she was dimly aware that the man had moved to the stool next to her and was rubbing her back in a comfortable, fatherly way, while calmly telling her that everything was going to be fine.

She looked up at him through her tears. "You don't know a thing about my situation."

The man shrugged and gave her a quirky smile. "How long have you been sober?"

"What?"

"It's a simple question. I know you know the answer."

She sighed. "My last drink was eighteen years, ten months and twenty days ago." Since she'd found out she was pregnant with her daughter and realized that her totally out-of-control lifestyle of parties, alcohol, and nose candy had to end.

"You can call me Khalish," the man said. "I'm afraid you'd find my full name terribly difficult to pronounce." He looked down at her shot glass. "Offer me your drink."

Anna tilted her head and looked at him for a moment. He had blue eyes in a weathered face that made it hard to guess his age, although he certainly wasn't young. There was a strange intensity to his gaze, as if her offering the drink to him was somehow important in a way that she didn't understand. She pushed the shot glass in his direction, though her emotions were in such a whirl that she couldn't have said precisely why she did it. Except that, somehow, she trusted Khalish.

He smiled and reached up to gently cup her cheek in his hand. "Go clean yourself up, Anna. When you come back, you can tell me about your problem."

Anna nodded, unable to speak, suddenly hopeful that maybe there was a way out of her situation. A way for her husband and daughter to survive the catastrophe that had befallen them. It didn't occur to her to wonder how Khalish knew her name.

* * *

After Anna left to find the bar's facilities, such as they were, Khalish crooked his finger and beckoned the bartender over.

"I see you tricked your way into getting a drink," Gil said.

"It's not trickery," Khalish answered. "She gave me an offering. She needs our help."

Gil raised his eyebrows. "Our help?"

"Yours, really," Khalish admitted. "At least right now."

"How do they say it nowadays?" The bartender pretended to think for a moment. "Yes, I remember now. Screw you. I don't do the bidding of the gods, not even a minor has-been like you."

Khalish laughed. "Don't get uppity with the gods, Gilgamesh. It didn't work out so well for you last time."

Gil leaned over the bar, which might have been intimidating to most people, but intimidation emphatically didn't work on Khalish. As divine beings went, he was barely on the scale, but if intimidation had an opposite, opposing force, he basically embodied it.

"Gil," he whispered. "The man at the table by the door has been trailing Anna to make sure she follows the instructions she's been given. Since she hasn't, he's going to kill her as soon as she leaves. I admit, you don't have to do anything I tell you, but if you don't take him out, her blood will be on your hands, not mine."

"Why don't you do it, then?"

Khalish sighed. "I'd be happy to. The man's a murderer, a rapist, and a thief. But I'm bound to influence, not to intervene directly. It's better this way. We really don't need another fiasco like Pompeii." He shook his head. "Just help her, Gil. Please."

Gil grimaced and walked away. Khalish turned to watch as the burly bartender stepped out from behind the bar and approached the man at the table.

"Why have you been following that woman?"

The man cursed at Gil, then fumbled his jacket open and started to draw a gun. Gil struck out with a fist that smote like lightning, knocking the man backwards out of his chair and slamming his head into the wall. While the man was still dazed, Gil reached down with both hands and grabbed his

head. Twisting, he deliberately snapped the thug's neck.

Then he picked up the man's body, threw it over his shoulder, and carried it past the bar. "Nobody threatens me with a weapon in my own bar. I assume you can dispose of the body after the bar closes?"

"Yes," Khalish said. "That I can do." His lips quirked up into a half-smile. "Being dead and all, I hardly think that will count as an intervention."

Gill nodded. He shouldered open the door to the storage room and dropped the body inside with a dull *thud*.

* * *

Anna returned from the restroom with her face scrubbed and her hair pulled back and tied. She plopped herself onto the stool next to Khalish and fixed him with an intent gaze. "How did you know my name?

"I'm a god," Khalish said, smiling. "I'm supposed to know things."

She gave him an incredulous look. "You're God?" To think, she'd actually taken this loon seriously. Her family was in danger and she was wasting time with this idiot. Of course, she was an alcoholic in a bar during a crisis, so he wasn't alone in being a total idiot.

"Not God, or at least not the one God you're thinking of. I'm an old god, Anna. The God you speak of is but a baby compared to me."

She rolled her eyes. "You expect me to believe this? Seriously?"

"You are the descendant of countless generations of forgotten ancestors, the last in a long, long chain. Before the Sumerians, the Assyrians, and countless other tribes and civilizations lost in the deepness of time, I was there. I was the voice whispering in the back of people's minds, helping them conqueror their fear of the darkness, of the ravenous forest fires that plagued their migrations, of the ever-encroaching ice, and their unreasoning horror of the glowing eyes in the shadows beyond their campfires. I was perseverance and fortitude and courage. I was the spirit that never gave up hope, even when all was lost."

She had goosebumps on her arms. For just a moment, she believed him, then reason took hold again. "You're insane."

"No." Khalish shrugged. "Just operating on a plane you're not used to."

"Yeah, right." She turned to the bartender. "This guy's like, you know, totally out to lunch."

Gil stopped wiping down the bar top and fixed her with a steady gaze. "Well, he can be like a sharp stone in a boot sometimes, but he is a god, though not a very powerful one anymore."

"No worshippers," Khalish said, smiling sadly. "It happens to all of us

eventually, I suppose."

She stood up, the stool sliding backwards as she did so. "I'm outta here, guys." She shook her head. "This is way too crazy for me." She walked away from the bar.

Before she got to the door, Khalish said, "They won't honor their promise, you know." Anna stopped in her tracks, her back still facing him. "They need to make sure all the witnesses that can identify them are dead or their little streak will come to an end." She turned around and glared at Khalish, her chest heaving with suppressed emotion. "You're just the latest in a long, long line of robberies in cities all across the country."

"You're in on it."

"Never," Khalish stated flatly. "My oath on that in any form you'll accept."

"He's not involved," Gil interjected helpfully.

"You gave me an offering. Do you want my help or not?"

Anna stalked up to Khalish and looked him straight in the eyes. With her low heels, they were almost exactly the same height. He met, and held, her gaze without flinching.

"Yes," she said, finally. "I want your help. But if you're playing me, I will rip your heart out and feed it to the crows."

Gil said, "I think I like her."

Anna shook her head tiredly and gave Gil the kind of look that women give men who aren't housetrained. Khalish patted the stool next to him and she took a seat.

Khalish picked up the shot glass and downed it. Anna had the sense that a bargain had just been finalized. "Ah, the good stuff." Looking over to Gil, who was leaning on the other side of the bar, he said, "You never give *me* the good stuff."

"She's prettier than you." Gil chuckled. "And you never have any money, so you're lucky I pour anything for you at all."

Khalish sighed, then turned his attention to Anna. "Tell us about your predicament."

"I thought you knew it all, being a god and everything."

"Well, I'm not an all-seeing, all-knowing god, though I do get flashes. I know enough now, I think, to understand the basic shape of your situation, but it's best to fill us in completely. Especially since Gil's involved now, too."

Anna could feel her eyes welling with tears, but she refused to cry again.

"My husband, Scott, went out the door this morning to go to work. They were waiting for him outside with baseball bats."

<p style="text-align:center">* * *</p>

Anna sat at the kitchen table, nibbling on an English muffin while Patty, her eighteen-year-old daughter, prattled on about her summer vacation plans. She heard the front door open and didn't think much of it. Scott was always forgetting something and then coming right back in to get it, like his laptop bag, his lunch bag, or his access badge for work. It was amazing how such a smart man could be so forgetful.

Patty got up and headed for the door to the living room. Grinning, she said, "Dad, did you forget—" Then she screamed as she rounded the corner. Still screaming, she backed up hurriedly as two men stepped into the room, pushing a bleeding and obviously badly beaten Scott before them.

Scott was being held upright by the larger of the two men, possessed of a jutting jaw and long, Southern-style sideburns that curved at the bottom. The man slammed Scott headfirst into a kitchen cabinet. Scott crumpled to the floor, unmoving. A small pool of blood gathered around his head. Anna remembered that head wounds bled copiously, then wondered why she was so calm. Maybe it was shock. She found herself still holding her English muffin a hand's width in front of her mouth.

Patty was still screaming. The smaller man turned to his companion. "Shut her up."

The man who'd just hurt her husband reached behind him and pulled out a baseball bat that he'd tucked into the back of his pants. He lunged forward with the bat as if it were a sword and drove it into Patty's stomach. She folded up like a wet tissue, ending up in a fetal position on the floor and gasping for breath.

Anna dropped her English muffin and stood up so fast that her chair tipped over. "Leave her alone!"

"Or what?" The smaller man casually set his own baseball bat on the counter, then pulled out a gun. Anna decided he was the dangerous one, and not just because of his firearm. His dark hair was shaved short on the sides, but long and combed back on top. There was a teardrop tattooed next to his left eye. He looked stylish and dangerous, like a Hollywood movie villain. It seemed like a carefully cultivated look.

She didn't say anything. It was clear who had the upper hand.

He stepped closer to her, extended his arm full-length, and held the gun up to her head. "Oh, hey, did we catch you eating breakfast?" She was pet-

rified. Nobody had ever pointed a gun at her before.

"Who are you?"

He smiled, though it never reached his eyes. "I'm Moe and my large buddy here is Larry."

"W-w-what do you want?"

"Well, honey, we gotta talk about the Rules." He waved his gun around casually. "See, you follow my Rules, you all get through this just fine. If not, we'll kill you. You gonna follow the Rules?"

"Yes," Anna said. Like there was a choice.

"Good," Moe said. "The first Rule is, you gotta provide a most excellent breakfast. And not this hoity-toity muffin shit." He took a few steps back, turned his head to look at Larry. "Check the fridge." Anna wanted to just collapse and start crying, but she needed to be strong for her family.

Larry opened the fridge. "Hey, we got steak and some eggs."

"Rule Number Two. You will wear nothing but bra and panties in our presence. So, take it off, lady." Moe gestured with his gun.

Anna just stared at him. She'd heard the words, but it was if she was having a problem processing them.

"Larry, she needs some encouragement."

Without a word, Larry walked over and swung his bat down on Scott's arm. She heard a crunch that sounded like breaking bones.

Numbly, Anna stripped out of her dress. She watched, seething, as they made Patty do the same.

There were more rules: giving up their cell phones, staying away from windows, not answering the door, and more. Moe had a list that he pulled out of his pocket. But even Anna was surprised at their end goal.

* * *

"They made me cook them breakfast in my underwear. Steak and eggs and bacon and toast with jam." She clenched her jaw with anger. "While my husband lay bleeding on the floor."

Gil slammed his mighty fist on the bar. "If I could leave this abode, I would smite them for you."

Anna cocked her head quizzically.

"Gil has the bad habit of pissing off the gods," Khalish said. "He's cursed to never leave this bar."

"Oh." Anna supposed that once you started believing in obscure, has-been gods, nothing else should really be a surprise.

"Go on," Khalish said, gently.

"They want me to rob a bank for them." She wiped her eyes furiously, struggling to keep from crying again. "They already picked it out. First National, on Jefferson Drive, because it doesn't have any barriers between the cashiers and the customers. They gave me instructions on how to make sure I got all the cash, but none of the die packs. And a sawed-off shotgun with no ammunition, so I'd have something to threaten the bank employees with. They said if I didn't do it, they were going to kill my husband, then rape my daughter and kill her too."

Gil said, "They're eventually going to kill your family anyway, even if you give them what they want." At Khalish's questioning glance, he responded, "What? I was a king once. I've put brigands like these to death before."

Khalish nodded. "He's right."

"I thought about the police," Anna said, "but I don't think Moe is the kind of guy that will give up."

Khalish looked away, as if he was gazing into a far-off vista that only he could see. After a moment, he said, "There are very, very few probability lines where police intervention works." He turned and fixed his blue eyes on her face. "Their training is to contain the situation and then negotiate. As you've surmised, these men will go down fighting rather than be taken." He shrugged. "Your best chance is to ambush them and kill them."

Anna stared at Khalish. She wasn't any sort of Rambo. Hell, she'd even been a failure as a Girl Scout. And yet Khalish was telling her that she was going to have to take on two hardened criminals.

"She's going to need a weapon," Gil said.

"Indeed."

"I'll be right back."

Gil turned and walked to a door that Anna assumed was a storeroom of some sort. He stepped in and closed the door behind him. A moment later, he exited the room with a gun in his hand. He set it down on the bar in front of Anna.

Khalish grinned in a feral way. "This will do the job nicely."

"She's going to need a plan, too."

"Yeah," Anna said dryly, "and maybe some help from Batman, as well."

Khalish gave Gil a puzzled look. Gil shrugged, as if to say that he was just as baffled as Khalish.

Gil said, "Is this … Batman … a god, too? I've not heard of him."

* * *

Anna pulled her car into a parking space in front of Borders, the local super-sized bookstore. She reminded herself that this was the easy part of the plan, then pushed everything into a mental compartment so she could focus on the task at hand. Taking a deep breath, she got out of the car and hurried into the store. Just inside the front entrance, there was a small stack of blue plastic baskets with black carrying handles. She grabbed a basket, then filled it with a bunch of mass market paperback books from the table of bestsellers that had been placed prominently in the center of the store's main aisle.

Regular-sized books, not massive tomes like *The Game of Thrones*. She needed smaller books.

Apparently, a lot of people shopped for books around lunchtime, because there was a line. Or maybe it was because of the rumors that the store was in financial trouble. She waited impatiently, fidgeting nervously until it was her turn. When she plopped the basket on the counter, the cashier, a woman in her early sixties with an improbable hair color, took one look and laughed.

Smiling, the cashier said, "Find everything you were looking for?"

"Yes." The woman seemed a little taken aback by her terse answer and lack of an answering smile.

The woman started pulling the books out of the basket and ringing them up. "My, I hope you don't mind me saying this, but you have very eclectic tastes."

Anna shrugged. "Sometimes you just need to stock up on books."

"Well, all right, if you say so."

When she finally got back to her car, she put all of the books in the duffle bag that her assailants had provided her to hold the cash from the bank job. Zipping up the bag, Anna considered it glumly. To a quick glance, she supposed that the bulging bag might look like it was full of cash, specifically the wrapped stacks of cash that banks kept in their drawers. But to her, it looked like it was full of books. It would have to be good enough.

Now, the hard part. She was so scared her hands were shaking. She clenched them around the steering wheel to still them.

Right now, she was safe. The two thugs couldn't do anything to her. Well, except obviously kill Patty and Scott. Safety for her wasn't a choice, though. She'd never be able to live with herself if she abandoned her family. She had to go home and face the wrath of Moe and Larry. Kill or be killed, like some modern-day update of that old western, *High Noon*.

No more delays. She inserted her key. A moment later, she was pulling her car out of the parking lot. Ten minutes after that, she was driving through her neighborhood. All the familiar houses, with all the usual people going about their business just like normal, clueless of the disaster that threatened her family.

A block away from her house, she swerved to the side of the road and screeched to a halt. She got the door open just in time as she threw up.

From the sidewalk, a man walking a yellow Lab called out, "Are you all right, ma'am?"

"Yeah," she said, wiping her mouth with a tissue. "It's just morning sickness." It was the quickest excuse she could come up with and it seemed to satisfy the man, who let his dog pull him away.

She didn't know if she could do this. She was having trouble catching a breath. Taking on two stone-cold killers, by herself. It was crazy. Just absolutely insane.

You can do this. You're stronger
than you think you are.

She looked around wildly to see where the whispering voice had come from. There was nobody nearby, not the dog walker or Khalish or anybody else.

Eerie.

This is what she got for hanging around with obscure gods and cursed bartenders.

OK, if she was going to do this, she needed to get herself under control. She leaned back and concentrated on managing her breathing. Once she stopped hyperventilating, a strange sort of fatalism set in, as if she were an arrow loosed from a bow. Her course was set; there was nothing left to do but continue onward to the target.

She got the gun out of the glove compartment, made sure the safety was on, and tucked it into the back of her pants.

Then she drove home and pulled into the driveway, like it was just an ordinary day.

She got out of the car, grabbed the duffel bag and walked to the front door. Her mouth was dry. She was sweating. She unlocked the door and pushed her way in.

Larry was right there as she opened the door.

"You got the money?"

"Yeah," she said, lifting the bag slightly. "I'm a bank robber now. Yay." Hopefully the bag looked like it was full of money.

She couldn't see Moe or Patty because Larry was blocking her view of the living room. And she couldn't just walk past him, because then he'd see the gun tucked into the back of her pants.

He smiled. "I love it when a plan works." He probably wouldn't love it so much when he found out about her revision to their plan. If she could just get the big lug out of her way.

"Let's go show Moe the money," she said, nodding towards the living room.

He turned and walked a few steps away. She caught a glimpse of pink beyond him to her right. Patty was wearing pink lingerie, so that placed her on the couch. She still couldn't see where Moe was.

Larry stopped and turned around. "Hey, where's Curly? He should be right behind you."

Anna had no idea what he was talking about. She made the snap decision that this was the best ambush situation she was going to be able to achieve. She couldn't afford to let Larry get close to her again.

She dropped the duffel bag, pulled the gun out from behind her, swept the safety back with her left hand, and shot Larry in the center of his chest. Startled, he looked down at the spreading circle of blood staining his shirt, then stumbled in her direction. She shot him again in the head and moved right as he fell.

Her shift in perspective revealed that Moe had been in the living room, too, but Larry had inadvertently blocked her view of him. While she'd been shooting Larry, Moe had drawn his own gun and started charging in her direction. He shot first and she felt the passage of the bullet as it passed an inch or so away from her head. She fired back and missed, but his next shot went wild, too. Then she shot again and hit him in the right shoulder. He bellowed and dropped his gun but kept moving.

"Mom!" Patty screamed.

Anna tried to dodge out of Moe's way, but he slammed her into the wall. She felt the drywall give way as her head hit it. The impact knocked her gun away.

"You're not following my Rules," he shouted, savagely punching her in the stomach. She doubled over in pain. "I'm gonna make you watch while I rape your daughter again, then I'm gonna choke the life out of both of you."

She was trying to process the fact that Patty had already been raped as he began pummeling her, knocking her against the wall again and again with the force of his blows.

Get out of there. Don't let him keep you
trapped against the wall.

Anna stomped on his foot with her low heels. Moe roared in pain and anger. While he was momentarily distracted, she kneed him in the crotch and broke out of his grasp.

She got three steps towards her gun before he grabbed her long hair and yanked her to a halt. Her scalp felt like it was on fire. He punched her in the kidney and she screamed in agony, then Patty was there trying to help.

Moe backhanded Patty and she tumbled over the arm of the loveseat with a scream. As Moe turned back to Anna, she headbutted him and felt his nose break with a splash of blood. He shouted inarticulately and knocked her backwards onto the glass coffee table with its wrought iron supports. The table shattered under their combined impact, leaving Anna sprawled in a welter of safety glass shards, with Moe on top of her. The thug wrapped his hands around her throat and choked her. She grabbed ineffectually at his wrists. His hands felt like steel bands around her neck.

If you match him strength for strength, he'll beat you.
Hit him where he's weak.

Anna could feel the edges of her vision closing in. She cupped her hands, then slammed them into his ears as hard as she could. He yelled, "Die, bitch!" and kept choking her. She punched him in the right shoulder, right where she'd shot him. He screamed, his right arm collapsed, and he fell to the side, loosening his grip on her throat.

She gasped with relief as air flooded back into her lungs.

Keep up the pressure. Don't give him
any time to recover.

She rolled away from Moe and felt a wrought iron table leg poke her in the side. She grabbed it and lashed out, battering the thug's head. She got to her knees, felt the sting as she cut them on glass shards, and screamed with

rage as she hit him again and again and again, until his head was smashed and she was splattered with blood and she didn't think he'd be getting up any more.

Anna looked up and saw Patty staring at her with wide eyes.

She dropped her makeshift club and painfully stood up. "Nobody messes with my family."

* * *

Later, in the hospital ICU, after the excitement of the police and the emergency vehicles and the press, Anna looked back at her husband from the doorway, his still form wrapped in bandages and attached to all sorts of tubes, wires, and monitors. He was stable, the doctors had said, though they wanted to keep him for observation for a few days, and he'd even recovered consciousness long enough to give everyone a thumbs-up. Broken ribs, a rather severe concussion, lots of contusions and a rather badly broken arm that was going to require some surgery, but that could wait for a few days.

She turned and made her way through a maze of therapeutically pastel-colored passages until she reached a long hallway that smelled of Lemon Pledge and other odors she suspected she didn't want to identify. She pushed through a set of double doors and found herself in Emergency, with its bright lights and extra-wide corridors. After one wrong turn, she got herself oriented and found her daughter's room.

As Anna entered the room, Patty said, "My Mom was a total bad-ass." She looked up and smiled when she spotted Anna. "She just took those guys *down*."

The individual she'd been talking to—a tall, black man wearing a stylish business suit sans tie—turned as she approached and gave her an appraising look. Had to be a cop, the way he looked at her.

"Mrs. Brodie?" he said, holding out his hand.

"Yes." She grasped his hand and he gave it a firm shake, just enough to be authoritative without approaching overbearing. "But you can just call me Anna."

"All right, Anna." He grinned at her. "I'm Detective Shade Michaels, Philadelphia Homicide. Just a formality in a case like this, but I've got a few questions for you." He gestured toward the door. "If we can go someplace more private, please?"

She led him down the hallway where they stopped near yet another set of double doors. Hospitals really were like mazes.

"The guys you called Moe and Larry, well, they're real bad guys. No-

body's going to miss them." He raised an eyebrow, which gave him a raffish look. "In fact, I'd go so far as to say you did the public a service."

Anna quirked her lips in a half-smile. "Thanks, I think."

"Interesting, though. We never did find that bar you said you went to … what was it called?"

"I have no idea," she said. "I never really looked." Anna decided that Shade was considerably sharper than the cop that took down her statement before she and her family had been whisked away to the hospital.

"In your initial report, you said that one of the perpetrators mentioned somebody named Curly. Implying that there might have been a third man."

"Yes."

"Well, somebody reported a body in that general area, behind what used to be Linda's Cafe. Turns out, that guy's fingerprints are all over the gun you used." He shot her a quizzical look. Another carefully calculated mannerism. She'd bet he was excellent in an interrogation room. "You want to explain that?"

She shrugged. Inside, she was shocked. Her mind worked furiously. Maybe Curly had been the guy in the car, the one that had come into the bar after her. Oh, shit. Maybe that was why Khalish had suggested she leave to fix herself up.

"I've got absolutely no idea." She cocked her head. "I thought figuring these things out was your job."

"Indeed." He leaned against the wall and stared intently at her for a moment. "I'll give you my theory. You were followed by a third man, someone who was supposed to make sure you pulled off the bank job."

"Possible. I did see a man in his twenties with long hair." That was why Larry had been surprised. He'd been expecting his other partner to be right behind her.

"Right." Shade nodded. "Either you knew you were being followed, or not. But you decided to seek out some friends, maybe somebody from your days on the wild side." That was fast work, digging up her sordid past in less than four hours. "They took out your stalker—somebody snapped his neck like a twig—gave you his gun, and set you up so you had a chance to take out the other two."

She frowned. Definitely Gil's work; he'd seemed more than strong enough to break a man's neck. "It's a good theory." She leaned against the wall next to him. "It's still wrong, though." Way wrong, but also strangely on point, too. "Besides, if I had a friend that tough, why wouldn't he have

come along with me to help out?"

The detective sighed. "That *is* a flaw in my theory."

"So, really, you got nothing."

"Yeah," he said heavily, fixing his gaze on her face. "On the other hand, I know your story doesn't quite check out, Mrs. Brodie. I don't care that much—this time—because all three of these asswipes needed to be taken off the street. But … don't cross my path again. Seriously."

Anna nodded. "Understood."

<div align="center">* * *</div>

Much later, after she'd rocked Patty to sleep in their hotel room, Anna quietly left and returned to her home. It was after two in the morning and the crime scene techs were long gone. There was yellow police tape across her front doorway, fluttering in a slight breeze.

She was more tired than she could possibly believe, but she hadn't been able to get to sleep. Making the best of the situation, she'd decided to leave Patty sleeping peacefully and quickly go home and pack some clothes for them for the next week or so. No way were they returning to the house to live until the bloodstains and the wreckage were gone.

She ripped the crime scene tape down and went in, flipping the wall switch on as she went. The air carried the coppery scent of blood and the sharp tang left behind by gunfire. The living room was a shambles, a blood-spattered debris field centered around the smashed coffee table. There were outlines in masking tape where the bodies of her attackers had come to rest. Good riddance to them.

Anna walked into the kitchen. She got a saucer out of a cupboard and then pulled a candle out of a drawer. She lit the candle, got it situated firmly on the saucer with a dab of hot wax, and then set the saucer on the counter.

She bowed slightly to the candle and said, "Thank you, Khalish."

You're welcome.

𝔄le 𝔉or 𝔥umanity

Mike Marcus

Joe drove to the grocery store on empty roads, seeking the milk he'd forgotten while shopping earlier that day. He arrived just after six to a darkened store, his car crunching across the deepening blanket of snow covering the parking lot that had been packed only an hour before with Christmas Eve shoppers. He sat in the car staring vacantly at the neon sign, the car windows fogging from his breath.

When the cold started to seep in, waking Joe from his daze, he started the engine. *I just want to go home, climb into bed and wake up two days from now, after Christmas is over and I don't have to think about it,* he thought.

Despite his intent to go home, Joe found himself pulling into the parking lot of The Four Bucks. He'd visited the pub a few times before and the lights were on. From the parking lot Joe smelled wood burning in the fireplace.

I don't want to spend Christmas Eve in a bar, but it's better than alone at home surrounded by Eleanor's things, Joe thought. *Even if my only company is Gil. The guy is strange, but he pours a pretty good beer and it's better than being alone tonight.*

When Joe entered The Four Bucks, he found Gil standing behind the bar, looking toward the door as if he'd expected him.

"I don't want to keep you from your holiday," Joe said, stepping up to the bar. "If you want to close, just let me know and I'll head out."

"Why don't you take your beer over by the fireplace and I'll join you in a few minutes. An old friend of mine will be here soon and you're welcome

to join us this evening," Gil said, handing Joe a glass stein of amber lager. "I have the sense you're supposed to be here this evening."

Joe sipped his beer from near the fireplace, watching silently as Gil moved around the room, turning off overhead lights and lighting white pillar candles on the scattered tables and tall tapers perched in brass holders on the windowsills. Swags of evergreen hung around the room, filling the bar with the sharp, clean smell of pine.

"Thanks for letting me join you and your friend tonight," Joe said as Gil settled into the leather chair opposite his own. "My wife loved Christmas. She died last year and I just couldn't bring myself to sit alone at home tonight. Ellie was a fanatic for everything Christmas. Her family never had much when she was a girl, but once we were married she was all about tinsel and lights and giant Christmas trees. I think she'd like how you decorated this place."

"I'm glad you think she'd like it. I prefer the old thinking of the winter holidays. Evergreens to remind us that spring will return, and candles to help us through the winter darkness. I've celebrated the old traditions for a long time. Nick would be disappointed if he saw that I'd strayed from them."

"Your friend 'Nick' is visiting you on Christmas Eve?" Joe asked. "Please don't tell me you're putting out milk and cookies for him, as well."

"No, he's more a stew and ale kind of guy," Gil said with a smile. The bartender checked his watch and fetched an armful of cedar planks from the nearby closet, stacking them carefully upon the embers in the fireplace. The wood, fresh and sweet, smoked heavily before finally catching fire, the aroma of cedar mixing with pine.

"Cedar is nice, but wouldn't it be put to better use in your closet rather than the fire?"

"Another tradition, maybe the oldest and one of the most important. I don't know that Nick would be able to find me if it wasn't for the cedar," Gil said, standing up and staring into the growing fire. "I was burning cedar the first time he showed up at my bar."

"You two go back a ways, I take it," Joe remarked, intrigued by the strange collection of traditions.

"Pretty far. He was the first to try the special brew I'm tapping tonight. Every Christmas Eve Nick comes by and we open a small keg. I think you'll find it different than any other beer you've had," Gil told him, turning to look at Joe with a smile before walking toward the kitchen. "Give me a mo-

ment. I need to get a few final things ready before he arrives."

"Are you sure he's going to make it tonight? The snow was getting pretty bad when I pulled into the parking lot."

"Oh, the weather really doesn't bother him," Gil said, returning from the kitchen with a small wooden cask. He handled it easily, balancing the cask on the edge of the bar. He set an old-style wooden barrel tap with a silver fitting and a heavy wooden gavel next to the cask, along with three ceramic steins.

Gil returned to the kitchen and brought a worn cast iron pot with a broad lid to the fireplace. He set the pot amidst the coals, the flames licking up its sides. It reminded Joe of the cauldron used by Macbeth's witches.

A heavy knock sounded at the front door, like a distant roll of thunder. Gil stepped quickly to the door and pulled back several locks that Joe had not noticed. They looked old, yet sturdy, and required an unusual pattern of key and knob turns, reminding Joe of the locks he'd seen years ago in the Tower of London. Another harsh knock swung the door open and a blast of icy wind ripped through the bar. The candles fluttered and the fireplace flared high, as though the flames themselves announced the visitor's arrival.

As Gil secured the door and reset the locks, Joe studied the newly arrived man covered in a long fur cloak, brushing the snow from his shoulders. Gil embraced him, and after a hushed welcome, took him by the arm and escorted him close to the hearth.

"Nick, it is my privilege to introduce Joe Thomas. Joe, this is Nick, one of my oldest friends." While Joe had expected something unusual from Nick based on the traditions that Gil had mentioned, he was entranced by the man standing before him.

Nick wore a heavy, dark fur cloak befitting a Viking and a matching fur hat. Beneath the cloak he sported a quilted forest green tunic and wine-colored leather pants. Tall leather boots nearly reached his knees. When Gil helped Nick with his cloak, Joe could see that despite the initial appearance, the man beneath was far from the image of a Viking. He appeared ancient, with deep crevices lining his face. Two bushy white eyebrows perched above weepy, jaundiced eyes and a wispy white beard clung to his cheeks. He was of medium height but slender as a rail, his back bent with age.

"It's great to meet you, Nick," Joe said, standing and extending his knobby, arthritic hand. He wasn't surprised to see Nick's equally claw-like hand. "Gil has been telling me a little about the Christmas Eve traditions the two of you keep."

"Thank you, Joseph. Please, sit," Nick said, gently settling into the chair opposite him and looking around the pub. "Gil and I have been meeting together on Christmas Eve for many years, though I do have to say, Gil, I think this is one of the nicer of your establishments."

Nick's age and poor health grew more apparent by the firelight. The skin on his face and neck appeared paper-thin and his mouth was nearly devoid of teeth. Dark liver spots covered his hands and his fingernails were unkept and yellowed. A map of wrinkles and channels lined his face, centered around an oversized, crooked red nose.

A loud pop drew Joe's attention to the bar. He turned to see Gil setting the gavel down, the tap now in place as he poured beer from the cask into two of the steins. He handed one to Nick and set the other on the nearby table.

"I put the stew on the fire just a while ago, so it should be ready soon," Gil said.

"I have a little time before I have to be on my way," Nick remarked, taking a long pull from his tankard of ale and wiping the thick foam from his mustache. "So, Joseph, I heard that you were a school teacher."

"Yes," Joe confirmed, looking at Gil, surprised the bartender had mentioned him to his old friend. "High school history mostly, but I liked to dabble a little. Middle East cultures, philosophy, theology."

"Theology, you say," Nick said, nodding and staring into the fire. "Hopefully not just the big three religions. Over the years I've found that those who follow them tend to believe only their faith matters. There's so much more out there in the pantheon of the gods."

"I tried to avoid the big three whenever I could. I taught some Far East religions but most often stayed with the ancient middle east, Germanic, and Norse mythologies. So much of that really inspired what became the big three," Joe explained. "I liked students to make a connection between those cultures and what they are taught today. Religion today has its roots in the old gods more than anyone likes to admit."

Nick chuckled at Joe's last statement and nodded, taking another drink. Gil removed the heavy lid from the pot and dished large portions of thick stew into wooden bowls, handing one to Nick and Joe each.

"This is an old recipe that may be a bit strong for your palate," Gil said to Joe. "It's made with some of the ale I brew for Nick's visit, so you may want to take your time with it."

Thick clouds of steam rose from the bowl, and Joe let its warmth soak

into his hands. *I can't remember the last time I felt this hungry,* he thought, stirring the hearty stew and inhaling its deep, complex aroma. Over the past several months Joe hadn't had much of an appetite and it was beginning to show in his face as his reflection in the mirror each morning grew gaunter and more stricken. The doctors said it was a side effect of the chemotherapy, but the treatments were slowing the spread of his cancer. Joe thought of it as just another sacrifice at the altar of modern medicine. But just the smell of the stew made him want to eat.

Joe clutched the bowl to his chest and spooned up a thick chunk of meat and carrot, glazed in dark, spicy gravy. From the moment the spoon touched his lips Joe felt more alive than he had since before Eleanor fell ill. There was something about the stew that made Joe feel more aware, more in the moment. He ate ravenously, barely stopping for a breath, scraping every last drop of the gravy from the bowl and licking it from his spoon. Joe felt that he'd awakened from a long, restless sleep full of horrible dreams to find a beautiful spring morning.

Sitting back in his chair, the empty bowl in his lap, Joe realized sheepishly that Nick and Gil had been watching him.

"I'm glad you like the stew," Gil said, laughing, patting Joe on the shoulder as he walked back to the bar to refill his stein.

"Truly the food of the gods. You have outdone yourself again, my friend. If you don't mind, I am going to help myself to some more ale," Nick said, lifting his stein in toast to Gil and rising easily from his chair, standing tall and stretching in front of the fire, his joints popping as he reached toward the ceiling.

So consumed with how he felt from the meal, Joe didn't notice Nick walk easily across the room, gliding smoothly between the tables, his gait long and strong. He didn't see that Nick's hair seemed fuller, covering his head with a thick snow-white mane, as generous as the beard that now covered his face. The clothes that hung loosely from his frame when he arrived now fit snugly. His hands became heavy and strong, his large tattoo-covered forearms shaped and muscular. But Joe wasn't watching Nick transform— Joe was watching himself change.

Only after finishing the meal did Joe realize the low, persistent ache that had invaded his body with the cancer was gone. The ever-present cold in his bones had faded, replaced with a warmth and strength that he had not felt in years.

There must be more alcohol in this stew than I realized, Joe thought. But

by the firelight he noticed his hands appeared stronger, younger. The liver spots that had blemished his hands for a decade were gone, and the muscles and skin looked as strong and healthy as they had been in his youth. Joe stood easily and stepped to the mirror above the hearth. The face staring back at him was one he had only seen in his old Army photos for the past 40 years. Joe raised his hands to his face, feeling his cheeks and nose, running his hands through his thick auburn hair, before turning to face Gil, who now stood next to him, facing the mirror.

"What is this, some sort of trick? This isn't funny. You don't mess with an old man like this," Joe snapped, a hand rising quickly to his throat. His voice was again a strong baritone, not the froggy, creaking voice of an old man.

"There is no trick. There is no joke," Nick said from bar, his deep bass echoing in the pub. Joe looked toward the bar and where Nick should have been standing was a monster of a man. His white hair was pulled back and held tight with a black ribbon, his beard braided into a single tail hanging down from his chin. His eyes were bright blue and shimmered in the fire-light like open water under a bright sun. His once pale and blemished skin was tan and radiated health. "I thought the same when I first tasted the ale a long, long time ago. But I promise, my friend, what you see and feel are very real. Gil, I believe it is time."

Gil, still standing next to Joe, reached above the fireplace and swung the mirror toward the ceiling on a set of hidden hinges, revealing a glass-front-ed case inset in the stone chimney. A large sandstone tablet was mounted behind the glass and seemed to glow in the firelight. Joe stepped closer, star-ing at the strange glyphs and symbols carved into the tablet and realizing the glow came not from the fireplace but from the tablet and the symbols themselves. He recognized several of the ancient languages scribed onto the table: Sumerian, Akkadian, Celtic, Egyptian, Hebrew, Chinese, Norse. Joe reached up and ran his fingers over the glass, feeling the energy emanating from the symbols. Closing his eyes, Joe heard ancient voices chanting, a cacophony of voices and languages all speaking directly to him.

Joe opened his eyes, the voices fading when Gil reached up and gently removed his hand from the glass. "A long time ago, I was the leader of a great nation, but I became greedy and envious of the gods. I yearned for their immortality and pursued it without hesitation," Gil told him. "After many years of searching, a witch granted me the immortality I desired, but with a price I did not expect. The witch gained her freedom, but my soul

was eternally tied to this tablet and to this tavern.

"I cursed the gods for their trick, for my damnation. Over the centuries I learned much about the tablet and about my own destiny and the destiny of mankind. I have discovered many of the secrets of the tablet and the potions that it details. One of those is the recipe for our ale."

Joe looked from Gil to Nick, then to the mirror and back to the tablet. "If I wasn't seeing this with my own eyes I could never believe it. I still don't know if I believe it. Why are you sharing this with me? We barely know each other, and neither of us knew I would be here tonight."

"I didn't know you were coming tonight, but I had a sense that tonight was different," Gil said. "And I didn't choose you."

"It's the gods who have chosen us, just as they chose Gilgamesh, or Gil, as we now call him," Nick said from the bar, draining another stein of beer and letting loose a deep belch. "When you've been here before, haven't you noticed there are rarely any other customers? You know this place as The Four Bucks. I first knew it as Mohammed's Coffee House in Myra. But to Gil and the gods it is always the Ur-bar, regardless of where or when it may appear."

Joe thought back to the first time he'd noticed the place. It had been one of his last days with Eleanor. She'd had a particularly rough day and the doctors recommended she stay in the hospital that evening. Joe wanted to stay, but she wouldn't allow it. *Go home, have dinner, watch the game, and fall asleep in your recliner*, she told him from her hospital bed. Joe's eyes teared at the vivid memory. It felt more like he was watching a movie of his life than simply recalling a memory.

Joe had probably driven down that road a thousand times but hadn't seen the sign for The Four Bucks, or even noticed the low stone building, until he found himself parked directly in front. He remembered not wanting to go home, not wanting to spend the evening alone in the house he built with Eleanor. He knew that, too soon, he would be alone for good. So, Joe wiped his eyes, entered The Four Bucks, and was greeted by Gil from behind the bar.

"For some, the Ur-bar presents itself at the time they most need it," Gil explained. "That's one of the inscriptions on the tablet, at least somewhat. It's a little more poetic in the original Aramaic. When you walked in that first time, I could feel the magic thick in the air and the tablet glowed much like it does tonight. Over the ages, I have learned that every man has a role to play, whether they wish it or not. I accepted my role as keeper of the tab-

let, the sacrifice I made for the immortality I sought, unwillingly as it may
have been. I do not pretend to understand the magic involved. I am but a
servant of the gods."

"But what does it want from me? I'm just an old man dying of cancer.
What did it ask of you?" Joe pleaded, looking to Nick.

"You don't recognize me on my most important day of the year?" Nick
asked incredulously, grinning at Gil. "I have been known by many different
names. The Wanderer. Wodan. Sinterklaas. St. Nicholas. Father Christmas.
And, in more recent years, Santa Claus. I was a selfish man, focused on my
own worldly pleasures, until I found myself alone one night in the coffee
house with a man who served me a strange, strong ale and told me an unbe-
lievable story. The gods revealed themselves to me that evening, and every
Christmas Eve since then I have followed the scent of cedar to Gil's estab-
lishment. I drink the ale and I continue on, strong and healthy for another
year."

"But you aren't tied to the bar like Gil? You can go as you please?"

"I am tied to the tablet in that my immortality wanes over the year. I am
certain that if I did not return every Christmas Eve to drink and sup and wor-
ship the gods, the god of death would find me as it finds all men in time."

Gil laid a heavy hand on Joe's shoulder and turned him toward the tablet.
"The gods have chosen you as their vessel. You have been offered a chance
to live as Nick does, as a servant of the gods benefitting all mankind.

"Nick has been doing his part to help the world for a long time. We all
know of the problems in the world, and things are only getting worse. Man
has forgotten his gods and their teachings. Man commits murder and de-
stroys the world without a second thought. The world slips toward greater
chaos every day. You have been chosen to help slow that slide."

"But I'm not a god," Joe protested. "How am I supposed to stop chaos?
There's already a Santa Claus. I think people might notice if suddenly there
were several of us running around."

"People notice less than you may think. And there can be as many of us
as the gods wish," Nick told him. "We do most of our work in secret. We
aren't broadcast into every home like a televangelist, although that might
not be such a bad idea. It's more that our presence, our simple existence,
inspires hope. At least, that's what I've figured out over the past thousand
years or so. The gods aren't always so great at giving instructions or expla-
nations. The fact that people believe in me, even if it is a fat man in a red
suit, gives them hope. You can see it every December. People are a little

nicer to each other for no selfish reason. They are feeling my presence, the presence of the gods, and the inspiration that they could be better people."

"And it seems that the gods have selected you to be part of that greater good," Gil said. "You are a good man and the gods have decided that you are needed in this world, at least for a little bit longer."

Nick lumbered over from the bar with a third stein, offering the dark, spicy beer to Joe.

"Will you accept the offering of the gods? If you accept, we will meet here every year to celebrate our work, to drink this ale and eat this stew and offer our thanks. You do have a choice. You can turn away, spend your remaining mortal days as you wish, and die like almost every man before you has done. Or you can join us in our service to the gods and help make this world just a little bit better."

Joe sat silently in front of the fire, considering the unbelievable. He thought of the doctors, encouraging him to continue the chemotherapy despite the horrendous side effects, trying to convince him that there was still hope for a cure when he decided to stop the treatment. He told them if chemo was only going to extend his life by a few months, but he would be sick and miserable during that time, he'd rather enjoy his last few months and see his Eleanor sooner rather than later. He thought of her last days, slipping in and out of consciousness, a ghost of her former self. He thought of his last real conversations with her those last days she was truly still aware, before disappearing into the fog of medication and death.

I want you to go on, she had told him. *I want you to be the best man you can be, the man I know you are. When the time is right and you have done everything you can to make the world a better place, we'll be together again.*

Tears stung Joe's eyes as he thought back to the best and worst days of his life with Eleanor, of her last words that now seemed like she had foreseen the opportunity before him. Nick handed him a soft red handkerchief without a word and set the full stein on the table near Joe's elbow. Wiping the tears from his eyes, and with Eleanor's words still echoing in his ears, he picked up the stein and stood, turning to face Gil, Nick, and the tablet, now glowing even brighter above the fireplace.

"For my Eleanor," he said, raising the stein and drinking deeply on the first Christmas Eve he would share with his new friends for many, many years to come.

West Side Ghost Story

Kristine Smith

"Bourbon. Neat." I waited for the bartender to ask which brand I wanted—every bar these days has a shelf-full and everyone makes a big deal like *oh, I only drink this distilled by Kentucky elves under the light of a blue moon* but I can't tell the difference. I only drink it because it's popular and taking it neat gets me noticed. I mean, isn't that why you drink it?

Be honest. Honesty's important.

Anyway, this guy didn't ask. He just reached under the bar, pulled out a green bottle—tall and skinny, like for a liqueur, not a bourbon bottle at all—and poured something brown into a shot glass and slid it toward me.

I stared at it. Sure, it looked the right color, but it was cloudy, swirly, and a bit glittery. Like shampoo. Like no whiskey I'd ever seen. "I asked for bourbon." I looked the bartender in the eye, something I usually avoid because when you see them clearly that means they see you, too. "What's this stuff?"

Instead of answering, he disappeared into a backroom, emerging a few moments later with a bowl of lemons. He pulled a knife from a loop on his belt, then took a lemon from the bowl and started cutting it up.

I inhaled—my mouth watered. Rich aromas had followed him from the backroom, roasting garlic and frying onions. Freshly brewed coffee. I debated ordering something, but I didn't want to give him the satisfaction. "Excuse me? I asked you a question." When he didn't turn around, I wad-

ded up a paper napkin to throw at his head, then stopped in mid-crumple. Somehow, he didn't seem the type to take assault by paper product well. He wore jeans and a light blue button-down, this summer's uniform for trendy bartenders, but no way did he fit the mold. Too tall, for one thing, six six at least, dark and bearded and block-out-the-sun broad.

On top of being scary-big, he had an edge to him, but *edge* was the wrong word and yet I couldn't think of a better one. It's just the way he handled that knife, *flick flick*, turning that lemon into wedges and paper-thin slices before I could blink twice. He looked like he belonged over in Jersey, in some dive where he'd break up half a dozen fights a night and keep a sawed-off stashed under the bar just in case.

He wouldn't hurt a woman. I repeated that over and over as I sat up straighter, shoulders back to highlight my first line of attack. Pushed a hand through my hair—

—and stilled.

What the hell. My heart stuttered—I could feel the *thrum* against my breastbone. Stick-straight and shoulder-length and as silky as expensive conditioner could make it—that's what I should've felt.

Instead, I felt curls, springy and coarse. Terrier hair.

I tugged at one spiral, pulled it straight until I could see the ends. *Dark brown.* No, they should've been ash blond, the lightest I could go and not risk my hair shattering like spun glass.

I grabbed another curl, yanked it too hard, felt the weird popping sensation as strands came out by the roots. Counted to three, then looked at them.

Damn. Dark brown wire, my Hair From Hell. It had covered my head like a pile of rotini until I moved to New York and Ginny taught me how to bleach and dye and use a flat iron. *Better to not look like your driver's license photo in our line of work,* she said that first time, eyes watering from the ammonia stink of the dye.

Call Ginny. Ginny Klimt. My best friend. My only friend, really. Trust is hard when you make your living by messing with people's heads, but I know I can always trust Ginny. I reached out to the stool next to mine because that's where I always set my bag—

—and grabbed air.

I looked over. No tan leather tote, which meant no phone, no ID. No emergency change of clothes, or makeup, or the scarf I used to hide my hair when I needed to disappear into a crowd.

I took a deep breath and looked down. It was a work day, so I should've

been wearing a dress. The peach one that belonged to Ginny, that went so well with the hair.

Instead, I wore my favorite jeans, faded near to white and blown out at the knees, battered red high-tops, and the oldest of my Lou Reed T-shirts, black worn to gray from laundering, a souvenir of a concert years past.

I slid off the barstool and wended my way through the maze of tables and booths to the far side of the room. Early afternoon sun streamed in through wide windows, flashing off the cars that shot along the West Side Highway, reflecting off the river beyond. At least I was still in New York.

But why am I on the West Side? I always stuck to Midtown during work hours—the never-ending bustle meant less chance of me running into former marks. I looked back at the scatter of customers, fingers crossed there was no one I recognized: an elderly woman in an old-fashioned dress, a pair of younger women whispering over their drinks, a middle-aged man, jacket tossed to the side and tie loosened, staring into his coffee. As I watched, he drifted in and out of focus, then vanished with a sound like a sigh.

I walked back to the bar, picked up the glass, and drank the shimmering brew in one gulp. It felt warm going down, like any hard liquor. But it tasted odd, herbal and sharp, the way pine trees smelled. I stifled a cough, waited for the ache in my throat to ease. "I have a question."

The bartender had moved on from lemon slaughter to polishing wine glasses. He turned, which allowed me to see his shirtfront, spotless except for three letters, handwritten in ink above one breast pocket, worn to gray by washings and time. *Gil.*

"Hi, Gil—my name's Sherry." I smiled as I said his name—men like it when you do that. "I don't have my phone. Could you please tell me what time I got here?"

"A few hours ago." Gil didn't smile back.

"But I just—" I wanted to say that I had just arrived, even though the sense dawned that it wasn't true. *Damn.* "How much have I had to drink?"

"Just that." He jerked his chin toward my glass.

"Did I come in here alone?"

"Yup." He stopped in mid-wipe, eyes narrowing. "Something wrong?"

"Yeah." I got back up on the barstool. "I'm supposed to be at Grand Central."

"Train to catch?"

"No, no—" Heat flooded my face; I blamed the liquor. "I usually drink there."

"After work?"

I started to answer. Stopped. Tried to think of weasel words, the lies that always flowed so easily. Then I looked Gil in the face again, his eyes like dark, cold stone. With some men, you know a lie would be a waste of time. "It is my work." I slid my empty glass back and forth.

One eyebrow twitched. "You drink for a living?"

"I get people to buy me drinks." Certain kinds of people. Men, mostly, the good suit and leather briefcase types, who could be counted on to cough up a few bucks to help pay the back rent or ransom the towed car or lost dog or otherwise act the hero in my manufactured crisis of the day. "I'm not usually dressed like this." I looked down at my clothes and tried to remember what happened to the dress. It was Ginny's favorite, a prized conquest from a designer sample sale. She'd kill me if anything happened to it. "I must be dreaming." I pressed a hand to my chest. The ache in my throat had moved down. Just a little twinge, at first, like I'd strained a rib cage muscle.

Then it ramped up fast, as though I had the wind knocked out of me. I grabbed the edge of the bar and held on. "Wow." I had to breathe through my mouth—short, shallow gasps. "Never had a dream that hurt before."

Light flickered in Gil's eyes. The barest softening. "You're not dreaming."

I looked past him and caught sight of myself in the mirror that backed the bar. That damned curlicue hair. Apple cheeks and bare skin and the baby face that always got me carded.

Then a dark spot appeared between my tits and I felt that weird sensation of warmth leaving my body. I looked down and watched as black spread through the gray cotton like ink in water, turning Lou's face into a dark blob.

I touched the stain—it felt warm, but dry. "Can you see this?"

"Yup."

I pulled out the neck of my T-shirt and looked down, spotted the neat little hole just to the left of my sternum. "I've been shot."

"Yup."

"Is that the only word you know?" As snappy replies went, that was pretty weak, but irritation had given way to more immediate concerns. "So I'm not dreaming. That means I'm awake."

Gil started to speak, then shook his head.

The pain and pressure had vanished. When I touched the hole, it didn't even hurt.

Sometimes I'm slow—I admit it. But I do catch up eventually. "Am I

dead?"

Gil flipped his towel over his shoulder and leaned on the bar. "Yes."

* * *

I have to walk when I'm nervous. It would be fair to say that this was one of those times.

If Gil knew how exactly I came to get shot, he chose not to share that information. I left him filling the ice chest, headed out the door, found myself in a tiny hotel lobby. An *old* lobby. Cracked tile floors. Pale turquoise walls. A battered wooden check-in counter, currently staffed by a man in an old-fashioned bellhop uniform complete with one of those little round hats. I usually had no use for shabby chic, but these signs of age calmed me. I recognized this place.

The *Emmaline*. A former sailors' hostel, with teeny tiny guest cabins and a rooftop bar and a ballroom where Lou Reed had once given an impromptu concert in the late 70s. When I arrived in New York, I compiled a list of locations where he'd performed over the years and had been visiting them one by one. But I hadn't yet made it to the *Emmaline*.

I boarded the elevator. I had to concentrate to push the button beside the tarnished brass plate that bore the word BALLROOM in Art Deco lettering, but finally managed to depress it just enough. I inhaled odors of pizza and stale perfume and wondered who had left them behind. Were they dead or alive? Could I see them? More importantly, could they see me?

More smells flowed into the elevator when the door opened—pot and cigar smoke, grilled meat and the sharp stink of spilled beer—but the crowd I thought I'd see as I entered the ballroom proved nonexistent. I heard them, however, booming male voices and high-pitched female laughter, layer upon layer of sound, chronologic strata of parties past.

And threading through them all, Lou's baritone, half-speaking half-singing about a little girl listening to the radio.

"Rock 'n' roll." I sat on one of the round banquettes arranged at one end of the ballroom like velvet-upholstered spinning tops. Potted palms lined one wood-paneled wall, an immense bar spanned the far end, and a disco ball, of all things, shimmered above the polished wood dance floor. I counted the silver tiles as the ball rotated, tried to swamp the tangle in my mind with numbers even as I fingered the hole in my chest. *It didn't happen here.* I'd have felt it, I'm sure. I'd have known.

But why? I thought back to all the marks I'd scammed over the weeks. *All I took was money.* Money they could afford. *And I gave them something,*

too. I flattered them, made them feel important. As for what happened before I came to New York, okay, I wasn't the world's best person. I took care of myself and maybe some people took exception. That was why I had to relocate.

"You're new."

I flinched, turned, and looked over the top of the banquette to find a man leaning against it. My age, mid-twenties, maybe younger, short and skinny with a ton of black hair and a lopsided smile. He wore white trousers, a blue and white striped T-shirt. Bright, clean clothes, but old. I could tell from the style. "You can see me?"

"Yes. Of course." He held out his hand. "Anastasios. But everyone calls me Tasso."

"Sherry." I felt warm skin and bone and muscle and wondered if this was how ghosts ran into one another. Just strangers passing through, saying *Hi.* "Who's everyone?"

"Maybe you saw the twins in the bar, yes, and Dora? She's the old lady. And there's Sam from Hoboken and the Subway Girl—you'll meet them, too." Tasso cocked his head and studied me. "You're like them. Like me. Sent here before your time. But don't worry. The memories of what happened? They come back. I say this because you look scared. But you'll be all right. Gil gave you the little drink, yes?" He held up his thumb and forefinger, then spread them an inch or so apart. "The green bottle?"

"Yes." I licked my lips, tasted the bare hint of pine. "What was it?"

Tasso tapped the side of his head. "It helps the memory. It helps the fear." He leaned forward on his elbows, hands draped over the top of the banquette. "Gil knows what to do. He's been around a long time."

I watched Tasso's fingers twitch. One second, the skin looked bruised, a forefinger crooked as though broken. The next, his hands looked flawless. "When did you get here?"

"Fifth day of June. Nineteen hundred and five." Tasso pointed in the direction of the river. "I drowned." His voice lowered as his eyes narrowed. "Someone pushed me in. Someone I thought a friend."

"Why did they do it?"

"Does it matter?"

"I don't know, maybe. It could've been because of something you did." I stood and backed away from the banquette as Tasso's eyes widened. "I'm sorry. That was bad. I didn't mean it." I swallowed hard as, just on the edge of hearing, I heard Lou again, singing about a perfect day. *Really, Lou? Re-*

ally? "What is this place? Hell? Please don't tell me it's heaven."

Tasso shrugged, palms facing up and fingers spread wide. "This is life. Your new life."

"What's new about it? I'm in a hotel in the West Village."

"You are in *a* hotel in *a* West Village. Not like the one you knew but it shares space with it." He covered his face with his hands, then looked at her through his fingers. "Gil explained it to me once. In Greek, even, and I couldn't understand." He lowered his hands, paced a tight circle, then stopped. "It is an afterlife, a world that is just different enough. It could be better than the old one. It could be worse. You do what you can and sometimes, like with your old life, you get a little help."

"You mean Gil? He hardly spoke to me, he just—"

"Let you figure it out." Tasso's gaze softened. "It's better if you figure out what happened for yourself. Because that means that, deep inside, you knew it all along." He started to say more, then glanced at one of the ornate wall clocks and gasped. "I'll be late—have to go."

"Go where?" Early, late, on-time—didn't all that stop after you died?

"Work."

"You're kidding?" I started after him. "Where?"

"Maybe you'll see." Tasso trotted towards the vast double doors of the ballroom entry. "*Ya,*" he called over his shoulder. "That's Greek for goodbye. Maybe I teach you more Greek later." Then, with a wave of his hand, he stepped through the portal and vanished.

* * *

I wandered the ballroom for a while, poked through the palms and behind the bar. Danced solo in the middle of the floor. Hotel staff came in a few times to clean or grab a smoke or just sit and stare at the disco ball. None of them saw me. At first I was tempted to give them a scare, tip over a tree or flap the curtains, but I decided against it. From the looks of things, they used the ballroom as a hideout from supervisors and I didn't want to frighten them away.

I rode the elevator down to the lobby, then froze as the doors opened and a trio of teenaged girls piled in. As they pushed through me, I sensed a weird vibration along my spine, the warmth of blood and the flutter of heartbeats. Read the thoughts racing through their minds. *Can we—will she—does he—*

Head buzzing, I stepped out into the New York summer. Felt the sun on my face and smelled vehicle exhaust and fried food aromas from a nearby restaurant and wondered how in hell this all worked. Was I a ghost or what?

Was this some alternate universe? Tasso's words drifted through my head. *Not like the one you knew but it shares space with it.*

I headed down Washington Street, my steps silent. The pavement felt weird beneath my feet, firm yet soft, like a lawn that needed rain. The scenery shifted in and out of focus, layers upon layers, horse-drawn wagons, cars from Model T's to Teslas. Men in hats and round-collared suits, in shorts and flip-flops. Women in long skirts with bustles, cut-offs and camisoles.

Then I passed a garbage can on which someone had stuck a poster of Lou Reed as the Statue of Liberty. Transformer-era Lou, smooth of face, his El Greco eyes fixed upward like a whacked-out Madonna, torch aloft. The image winked at me as I drew close. I crouched in front of it. "What the hell, Lou?" I waited for it to say something, but it had gone back to being a drawing again, water-stained, ink faded by the sun.

I stood and resumed walking. My world had gone mad. The one thing I could do to give it a little order was to find out who killed me, and why.

* * *

I stood across the street from the red brick building I had called home for the last few weeks of my life. Ginny's place was on the third floor, a corner apartment with two bedrooms and two bathrooms. Seven grand a month plus parking and maintenance fees.

An old job that paid really well, Ginny had told me when I asked how she could afford the place. I kicked in what I could and in exchange Ginny taught me how to charm my way through life. Training, she said, for the big score. New clothes. New hair. New IDs from someone who knew someone. *It's going to be huge*, she told me as she taught me how to walk, how to talk. *We'll be able to retire.* When I pressed for details, she deflected me and yeah, okay, that did bother me. But she was able to afford that apartment without my help, and yes, I did check.

As I pondered all this, I spotted Ginny hurrying up the other side of the street, head down and shoulders hunched. I jaywalked, felt the cold gasoline-scented shudder as a Ford Escape drove through me. "Hey, Gin."

She slowed, stopped, then looked in my direction, eyes hidden behind huge sunglasses. I didn't know how much time had passed since she last saw me, but she looked worse than I'd ever seen her—blond hair twisted into a messy topknot, T-shirt and cargoes that looked pulled out of a dirty laundry basket.

"Gin?" I had no clue whether she could see, hear, or sense me at all, but I had to try. "It's Sherry. I need your help. I need to reach you. I'm trying

to figure out—" Before I could finish, she broke into a run and darted into the building. "Gin!" I ran after her, then staggered as something else passed through me.

No, someone. A man, enraged—I felt his anger like barbed wire and broken glass. He darted around a taxi cab, thumping the hood with his fist when the driver laid on the horn, spinning out of the way of a bicyclist, pushing through a trio of women and sending one tumbling to the sidewalk. Shouts followed him as he tried to wedge through the entry door before it closed, but Ginny had gotten in ahead of him. As he beat on the glass, someone shouted they had called the police, while two men closed in after him. He fought them off when they tried to restrain him, then ran down the street.

I tried to follow him but lost him as the layers of the city swallowed him up. All I saw were jeans and a dark blue T-shirt covering a slim frame, a shock of brown hair. I struggled to recall if I had seen him before, but in my time living with Ginny, visitors had been limited to restaurant delivery guys. *We deal with men all day*, she said. *At night, I'm off the clock.* At the time, I didn't care—I was just happy to have a roof over my head. But now it hit me that Ginny might have a reason to want to be alone.

<p style="text-align:center">* * *</p>

One good thing about being whatever I was—it didn't matter that I had forgotten the apartment building's entry code. I walked through the glass and past the security desk. Considered attempting to float upstairs, but decided to save that for another time and boarded the elevator. I shared it with an oblivious woman and her toddler son and didn't bother to step aside when we stopped on the third floor and two men got on before I could step off. I sensed anticipation as I passed through them into the corridor, the possibilities of a night out complete with images, and tried without success to shake off the embarrassment I felt about this mind-reading thing I had developed. I'd have given a lot for this talent in my old life, but now it bothered me.

Should I knock? I stood before the door to Ginny's apartment, felt the sensation of cool velvet as I pressed my hand to the panel and watched it pass through. "Oh, hell." I took a deep breath and walked inside, down the short entryway, walls hung with the museum prints, into the living room, with the hardwood floor and incredible views.

I found Ginny in the kitchen, crouched on the floor in front of an open cupboard, pulling out packages and pouring the contents on the floor. Dried pasta. Cereal. Rice. After she emptied the boxes and bags, she rummaged through them, pulling out bundles of plastic wrap bound with rubber bands.

She pulled one apart—it was a wad of bills, tens and twenties, hundreds if not thousands of dollars.

A flash of pink caught my eye and my stomach flipped as a scene replayed. Cashing a check from one of my marks, a ten-dollar bill the teller handed me half-covered with a pink stain. *I gave it to you, Gin. You said you needed it for the pizza guy.* So what was it doing hidden in a box of gluten-free rigatoni?

Funny, the cascade that one memory can trigger. How Ginny always had to collect the mail herself and never wanted me to answer the door. How she talked a lot about the future, but never answered my questions about the little things that went on every day. And because I had my own problems and needed a place to hide, I never pressed. "Hello, Ginny."

Ginny paused, then looked in my direction. She had pushed her sunglasses up on her head, revealing red-rimmed eyes swollen from crying. Her skin looked waxy in the harsh lighting. Sickly pale. She eased to her feet, pausing when she lost her balance and stepped in a pile of cereal. The crunch seemed to echo.

I reached for the jars and bottles on the counter, hoping to rattle one to get her attention. But my hand passed through them as it had through the door. *Dammit.* Before I could stop myself, I struck the granite with my fist.

Impact. Glass and metal shook, one jar bouncing high enough to tip and roll over the edge. Reflex kicked in and I tried to catch it. For a bare instant, I felt the cool glass, but instead of stopping it, I sent it tumbling through the air. It struck Ginny's leg, hit the floor, and shattered. She screamed.

Then she looked in my direction. Her eyes widened and she backed up, collided with the counter, then scooted along the edge. "You're dead." She said it over and over, barely above a whisper. "I saw you. They told me."

"The cops?" I took a step toward her, stopped when she whimpered. "Do they know who shot me?"

"Shot you." Ginny's knees sagged and she held on to the edge of the counter.

"Gin, I know you must feel really shook right now, but I need you to tell me what happened. I need to know why." I looked down at the front of my T-shirt, saw the dark stain spread. *Shit.* "Just please, ignore what I look like right now. Pretend I'm alive. Close your eyes or something. But please, talk to me."

"You're a ghost." Ginny's voice sounded a little stronger, though she still looked ready to faint. "Are you here to haunt me?"

"No. Why would I?" I shook my head, then pointed to the mess on the floor, the bundles of cash. "What's with all this?"

"I'm in trouble."

"Yeah, no kidding. Who was that guy who tried to get to you?"

"What guy?"

"Dammit, Gin. I was right outside. I saw the whole thing."

Ginny licked her lips. "That was Billy." She flinched as she spoke his name. "I have to get away from him."

"Who is he?" I felt something hard hit my hip and realized I'd leaned against the counter. I placed my hand on the granite, felt the small chip on the edge where I'd dropped a bottle of wine. "What does he want?"

Ginny pushed one of the wads of cash with her toe. "It's my money."

"Really? All of it?"

"Yes." Some of the old strength returned to Ginny's voice. She stood up straighter. "He thinks he helped, but he didn't. But he isn't going to leave me alone, so I need to get out of the city."

"And go where?"

"I have a friend. In Connecticut."

"Does he know he's your friend?"

"Yes, he knows. Why are you being so mean?" Ginny pulled the sunglasses off her head, worked the earpieces back and forth until one snapped, then threw them to the floor. "I'm sorry. About what happened." She stared down at the wreckage. "You really don't know?"

I looked around the kitchen, then back into the living room. *Nice floor, isn't it?* That voice in my head, unbidden. What was it trying to tell me? Things you know already, Tasso said, but I didn't know anything. That's why I had to come here. "I don't remember a damned thing."

Ginny pressed her hands together. They looked a mess, fingertips red, nails bitten to the quicks. "They told me that you were in the wrong place at the wrong time. You were in a bar and a fight broke out and someone pulled a gun and you got shot."

"An accident?"

"Yeah."

More of Tasso's words came back to me. *Sent here before your time.* Well, the role of innocent bystander would certainly qualify. But I could ponder it later, in the quiet of the ballroom. Now I needed to help out Gin. She had apparently held out on me, but still, I owed her something. "So. Connecticut."

"My friend's sending a car for me."

"Is he really?"

"You didn't sound this cynical when you were alive." Ginny gathered up the bundles of cash, then reached into the cupboard under the sink. "I'm sorry about what happened to you, I really am." She pulled out a paper bag and stuffed the money into it. "But it was an accident and let's be honest, it wasn't like we were really that close."

Honesty's important. I touched the counter, to see if it still felt real. This time, my fingers sank into the slab.

"So, you know, maybe we can talk sometime later. A seance or something. After this all blows over." Ginny's footsteps crunched, flecks of pasta skittering across the floor. "You're fading," she said as she brushed past me. "Guess that means you're going bye-bye."

"Looks that way." The kitchen shimmered in and out of focus. I could see layers again, dirty dishes in the sink, workmen installing the cabinets. Felt the rush of wind from a time before windows, before walls, before the building existed.

Then I followed Ginny into the living room and smelled blood.

"I need to pack—" Before Ginny could finish, a soft *click* filled the room. Then came the sound of a door opening. Footsteps.

"Hello, bitch." Billy entered. Soft, boyish face and dirty hands—definitely not Ginny's usual type. He held up a couple of lock picks. "The delivery bay in the back. The lock on the sliding door is busted. You'd think a fancy place like this would have better security, wouldn't you?"

What happened next happened fast, the way these things do. Billy started to move past me to get to Gin and she screamed and I stepped between them. He barreled past me—tried to, at least. I saw the confusion in his eyes as he collided with someone he couldn't see.

And then he could. "What the fuck what the fuck." He stumbled backwards. "You're supposed to be—"

"Dead. I know." I realized then what had happened. *Emotion. Anger.* When I let it out, they could see me. *Stay angry.* My hand closed over his wrist—I felt the warmth, the skin and bone, and squeezed until he let out a faint squeal.

Then I saw him as he'd been some time before. Face twisted in anger, a gun in his hand. "I remember now. I heard you enter. Gin had just left and I thought she had forgotten something." I looked toward the hallway that led to the bedrooms and saw myself standing there. My old self, in the peach

dress and the heels and the hair. "I stepped out to see what was up. I came in here. The lights were out and the blinds were closed, so it was dark. You didn't even say a word. You just—" I mimed shooting the gun. "After that, I don't know what happened. I guess you couldn't find the money."

Billy shot a glare at Ginny that should've dropped her where she stood. But the expression died when he turned back at me. I'd had men look at me in so many ways over the years. So many emotions—lust, anger, hatred. But never fear. I took a step towards him and he backed away and pressed against the wall like he could squeeze his way through it if he tried hard enough.

"I thought it was her. You had the same—" He grabbed a handful of his hair. "I didn't know it was you. I thought it was her." He slid down to the floor, legs working in slow motion, his shoes etching black scuffmarks on the wood. "She took my money. I got it from work and gave it to her to keep in case they searched my place, and next thing I know she's not answering my texts and she's never around here and goddammit that's my money."

I looked at Ginny and her layers fell away. All her armor. I saw her as she once had been, as she still was deep down, wavy brown hair and a few extra pounds and a gaze that darted one way, then the other, like a trapped animal looking for an escape route. "This was your big retirement plan?"

Ginny jerked her head towards her partner in crime. "I needed to get rid of him first because he was starting to scare me." She met my eyes for a moment before looking away again, but a moment was all it took. "I was going to tell you. Honest."

Sometimes it really does hit you so hard that you stumble. The realization. The knowing. *Men prefer blondes*, Ginny had told me. Seemed like months before, but hadn't it really been last week? I'd had a bad day at a high-end bar. Five hours and not one approach, much less an offer of a drink. *Besides, you look too much like their daughter.* That was the night she dyed and straightened my hair, then trimmed it into a shoulder-length bob like hers.

Look, she said as she bent close, mirror in hand. *We could be twins.*

I walked around the living room, noted the location of the couch and the chairs and the fancy rugs. Did anything look different? Was anything missing? I toed the edge of a rug, brilliant red and gold, an abstract leaf pattern. "This is new, isn't it?" I heard Billy groan as I crouched, then lifted one corner. Ginny had moved behind the couch, fist pressed to her mouth.

The stain was hard to see at first. But the floor had a rough finish, which

made it hard to clean completely. I could just pick them out, the flecks of brownish red filling the tiny nicks in the grain. I placed my hand on them and felt the warmth, the soft flutter of a heart beating its last. My heart. What had they done with my body? Did it matter? "Get out." I turned to Billy. "Just go."

Billy sprang to his feet and started for the door. Then he stopped, hands working, rubbing his thighs, forming fists. "What about my money?"

I flicked a finger at Ginny. "Give him the money. He's the one who's going to die when whoever he stole it from finds out it's missing." I took a little cold comfort from the sound Billy made as he closed his eyes and shivered.

"I should get to keep some of it." Ginny's voice steadied, as it always had when negotiations got underway. "For my trouble."

I shrugged at Billy. "She has a point. She hid it for you, which means they might come after her, too. You owe her something."

"Like hell I do." Billy started towards her, then stopped when I moved to cut him off. "Five."

Ginny laughed. "Fifteen."

"Ten."

"Fifteen."

Billy started to argue. But he couldn't stop looking at me, and that seemed to take the fight out of him. "Yeah, fine." He made a show of looking around the living room. "That'll cover what, two months in this place? Then where will you go?" He twitched back and forth on the balls of his feet while Ginny extracted her share. Then he circled around me, taking care to stay beyond arm's reach, yanked the bag from her hands, and ran.

Ginny sighed as the door clicked shut. "Why did you let him leave?" She frowned at her plastic-wrapped payoff, then stuffed it in her pockets. "Couldn't you have scared him to death or something?"

I walked to the front window and pressed my hand to the glass. I was still solid enough to feel the warmth. "You set me up."

Ginny sniffled and wiped her eyes. "I didn't know he'd kill you."

"Stop it." I waited until she ditched the *poor me* expression and looked me in the face. "What did you think, that he'd panic after he realized he'd made a mistake and leave you alone?"

"What are you going to do? Are you going to haunt me now?" Ginny's face brightened and she stepped closer. "You could haunt Billy. He's the one who shot you. He's the one who killed you. He's the one who deserves—"

"Shut up." I gave the glass a final pat. "I am not going to clean up after you."

"Nobody knows you're dead." Ginny followed me to the door. "Your family doesn't even know where you are. I bet they don't even care." She tried to move past me and block my path. "Hey, you could be, like, my ghost bodyguard. Like what you did now. We could be a real team."

"I told you to shut up." I tried to walk through her. But I was still too solid and I wound up knocking her against the wall. I caught the fear in her eyes and backed away, hands raised. I didn't want to hurt her. I just wanted to get away. "I trusted you." Just like Tasso had trusted his friend, and no doubt like others in the bar had trusted someone. I tried to think of what else to say, cutting, acid judgment. But words would never make a dent in Ginny's hide and killing her—assuming I even could—would just mean that I'd see her at the *Emmaline*. I never wanted her to set foot in the bar, or watch Gil pour her the little drink. "Goodbye."

I actually had to open the door to leave the apartment. An older man edged away from me when I entered the elevator. Once I got outside, it took ten minutes of deep, slow breathing before I became invisible again.

* * *

I wandered until I found myself heading up Washington, then noticed a crowd gathered in front of a food truck. They weren't office workers, though. They were dressed in all different ways, from colonial garb to modern. One guy in white tie and tails even rode a horse up to the window and trotted away holding a large sack.

As I drew closer, an elderly woman broke away and tottered in my direction, a paper boat in hand. For a moment, a shadow closed in behind her, arm raised. Then, it vanished. "I don't usually eat in the street, but it's so good." She waved a plastic fork at me. "I'm Dora, dear—I saw you in the bar. We must talk later." She stepped out into the street and continued to peck at her food as cars and trucks drove through her.

I got in line and spotted Tasso peeling potatoes at the counter. "So this is where you work?" He looked down at me and smiled, but before he could say anything, a door at the opposite end of the truck opened and Gil stepped inside. Behind him, I caught a glimpse of the bar. It looked busier than it had been when I was there, every stool and many of the tables and booths occupied. "How did you do that?"

Gil cocked an eyebrow. "Magic?".

"But a food truck?"

"It's New York." Gil grabbed a ladle and scooped something steaming and fragrant out of a pot into another paper boat. "Try this. It's a new recipe."

I stepped around a fire hydrant and up to the window. "Aren't you worried about getting a ticket?"

"I would be if anyone who wrote them could see us."

I took hold of the boat, sniffed a muddle of chicken and strange vegetables and spices, then took a tentative bite. "It's good." I leaned against the truck, felt the machinery vibration. "So."

Gil waited on the next customer, but kept an eye on me. "So?"

"I've joined a really special club, haven't I?"

Gil nodded. "Jealous lovers. Greedy relatives. Friends who were not as they seemed." Steam puffed around him as he flipped the contents of a fry pan. "You found out what you needed to know."

"You knew it already, didn't you? You could've saved me a lot of time."

"Because you would've believed me?" Gil set down the pan, picked up a knife, then paused. "I am sorry."

I shrugged. "Ginny asked me if I was going to haunt her."

"Will you?"

"What would be the point?"

"Revenge. Justice. Why else would you do it?"

"I won't say that it didn't cross my mind." I stabbed a hunk of chicken with my fork. "She's in real trouble."

Gil nodded. "Yes, she is."

I looked around. "I'll be seeing her around here soon, won't I?"

"I'm afraid so."

"You'd serve her?"

"He has to." Tasso brushed off a bit of potato peel that had stuck to his T-shirt. "He's the bar and the bar is him. He can never leave it. He must tend it until the end of time." He started to say more, but Gil caught his eye and he fell silent.

Gil sighed. "Tasso's correct." He wet a napkin in the sink and handed it down to a young woman holding a food-encrusted toddler. "The bar is a gateway. A first stop along a new path. Some need only a short rest before moving on." He set his massive hands on the counter and surveyed the crowd like a proud father. "But others need more time, and for them, the bar becomes more than just a bar."

I studied his face and saw the shifting in and out that I had seen with

Tasso, Dora, Ginny and Billy. The layers of being, of what he was now and what he had once been. Scars. Braided hair. A helmet. A sword. A crown. I realized then how long he had lived, all he had seen, the others he had known, and knew that he had decided long ago to make a place for those who needed it. And I sensed deep down that there was room for me in this place, and that for the first time in my life, I could belong somewhere.

<p align="center">* * *</p>

I hung around the truck until it closed and introduced myself to a few of the regulars. The Twins. Sam from Hoboken, who like me had been the victim of a murderous business partner. We compared notes for a while and agreed to meet at the bar later for a drink.

Afterwards, I walked. Strange, this new sunlight. Diffuse, as though filtered through leaves. I headed back to the garbage can with the Lou Reed poster. When the image saw me coming, it rolled its eyes and growled. "You again."

"Yeah, me again." I sat on the sidewalk beside the can. "Are you really Lou?"

"I am *a* Lou." The face grinned. "One of many."

"Rats."

"Rough day?"

"Educational."

"Busload of Faith, girl. That's what it takes." The image grumbled under its breath, then lowered the torch—lines blurred and shifted until it lengthened into a guitar neck and the flame grew and rounded into the body. I rested my head against the can, watched the overlay of street scenes. and listened to the music—"Sweet Jane" into "Sunday Morning" into "Satellite of Love."

Then came a pause. "How about 'Femme Fatale?'"

"Not that one."

"'Beginning to See the Light?'"

"That works. That works just fine." As the song rumbled in my ear, my strange day settled into quiet night. The first setting of my new sun, different yet the same, followed by more stars than I had ever seen before, and the promise of a new day.

Thievery Bar None

Aaron M. Roth

Barasa sometimes thinks of himself as a sort of Robin Hood figure. The only significant difference, he tells himself, is that instead of stealing from the rich and giving to the poor, he steals from the rich and sells to other rich.

His current customer today, sitting across from him, is slowly turning over the chalice in his hands. They have demanded that Barasa travel all the way to Perth for the transaction. Back in the days when his finances were greater and the physical threats to his person lesser, he would have scoffed. He always found traveling a real pain. But today, Barasa needs this. Needs something quickly. His debtors can extract payment in multiple ways. Barasa hopes he'll be able to pay with money.

The stranger is frowning at the fragile vessel, appraising it, or pretending to at least. At this initial stage, with a new person, Barasa always finds himself wondering, *Will this one see how beautiful it is?*

What the curves of a beautiful woman are to some men, is what the unique bends in an antique object are to Barasa. Barasa will speak to new pieces as if to court them, telling them how their previous owners didn't appreciate them like Barasa does. Genuine antiques from the ancient or even pre-modern past. "There is nothing like it. Nothing like you!" Barasa will say in conversation with an old desk. "Nothing!" Turning to a grandfather clock he might then admit, "Okay, to be fair, repros these days can be *very* much like you. But isn't it exciting, even when you need a machine to dis-

tinguish between them?"

Rubbing the table at which he is seated, Barasa is reminded that this tavern isn't anything special. Which is good. He chose it for being large and low-key. The mix of patrons here was such that Barasa could blend in and his presence would not be remarkable. This table is a repro, but it's a good one.

Barasa liberates treasures from unworthy owners. As for the new owners—well, Barasa thinks, a person who is willing to purchase an object on the black market, such that it can never be publicly displayed? Such a person can be said to appreciate its intrinsic value.

This stranger is now running an erometer all around the object. Barasa is a big advocate for them. "Great little inventions," Barasa will say, openly recommending them to clients. "Better than carbon-dating." If they hadn't been invented in the early twenty-second century, differences between fakes and real antiques may have become so indistinguishable that Barasa's line of work wouldn't exist.

The stranger is holding it wrong though. He seems to be more unsophisticated than Barasa would prefer, but that is par for the course. Barasa reminds himself that a poseur's currency holds the same value as anyone else's. He is running a business.

"It seems genuine, as you said. The condition leaves something to be desired. See ..." the customer begins.

"The condition is *excellent*, just as described." Barasa interrupts, familiar with all the feints of negotiation. "I'm not giving a discount." A bluff, today.

"What about a bulk discount? Do you have any other artifacts from the categories on the list I sent you?" the stranger rejoins.

Ah, if only! Barasa thinks, closing his eyes briefly and stifling a sigh of anguish.

"I just recently had a relevant lot," Barasa admits, "but I already committed to sell it to someone else." Sold, but never delivered.

A pit forms in Barasa's stomach. A thirty-one-piece Japanese moriage dragonware tea set. The collection was ornate, well preserved, used by famous figures, and of provable provenance and origin (Noritake, Nippon-era). It would have been his biggest profit ever. (And put him in good with Julen Baz, a mover and shaker in the Mombasa underworld.) The advance alone was more than his other top five sales combined. "And yet," he berated himself on perhaps an hourly basis since then, "like a *mjinga*, I had to spend it all before the transaction was complete." The police had discov-

ered and broken up the handoff, arrested Barasa's proxy (and Baz's), and confiscated the merchandise for themselves. Baz was angry and demanded a refund, which Barasa could not pay.

The stranger is looking down, still considering.

They are interrupted as a muscular arm delivers two giant mugs of beer. Barasa doesn't look at the server, just continues evaluating the stranger, who smiles for the first time.

"Ah! Thank you. Listen," the stranger says earnestly to Barasa, "The beer here is the best. I'm sure it's better than whatever swill you have in Africa."

Barasa is no fool and he smells the beer and looks at it, letting his olfactory and ocular implants check for poisons. Seems to be clean. Barasa is also a salesman, so, hiding his annoyance he lifts his mug, clinks it with the stranger's, and drinks.

Really though, Barasa thinks, in Kenya you can get tea from the best tea leaves in the world (to this day exported to other regions for blending with inferior local teas!) and consume a beverage that doesn't require dulling the senses to enjoy. The beer back home is just fine, too.

The stranger sighs, says, "I'm sorry, I don't think I'm interested after all," and hands Barasa back the chalice.

Somewhat surprised, Barasa takes it back. He looks at it and by habit holds it in his left hand and rubs the surface with the thumb of his right. Then, after a few moments, with an affronted grunt, he pauses and squints.

"Ha. What a cheeky bastard ..." Barasa mutters under his breath, setting the vessel down on the table. He picks up his mug of beer and in a swift motion brings it down upon the chalice. Flecks of material and beer litter the table as well as the shocked figure of the stranger himself. The din of the bar is loud and, after a few glances at the sound, no one else seems to pay them any heed.

"Nice repro," Barasa says, "but if you want to keep the chalice, you have to pay for it."

Glaring at the stranger, Barasa projects a menacing contempt. The stranger taps a pocket on his coat absently and looks down, sullen and ashamed—and frightened, Barasa hopes—and after a moment his eyes flit up tentatively at Barasa before returning to the floor. Barasa's neural implant indicates that the payment has been received.

"Ok," says Barasa. "We're square."

The stranger rushes out. Barasa grins. Any sale is a successful sale. He

decides that it has been worth the intercontinental trip. He leans back and stretches, taking in the room again. He has staked it out ahead of time, of course, but it doesn't hurt to look around again, check for watchful eyes. All seems well.

He figures he will linger for a few minutes and then leave. He stands and ambles to the wall. Hanging on it, among other junk, is a quite impressive ancient-looking stone tablet. Barasa smiles. He can appreciate this.

You're a piece of good work indeed, Barasa thinks, addressing the tablet. *No cheap knockoff, you. What are you supposed to be, Egyptian? No, Sumerian. Good attention to detail. There are actual characters on you, not just squiggles. The wear is a bit much. Wear comes from being out in the elements, or from being used. A stone tablet, found in the ground after thousands of years, wouldn't look like this. Now, if a tablet like you had actually been in a bar for a few thousand years—oh. Ha, that is some subtle humor.* Barasa really hopes he is laughing at the fine joke of a master reproductionist and not reading too much into the shoddy craftsmanship of a rube.

Barasa takes out his own erometer. It is fine-grained enough to be useful for recent constructions, too. Might tell him enough info to track down the artist. Barasa likes to keep abreast of the latest advances in the field so that he can stay ahead of the game himself.

He begins to run it over the surface of the stone. Then, pulse quickening, he continues to run it over all of its parts. "No," he whispers, "it can't be." The device is telling him that it is genuinely old. Really old.

It has to be a fake, given the grungy nature of the establishment. But his erometer is state of the art. If it can be fooled, Barasa realizes, then it would be enough to fool any client. To top it all off, a quick check discovers that nothing matching its description even appears in the Worldwide Database of Artifacts and Collectibles.

This is big, Barasa confirms as he thinks through the possibilities, *Julen Baz might like it. Pay off the debt. Or even sell to someone else at a high price, pay off Julen Baz, and still come out ahead.*

Oh yes, this is going to be a profitable trip.

He looks around. No one is taking an interest in him. He looks at the large man behind the bar, who is concentrating on cleaning a glass. Barasa's earlier customer had noted him as the owner of the place. An imposing man physically, to be sure. Barasa sizes him up. He watches the owner interact with his space and his customers at the bar. He is secure in this space, almost a part of it. The owner looks like he belongs there, serving drinks,

more than any barkeep Barasa has ever seen, somehow. Yet, probably the owner knows not much in life beyond running his bar. His security will probably be good. But Barasa wonders, does he realize the treasure that is out here, worth more than any liquor on the shelf? Barasa's profile of the establishment (the standard one he undertakes before any meeting, even in public) seemed to indicate there is no computerized security system. A physical lock seems to be it. (Perhaps, Barasa assumes, the liquor itself is stored in a more secure inner vault each night?)

"I don't think he understands you," Barasa murmurs to the tablet, "I don't think he sees you like I do ..."

Barasa doesn't want to underestimate things by anticipating an easy job, but there is no question it's doable.

In a few nights' time, Barasa will steal the stone tablet.

* * *

The piece is located in a bar, so this early morning hour is when it has to be done—well after closing, but still before sunrise. Barasa stands outside the bar's back door, next to a large suitcase, listening to the readings from sensors he has placed strategically on the outside of the building days earlier.

There is a single occupant that his tools can detect (the owner, he supposes), seemingly asleep, as he has been each day by this time. Barasa silently approaches the back door and begins to work. An observer would see an unremarkable man nonchalantly unlocking a door and entering. His hands hide the automatic lock-picking device he uses on the keyholes. A practiced casual downward swipe with the laser-blade clips off the deadbolts.

Barasa is on high alert as he enters, taking a cautious step inside, prepared to deploy any number of countermeasures or even flee, depending on the security he encounters within. His prep scouting has not uncovered any defensive measures, but one can't rely on that.

Nothing happens. No automated defense drones. No beeps of tripwires, fake or real. His sensors, feeding data to his implant, do not detect any silent calls to the police or private security services.

Well then, he thinks, time to get to work, though he can't relax his vigilance. Barasa drags in the suitcase from outside and closes the door.

He approaches the tablet. In the darkness, it seems to have its own glow. It is valuable. Barasa can't help but fantasize: what if it really is as genuine and as old as the erometer claims? Barasa's heartbeat accelerates as he opens the suitcase. Inside it are swaddling materials to pack the artifact

safely, along with other tools. He takes some of the bundling material out of the suitcase and leaves it open beneath the artifact. Barasa looks at how it is secured. It seems to be simply resting on a stand on the wall, not secured in any special way.

He grips the tablet and pulls it down, causing it to fall into the suitcase with a thunk. He hopes the owner will not wake up at the sound. He pats his weapon holster, reassuring himself that he is prepared for that contingency, too. This doesn't seem to him to be a posh part of town where a death would kick up a fuss.

Still, he works quickly, packing in the artifact as safe as can be made and securing the suitcase.

Then, he exits the bar, lugging the suitcase with the stolen tablet behind him.

* * *

Barasa is nothing if not dedicated. To avoid there being a record of his having been near the bar this night, he spends an hour lugging the suitcase across town, taking a route he has planned so as to avoid electronic surveillance. Only then does he trigger his neural implant to call for a taxi.

At the intercontinental train station he is a passenger like any other, ticket purchased a few days earlier. His latest acquisition weighs a ton, though. It seemed to get heavier over the course of traveling here. Barasa is drenched in sweat and can barely move. Rolling it down the street was one thing, but he has a redcap carry it into his private cabin and help stow it in the luggage compartment above the seat.

After tipping the redcap, Barasa closes the door to the luggage bin, ensures the door to his cabin is locked, and flops down in the seat.

He smiles, lets out a laugh that in his drained state comes out as soft guttural noises. *Too early to celebrate*, he reminds himself ... *but still, it should be smooth sailing from here.*

It will take full-nine hours on the high speed intercontinental to reach Mombasa from Perth, travelling under the Indian Ocean in a straight shot through the vacuum tube.

Too physically tired to move, too hopped up on adrenaline to rest, Barasa sits, ponders, and plans.

After an hour, the food and beverage trolley rolls by. Barasa downloads the menu in his head, opens the door to his cabin, and asks the robot for water, no ice, the chicken biryani, and two packs of cookies. At a mental command, a table folds down from the wall. The attendant-bot hands him

the two cookie packs, pulls out a hot covered foil tray from the interior of the cart, and sets it on the table in his cabin. Then the attendant takes a cup and places it under a spigot, pulling down the handle. Barasa grimaces as he sees brown liquid fall into the cup before the bot sets it on his table. Barasa grunts. He hopes it's a technical malfunction, some syrup getting squirted in, and not some kid pissing in the water container as a practical joke.

Barasa pushes the "beverage" to the other side of the table and focuses on his food. He opens the top of the biryani container to find that in reality it is fish and chips. He raises his eyebrows and shakes his head. Clearly the food trolley is malfunctioning on multiple levels (probably a software bug, he thinks, all they would have had to do was change the menu for this one), but maybe he's in the mood for fish and chips anyway. He digs in.

What a heist, Barasa thinks as he chews. *What a find! Once safe back at the shop, I'll give it a more thorough inspection. It should be in a museum, really. Good thing it's not.* Barasa doesn't test museum security.

"Don't steal jewelry from a jeweler, nor the artifacts from a museum. Steal them from people who don't know enough to protect them sufficiently," Barasa will often confide to an artifact gained in such a manner. "That's the way to go."

"A good find indeed." he says aloud, grinning wide.

And, even though he had not intended to order it, the fish and chips is good enough for a train ride, if a bit bland, and leaves him full and satisfied.

Opening a pack of cookies Barasa reaches in and pulls out a pretzel. So, it is a mislabeled bag of pretzels. *Ha,* he thinks, *factory really messing up.* Still, he wants a cookie.

He opens the other pack of cookies and pours them onto his plate. Beer nuts roll out. He has beer nuts and pretzels. Following a meal of fish and chips.

Barasa squeezes the back of his neck. Then he looks around the tiny cabin, not focusing on anything in particular. He assumes what he is feeling is nothing more than on-the-job nerves. Wouldn't be the first time. He tells himself that there is nothing threatening about mislabeled bags and wrong menus.

He eats a beer nut.

Beer nut. Pretzel. Fish and chips.

The dark beverage across the table stares at him. He glares back. He pulls it towards himself. Sniffs it.

Beer.

He asked for water and the damn malfunctioning bot gave him beer. He pushes it away again. *That's some malfunction*, he thinks.

He suddenly has an unsettling vision of his train compartment as a trap, like a prison floating in the vacuum.

"No," he whispers. He is travelling home. "Everything will be fine. The size of the catch is just bringing on the jitters, right?"

He leans back.

At the very least, he is tired. Been awake for a whole day and half by now.

Eventually, he falls asleep.

* * *

He wakes up gently. Still lying on his seat in the cabin. The cushion is soft on his face.

The rhythmic sounds of machinery soothe his ears. He hears muffled voices and a laugh from a neighboring cabin. He hears the barely perceptible hum produced by the systems on the train. He hears the clink of glasses hitting together—

"What?"

Barasa sits bolt upright. He stares.

Across from him, above the facing seat and hanging from underneath the luggage compartment, are rows of hanging glasses. They hang upside down and hit each other gently.

"So. Ok," his mind groggily tries to sort this out. "Someone came in while I was napping and put up these glass racks. That is some effed up shit right there. That's a bit frightening just on account of how weird it is. This cannot be blamed on a software malfunction.

"Unless … did I just not notice them initially? As high strung as I was? No. Train cabins do not have rows of glasses hanging upside down. You don't find that in a train cabin, you expect that at a restaurant maybe, or a bar—"

Barasa looks down at the remnants of his meal, trembling a bit.

Despite the dryness of his throat, he does not even look at the beer. He prefers to forget that it is there.

"This train ride needs to end," Barasa pleads. "It *needs* to *end*. That is all." He checks how much time is left. Forty minutes.

It would be impossible for him to fall back asleep now. He considers calling an attendant to ask about the rack or to request changing compartments, but he doesn't want to draw attention to himself. He sits and stresses.

He puts everything on the table in the trash and puts the table up. *It doesn't make any sense. What's happening doesn't make sense. Someone is pulling some prank on me maybe? But, in the middle of a job, when no one should know where I am? In a train?* He is not sure if it's a message from someone, or what kind of message that would be, or what would motivate a person to do this. A less rational part of his mind screams *juju!,* but he hasn't really believed in that since he was a child. "Who did this?" he wants to know. "And why?"

He pokes his head out of the cabin. The passageway is empty. He pulls back inside.

The clinking of the glasses unnerves him more and more. It seems to only increase.

Finally, after an excruciating wait, the train arrives.

Opening the luggage compartment, Barasa sees his suitcase—surrounded by bottles and bottles of liquor and spirits. Barasa throws them to the floor and pulls the suitcase down. It crashes into and smashes some of the bottles. Barasa does not care. Let them be smashed. He wonders where they came from. Maybe he didn't notice them when he put the luggage in at the beginning? Yet, at the beginning of the ride, the luggage had seemed to barely fit.

He has to get out of here. He can't wait for the redcap. He needs to get off this train *now*.

Barasa looks down the passageway, spying a brawny fellow walking closer.

"Hey you!" Barasa says. "Can you help me carry my luggage off the train?"

The person protests that it's not their job. Barasa ducks back into his cabin, finds the most expensive-looking bottles that are unbroken and brandishes them as an offer.

"Take this," Barasa pleads, "or any of the other bottles you want!"

In return for these scotch whiskies, stuffed into the person's backpack, Barasa receives assistance with his suitcase.

Though still out of sorts, Barasa is pleased. Mombasa. Familiar turf. It's still the afternoon here, due to the time change. Emerging into the city air, he first smells the mingling of ocean, palm oil, and cement dust. As he walks another step the scents from the sweat of the crowds and the exhaust of off-grid machines flouting the green laws make themselves known, along with that classic mix of spices he didn't know was especially Kenyan until

he first traveled abroad. Looking up, he sees the heights of buildings rise almost in a slope from the squat ones here, not far from the water, to the reaching towers in the distance in the heart of the city. Public transportation slowly grows in capacity, but so too does the population of people who seek to use it, and so everything is always crowded.

The tuk-tuk ride home is wonderfully uneventful. He watches the scenery of the different neighborhoods: the vehicles and drones that bustle about the industrial zone; the streets filled with cars, buses, tuk-tuks, bicycles and other manner of contraptions. All over, people of so many different kinds. Some hurry about their business. Others retain a carefree, slow-paced nature even in this busy place. Some neighborhoods will be full of music and dancing all afternoon and evening. When the tuk-tuk is forced to slow, he hears snippets of conversation in the many languages native to his hometown. Foreign languages are not out of place either. Now they ride on to a neighborhood where residents and businesses are interspersed, neither too quiet nor too loud. Busy enough that he and anyone he meets can come and go and be lost in a crowd, but still such that there exists a low-traffic alley where Barasa now tells the driver to enter and let him off. It's only slightly quieter here, but even that modicum is noticeable. The sounds of the city are still present, but dampened and hidden by the surrounding buildings.

The entrance to Barasa's own abode slash workshop slash showroom is, for the uninvited, impossible to enter. (Nor would you even notice it was there unless you were looking specifically for it.) Physical and digital locks and security systems on the entryways and internal spaces abound. Barasa does not take any chances nor spare any expense in this regard.

At the threshold, he takes a moment to enter the proper codes and authorizations, and then hauls his suitcase inside.

He opens the suitcase. The artifact is still there. (Of course, he reprimands himself gently, what did he expect?) Nothing has crept into his luggage that shouldn't be there.

His place is as he left it. Sometimes he has a qualified customer who wants to "browse," so he has a bit of a showroom for that purpose. Not his top pieces, but a good-looking array. A few furniture pieces strewn about. Several wooden cabinets. All the furniture is empty. He doesn't use any of the merchandise functionally. Glass display cases hold jewelry and other small artifacts.

Now he can relax. The train ride feels like a bad dream. The increasing anxiety he felt during the trip seems unwarranted and shameful now that

he is secure. The tavern that sourced his new treasure is literally an ocean away.

Barasa does a thorough check of his security measures, making sure that everything is fully armed. Then he goes downstairs to his private residence beneath the showroom and takes a shower.

The job is done. The artifact is in his possession, secure in his home. Whatever was happening on the train, assuming there was even anything at all outside of his imagination, cannot get to him now. And indeed, there is no fortress like the home of Barasa.

He is safe.

* * *

Ravenous, he cooks himself up a batch of karanga. While waiting for it to cook, he opens a pack of cassava crisps to munch on and is happy to find cassava crisps inside. When the stew is ready, he eats it with chipatis.

When Barasa finishes his meal, an irrational fear seizes him. He rushes from his kitchen up to the front room.

All seems well. The tablet lays in the open suitcase. The room is the same as always. But then, he admonishes himself once again, what did he expect?

Still, he heaves a sigh of relief and ensconces himself in a comfortable chair. Not an antique, the chair was a repro, meant for actual sitting.

Barasa sits and surveys his domain.

Suddenly the door to his storeroom opens and a giant of a man casually walks out. Well-built and handsome. Dressed in the Western fashion, but not of the West. Barasa can usually tell someone's background, having grown up in the multicultural mix that contemporary Mombasa has become, but he cannot place this man's ethnicity. He can't shake the feeling that he's seen this man somewhere before.

Without moving a muscle, via neural implant, Barasa instructs the house security system to subdue the intruder. The system tells him there are no intruders. "What?" He queries the system regarding persons on the premises.

Barasa Komen, resident
Gilgamesh, resident

So, he thinks, that's who he is dealing with: some sort of expert hacker calling himself Gilgamesh. It would not be the first time Barasa was outclassed in some capacity—but he still always came out ahead. The intruder hasn't tried to kill him, which must mean this "Gilgamesh" wants some-

thing—or else didn't know he was here.

The man is standing in the middle of the room, surveying it appraisingly. *Not like a buyer,* Barasa notes in his mental assessment. *Like an owner. Like a* sonko. *What an arrogant shit.* Eventually, the man's gaze reaches Barasa.

"Gilgamesh," says Barasa.

"Please," says the man, "call me Gil."

Gil begins to take some of the tables and place them in a row a few feet from the cabinets. He lifts them with impressive ease.

"You are in my showroom," says Barasa. He wants to punch this Gil in the face and upbraid him for touching his tables, but that can wait. Barasa knows that he needs to keep his cool and figure out what he's dealing with here. He clenches his teeth and, with some effort, does no more than stand up.

After Gil does not respond, Barasa decides to cut short the waiting game and ask the obvious.

"Who are you and what are you doing here?"

Gil pauses.

"You seemed to already know my name. If you don't know who I am, that's more your fault than mine. But come, have a drink with me."

Gil opens a wooden cabinet that should be empty and pulls out a bottle of gin. Barasa notices that the glass cases along that wall now have various liquor bottles disturbing the jewelry and other items on display there. *Just like on the train,* Barasa realizes. *Were they already here when I got back?*

Barasa says only, "No," in reply. Barasa is walking in an arc, slowly approaching the table where Gil stands. *Only one of us is leaving here alive,* Barasa thinks. *I don't care what your game is, 'Gil,' I will not forgive this trespass.* Barasa smells each distinctive piece of furniture as he passes it. Gil turns as Barasa circles, and Barasa's every muscle is tensed as he tries to determine what is going on and when to strike. *But what can I do?* he wonders. Barasa curses technology, knowing that if the security system were functioning properly this Gil would be riddled with holes by now.

"As for what I'm doing," Gil continues, unfazed, "right now I'm setting up, and soon I expect I'll serve some customers."

"Customers?"

"Yes," Gil explains, "you see, this is a bar."

At that Barasa erupts, voice aflame.

"It'll be a bar when the donkeys have grown horns!"

This. Barasa thinks in silent rage, *this one. This one right here has been*

playing some sort of psychological game with me for the past two days.

Gil shrugs.

Barasa has been threatened with death and mutilation. He's been beaten up more than once. He's grown accustomed to that sort of risk, accepting it as a hazard of his business. This new perversion is, to Barasa, somehow even more intolerable.

The front door opens and a new person enters, then stands and looks around uncertainly. *What the hell?* Barasa thinks. *Has all security just been disabled?* Barasa wonders if this is some accomplice of Gil's.

"Can I help you?" Gil and Barasa say in accidental unison.

"This ... is a bar, right?"

No, Barasa thinks to himself, staring incredulously, *No, it is not.*

"I'm sorry," says Barasa. "You must be mistaken. This is simply my personal residence and you are a trespasser."

"But ... there is a sign? I just thought ..." the newcomer trails off.

"Sign?" says Barasa, alarmed. He knows the entrance here should be nondescript, almost hidden.

Sidestepping to the door so that he can keep the conspirators in sight, Barasa pokes his head outside to find that the entire façade of his building has been changed. No longer anonymous, it has an attractive wall, and a noticeable doorway, and above it—"Oh, *no,*" Barasa groans—there is a sign. Wooden in appearance, attached to the wall. Altogether the impression is such that Barasa half-fears he'll soon be hearing chakacha and benga spilling out of the premises. The sign reads, "Mahali Ya Barasa." Barasa's Place. His mind fills with horror, *"No no no no no NO NO NO—"*

Barasa dives back inside.

The newest threat is sitting at the bar and Gil is pouring him a drink. "At the bar"? Barasa catches himself but realizes it is the natural thing to call it. No longer does it look simply like priceless antiques pushed into a line, but like a place that is meant to be stood or sat at. No longer are the bottles behind the "bar" haphazardly arranged as if dropped into the display cases at random, but rather neat and in a row, the jewelry and other small goods pushed to the side and seeming out of place.

Barasa rushes past them into his storeroom.

"What in the name—"

His storeroom has been transformed. There is a bed. There are all manner of strange artifacts strewn about—and Barasa has *seen* strange artifacts, but not like these—and the room seems larger somehow.

After a frenzied search, Barasa finds his axe with the long handle and grabs it. On his way back outside, a part of his mind registers the fact that there seem to be additional stools and chairs that he's never seen before now in his showroom. Returning to the sign, he hacks it down.

He carries the sign inside. As riled as Barasa is, he still appreciates the material. Good quality repro, feels nice. It'd feel nicer slamming against both these invaders' heads though.

Back inside, Barasa approaches the bar, mind screaming. He knows he's got to do something soon before things get more out of hand. Gil gives him an innocent smile. Barasa thinks that Gil deserves to lose all of those teeth.

"Here," Gil says, pouring a drink. "For you." Barasa uses the wooden sign to push the drink away.

Oh great, Barasa notes mentally, *the 'customer' is fondling a snuff box, looking at it. The hits just keep on coming, don't they?*

That's a good item. He took this snuff box about a year ago from an Antonio Suarez, and—"Oh SHIT," he murmurs as the realization hits him.

"I used to have an antique snuff box just like this," Antonio is saying, looking up at them, "but it was stolen." Barasa puts on a poker face.

"Oh? That's interesting. My friend here," says Gil, gesturing at Barasa, "has actually recovered quite a few stolen antiques."

"This ..." Antonio says, head near the base, "this is the very inscription that was on mine. This is the very one that was stolen from me!"

"Oh, excellent," Gil says, looking at Barasa now, "it's always a pleasure to know when a valuable object is reunited with its owner."

Antonio seems a bit shocked. He glances from one to the other, seemingly unable to settle between gratitude and suspicion. Barasa remains stony-faced, weighing the chances of taking Antonio out right now. He decides to cut his losses and elects to give a nod. With the seeming unreliability of his security measures, Barasa doesn't know if he could prevail without one of them stopping him. Better to face Gil, the bigger threat, without complications.

"We're closed now. You'll have to leave. Take your snuff box," Barasa says, and it pains him to say it, but he doesn't need this guy hanging around. As they say, he tells himself, blessings are better than possessions. Antonio unsteadily stands, clutching his snuff box, and exits.

Gil and Barasa remain unmoving until the door closes behind the customer.

Barasa scrutinizes Gil. Then it hits him. Where he's seen this one before.

"You own that tavern in Perth. Across the ocean." Barasa says slowly.

"I used to," grants Gil, "until yesterday. I remember you there. You were admiring my tablet. The one that's sitting in that suitcase over there now."

Barasa resists the urge to turn.

"I don't often get to choose where I go, so when I overheard your conversation, I thought I'd take advantage of this opportunity." Gil continued. "I thought Mombasa might be fun. Why else do you think I let you take the tablet?"

"Oh?" says Barasa, calculating how much to acknowledge and how much to dissemble. "I saw it, yes, but the tablet in my possession over there is just a fabrication I made myself, inspired by what was hanging in your tavern."

"Well, you have certainly produced quite the fabrication," says Gil, chuckling. "The truth is, wherever that tablet goes, a bar goes with it. And I go with the bar."

Gil folds the rag on the counter, and all the humor is lost from his voice when he speaks next.

"All the same, you *stole* my tablet. I didn't even know if such a thing was actually possible. But here it is. You've taken it, and so, you have brought *me* here. What is strange, though, is that for some reason it doesn't seem possible for me to take it back from you in turn. Perhaps because I let it be taken willingly. I'm not sure. But now I must have it back. I am still bound to it, and I am not done serving drinks to those who are in need."

Barasa doesn't quite follow every reference Gil is making, but about one thing Barasa is certain. He is not about to just give up the tablet, even if Gil suspects the truth. This will be the crown jewel of his collection. It is undoubtedly the finest piece he has encountered in his life. But with the frenzy of the past couple of days, he hasn't even had a chance yet to sit with it, admire it, and enjoy its company. Even putting aside the threat Gil poses to him personally, no way is he going to give it up, not even if Gil begs for it. Not even if he pays for it. Certainly not through demands.

"I am sorry for whatever you think happened, but *this* tablet is mine," Barasa responds, "I am keeping it, and you need to leave." In his head Barasa mentally reviews all the weaponry he has at his disposal. Clearly, he reasons, the home system has been tampered with so as to prevent its use in attacking Gil. Given that, he doesn't think there is much he can use, but he still has options.

"One possibility I see, given that the bar is to be located here," said Gil,

whose mouth was smiling but whose eyes were not, "is for you to help me run this bar. You are not doing good things with your life. But you can change. You would not be the first on whom I showed favor in this way. You can make an honest living. I can offer you protection, and a way out, and all you have to do is relinquish the tablet to me."

"Ah, how generous. Thank you," Barasa says, as if considering the proposal, all the while moving forward and into position. "But this is my home. This is NOT—" Barasa brings up the wooden sign "—A BAR!" And he brings it down atop Gil's head.

Or at least, that was the plan. Instead, Gil swats at the heavy wood and Barasa is forced to shield his eyes as it shatters into sharp stakes.

Barasa tries to swing the axe at Gil before he can recover, but Gil grabs it just above the blade and, wresting it from Barasa's grip, flings it to the opposite side of the room.

Barasa takes a few steps back, out of Gil's reach, and pulls out a pistol, pointing it at Gil. A good old-fashioned mechanical weapon. Not something that can be hacked. No way for Gil to defend against this.

Gil moves before Barasa can react and he feels a pain in his hand as he drops the gun. Gil had flung a broken shot glass right at his hand! Barasa steps over to pick up the gun again but Gil is there first, picking it up and pocketing it.

"You cannot hurt me in my own bar," Gil says, "and I don't think you're really listening to me either." Another step and Gil is upon him. Barasa picks up a piece of the splintered wood in each hand and as Gil bends down Barasa lunges, one stake aimed for Gil's eye, the other for his neck. Before they make contact each wrist is gripped in a hand like a vise and Gil twists Barasa around, bringing his hands together behind his back.

Gil lifts Barasa full into the air and presses him face down onto the countertop. Barasa feels his hands being bound behind him. By the texture, it must be the cleaning rag, twisted up.

Barasa feels himself being turned, and now he is staring into Gil's eyes. He struggles a bit but the binding on his hands is strong. A large, firm arm presses down atop him.

"I am going to have to rescind my job offer, I'm afraid," Gil says. "It's not that I think you'd be bad at mixing drinks, you understand. I just don't think we'd get along so well. I'm not feeling like this would be a great location anymore, either."

Barasa lays there, unable to see a way out of this. Whatever he does, he

cannot seem to overpower or outwit this intruder. Neither physically nor technologically. Is this the end?

"You have two choices now. One, return the tablet. I'll take it and leave. While I'm not worried about my own safety, I don't want to endanger my customers, nor have you scare them all away. Perhaps this was a mistake and I should have just let myself go where the tablet takes me, as always. All the same," Gil says, his voice turning colder, "you do have another choice, should you decide to keep the tablet. And that is that I continue to operate this bar as planned. I'll continue to bring in customers, some of whom you may know, like our friend just now. It makes no difference to me.

"But there's more, too, if you force me to stay. For what you have done to me and the reception I have been given, I will make sure that in addition to losing what you have, you will never gain another antique treasure. Not by theft and not by honest purchase. You will never come into contact with anything that's not printed out of cheap plastic."

Barasa shudders. He can see his life unfolding before him now, all the work he's done unraveled, all his joy taken from him. "Nothing old ..." Barasa mutters.

"Nothing old," Gil agrees. "Nothing but me!" Gil laughs a hollow laugh, as if his deep voice were echoing within a great underground cavern. "I can leave with my tablet, or I can stay here and run the bar." Gil's words, despite their menace, feel to Barasa more like a statement of some natural law than a threat.

Barasa recalls the unnerving train ride, the surreal transformation of his own home, the superhuman strength of Gil, and the horror of his threats. The tablet started this mess. Is it worth keeping, for the sake of his personal ruin? Barasa is convinced now that Gil could make good on what he said. They are not empty words.

"Fine," Barasa spits out, bitter and dejected in defeat. "Untie me and take the damned tablet. You can have it."

Gil turns Barasa upright into a sitting position, facing the wall. Barasa hears Gil drag the suitcase over and then feels his bonds being loosened. Barasa rubs his wrists and turns around.

When he sees Gil, he stares, dumbfounded.

Gil holds the tablet, familiar with it like Barasa will never be. And all around them swirl colored dust. Yet there is no wind, nor do these colors seem to interact with the physical world, aside from Gil and the tablet, who are disappearing.

It all happens in a second. It's over before Barasa grasps what he is looking at.

The showroom is a disheveled mess. Splintered wood and broken furniture lay all about, punctuated by shattered bottles, their former contents ruining the floor and some upholstery. Still, as much as he rues losing out on the bounty he hoped for, he finds himself relieved. In his heart, he knows that he *really* doesn't need the strangeness of Gilgamesh in his life.

Julen Baz is still an issue, along with all his usual problems. Compared to this Sumerian craziness, however, it all seems very manageable. Barasa hopes to still be able to find some nice antiques, using his more usual methods. He hopes that he can rustle up some nice non-magical artifacts soon.

Ones that do not come with bars attached.

𝔚𝔞𝔫𝔡𝔢𝔯𝔩𝔲𝔰𝔱

Juliet E. McKenna

The summer sunlight was shining full on the windows and the climate control wasn't quite keeping up with having so many people in a seminar room this size. The comfortable warmth was making Adie drowsy. That and not having had nearly enough sleep last night, or the night before. But there were so many parties celebrating graduation and it wouldn't do to be rude by turning invitations down. Good manners were prized on Mars, and with good reason.

She shifted in her seat and made an effort to look interested as Doctor Reynolds continued talking.

"The more renewable power we can generate for ourselves, through solar panels, wind turbines and our geothermal resources, the better it will be for our economy. Obviously, we have all the deuterium we might need for our own reactors, but it's our most valuable export. Earth, Luna, the Belt, and the Saturn and Jupiter stations have no real alternatives to fusion. The more fuel we can sell to them, the more investment we can fund here at home. Of course, that means we're buying plenty of raw materials from the Belt and the Outer Stations, as well as the Earth hi-tech we're not ready to make for ourselves yet, so everyone's a winner."

Doctor Reynolds grinned as he snapped his fingers and the holographic display switched to a detailed engineering schematic. "Now, this is the next generation of solar panels that we're currently working on."

It was no good. Adie couldn't concentrate. It wasn't as if she'd ever wanted to become an electrical engineer. It wasn't as if any of the career track speakers were offering the future she wanted as an option.

Fortunately, from where she was sitting, she could gaze out of the window without it being too obvious. Better yet, this teaching block was in one of the outer domes of the UofMars campus. Best of all, the seminar room looked outwards rather than inwards towards the rest of the complex.

The dome's spiderweb of polyhedral latticework was barely ten meters away and the panels had recently been replaced with the latest glass-composites that shrugged off even the worst Martian dust storms. Adie could see all the way to the horizon, where the rich ochre mountains met the luminous beauty of the silvery-pink sky.

Closer to the dome, geometric patches of gray-green still looked bizarrely out of place against the familiar russet ground. Adie wondered how long it would take her to get used to seeing these new, experimental plants growing outside the university's greenhouse complex. Would she be working with projects like that if she opted for a future in Botany? Doctor Elliot's presentation this morning had certainly been intriguing. Still, Adie wondered how long anyone could stay enthusiastic about atmosphere enrichment when progress there would be measured in decades, with the botanical contribution measured in centuries. That wasn't her main problem though. Botany just wasn't what she wanted to do with her life. Not here, anyway.

"Any questions?" Doctor Reynolds was looking around the seminar room for hands. Adie hastily focused on the holographic display before he noticed her. He couldn't slap her with a demerit for lack of attention now that they'd finished classes, but he'd still be offended and he didn't deserve that. Add to that, if she was ever going to persuade her parents to give her plans their blessing, she'd need to convince them that she'd given each and every alternative a thorough assessment before rejecting it.

Two rows over, Jona had his hand up, leaning forward in his seat. "What are the resistances in these new alloys?"

Several other students had similar technical questions and Adie found herself smiling at Doctor Reynold's enthusiasm as he answered them. The veteran engineer was clearly going to enjoy working with these keen newcomers.

The hour chime interrupted him and he gave a rueful shrug. "Well, thanks for your attention. You know where to find me if you want to follow up on anything. Now go and enjoy your break."

His last words were all but lost in an enthusiastic round of applause. Adie wasn't surprised to see Jona join the cluster of students at the front of the room, eager to learn more. Everyone else was switching their dataslates from group to solo mode and filing out through the door, just as happy to be released.

Lex fell into step beside her. They were barely a meter down the corridor when he heaved a sigh that turned into a jaw-cracking yawn. He scrubbed his face with his hands. "Tell me I didn't start snoring in there?"

Misha was walking a few paces ahead of them. She looked back and laughed, not unkindly. "No, but it was close. What were you doing last night?"

Lex looked a little embarrassed. "Bar crawl. Me and Naz bet Pat and Vida that we could tag more domes that they did before powerdown. But I really will turn in early tonight," he assured them both.

"Shall we get some coffee?" Adie suggested.

"Maybe later?" Misha moved to the side of the corridor to avoid getting in anyone's way. "I want to check in with the Habitation Executive."

"You're thinking of applying there?" Adie was surprised. Misha was the last person she would expect to opt for Bureau Track.

Misha shook her head. "There's a new dome cluster just been announced." She couldn't hide her eagerness. "With plenty of single-residence units."

"Let's all put our names down." Lex shook off his lethargy and lengthened his stride.

Adie slowed instead. "I'll do that later. I said I'd check in at home before Mum starts her shift."

Lex nodded his understanding. "You don't know how lucky you are, to have such great parents."

Adie managed a cheery grin. "Oh, believe me, I know it."

They reached the block's outer door and the crowd of students scattered. Some headed for other campus domes while the rest followed the colored paths to the different shuttle locks.

"Will we see you later?" Misha asked. "At Tavu's, to see the new vid he's got?"

"Absolutely," Adie assured her.

"It sounds amazing." Misha grinned.

Lex laughed. "That's one word for it."

Adie turned right while the other two went straight on. It wasn't far to the shuttle lock she needed and her luck was in. The outer doors were closed

and the fat-wheeled roly-poly vehicle was waiting with its doors hospitably open. About half the seats were taken and it was filling up fast. Adie slid across to the window so that a burly tech following her aboard could enjoy the leg room on the aisle.

The shuttle doors closed with their reassuring clunk and hiss and then the dome's double-layered doors sealed themselves. Adie noticed a man a few seats away craning his neck to be quite certain the safety lights had cycled all the way through before the outer doors slid apart. Still, he wasn't clutching an emergency breather bag so he couldn't be too newly arrived from Earth.

She exchanged a discreet smile with the tech who sat beside her. Everyone grew up here learning it wasn't polite to make fun of Greenies but true-born Rusties could always share an unspoken joke.

The pre-programmed shuttle trundled along its tunnel, with the walls so gossamer-thin they were barely noticeable. Adie could see the newcomer still eyeing the struts and panels closely. Was he expecting the shuttle to spring a leak, triggering the tunnel to wrap itself around the vehicle as an emergency seal? Or was that very idea what was making him so nervous? But claustrophobia was one of the first things Earth emigrants were screened for. They couldn't even buy a ticket for the Red Card Lottery without passing such basic tests.

Still, Adie allowed, she'd never walked anywhere without a layer of protection between herself and the atmosphere. Dome-and-tunnel life must take a bit of getting used to. She watched a dust devil whirl across the gravel, stirred up by the warming sun. What would feeling weather on her skin instead of seeing it through glass-composite be like? Probably weird enough to freak her out, at least the first few times.

Not on Mars though. These days Adie just nodded and changed the subject whenever Ma said the Polar Thawing Project would unlock enough carbon dioxide to thicken the atmosphere to human tolerances inside ten years. For one thing, Ma had been saying that for at least five years, ever since she'd taken charge of the orbital mirror monitoring office. For another, that would only mean that Martians could go outside without full environment suits. They'd still need breathing apparatus for Adie's lifetime and beyond.

"Brahe Cluster," the shuttle's AI announced cheerfully as they entered the airlock. "Next stop Huygens."

Adie waited her turn to disembark. Once inside the entrance dome, the other passengers headed home or paused by the coffee-and-snack bar. She

skirted the slew of tables and chairs and followed the familiar patterned path through the four-dwelling domes to the home she'd known all her life. As she reached for the door handle she wondered what living on her own might be like. And not just in a new dome cluster, alongside Jona, Misha, Lex, and all the other people she'd known since kindergarten.

"Hiya!" She closed the door securely behind her.

Ma emerged from the kitchen, a bowl in one hand, chopsticks in the other. "Had a good day?"

Adie nodded but couldn't bring herself to lie. Every passing day just added to her frustration as everyone around her got more enthusiastic about potential career tracks, while no one even mentioned the possibilities she wanted to explore.

"What have you got tomorrow?" Ma scooped up rice and vegetables, eating quickly.

"Methanation and the Sabatier facilities. Advances in Aquaculture. Outgassing the regolith." Adie ticked them off on her fingers.

And that would be that. The graduating class would have five days to make appointments to ask whatever questions they might have, and then they'd be expected to list their top three track choices. Good Martians always did what was expected of them.

Ma nodded, content. "All of those are good options."

"You'd be happy with me choosing any of them?"

"Absolutely. Or following your father. You know that." Ma ducked back into the kitchen to put her empty bowl in the sanitizer.

Not for the first time, Adie thought how much easier this would be if her parents were overbearing and convinced they knew best, like Tasie's. Everyone was supporting his determination to head for Finance Track instead of signing up for Genetics like his mum and dad.

Da appeared at his study door just in time to hear Ma. "How have you found the social and cultural track presentations?"

"They've all been very interesting." Adie managed a smile and walked through to the living room.

Da followed and grinned as he joined her on the couch. "Even if they're not really for you."

How could he know her so well and understand so little about what she wanted to do with her life? Adie hesitated. Was this the time to try convincing him?

Ma came in and gestured at the vid wall. The newsfeed appeared. The

ticker along the bottom of the screen assured everyone that all systems and domes were Gold Status.

Adie could barely remember the last time a cluster or tunnel had been flagged Silver and there hadn't been a Code Bronze in her lifetime. But everyone always checked; Greenies out of newly-learned caution and Rusties out of lifelong habit. Adie wondered how long it took to shed such routines.

"They're just repeating the news from yesterday." Da snapped his fingers in his personal code to summon up the holocontrol.

"Wait a moment." Adie raised a hand. "Please."

"What is it?" Ma focused on the screen, where scientists in saris and suits were congratulating each other with gleeful shouts and tears of triumph. She clicked her tongue, dismissive. "The JC-9745 probe? It'll be months before they release any of the data."

"It's still an incredible achievement." Maybe if they kept talking about it, Adie would find some way into the conversation she really wanted to have with her parents. "Getting a probe to hyper-jump out to an exoplanet system and jump safely back again."

"One, and only one, out of how ever many probes sent out, at who only knows what cost?" Ma looked at the vid, disapproving. "Think what we could do with the resources that Exoplanet Track sucks up? How much could that amount of credit help the poor wretches on Earth?"

Adie seized on that. "Isn't the whole point to find planets where all those Earthers stuck on subsistence can enjoy a life as good as ours?"

"You think Earthers raised on a lifetime of handouts have got what it takes to start a colony from scratch? Even with all we could teach them?" Ma raised incredulous eyebrows.

"There are more than enough Earthers who've been educated as well as any Martian," Adie began.

"Then they'll have decent jobs and prospects where they are, and too much sense to take a one-way trip into the unknown," Ma said firmly. "You have read my grandfather's diaries? You did study the Noachis Disaster in school? And those colonists were within a forty-day plasma-jet trip back to Earth."

Da chuckled. "There are already three games in development that I know of, charting the first exo-pioneers' hair-raising adventures."

Ma turned her back on the screen, her attention diverted. "Are you writing any of the music?"

Da shook his head. "I'm still working on The Tharsis Chargers

soundtrack."

Adie clenched her fists so hard her fingernails dug into her palms. "You know, if the probe data does say there's a habitable exoplanet—"

Ma's wristcomm chimed. "That's my shuttle on its way." She stooped to kiss Da and then Adie. "Enjoy your dinner."

"See you later." Da got up from the couch to follow Ma out of the living room and headed for the kitchen. "Are you ready to eat?" he called out as the outer door resealed itself. "I've got fresh tilapia."

Adie's throat was so tight with frustration that she felt food would choke her. "We can eat later if you're still working. Tavu's got a new vid he wants to share."

Da closed the fridge and nodded. "Okay then, I'll finish the piece I'm revising and comm you when I'm done. You go and see what Tavu's got his hands on. If it's any good, make sure he sends it along to me."

"Will do," Adie promised. "I'll just get changed first."

A swift shower washed away her lingering tiredness and some of the tension in her neck, for the moment at least. Fresh clothes were welcome too, after a long day of sitting about. She couldn't dump her dissatisfaction in the laundry cycler though, along with her creased tunic and trews.

She checked her wristcomm for the time until the next shuttle to Seleucus Cluster. It was soon enough that she headed out. Da was already back in his study, door considerately closed. Outside, through the dome wall, the sun was a bright flare on the knife-edge of the mountains, illuminating the rose-pink dusk sky.

Tavu's parents' house was a short walk from the Seleucus entrance dome. His Ma opened the door to Adie and his Mum waved from the kitchen. The living room was already full of friends from class.

"Sit here." Misha shuffled up to make room on the end of the couch.

Lex certainly didn't mind her getting closer to him, Adie noted.

Tavu was sitting on the floor by the vid wall. "Shall we get started?" As everyone nodded, he clapped his hands and the holocontrol appeared. "Brace yourselves," he warned with a wicked grin.

Silence fell as the vid began with archaic music playing over a title.

Flash Gordon's Trip to Mars

Everyone stared at the screen, astonished.

"It's in grayscale?" Misha was incredulous.

"Everything was back then," Tavu said smugly. "This is from 1938."

The vid continued. Adie watched, sitting quietly amid the howls of

laughter and endless, bemused questions.

"What by all the stars is that thing?"

"A newspaper printing press."

"That's a hardcopy datastream," Calla said helpfully.

Silence fell when a man with skin as dark as Jona's answered a door. Everyone watched the conversation unfold, as uneasy as they were confused.

Misha looked around. "Is this what Professor Jakande means by the black and white era in old vid?"

No one could answer that. Lex cleared his throat. "Did everyone have to wear a hat back then? Was there some law about it?"

It wasn't much of a joke but people laughed all the same. The ridiculous story continued and the questions started up again.

"Would people actually go flying in craft like that?"

Adie wondered if Pat meant the ancient airplane currently on the screen, or the bizarre sparking thing these improbable people were calling a rocketship.

"Is Mongo what Earthers were calling Mars back then?" Jan was utterly mystified.

"It all gets explained," Tavu promised.

As the end credits rolled, Misha shook her head. "I know it was two hundred-odd years ago, but surely Earthers knew better than that, even then?"

"Who wants to see the next episode?" Tavu's hand hovered, ready to flip the holocontrol. His face fell as he got more protests than approval. "Adie?" He looked beseechingly at her.

She raised her hands. "Not on my account. Though if you put it in your public stream, my Da will be interested."

"Good idea," Pat approved, echoed by the others willing to watch more of this curiosity.

Tavu conceded defeat and dismissed the vid with a gesture as he got to his feet. "Who wants something to drink? Snacks?"

"That certainly wins the semester." Jan twisted around to speak to Adie.

"If not the year," she agreed. "And it's got to be the oldest vid we've seen with Mars in it."

On his way back from the kitchen with a tray full of glasses, Dai tapped Jan's knee with a careful foot. "So what tracks are you considering?"

Unsurprisingly, pretty much everyone was discussing possible career choices. Was it even worth listing one of the most popular tracks, if you weren't absolutely committed? Dai had a complicated theory about a Fac-

ulty algorithm that would factor all your relevant grades since kindergarten into your ranking for each speciality within a track.

Pat wanted to know if it was really true that switching tracks didn't count against you, if you realized you'd made the wrong choice by review time in half a year. Had anyone overheard their parents saying anything about people from previous classes doing that? How easy would it be to catch up?

Misha was wondering if listing early made any difference, to show you were really dedicated. Faculty said no applications were considered before deadline, but that wasn't the same as saying no one noticed the order they arrived in.

The one thing that everyone agreed on was making no choice was no option at all. Every family had a story about some cousin who'd opted out of track listing and ended up in waste management or worse. There was a job for everyone on Mars and every job had to be done.

Adie listened and waited for a lull in the conversation. "Is anyone thinking of going off-world?"

Everyone looked at her, wide-eyed. She sipped her drink to avoid meeting anyone's gaze.

"Earth, you mean?" Misha grimaced. "Not with that gravity. And I mean, I know things have improved a lot over there, but they still have a long way to go."

Adie shrugged. "There's Luna, or the Belt, and the Outer Stations are only a hyper-skip away."

"Living without windows or seasons or sunlight?" Lex shuddered dramatically. "Count me out."

"Why would I take a place from some poor Earther wretch wanting a better life?" Pat was genuinely puzzled.

Adie managed a grin, so everyone could think she was teasing. "Where's your sense of adventure? What about the thrill of the unexpected?"

"Adventures like being stuck in a sealed station when some virus mutates? No one expected the Gowrie Plague, did they? No thanks," Tavu said, to widespread and fervent agreement.

"What about the JC-9745 probe?" Adie looked around, hoping this news might have sparked someone's imagination. "Isn't anyone interested in Exoplanet Track? We could be sending out hyper-jump ships inside five years."

"But why would we?" Misha was as baffled as she'd been the first time Adie tried to discuss travel to another system.

Calla nodded. "Our grandparents came here to find humanity a new

home because Earth was being choked by pollution and greed." She could always be relied on to explain things that everyone already knew. "Now we have everything we need, and the Earthers can escape to Luna, the Belt, or the Outer Stations."

"Maybe so." Adie gave up. She'd tried to talk to all of her friends before, individually, and not one of them understood. She already knew how the rest of this conversation would go, as predictable as a shuttle route. Lex would list a seemingly endless roster of dangers that no one in their right mind would risk. Jan would be concerned that something was making Adie so unhappy that leaving Mars looked like her only way out. Calla would insist that listing Exoplanet Track wasn't an option because they hadn't had a careers presentation about it. Adie could challenge them, of course, demanding hard data and reasoned debate instead of cluster whispers. But that wouldn't change anyone's mind and it didn't do to start an argument without good reason. Every Martian grew up knowing that. She finished her drink and pretended to check her wristcomm.

As she got to her feet, Misha looked up from the couch, surprised. "You're going?"

Adie nodded, just about smiling. "Dad was still working when I got back, so I said I'd eat with him when he finished." That wasn't a lie, even if it wasn't the whole truth.

She managed to get out of the house without getting caught up in anyone else's conversation and was able to wave a polite goodbye to Tavu's Mum as she headed for the front door. Out in the dome, she heaved a sigh and walked away, fast enough for anyone watching to think she did have a shuttle to catch.

Reaching the entrance dome, she slowed and checked her wristcomm. She'd actually have quite a wait at this time of the evening. Well, there were comfortable seats to be had and the dome bar was open, over on the far side of the broad plaza. Adie wasn't playing the bar-tagging games that amused Lex and the others, now that they could all legally be served alcohol, but she might as well have her first Seleucus Cluster drink.

She walked over, taking a proper look at the bar for the first time. She'd vaguely registered the concession changing hands a few months ago, but no more than that. There was no point when there wasn't a wristcomm on the planet that would disburse credit for an underage drinker. Adie knew that for a fact. Lex had chased down every possible rumor of synthetic comms to absolutely no avail.

Drinks were served from the open side of a long booth with tall stools along the counter. Those were all empty at the moment. The few other customers preferred the tables and chairs dotted in hospitable circles close by.

The booth itself was fascinating. The plexglass walls were made up of box-like compartments, each one holding what looked like an Earth artifact. Adie recognized a pre-holotech keyboard, some model automobiles, a hardcopy book. There were telephones, from hardwired to handsets like primitive dataslates. Intrigued, she wandered around to the far side and found an array of ceramics, from a frolicking porcelain shepherdess through vases in all sorts of colors down to a sizeable slab of what she guessed was terracotta, in the bottom corner.

Bizarrely, that was about the only thing that didn't look out of place here on Mars. Its reddish hue matched perfectly with the gravel outside. Mind you, Adie had no idea what the geometric markings and holes punched into it might mean. She wondered vaguely if it was something from the dawn of data programming.

None of the collection could be real, of course. Even now that a hyper-hop put Mars within three days travel of Earth, the resources expended in making the hop meant that people travelled with a minimal cargo allowance. Only things that couldn't be made on Mars were shipped and that list of things was getting shorter each year.

She walked back to the front of the booth and took a stool at the counter.

The barman was polishing a glass. "What'll you have?"

He was an Earther by his accent, tall, with earth-gravity muscles. His eyes were green and his hair was black and curly, like his beard. She wondered how many sessions in an envirosuit it would take before he depilated that away.

"Well?" he prompted.

"Er ..." Adie realized she had no idea what she wanted to drink.

The barman stretched out a hand so that his wristcomm was close enough to access her identification data. He smiled amiably. "First time?"

"Something like that," Adie admitted.

"Why not try a beer?" he suggested. "Something light?"

"Okay, thanks." That sounded safe enough. Adie wasn't about to risk miscalculating like Jona last week. Everyone had heard about that within the hour.

"Brewed it myself." The barman pulled a lever and a spigot dispensed a foaming, amber liquid. "Nothing synth in it."

"Really?" Adie had no idea how beer was made, but the greenhouse clusters were growing all sorts of things these days. She accepted the tall glass with a nod and took a cautious sip. It wasn't what she expected, though she didn't really know what she'd imagined. Most importantly, it was pleasantly refreshing with a lingering citrus tang.

"Thanks." As she took another swallow, she held out her hand so he could swipe her comm for the credit.

"First one's on the house, no charge." He waved a dismissive hand before extending it. "I'm Gil."

"Adie." She shook politely. "So, do brewers get extra points when they apply for the Red Card Lottery?"

He grinned. "Something like that. I fancied a new challenge. How about you?"

"Me?" The question caught her unawares. She took another swallow of beer to cover her confusion.

Gil nodded at her wristcomm. "Just graduated, you must be weighing up career track possibilities with your friends."

Of course, he must have talked to any number of her classmates over the past week. Adie sighed. "No one wants to discuss off-world options."

Surely he would understand, if he'd persisted all through the Lottery selection process.

"You want to get away?" He looked sympathetic.

"What? No." Suddenly, all the frustrations she'd been keeping a lid on boiled over. "Why does everyone always say that? I've got nothing to run away from. My parents are great, I love them dearly, and heavens above, this is Mars, not Earth. We're safe, secure, prosperous—"

She shook her head and took another drink. "Why doesn't anyone understand? It's not about getting away. It's about what you're heading for. It's about not knowing what you'll find—"

As she struggled to explain, inspiration struck. She tapped her wristcomm to call up a holodisplay of her personal library. "Look how people used to see Mars. Have you read any of these?"

She tapped the icons to enlarge the book-art thumbnails. Not just the Edgar Rice Burroughs and H.G. Wells that everyone read before Lit Classics took them on to Leigh Brackett, Ray Bradbury, and Robert Heinlein. Adie had personal crawlers programmed to search the datastreams and she read everything they could find, from stories even older than Tavu's grayscale vid, through to the Golden Age of the early 21st Century.

Not to score points with her classmates, as they competed to find the most obscure and bizarre Martian fiction each semester, but to see her home through as many different imaginations as possible.

"It doesn't matter that they were wrong, that there are no frozen canals to skate on, or monsters building tripods. Just look at the possibilities they saw. See how all these writers relished the thrill of the unknown? People back then were ready to take on all the risks and challenges. That's what brought the first settlers here, when travel to Mars was a nine-month, one-way journey. Did you know that their families revived an Old Earth tradition called an American Wake? Back when it took just as long to sail Earth's oceans, they'd have a party to say goodbye forever, when someone was leaving home for a new life abroad. My great-grandparents didn't know that they'd succeed in colonizing Mars, or get back safely if it all went wrong, even with all the automated preparations the robots had done. They still came."

Gil nodded, setting down the glass in his hand and picking up another one to polish. "Wanderlust."

Adie dismissed the array of icons with a gesture, disappointed. "You can't believe in that, surely?" She thought that Lottery applicants were screened for the viral ideas that had long been proven as dangerous as diseases.

But the barman was looking puzzled. "What are you talking about?"

"DRD4-7R? The Wanderlust Gene?" Genetic determinism was only one of the superstitions that had threatened chaos in her grandparents' day, when anyone with enough money could still buy a plasma-jet trip to Mars and a berth in a separatist settlement.

Gil was shaking his head. "I'm talking about the urge to find out what's over the next hill, or beyond the horizon. People have been doing that since—since the Assyrians first brewed beer." He grinned and gestured towards Adie's half-drunk glass. "Who do you suppose first had that idea, thousands of years ago? How many people do you think back then shook their heads and sucked their teeth and asked what was the point? I bet there were plenty saying nothing would come of it, that there were already enough good things to drink. But somebody persisted. More than one somebody, probably. I don't suppose they got it right the first time, or the first ten times, maybe fifty. They didn't give up though, and that meant humanity got something new and wonderful."

As he spoke, he was pouring himself a glass. He raised it to Adie in a toast. "Here's to looking for new things."

"And to seeing what's over the next hill." She returned the salute. "Or on

the first exoplanet."

"Did you see the news about JC-9745 probe?" Gil said eagerly. "I can't wait to see the first datastreams."

"Me too." Then her wristcomm chimed to alert Adie to an approaching shuttle. "I'd better get back home. Thanks for this." She drained her glass.

"See you again," Gil said amiably. "Until you leave."

Adie grinned. "Count on it."

As she walked to the shuttle, her spirits rose at the thought of having someone to talk to about the jump-probe's discoveries. Who knew what JC-9745 might have found? How about alien life more advanced than the Europa Ocean's invertebrates?

First things first, though. As the shuttle doors closed, she began running through the conversation they'd just had in her head. Now Adie knew exactly what she was going to say to her parents, when she showed them her Exoplanet Track application.

About the Authors

RACHEL ATWOOD grew up enchanted with British History. Now she writes historical fiction with enchantments. Her first historical fantasy novel, "Walk the Wild with Me," will be released by DAW Books in 2019.

JACEY BEDFORD is a British writer, published by DAW in the USA. She writes science fiction and fantasy. Her *Psi-Tech* space opera trilogy consists of *Empire of Dust, Crossways*, and *Nimbus*. Her historical fantasy trilogy is 2/3 complete with *Winterwood* and *Silverwolf*. Expect the third instalment, *Rowankind,* in November 2018. Her short stories have appeared in anthologies and magazines, and have been translated into an odd assortment of languages including Estonian, Galician and Polish. She's been a folk singer with vocal trio, Artisan, and her claim to fame is singing live on BBC Radio4 accompanied by the Doctor (Who?) playing spoons. Webpage: www.jaceybedford.co.uk

DIANA PHARAOH FRANCIS writes books of a fantastical, adventurous, and often romantic nature. Her award-nominated novels include The Path series, the Crosspointe Chronicles, the Diamond City Magic books, and the Mission: Magic series. Her novels have been translated into German and French. She holds a Ph.D. in Victorian literature and literary theory, and an MA in fiction writing. She's been teaching for more than 20 years.

She's a member of SFWA and NINC. She's owned by two corgis, spends much of her time herding children, and likes rocks, geocaching, knotting up yarn, and has a thing for 1800s England, especially the Victorians. For more about her writing, visit www.dianapfrancis.com.

DAVID KEENER is an author, editor and public speaker from Northern Virginia, where he lives with his wife and two inordinately large dogs. He writes science fiction, fantasy and mystery but loves the idea of mashing up his favorite genres in new and (hopefully) unexpected ways. He is the grand instigator behind the *Worlds Enough* anthology series, and co-editor of the first volume, *Fantastic Defenders*. He frequently speaks at conferences and conventions, where he often conducts workshops on writing or public speaking. Find out more about him and his books at his web site: http://www.davidkeener.org

WILLIAM LEISNER is the author of the *Star Trek* novels *The Shocks of Adversity, Losing the Peace* and *A Less Perfect Union*. His original fiction includes the ebook *A Dimension of Death*, which sees Rod Serling team up with Gene Roddenberry to solve a murder on the set of *The Twilight Zone*. Yes, he's that geeky. A native of Rochester, New York, he currently lives in Minneapolis.

MIKE MARCUS is a U.S. Army veteran and communications professional just beginning to flex his fiction writing muscles. This is his first professional fiction piece. Mike is a native of Mechanicsville, Md., and a graduate of Frostburg State University in Frostburg, Md. Mike lives in Pittsburgh, Pa. with his wife, Amy, and Rottweiler-mix, Millie. Find Mike on Twitter at @MikeMarcus77.

JULIET E. McKENNA is a British fantasy author. Loving history, myth and other worlds, she has written fifteen epic fantasy novels, starting with *The Thief's Gamble* which began *The Tales of Einarinn*. She writes diverse shorter fiction, from stories for themed anthologies such as *Alien Artifacts* and *Fight Like A Girl* to forays into dark fantasy and steampunk. Exploring new digital opportunities in association with Wizard's Tower Press, she's re-issued her early backlist as ebooks as well as publishing original short story collections and most recently, the modern fantasy The Green Man's Heir. Visit julietemckenna.com or follow @JulietEMcKenna on Twitter.

R.K. NICKEL works as a screenwriter in Los Angeles. His first feature film, *Bear with Us*, is available on Amazon Prime, and "Stellar People," a sci-fi comedy series he wrote for Adaptive Studios, will be coming out sometime in 2018. He dove into his prose journey in 2017, and since then has made 6 sales and attended both the Odyssey Writing Workshop and the Launch Pad Astronomy Workshop. When he's not writing, he's probably playing an escape room or some Magic the Gathering. Or drinking coffee. Mmm…coffee. For more, check out @russnickel on Twitter or www.rknickel.com.

New York Times bestselling novelist **GARTH NIX** has been a full-time writer since 2001, but has also worked as a literary agent, marketing consultant, book editor, book publicist, book sales representative, bookseller, and as a part-time soldier in the Australian Army Reserve. Garth's many books include the Old Kingdom fantasy series, beginning with *Sabriel*; SF novels *Shade's Children* and *A Confusion of Princes*; and novels for children including *The Ragwitch*; *The Seventh Tower* sequence; *The Keys to the Kingdom* series and *Frogkisser!* More than six million copies of his books have been sold around the world and his work has been translated into 42 languages.
Facebook: www.facebook.com/garthnix
Twitter: @garthnix
Webpage: www.garthnix.com

As an author, **AARON M. ROTH** writes stories about the future. As a scientist , he researches artificial intelligence and robotics at Carnegie Mellon University. Visit his website at www.aaronmroth.com.

KRISTINE SMITH is the author of the Jani Kilian series and other science fiction and fantasy novels and short stories under her own name. As Alex Gordon, she has written the supernatural thrillers Gideon and Jericho. Her fiction has been nominated for the Locus Award for First Novel, Philip K. Dick Memorial Award and the IAFA William L. Crawford Fantasy Award, and she was the 2001 winner of the John W. Campbell Award for Best New Writer. She lives in Illinois.
Webpage: https://www.kristine-smith.com
Twitter: KSmithSF
Facebook: https://www.facebook.com/KristineSmithBooks

KARI SPERRING is the author of two novels (*Living with* Ghosts [DAW 2009] and *The Grass King's* Concubine [DAW 2012]. As Kari Maund she has written and published five books and many articles on Celtic and Viking history and co-authored a book on the history and real people behind her favourite novel, *The Three Musketeers* (with Phil Nanson). She's British and lives in Cambridge, England, with her partner Phil and three very determined cats, who guarantee that everything she writes will have been thoroughly sat upon. Her website is http://www.karisperring .com and you can also find her on Facebook.

A.E. STANTON likes horses and motorcycles, the past, and the far future. A.E. also likes to act like a crotchety curmudgeon but can rarely pull it off for long, because it must be admitted that fast cars, dentistry, penicillin, indoor plumbing, and central heat and air make life in the here and now pretty darned nice. A.E. writes stories set in the Old West, in the post-apocalyptic future, and any combo therein. When not riding or writing, A.E. spends time thinking about writing or riding. Reach A.E. (aka Gini Koch) at Old Westerner (http://www.ginikoch.com/asbookstore.htm).

JEAN MARIE WARD writes fiction, nonfiction and everything in between, including novels (2008 Indie Book double-finalist *With Nine You Get Vanyr*) and art books. Her stories appear in numerous anthologies, including *The Modern Fae's Guide to Surviving Humanity*, *Were-*, and *Tales from the Vatican Vaults*. The former editor of *Crescent Blues*, she co-edited the six-volume, 40th anniversary World Fantasy Con anthology *Unconventional Fantasy* and is a frequent contributor to BuzzyMag.com. Her website is JeanMarieWard.com. She can be found on Facebook and Twitter at www.facebook.com/JeanMarieWardWriter/ and @Jean_Marie_Ward, respectively.

About the Editors

PATRICIA BRAY is the author of a dozen novels, including *Devlin's Luck*, which won the Compton Crook Award for the best first novel in the field of science fiction or fantasy. A multi-genre author whose career spans both epic fantasy and Regency romance, her books have been translated into Russian, German, Portuguese and Hebrew. She's also crossed over to the dark side as the co-editor of *After Hours: Tales from the Ur-Bar* (DAW, March 2011) and *The Modern Fae's Guide to Surviving Humanity* (DAW, March 2012), *Clockwork Universe: Steampunk vs. Aliens* (ZNB, June 2014), *Temporally Out of Order* (ZNB, August 2015), *Alien Artifacts* (ZNB, August 2016), *Were-* (ZNB, August 2016), and *All Hail Our Robot Conquerors!* (ZNB, August 2017).

Patricia lives in a New England college town, where she combines her writing with a full-time career as a systems analyst. To offset the hours spent at a keyboard, she bikes, hikes, cross-country skis, snowshoes, and has recently taken up the noble sport of curling. To find out more, visit her website at www.patriciabray.com.

* * *

JOSHUA PALMATIER is a fantasy author with a PhD in mathematics. He currently teaches at SUNY Oneonta in upstate New York, while writing in his "spare" time, editing anthologies, and running the anthology-producing small press Zombies Need Brains LLC. His most recent fantasy novel,

Reaping the Aurora, concludes the fantasy series begun in *Shattering the Ley* and *Threading the Needle*, although you can also find his "Throne of Amenkor" series and the "Well of Sorrows" series still on the shelves. He is currently hard at work writing his next novel and designing the kickstarter for the next Zombies Need Brains anthology project. You can find out more at www.joshuapalmatier.com or at the small press' site www.zombiesneed-brains.com. Or follow him on Twitter as @bentateauthor or @ZNBLLC.

Acknowledgments

This anthology would not have been possible without the tremendous support of those who pledged during the Kickstarter. Everyone who contributed not only helped create this anthology, they also helped solidify the foundation of the small press Zombies Need Brains LLC, which I hope will be bringing SF&F themed anthologies to the reading public for years to come . . . as well as perhaps some select novels by leading authors, eventually. I want to thank each and every one of them for helping to bring this small dream into reality. Thank you, my zombie horde.

The Zombie Horde: Glennis LeBlanc, Kiya Nicoll, Jenny Barber, Ash Marten, Simon Dick, Y. K. Lee, Katherine Malloy, Stephanie Cranford, Chris Matosky, David Perkins, Maureen Brooks, Kevin Wallace, Jonathan Briggs, Laura and Bill Pearson, Sheryl R. Hayes, Kim Lloyd, Tanya Gough, Matt K., Millie Calistri-Yeh, Caitlin Jane Hughes, Harvey Brinda, Julie Haddy, Carolyn Petersen, Konstanze Tants, Nellie B, Bryan Wetterow, Austin, Teresa Carrigan, Aurora N., Michael Fedrowitz, Darrell Z. Grizzle, Debbie Fligor, Mark Carter, Rebecca Sims, Sarah Cornell, David Zurek, Duncan & Andrea Rittschof, The Bowers, Paul McNamee, Pam Blome, Arej Howlett, Troy Chrisman, Larisa LaBrant, Mollie Bowers, Andrew Wilson, Patrick Thomas, melme, Noah Bast, Joseph Hoopman, Stephen Kissinger, Christine Swendseid, Mary Alice Wuerz, Chad Bowden, John Appel, M Harold Page, Lyndsey Flatt, Jesse Klein, Chris Huning, Lorri-Lynne Brown, Mary Soon Lee, Kevin Winter, Ronnie J Darling, John O'Neill, Lily Connors, Casey Sharpe, Kitty Likes, Wolf SilverOak, Elektra, Nicholas Adams, Benjamin C. Kinney, Cherie Livingston, Jaq Greenspon, Howard J. Bampton, David VonAllmen, Kristine Kearney, Erik T Johnson, Andrew Hatchell, Regis M. Donovan, Stephanie Lucas, Brian Quirt, Paul Musselman, Wendy Cornwall, Jaime

O. Mayer, Gina Freed, Vy Anh Tran, Elizabeth Kite, Claire Sims, Debbie Matsuura, K Kisner, April Broughton, R. Hamilton, Vincent Darlage, ANDREW AHN, Carol J. Guess, Cathy Green, Stephen Ballentine, Céline Malgen, Penny Ramirez, Julie Pitzel, Jake, Chrissie, Grace & Savannah, jjmcgaffey, Gabe Krabbe, Bregmann Roche, Patrick Osbaldeston, Lori & Maurice Forrester, Pat Gribben, Robert Claney, Patti Short, Shades of Vengeance, Patricia Bray, Leah Webber, Jen Woods, Rolf Laun, Tibicina, Martin Greening, Judith Bienvenu, Ty Wilda, Sasha, C. Lennox, Brendan Lonehawk, Tom B., Michele Fry, Helen French, Auston Habershaw, FrodoNL, Simba Pipsqueak, Vespry Family, Nancy Edwards, Melissa Tabon, Andy Arminio, K Crowell, Lawrence M. Schoen, Colette Reap, Michael Skolnik, Amy Goldman, Chris 'Warcabbit' Hare, Jo Carol Jones, Eduard Lukhmanov, M.J. Fiori, R.J.H., Eddy Black, Connor Bliss, Yaron Davidson, Annika Samuelsson, Sarah Cottell, Jerrie the filkferengi, Rick Galli, Jakub Narębski, Tanya K., Todd V. Ehrenfels, Liz Wyatt, Uncle Batman, David Eggerschwiler, Tibs, Orla Carey, Jessica Reid, Paul Bustamante, Henry Schubert, Melissa Shumake, William Hughes, Donovan DiPasquale, Gary Phillips, Jay Lofstead, Nathan Turner, Becky Allyn Johnson, Evan Ladouceur, Colleen R., L.C., Jenni Peper, Curtis Frye, Kayliealien, Richard James Errington, Kristi Chadwick, Rick Dwyer, Katchoo, Queen of the Nowells, Revek, Leila Qışın, Heidi Berthiaume, David J. Fortier, Gavran, Sarah Hester, Joanne Burrows, Elise Power, Tasha Turner, Scott Raun, Miranda Floyd, Jörg Tremmel, David A. Holden, Angie Hogencamp, Vicki Greer, AM Scott, SometimesKate, Mike Hampton, Lisa Kruse, Nick W, David Drew, Sidney Whitaker, James Conason, Nancy M. Tice, Sally Qwill Janin, Paula Morehouse, Elaine Tindill-Rohr, Christine Ethier, Kai Delmas, Todd Stephens, Mark Newman, Phillip Spencer, Deanna Harrison, Susan Carlson, Sharon Goza, Marty Poling Tool, Yankton Robins, Linda Pierce, Victoria L. Sullian, Niall Gordon, Peter T, 'Jonesy' Oberholtzer, Michael Abbott, Jonathan Collins, R Tharp, Dave Hermann, Paul y cod asyn Jarman, Hoose Family, Andrija Popovic, Keith Nelson, Paula & Michael Whitehouse, Tory Shade, Brenda Moon, Tina & Byron Connell, Deborah Crook, Moonpuppy61, Nathaniel Pohl, Ian Chung, Beth LaClair, L. E. Doggett, Kerry aka Trouble, Brad L. Kicklighter, Kristine Smith, Michelle L., Elyse M Grasso, Roy Sachleben, Jason Palmatier, Ajay O., Cyn Armistead, Brenda Carre, Alli Martin, Catherine Gross-Colten, Rebecca M, Gary Ehrlich, Mark Hirschman, Anthony R. Cardno, Mark Kiraly, Ed Ellis, David Rowe, Clare Deming, Kat S., VeAnna Poulsen, Sharon Wood, Chuck Wilson, C. L. Werner, Morgan S. Brilliant, Andy Miller, Anders M. Ytterdahl, Heidegger and Mocha, A. Walter Abrao, Max Kaehn, Barbara Becc, Chloe Turner, Jen1701D, Andrew Taylor, Mervi Mustonen, Kimberly M. Lowe, Amanda Nixon, 2-Gun Bill, T. England, Heather Kelly, Darryl M. Wood, Belkis Marcillo, Meredith B, Mark Slauter, Arin Komins, Svend Andersen, Jomelson Co, rissatoo, Misty Massey, Anne Burner, Keith Jones, Jenn Whitworth, Doc Concrescence, Anders Kronquist, Keith West, Future Potentate of the Solar System, Stephanie Cheshire, Ian Harvey, Erin Penn, Beth Lobdell, Khinasidog, Erin Kowalski, Helen Cameron, Kendra Leigh Speedling, Mary-Michelle Moore, Micci Trolio, Amanda Weinstein, Catherine Sharp, K. Gavenman, RKBookman, H. Rasmussen, S Baur, Eagle Archambeault, Keith E. Hartman, Tom Connair, Ivan Donati, Brian Hugenbruch, Paul D Smith, CGJulian, Jeffry Rinkel, Mark F Goldfield, Chuck

Hickson, Michelle Palmer, Alexander Smith, Bill Harting, Sean Collins, Paul Alex Gray, Jason Tongier, Pierre, Lark Cunningham, Brenda Cooper, Fen Eatough, Alysia Murphy, Ilene Tsuruoka, Sheryl Ehrlich, Tina Good, Shel Kennon, Judith Mortimore, Breagha, Fred and Mimi Bailey, Robby Thrasher, Rachel Sasseen, Thea Cooke, Peter Bernstorff, Dino Hicks, Margaret S. McGraw, Lace, Erin Himrod, Steven Mentzel, Samuel Lubell, Linda Bruno, Amanda Stein, Julie Holderman, D-Rock, Adam Thompson, Timothy Nakayama, Antonio Carlos Porto, Melinda Seckington, Nirven, Kristin Evenson Hirst, Mick Gall, Missy Katano, Ken Finlayson, Camden, Steven Torres-Roman, Jennifer Della'Zanna, Gretchen Persbacker, Crystal Sarakas, Michele Hall, K. Hodghead, Marla Anderson, Jennifer Berk, Christina Roberts, Steven Halter, R. Hunter, Ken Woychesko, Firestar, Cindy Cripps-Prawak, David Roffey, Coleman bland, Drammar English, Cheryl Losinger, Peter Hansen, Bryan Easton, Deirdre M. Murphy, Zion Russell, Danielle Hinesly, Dana, Jonathan S. Chance, Nick Martell, K. R. Smith, SwordFire, Jennie Goloboy, Chantelle Wilson, Jenni Hamilton, S. E. Altmann, Lara Ortiz de Montellano, Donna Gaudet, Thea Maia, Jamie Ibson, Wendy Kitchens, Sarah FW, Axisor and Mike, John B. McCarthy, Andrew Barton, Gordon Rios, Kerri Regan, M. E. Gibbs, Kelly Melnyk, Greg Vose, Joe Borrelli, The Mystic Bob, Chris Brant, R Kirkpatrick, Marzie Kaifer, Ingrid deBeus

CPSIA information can be obtained
at www.ICGtesting.com
Printed in the USA
LVHW110009160119
604106LV00002B/326/P